Selections from the
NOTEBOOKS OF
LEONARDO DA VINCI

Selections from the

NOTEBOOKS OF
LEONARDO DA VINCI

Edited with Commentaries
by
Irma A. Richter

OXFORD LONDON NEW YORK
OXFORD UNIVERSITY PRESS
1977

Oxford University Press, Walton Street, Oxford OX2 6DP

OXFORD LONDON GLASGOW NEW YORK
TORONTO MELBOURNE WELLINGTON CAPE TOWN
IBADAN NAIROBI DAR ES SALAAM LUSAKA ADDIS ABABA
KUALA LUMPUR SINGAPORE JAKARTA HONG KONG TOKYO
DELHI BOMBAY CALCUTTA MADRAS KARACHI

ISBN 0 19 281214 9

PRINTED IN GREAT BRITAIN BY
FLETCHER AND SON LTD, NORWICH

PREFACE

During his youth in Renaissance Florence Leonardo conceived of painting as the noblest calling open to mankind and embarked with enthusiasm in its pursuit.

It was not only the beauty of nature but also the spirit at work beneath the world of appearance that fascinated him. Combining an artist's sensitivity with a scientist's desire of knowledge, he analysed the objects of vision and the way in which vision functioned. This entailed the study of nature, its structure and life. As he proceeded his interest in natural science deepened. He used scientific methods of research in order to ascertain Nature's laws and introduce them in his own work. He pursued these studies not merely in order to paint certain pictures commissioned by patrons but for the attainment of creative power. His compositions expressed actions, emotions; faces were moulded by the life within. Landscapes represented the formation of rocks, the growth of plants, the movement of water.

He often made use of his knowledge and experience for practical purposes. Thus this man who created a few works of art divinely well was also a precursor of a new age in science and, incidentally, a civil and military engineer whose inventions embodied in elementary form the principles of modern machinery.

He was enabled to achieve this because he was an artist. In his time there were no professional scientists working by experiment; and the observations of natural phenomena as handed down by Aristotle and other ancient philosophers continued to form the foundation of an authorized creed accepted by the Schoolmen, who deprecated experimental methods as subversive and 'unlettered'.

But being an artist Leonardo steered a course guided by visual experience. His intelligence was free and wholly devoted to inquiry.

At times he realized what fateful catastrophes the well-conceived and universal laws of nature might bring about. Some other time, he was trenchantly critical of the inherent egotism and wickedness of man. Gradually his attitude towards the world became that of a strangely aloof and impersonal observer. When doubts arose in his mind regarding some ancient long-established belief, he would say so in his notes. But since he was not an abstract theorist intent on establishing a logical system, nor a modern scientist concentrating on a special line of research, but a 'universal' genius of the Renaissance intent on artistic creation, he attempted to ground his natural science on an acceptance of the philosophic system, inherited from Greek thought and medieval thought, which conceived of the universe as an organized cosmos corresponding to a work of art; and he profited thereby.

We are enabled to gain insight into his thoughts by reading his notebooks. He used to carry these about with him to sketch instantaneous impressions or to write down ideas as they occurred on the spur of the moment—observations made during walks and travels, reflections on events and persons, on his domestic problems, on his work, on life in general. Manuscripts have survived containing drafts of letters, fanciful descriptions and fables, rough copies of treatises on the power of water, on the art of painting, on the anatomy and movement of the human figure, &c. But they are just notes. Often, remarks on diverse subjects are scribbled on one and the same page, or restatements and clarifications of one and the same idea occur on another page. The following words written on the

front sheet of a manuscript on physics is descriptive of his method of writing.

'*This is to be a collection without order, taken from many papers, which I have copied here, hoping afterwards to arrange them according to the subjects of which they treat; and I believe that I shall have to repeat the same thing several times; for which, O reader, blame me not because the subjects are many, and memory cannot retain them . . . all the more because of the long intervals between one time of writing and another.*'

Leonardo's intention to sort his notes was never carried out. The present volume constitutes an attempt to co-ordinate a selection of them on subjects of general interest. The choice has often been difficult since he was fascinated and distracted by so many problems, depending on his mood and circumstances. We have limited ourselves to quoting typical examples of the main themes. The number at the end of each excerpt refers to pp. 394 ff. where the sources are given. The first three chapters deal with science and nature. In the fourth chapter his treatise on painting is summarized and the ever persistent problems of art are discussed. The fifth chapter contains writings of a literary kind—tales, fables, maxims; the sixth chapter gives reflections on life. In the last chapter references to Leonardo's personal affairs and to his work have been arranged in chronological sequence, strung on the unifying thread of his life, like a diary. Light is thrown on the circumstances in which he lived, on historical events and personages that influenced his course.

Readers must not expect a continuous and coherent narrative. In the circumstances the alinement of texts had to be 'staccato'. Leonardo did not claim to be a man of

letters nor versed in classical literature like most authors of his time. With them in mind he would humbly call himself uomo senza lettere; but with irony, for he was proud of his own method, since he had things to say that were beyond their ken; and he did so in the clear and forceful language of the Italian people.

Now, after five hundred years, Leonardo's notebooks are considered of priceless value, and are to be included in the series of World's Classics by the Oxford University Press.

Readers will see him at work striving to express his thoughts. They will learn to know him, and they will discern an underlying unity. For these manifold observations spring from one consistent spirit. The life of one of the greatest men of the Italian Renaissance is here painted by himself in words.

Vasari begins his biography of the artist by saying: 'Occasionally heaven sends us someone who is not only human but divine, so that through his mind and the excellence of his intellect we may reach out to heaven.' To live close to great minds is the best education, and the happiest thing that can befall us. It is the aim of this book to offer its readers such an opportunity.

1952

ACKNOWLEDGEMENT

The present volume owes its existence to the work of many scholars. Within the last seventy years Leonardo's manuscripts have been transcribed and published (see 'References to Manuscripts', page 393). Being written backward from right to left, since he was left-handed, they were difficult to decipher. It has been possible to date them and ascribe each notebook to a certain period of his life. Attempts to arrange his writings according to subjects have also been made, and translations from the original Italian into other languages are now extant.

Most of the material has been taken from Jean Paul Richter's *Literary Works of Leonardo da Vinci*, the second edition of which was published by the Oxford University Press in 1939, and we refer the student intent on a more thorough study to this work. There he will find the history of the various manuscripts and the original Italian text in its sonorous and powerful style, inimitable in another tongue. In the rendering of translations advantage has also been taken of the *Notebooks of Leonardo da Vinci* by Edward MacCurdy; and in writing the biographical chapter the periodical publications of the Raccolta Vinciana, L. Beltrami's *Documentie Memorie*, and the recent studies on the chronology of Leonardo's manuscripts by Sir Kenneth Clark have proved useful. Among other recent books that have been consulted are Arturo Uccelli's works on Leonardo's mechanics, J. McMurrich Playfair's on his anatomy, and G. Giacomelli's on his aeronautics.

CONTENTS

CONTENTS

I

TRUE SCIENCE

Leonardo's view of what science should be foreshadows the critical and constructive methods of modern times. He proceeded step by step. (1) Experience of the world around us as gained through the senses is taken as the starting-point. (2) Reason and contemplation, which, though linked to the senses, stands above and outside them, deduces eternal and general laws from transitory and particular experiences. (3) These general laws must be demonstrated in logical sequence like mathematical propositions, and finally (4) they must be tested and verified by experiment, and then applied to the production of works of utility or of art according to plan. For Leonardo's purpose in acquiring knowledge was that he might obtain power and produce creations of his own. Truth could thus be verified. He was opposed to philosophical systems founded solely on words.

I. EXPERIENCE

Consider now, O reader! what trust can we place in the ancients, who tried to define what the Soul and Life are—which are beyond proof—whereas those things which can at any time be clearly known and proved by experience remained for many centuries unknown or falsely understood.

Many will think that they can with reason blame me, alleging that my proofs are contrary to the authority of certain men held in great reverence by their inexperienced judgements, not considering that my works are the issue of simple and plain experience which is the true mistress

These rules enable you to know the true from the false—
and this induces men to look only for things that are pos-
sible and with due moderation—and they forbid you to use
a cloak of ignorance, which will bring about that you attain
to no result and in despair abandon yourself to melancholy.

I am fully aware that the fact of my not being a man of
letters may cause certain presumptuous persons to think that
they may with reason blame me, alleging that I am a man
without learning. Foolish folk! Do they not know that I
might retort by saying, as did Marius to the Roman Patri-
cians: 'They who adorn themselves in the labours of others
will not permit me my own.'* They will say that because
I have no book learning, I cannot properly express what I
desire to treat of—but they do not know that my subjects
require for their exposition experience rather than the
words of others. Experience has been the mistress of who-
ever has written well; and so as mistress I will cite her in all
cases.[1]

Though I have no power to quote from authors as they
have, I shall rely on a far bigger and more worthy thing—
on experience, the instructress of their masters. They strut
about puffed up and pompous, decked out and adorned not
with their own labours, but by those of others, and they
will not even allow me my own. And if they despise me
who am an inventor, how much more should they be
blamed who are not inventors but trumpeters and reciters
of the works of others.

Those who are inventors and interpreters between Nature
and Man as compared with the reciters and trumpeters of
the works of others, are to be regarded simply as is an object
in front of a mirror in comparison with its image seen in
the mirror, the one being something in itself, the other
nothing: people whose debt to nature is small, since they

* Marius' speech to the Quirites in Sallust, *Bellum Iugurthinum*,
ch. 85, § 25.

are only by chance invested with the human form, and but for this, I might class them with the herds of beasts.²

Seeing that I cannot find any subject of great utility or pleasure, because the men who have come before me have taken for their own all useful and necessary themes, I will do like one who, because of his poverty, is the last to arrive at the fair, and not being able otherwise to provide for himself, takes all the things which others have already seen and not taken but refused as being of little value; I will load my modest pack with these despised and rejected wares, the leavings of many buyers; and will go about distributing, not indeed in great cities, but in the poor hamlets, taking such reward as the thing I give may be worth.¹

The abbreviators* (of works) do harm to knowledge and to love, for the love of anything is the offspring of knowledge, love being more fervent in proportion as knowledge is more certain. And this certainty springs from a complete knowledge of all the parts which united compose the whole of the thing which ought to be loved.

Of what use, then, is he who in order to abridge the part of the things of which he professes to give complete information leaves out the greater part of the things of which the whole is composed. True it is that impatience, the mother of folly, is she who praises brevity, as if such persons had not life long enough to acquire a complete knowledge of one single subject, such as the human body. And then they want to comprehend the mind of God which embraces the whole universe, weighing and mincing it into infinite parts as if they had dissected it. O human stupidity! do you not perceive that you have spent your whole life with yourself,

* The name 'abbreviatori' was given to the secretaries at the chancery of the Vatican. Leonardo during his stay in Rome was impeded in his anatomical researches by the Vatican and in writing this may have had their obstruction in mind.

and yet are not aware of the thing you chiefly possess, that is of your folly? And so with the crowd of sophists you deceive yourself and others, despising the mathematical sciences in which is contained the true information about the subjects of which they treat. And then you would fain occupy yourself with miracles and write and give information of those things of which the human mind is incapable, and which cannot be proved by any instance from nature. And you fancy you have wrought miracles when you have spoiled the work of some ingenuous mind and do not perceive that you are falling into the same error as he who strips a tree of its adornment of branches laden with leaves intermingled with fragrant flowers or fruit in order to demonstrate the suitability of the tree for making planks. As did Justinus,* abridging the histories of Trogus Pompeius, who had written in an ornate style all the great deeds of his forefathers full of admirable and picturesque descriptions; and by so doing composed a bald work fit only for such impatient minds who fancy they are wasting time when they spend it usefully in the study of works of nature and the deeds of men.[3]

All our knowledge has its origin in our perceptions.[4]

The eye, which is called the window of the soul, is the chief means whereby the understanding may most fully and abundantly appreciate the infinite works of nature.[5]

Experience never errs; it is only your judgement that errs in promising itself results as are not caused by your experiments. Because, given a beginning, what follows from it must be its true consequence unless there is an impediment. And should there be an impediment, the result which ought

* Iunianus Iustinus, Roman historian of the second century, compiler of a selection from the general history written by Pompeius Trogus in the time of Augustus. The book was much used in the Middle Ages.

to follow from the aforesaid beginning will partake of this impediment in a greater or less degree in proportion as this impediment is more or less powerful than the aforesaid beginning. Experience does not err, it is only your judgement that errs in expecting from her what is not in her power. Wrongly do men complain of Experience and with bitter reproaches accuse her of leading them astray. Let Experience alone, and rather turn your complaints against your own ignorance, which causes you to be carried away by your vain and foolish desires as to expect from Experience things which are not within her power; saying that she is fallacious. Wrongly do men complain of innocent Experience, accusing her often of deceit and lying demonstrations.[6]

To me it seems that all sciences are vain and full of errors that are not born of Experience, mother of all certainty, and that are not tested by Experience; that is to say, that do not at their origin, middle, or end, pass through any of the five senses. For if we are doubtful about the certainty of things that pass through the senses how much more should we question the many things against which these senses rebel, such as the nature of God and the soul and the like, about which there are endless disputes and controversies. And truly it so happens that where reason is not, its place is taken by clamour. This never occurs when things are certain. Therefore, where there are quarrels, there true science is not; because truth can only end one way—wherever it is known controversy is silenced for all time, and should controversy nevertheless again arise, then our conclusions must have been uncertain and confused and not truth reborn.

All true sciences are the result of Experience which has passed through our senses, thus silencing the tongues of litigants. Experience does not feed investigators on dreams, but always proceeds from accurately determined first principles, step by step in true sequences to the end; as can

be seen in the elements of mathematics. . . . Here no one argues as to whether twice three is more or less than six or whether the angles of a triangle are less than two right angles. Here all arguments are ended by eternal silence and these sciences can be enjoyed by their devotees in peace. This the deceptive purely speculative sciences cannot achieve.[7]

Beware of the teaching of these speculators, because their reasoning is not confirmed by Experience.[8]

II. REASON AND NATURE'S LAWS

The senses are of the earth; reason stands apart from them in contemplation.[9]

Wisdom is the daughter of experience.* [10]

Experience, the interpreter between formative nature and the human species, teaches that that which this nature works among mortals constrained by necessity cannot operate in any other way than that in which reason, which is its rudder, teaches it to work.[11]

First I shall test by experiment before I proceed farther, because my intention is to consult experience first and then with reasoning show why such experience is bound to operate in such a way. And this is the true rule by which those who analyse the effects of nature must proceed: and although nature begins with the cause and ends with the experience, we must follow the opposite course, namely, begin with the experience, and by means of it investigate the cause.[12]

O marvellous necessity, thou with supreme reason constrainest all effects to be the direct result of their causes, and

* See Dante, *Paradiso*, ii. 94–96. 'Experience, the only fountain whence your arts derive their streams.'

by a supreme and irrevocable law every natural action obeys thee by the shortest possible process.[13]

Nature does not break her law; nature is constrained by the logical necessity of her law which is inherent in her.[14]

Necessity is the mistress and guide of nature.

Necessity is the theme and inventor of nature, its eternal curb and law.[15]

Nature is full of infinite causes that have never occurred in experience.[16]

In nature there is no effect without cause; understand the cause and you will have no need of the experiment.[17]

III. MATHEMATICAL DEMONSTRATION

The method recommended by Leonardo for submitting the results of his investigations corresponds to Euclidian geometry.

The presentation must be made in logical sequence. First came the statement of the theorem, the 'proposition'; then came 'concessions' or 'petitions', i.e. axioms which neither require nor are capable of proof and must be taken for granted; whereupon followed the examination of the subjects under consideration.

Let no man who is not a mathematician read the elements of my work.[18]

There is no certainty where one can neither apply any of the mathematical sciences nor any of those which are connected with the mathematical sciences.[19]

Whoever condemns the supreme certainty of mathematics

feeds on confusion, and can never silence the contradictions of the sophistical sciences, which lead to an eternal quackery.[20]

Science is an investigation by the mind which begins with the ultimate origin of a subject beyond which nothing in nature can be found to form part of the subject. Take, for example, the continuous quantity in the science of geometry: if we begin with the surface of a body we find that it is derived from lines, the boundaries of the surface. But we do not let the matter rest there, for we know that the line in its turn is terminated by points, and that the point is that ultimate unit than which there is nothing smaller. Therefore the point is the first beginning of geometry, and neither in nature nor in the human mind can there be anything which can originate the point. . . . No human investigation can be called true science without passing through mathematical tests; and if you say that the sciences which begin and end in the mind contain truth, this cannot be conceded and must be denied for many reasons. First and foremost because in such mental discourses experience does not come in, without which nothing reveals itself with certainty.[21]

Specification of what I ask should be taken for granted in my proofs with perspective. I ask, let it be granted that all rays passing through the air be of the same kind and travel in straight lines from their source to the objects that they strike.[22]

Here you must proceed methodically; that is, you must distinguish between the various parts of the proposition so that there may be no confusion and you may be well understood.[23]

See to it that the examples and proofs that are given in this work are defined before you cite them.[24]

IV. EXPERIMENT

But before you base a law on this case test it two or three times and see whether the tests produce the same effects.[25]

This experiment should be made many times so that no accident may occur to hinder or falsify this proof, for the experiment may be false whether it deceived the investigator or no.[26]

When you put together the science of the motion of water, remember to include in each proposition its application and use, in order that these sciences may not be useless.[27]

Science is the captain and practice the soldiers.[28]

O speculator on things, boast not of knowing the things that nature ordinarily brings about; but rejoice if you know the end of those things which you yourself devise.[29]

Those who fall in love with practice without science are like a sailor who enters a ship without helm or compass, and who never can be certain whither he is going.[30]

Mechanics is the paradise of mathematical science, because by means of it one comes to the fruits of mathematics.[31]

V. SEARCH FOR TRUE KNOWLEDGE

ALCHEMY

Leonardo admonishes alchemists to observe the processes of nature rather than search for gold. These early chemists whose operations extended through the Middle Ages left behind an extensive literature, the witness of the credulity and ignorance of those times. Until men like Leonardo began to observe Nature for the sake of learning her ways,

no real progress was made. In the following quotation modern scientific views are intermingled with medieval poetical fancies—gold is called an emblem of the sun, natural organisms are called 'elements'.

Nature is concerned with the production of elementary things. But man from these elementary things produces an infinite number of compounds; although he is unable to create any element except another life like himself—that is, in his children.

Old alchemists will be my witnesses, who have never either by chance or by experiment succeeded in creating the smallest element which can be created by nature; however, the creators of compounds deserve unmeasured praise for the usefulness of the things invented for the use of men, and would deserve it even more if they had not been the inventors of noxious things like poisons and other similar things which destroy life or mind; for which they are not exempt from blame. Moreover, by much study and experiment they are seeking to create not the meanest of Nature's products, but the most excellent, namely gold, true son of the sun, inasmuch as of all created things it has most resemblance to the sun. No created thing is more enduring than this gold. It is immune from destruction by fire, which has power over all other created things, reducing them to ashes, glass, or smoke. And if gross avarice must drive you into such error, why do you not go to the mines where Nature produces such gold, and there become her disciple? She will in faith cure you of your folly, showing you that nothing which you use in your furnace will be among any of the things which she uses in order to produce this gold. Here there is no quicksilver, no sulphur of any kind, no fire nor other heat than that of Nature giving life to our world; and she will show you the veins of the gold spreading through the blue lapis lazuli, whose colour is unaffected by the power of the fire.

And examine well this ramification of the gold and you will see that the extremities are continuously expanding in slow movement, transmuting into gold whatever they touch; and note that therein is a living organism which it is not in your power to produce.[32]

Of all human opinions that is the most foolish which believes in necromancy, the sister of alchemy. But it is more open to reprehension than alchemy because it never gives birth to anything except things like itself, that is to say, lies; this does not happen in alchemy, whose function cannot be exercised by nature herself, because there are in her no organic instruments wherewith she might do the work that man performs with his hands, by the use of which he has made glass, &c. But this necromancy, the flag and flying banner blown by the wind, the guide of the stupid multitude, which is constantly witness to the limitless effects of this art; and they have filled books, declaring that enchantments and spirits can work and speak without tongues, and can speak without organic instruments—without which speech is impossible—and can carry the heaviest weights and bring tempest and rain; and that men can be turned into cats and wolves and other beasts, although indeed it is those who affirm such things who first become beasts. And surely if this necromancy did exist, as is believed by shallow wits, there is nothing on earth that would have so much importance alike for the harm and the service of man; if it were true that there were in such an art a power to disturb the tranquil serenity of the air, and convert it into darkness, to create coruscations and winds with dreadful thunder and lightning flashing through the darkness, and with impetuous storms to overthrow high buildings and to uproot forests: and with these to shake armies and break and overthrow them, and—more important than this—to create the devastating tempests and thereby deprive the peasants of the reward of their labours. For what method of warfare can

there be which can inflict such damage upon the enemy as the power to deprive him of his harvests? What naval battle could be compared with that which he could wage who has command of the winds and can make ruinous gales that would submerge any fleet whatsoever? Surely whoever commands such violent forces will be lord of the nations, and no human ingenuity will be able to resist his destructive forces. The buried treasures, the jewels that lie in the body of the earth, will all be made manifest to him. No lock or fortress, however impregnable, will avail to save anyone against the will of such a necromancer. He will have himself carried through the air from East to West, and through all the opposite parts of the universe. But why should I enlarge further on this? What is there which could not be done by a craftsman such as this? Almost nothing, except the escape from death.

We have, therefore, explained in part the mischief and the usefulness that belong to such an art if it is real. And if it is real, why has it not remained among men who desire it so much, not having regard to any deity? For I know that there are numberless people who, in order to gratify one of their appetites, would destroy God and the whole of the universe. If this art has never remained among men, although so necessary to them, it never existed, and never will exist.[33]

It is impossible that anything of itself alone can be the cause of its creation; and those things which are of themselves are eternal.[34]

II

THE UNIVERSE

In Leonardo's time the universe was conceived as the work of an omnipotent and purposeful creator. Inside an all-inclusive sphere four elements had concentric regions assigned to them. Earth occupied the centre. Surrounding it was water; then came a layer of air; and then, enveloping the whole, fire. These four elements did not remain at rest in their own realms, but were constantly shaken and thrown into neighbouring fields; and it was their nature to drift back to where they belonged—their law of gravitation, so to speak. Leonardo had grown up with this conception based on ancient traditions and accepted it on the whole; and as he was self-educated it is at times difficult to discern whether certain of his notes expressed original ideas or were transcriptions from books procured during his continued efforts towards enlightenment.

In explaining phenomena, however, he did not refer to hypothetical unknown agencies but to the activities of Nature. While agreeing with some established theories he rejected others by his strictly empirical and experimental method.

He set out to examine the interactions of four natural powers: namely, weight and force, movement and percussion. These he observed at work within the four elements, in the heat of the sun and in the flame, in the wind, in the wave and the stream, in the formation of the earth's crust, in the growth of plants, in the muscular energy of men and animalss

He proceeded to establish laws governing the release of

power and its transmission. Why not control this power and make it available for mechanical work?

He experimented with leverage, haulage, propulsion, collision. Various inventions resulted from his studies. Yet it occurred to him that man might abuse his privilege in order to cause destruction. Furthermore, might not Nature rise in revolt and provoke a cataclysm? The first part of the present chapter contains a description of the physical world as Leonardo envisaged it. In the second part some of his notes on power and on theoretical mechanics have been co-ordinated. The third part gives a few of his numerous notes on applied mechanics: on friction, on weighing-instruments, tackles, wheels, screws, &c. His efforts to construct a flying-machine will be described in Chapter III.

I. THE FOUR ELEMENTS

Anaxagoras

Everything comes from everything, and everything is made from everything, and everything can be turned into everything else; because that which exists in the elements is composed of those elements.[1]

The configuration of the elements

Of the configuration of the elements; and first against those who deny the opinion of Plato, saying that if these elements invest one another in the forms which Plato* attributed to

* *Timaeus,* 55.

them a vacuum would be caused between one and the other. I say this is not true, and I here prove it, but first I desire to propound some conclusions. It is not necessary that the elements which invest one another be of corresponding size in all the parts that invest and are invested. We see that the sphere of the water is manifestly of varying depth from its surface to its bottom; and that it not only would invest the earth when that was in the form of a cube, that is, of eight angles, as Plato will have it; but that it invests the earth which has innumerable angles of rocks and various prominencies and concavities, and yet no vacuum is generated between the earth and the water; again, the air invests the sphere of water together with the mountains and valleys which rise above that sphere, and no vacuum remains between the earth and the air, so that anyone who says that a vacuum is there generated speaks foolishly.

To Plato I would reply that the surfaces of the figures which the elements would have according to him could not exist. Every flexible and liquid element has of necessity its spherical surface. This is proved with the sphere of water. Let me begin by setting forth certain conceptions and conclusions. That thing is higher which is more remote from the centre of the world, and that is lower which is nearer to the centre. Water does not move of itself unless it descends and in moving it descends. These four conceptions, linked two by two, serve to prove that water that does not move of itself has its surface equidistant to the centre of the world, speaking of the great masses and not of drops or other small quantities that attract one another as the steel its filings.[2]

The bodies of the elements are united and in them there is neither gravity nor lightness. Gravity and lightness are produced in the mixture of the elements.[3]

[With a drawing of four concentric circles enclosing the four elements and a weight placed on top. R., Plate CXXI.]
Why does not the weight remain in its place?

It does not remain because it has no support.

Where will it move to? It will move towards the centre. And why by no other lines? Because a weight which has no support falls by the shortest road to the lowest point, which is the centre of the world. And why does the weight know how to find it by so short a line? Because it does not go like a senseless thing and does not move about in various directions.[4]

The watery element will be pent up within the raised banks of the rivers and the shores of the sea. Hence the encircling air will have to envelop and circumscribe an increased and more complicated structure of earth; and this great mass of earth suspended between the element of water and fire will be hampered and deprived of the necessary supply of moisture. Hence the rivers will remain without their waters; the fertile earth will put forth no more garlands of leaves; the fields will no more be decked with waving corn; all the animals, finding no fresh grass for pasture, will perish; food will be lacking to the ravening lions and wolves and other beasts of prey; and men after many desperate shifts will be forced to abandon their life, and the human race will cease to be. In this way the fertile and fruitful earth being deserted will be left arid and sterile; but owing to the water being confined in its womb, and owing to the activity of nature, it will continue for a little while in its law of growth, until the cold and rarefied air has disappeared. Then the earth will be forced to close with the element of fire and its surface will be burnt to cinders, and this will be the end of all terrestrial nature.[5]

I. WATER

Water had a great fascination for Leonardo. He looked upon it as the driving force of the universe and thought that he might solve the mysteries of creation by studying the laws of its movement through earth and air.

Drawings and memoranda scattered over manuscripts of different dates show that the subject absorbed his attention more or less continuously. We can see him walking, notebook in hand, along the sea-shore contemplating the ebb and flow of the tides, the winds as they trouble the surface of the water, the surge of the waves, the drift of the sands; or he might be standing by the riverside watching the currents and eddies and inspecting the deposits on the banks; or lingering by a stagnant pond looking at the reflections, the lustre on plants, and the play of the fish beneath. Whereupon he would throw a stone into the still water and compare the ever-widening circles on the surface with waves of sound ringing through the air. Another time he may be walking up a mountain valley in order to trace a brook to its source while observing the waterfalls and the ceaseless grinding of rocks and pebbles. The existence of marine shells and fossils inland and at high altitudes and the varying strata of soil or rock led him to conceive of streams as chief agents in the formation of the earth's surface, and he foreshadowed the conception of gradual evolution. As engineer he embarked on schemes of canalization, irrigation, and drainage and the utilization of water-power for pumping, sawing, and grinding. As architect he designed fountains and landscape gardens. As artist he loved to introduce streams winding through rock formations into his backgrounds, for he claimed that the painter can represent both the human figure and inanimate nature, that man must be visualized as forming part of creation. His imaginative description of the Deluge (see p. 187 ff.) draws a picture of the destructive power of this element. He also wrote a book on The Nature of Water, *which lay in his room when the Cardinal of Aragon paid him a visit at Amboise in 1517 (see p. 384). A manuscript*

entitled 'On the Nature, Weight and Movement of Waters' is now in the possession of Lord Leicester at Holkham Hall in Norfolk.

Water is the driver of nature.

Water, which is the vital humour of the terrestrial machine, moves by its own natural heat.[6]

Write first of all water, in each of its motions, then describe all its bottoms and their various materials, referring always to the propositions concerning the said waters; and let the order be good, as otherwise the work will be confused. Describe all the shapes that water assumes from its greatest to its smallest wave, and their causes.[7]

Divisions of the book

Book 1 of the nature of water
Book 2 of the sea
Book 3 of subterranean rivers
Book 4 of rivers
Book 5 of the nature of the depths
Book 6 of the obstacles
Book 7 of gravels
Book 8 of the surface of water
Book 9 of the things that move on it
Book 10 of the repairing of rivers
Book 11 of conduits
Book 12 of canals
Book 13 of machines turned by water
Book 14 of raising water
Book 15 of the things which are consumed by water.[8]

From the Order of the Book of Water

Whether the flow and ebb are caused by the moon or sun

or are the breaking of this machine of the earth. How the flow and ebb differ in different countries.

How in the end the mountains will be levelled by the waters, seeing that they wash away the earth which covers them and uncover their rocks, which begin to crumble and subdued alike by heat and frost are being continually changed into soil. The waters wear away their bases and the mountains fall bit by bit in ruin into the rivers . . . and by reason of this ruin the waters rise in a swirling flood and form great seas.

How in violent tempests the waves throw down every light thing and suck much earth into the sea, which causes the water of the sea to be turbid over a wide space.

How loose stones at the base of wide, steep-sided valleys when they have been struck by the waves become rounded bodies, and many things do likewise when pushed or sucked into the sea by the waves.

How the waves quieten down and make long stretches of calm water within the sea without movement when two opposite winds meet.[9]

The Order of the First Book on Water

Define first what is meant by weight and depth; also how the elements are situated one inside another. Then what is meant by solid weight and liquid weight; but first what weight and lightness are in themselves. Then describe why water moves, and why its motion ceases; then why it becomes slower or more rapid.[10]

Of the four elements water is the second in weight and the second in respect of mobility. It is never at rest until it unites with the sea, where, when undisturbed by the winds, it establishes itself and remains with its surface equidistant from the centre of the world.

It readily raises itself by heat in thin vapour through the air. Cold causes it to freeze. Stagnation makes it foul.

That is, heat sets it in motion, cold causes it to freeze, immobility corrupts it.

It is the expansion and humour of all vital bodies. Without it nothing retains its form. By its inflow it unites and augments bodies.

It assumes every odour, colour, and flavour and of itself it has nothing.[11]

Water is by its weight the second element that encompasses the earth, and that part of it which is outside its sphere will seek with rapidity to return there. And the farther it is raised above the position of its element the greater the speed with which it will descend to it. Its qualities are dampness and cold. It is its nature to search always for the low-lying places when without restraint. Readily it rises up in steam and mist, and changed into cloud it falls again in rain as the minute parts of the cloud assemble and form drops. At different altitudes it assumes different forms, namely water or snow or hail. It is constantly buffeted by the movement of the air, and it attaches itself to that body on which the cold has most effect, and it takes with ease odours and flavours.[12]

It is not possible to describe the process of the movement of water unless one first defines what gravitation is and how it is created or dies. . . .

If the whole sea rests and supports itself upon its bed, the part of the sea rests upon the part of the bed; and as the water has weight when out of its element it should weigh down and press upon the things that rest on its bed. But there we see the contrary; for the seaweed and grass that is growing in these depths are neither bent nor crushed upon the bottom but they cleave the water readily as though they were growing within air.

So we arrive at this conclusion: that all the elements, though they are without weight in their own sphere, possess

weight outside their sphere, that is, when moved away towards the sky, but not when moved towards the centre of the earth. Because if an element moves towards this centre it encounters another element heavier than itself, whose thinnest and lightest part is touching an element lighter than itself, and whose heavier part is placed near the element that is heavier than itself.[13]

That power shows itself greater which is impressed upon a lesser resistance. This conclusion is universal and we may apply it to the flow and ebb in order to prove that the sun or moon impresses itself more on its object, that is, on the waters, when these are less deep. Therefore the shallow, swampy waters ought to react more strongly to the cause of the flow and ebb than the great depths of the ocean.[14]

This wears down the high summits of the mountains. This lays bare and removes the great rocks. This drives the sea from its ancient shores, for it raises its bottom with the soil that it brings. This shatters and destroys the high banks. In this no stability can ever be discerned which its nature does not at once bring to naught. It seeks with its rivers every sloping valley where it carries off or deposits fresh soil. Therefore it may be said that there are many rivers through which all the element has passed and have returned the sea to the sea many times. And no part of the earth is so high but that the sea has been at its foundations, and no depth of the sea is so low but that the highest mountains have their bases there. And so it is now sharp and now strong, now acid and now bitter, now sweet and now thick or thin, now it is seen bringing damage or pestilence and then health or, again, poison. So one might say that it changes into as many natures as are the different places through which it passes. And as the mirror changes with the colour of its objects so this changes with the nature of the place where it passes: health-giving, harmful, laxative, astringent, sulphurous, salt,

sanguine, depressed, raging, angry, red, yellow, green, black, blue, oily, thick, thin. Now it brings a conflagration, then it extinguishes; is warm and is cold; now it carries away, then it sets down, now it hollows out, then it raises up, now it tears down, then it establishes, now it fills up and then it empties, now it rises and then it deepens, now it speeds and then lies still, now it is the cause of life and then of death, now of production and then of privation, now it nourishes and then does the contrary, now it is salt and then is without savour, and now with great floods it submerges the wide valleys. With time everything changes. Now it turns to the northern parts eating away the base of its banks; now it overthrows the opposite bank on the south; now it turns to the centre of the earth consuming the bottom which supports it; now it leaps up seething and boiling towards the sky. Now it confounds its course by revolving in a circle, and now it extends on the western side and robs the husbandmen of their tilth, and then it deposits the taken soil on the eastern side. And thus at times it digs out and at times fills in, as it takes and as it deposits. Thus, without rest it is ever removing and consuming her borders. So at times it is turbulent and goes raving in fury, at times clear and tranquil it flows playfully with gentle course among fresh meadows. At times it falls from the sky in rain or snow or hail, at times forms great clouds of fine mist. At times it is moved of itself, at times by the force of others; at times it supports the things that are born by its life-giving moisture, at times shows itself fetid or full of pleasant odours. Without it nothing can exist among us. At times it is bathed in the hot element and dissolving into vapour becomes mingled with the air, and drawn upwards by the heat it rises until it reaches the cold region and is pressed closer together by its contrary nature, and the minute particles become attached together. As when the hand under water squeezes a sponge which is well saturated so that the water therein escapes through the crevices and

drives the rest from its position by its wave, so it is with the cold which the warm moisture compresses. For when reduced to a denser form the air that is pent up within it breaks by force the weakest part and hisses just as though it was coming out of bellows that are pressed down by an insupportable weight. And thus the lighter clouds which in various positions form obstacles in its course are driven away.[15]

Of Waves

The wave is the recoil of the stroke and it will be greater or less in proportion as the stroke is greater or less. A wave is never alone but is mingled with as many other waves as there are inequalities on the banks where the wave is produced. . . .

If you throw a stone into a pond with differently shaped shores all the waves which strike against these shores are thrown back towards the spot where the stone struck; and on meeting other waves they never intercept each other's course . . . a wave produced in a small pond will go and return many times to the spot where it originated. . . . Only in high seas do the waves advance without recoil. In small ponds one and the same stroke gives birth to many motions of advance and recoil. The greater wave is covered with innumerable other waves which move in different directions; and these are deep or shallow according to the power that generated them. . . . Many waves turned in different directions can be created between the surface and the bottom of the same body of water at the same time . . . all the impressions caused by things striking upon the water can penetrate one another without being destroyed. One wave never penetrates another; but they only recoil from the spot where they strike.[16]

When the wave has been driven on to the shore by the force of the wind it forms a mound by putting its upper part at

the bottom and turns back on this until it reaches the spot where it is beaten back anew by the succeeding wave which comes from below and turns it over on its back, and so overthrows the mound and beats it back again on the aforesaid shore, and so continues time after time, turning now to the shore with its upper movement and now with its lower fleeing away from it. . . . If the water of the sea returns towards the bed of the sea after the percussion made upon its shore, how can it carry the shells, molluscs, snails, and similar things raised from the bottom of the sea and leave them upon this shore? The movement of these things towards the shore commences when the percussion of the falling wave meets the reflex wave, for the things raised from the bottom often leap up in the wave that bounds towards the shore, and their solid bodies are raised in the mound which then draws them back towards the sea; and so continues the succession until the storm begins to abate, and they are left stage by stage where the greater waves had reached and deposited the booty which they carried, and the succeeding waves did not reach the same mark. There remain the things cast up by the sea.[13]

A wave of the sea always breaks in front of its base, and that portion of the crest will then be lower which before was highest.[17]

The spiral or rotary movement of every liquid is swifter in proportion as it is nearer to the centre of its revolution. This is a fact worthy of note, since movement in a wheel is so much slower as it is nearer to the centre of the revolving object. . . .[18]

[With a drawing showing water taking the form of hair.]

Observe the motion of the surface of the water, how it resembles that of hair, which has two movements—one depends on the weight of the hair, the other on the direction of the curls; thus the water forms whirling eddies, one part following the impetus of the chief current, and the other following the incidental motion and return flow.[19]

The centre of a particular sphere of water is that which is formed in the tiniest particles of dew, which is often seen in perfect roundness upon the leaves of plants where it falls; it is of such lightness that it does not flatten out on the spot where it rests, and it is almost supported by the surrounding air, so that it does not itself exert any pressure, or form any foundation; and because of this its surface is drawn towards its centre with equal force from every side; and so each part runs to meet another with equal force and they become magnets one of another, with the result that each drop necessarily becomes perfectly spherical, forming its centre in the middle, equidistant from each point of its surface; and as it is pulled equally by each part of its gravity, it always places itself in the middle between opposite parts of equal weight. But when the weight of this particle of water comes to be increased, the centre of the spherical surface immediately leaves this particular portion of water, and moves towards the common centre of the sphere of the water; and the more the weight of this drop increases the more the centre of the said curve approaches towards the centre of the world.[20]

If a drop of water falls into the sea when it is calm, it must

of necessity follow that the whole surface of the sea is raised imperceptibly, seeing that water cannot be compressed within itself like air.[21]

2. WATER AND EARTH

The surface of the sphere of water does not move from its circuit round the centre of the world which it invests at an equal distance. And it would not move from this equidistance if the earth, which is the support and the vase of the water, did not rise above it, away from the centre of the world.

The earth is moved from its position by the weight of a little bird alighting upon it.

The surface of the sphere of the water is moved by a little drop of water falling into it.[22]

It is of necessity that there should be more water than land, and the visible portion of the sea does not show this; so that there must be a great deal of water inside the earth, besides that which rises into the lower air and which flows through rivers and springs.[23]

Amid all the causes of the destruction of human property, it seems to me that rivers hold the foremost place on account of their excessive and violent inundations. If anyone should wish to uphold fire against the fury of impetuous rivers, he would seem to me to be lacking in judgement, for fire remains spent and dead when fuel fails, but against the irreparable inundation caused by swollen and proud rivers no resource of human foresight can avail; for in a succession of raging and seething waves gnawing and tearing away high banks, growing turbid with the earth from ploughed fields, destroying the houses therein and uprooting the tall trees, it carries these as its prey down to the sea which is its lair, bearing along with it men, trees, animals, houses, and lands, sweeping away every dike and every kind of barrier,

bearing along the light things, and devastating and destroying those of weight, creating big landslips out of small fissures, filling up with floods the low valleys, and rushing headlong with destructive and inexorable mass of waters.

What a need there is of flight for whoso is near!

O, how many cities, how many lands, castles, villas, and houses has it consumed!

How many of the labours of wretched husbandmen have been rendered idle and profitless! How many families have been ruined and overwhelmed! What shall I say of the herds of cattle which are drowned and lost! And often issuing forth from its ancient rocky beds it washes over the tilled (fields). . . .[24]

(a) The Deluge and Shells

Since things are far more ancient than letters, it is not to be wondered at if in our days no record exists of how these seas covered so many countries; and if moreover such record ever existed, the wars, the conflagrations, the deluges of the waters, the changes of languages and of laws, have consumed every vestige of the past. But sufficient for us is the testimony of things produced in the salt waters and found again in the high mountains, far from the seas of today.[25]

In this work of yours you have first to prove that the shells at a height of a thousand braccia were not carried there by the Deluge, because they are seen at one and the same level, and many mountains are seen to rise considerably above that level; and to inquire whether the Deluge was caused by rain or by the swelling of the sea; and then you must show how, that neither by rain which makes the rivers swell, nor by the overflow of the sea could the shells, being heavy objects, be driven by the sea up the mountains or be carried there by the rivers contrary to the course of their waters.[26]

You now have to prove that the shells cannot have originated if not in salt water, almost all being of that sort; and

that the shells in Lombardy are at four levels, and thus it is
everywhere, having been made at various times. And they
all occur in valleys that open towards the sea.[27]

Shells and the reason of their shape

The creature that resides within the shell constructs its
dwelling with joints and seams and roofing and various
other parts, just as man does in the house where he dwells;
and this creature expands the house and roof gradually as
its body increases, since it is attached to the sides of these
shells. Therefore the brightness and smoothness of these
shells on the inner side is somewhat dulled at the point
where they are attached to the creature that dwells there,
and its hollow is roughened, in order to receive the knitting
together of the muscles by means of which the creature
draws itself in when it wishes to shut itself up within its
house. And if you wish to say that the shells are produced by
nature in these mountains by means of the influence of the
stars, in what way will you show that this influence pro-
duces in the same place shells of various sizes and varying
age, and of different kinds?

Shingle

And how will you explain to me the fact of the shingle
being all stuck together and lying in layers at different
altitudes on the high mountains? For here there is to be
found shingle carried from various parts to the same spot by
the rivers in their course; and this shingle is nothing but
pieces of stone which have lost their sharp edges from hav-
ing been rolled over for a long time, and from the various
blows and falls which they have experienced during the pas-
sage of the waters which have brought them to this spot.[28]

If the Deluge had carried the shells for distances of three
and four hundred miles from the sea it would have carried
them mixed with various other natural objects all heaped

up together; but even at such distances from the sea we see the oysters all together and also the shellfish and the cuttlefish and all the other shells which congregate together, found all together dead; and the solitary shells are found apart from one another as we see them every day on the sea-shores.

And we find oysters together in very large families, among which some may be seen with their shells still joined together, indicating that they were left there by the sea and that they were still living when the strait of Gibraltar was cut through. In the mountains of Parma and Piacenza multitudes of shells and corals with holes may be seen still sticking to the rocks. . . .

Underground and under the deep excavations of stone quarries timbers of worked beams are found which have already turned black. They were found in my time in those diggings at Castel Fiorentino. And these were buried in that deep place before the sand deposited by the Arno in the sea which then covered the plain had been raised to such a height, and before the plains of Casentino had been so much lowered by the removal of the earth which the Arno was continually washing away from there. . . .

The red stone of the mountains of Verona is found all intermingled with shells turned into this stone; some of them have been sealed at the mouth by the cement which is of the substance of the stone; and in some parts they have remained separate from the mass of the stone which enclosed them; because the outer covering of the shell had intervened and prevented them from uniting; and in other places this cement had petrified the old broken outer covering.

And if you were to say that these shells have been created and still constantly are being created in such places by the nature of the locality and through the potency of the heavens in those spots, such an opinion cannot exist in brains of any extensive powers of reasoning, because the years of their

growth are here numbered upon the outer coverings of the shells; and large and small ones may be seen, and these would not have grown without food and could not have fed without motion, and here they would not be able to move.[29]

And if you should say that it was the Deluge that carried these shells away from the sea for hundreds of miles, this cannot have happened since the Deluge was caused by rains; because rains naturally force the rivers towards the sea with the objects carried by them, and they do not draw up to the mountains the dead things on the sea-shores.

And if you should say that the Deluge then rose with its waters above the mountains, the movement of the sea in its journey against the course of the rivers must have been so slow that it could not have carried, floating upon it, things heavier than itself; and even if it had supported them, then as it receded it would have left them strewn about in various places. How are we to account for the corals which are found every day towards Monferrato in Lombardy with worm-holes in them, sticking to the rocks which have been left bare by the currents of rivers? These rocks are all covered with stocks and families of oysters, which as we know do not move, but always remain fixed by one of their valves to the rocks, and the other they open to feed upon the animalcules that swim in the water and which, hoping to find good pasture, become the food of these shells.[30]

Here a doubt arises, and that is: whether the Flood which came at the time of Noah was universal or not. And it would seem not, for the reasons which will now be given: We have it in the Bible that the said Flood consisted in forty days and forty nights of continuous and universal rain, and that this rain rose ten cubits above the highest mountain in the world. But if it had been the case that the rain was universal it would have formed a covering around the globe spherical in shape. And this spherical surface is in every part

equidistant from the centre of its sphere; and the waters of the sphere finding themselves in the aforesaid condition it is impossible for the water upon the surface to move; because water does not move of its own accord unless to descend. How then did the water of so great a flood depart, if it is proved that it had no power of motion? and if it departed, how did it move unless it went upwards? Here, then, natural reasons fail us; and therefore to resolve such a doubt we must needs either call in a miracle to aid us, or else say that all this water was evaporated by the heat of the sun.[31]

(b) Rivers and Strata

Of the different rates of speed of currents from the surface of the water to the bottom.

Of the different cross slants between the surface and the bottom.

Of the different currents on the surface of the waters.

Of the different currents on the bed of the rivers.

Of the different depths of the rivers.

Of the different shapes of the hills covered by the waters.

Of the different shapes of the hills uncovered by the waters.

Where the water is swift at the bottom and not above.

Where the water is slow at the bottom and swift above.

Where it is slow below and above and swift in the middle.

Where it is slow in the middle and swift below and above.

Where the water in the rivers stretches itself out and where it contracts. Where it bends and where it straightens itself.

Where it penetrates evenly in the expanses of rivers and where unevenly. Where it is low in the middle and high at the sides.

Where it is high in the middle and low at the sides.

Where the current goes straight in the middle of the stream. Where the current winds, throwing itself on different sides.

Of the different slants in the descents of the water.[32]

What is the current of water?

The current of water is the concourse of the reflections which rebound from the bank of the river towards its centre, in which concourse the two streams of water thrown back from the opposite banks of the river encounter each other; and these waters as they encounter each other produce the biggest waves of the river, and as these fall back into the water they penetrate it and strike against the bottom as though they were a substance heavier than the rest of the water, and rub against the bottom, ploughing it up and consuming it, and carrying off and transporting with them the material they have dislodged. And therefore the greatest depth of the water of a river is always below the greatest current.[33]

I perceive that the surface of the earth was from of old entirely filled up and covered over in its plains by the salt waters, and that the mountains, the bones of the earth, with their wide bases, penetrated and towered up amid the air, covered over and clad with much high-lying soil. Subsequently the incessant rains have caused the rivers to increase and by repeated washing have stripped bare part of the lofty summits of these mountains, so that the rock finds itself exposed to the air, and the earth has departed from these places. And the earth from off the slopes and the lofty summits of the mountains has already descended to their bases, and has raised the beds of the seas which encircle these bases, and caused the plain to be uncovered, and in some parts has driven away the seas from there over a great distance.[34]

In every concavity at the summit of the mountains we shall always find the divisions of the strata in the rocks.[35]

How the valleys were formerly in great part covered by
lakes, because their soil always forms banks of rivers, and
by seas, which afterwards through the persistent action of
the rivers . . . cut through the mountains; and the rivers in
their wandering courses carried away the high plains en-
closed by the mountains; and the cuttings of the mountains
are shown by the strata in the rocks which correspond to the
sections made by the said courses of the rivers.[36]

A river that flows from the mountains deposits a great
quantity of large stones in its bed, and these stones still re-
tain some part of their angles and sides; and as it proceeds on
its course it carries down with it lesser stones with the
angles more worn away, and so the large stones make
smaller ones; and farther on it deposits first coarse and then
fine gravel, and after this follows sand at first coarse and
then more fine; and thus continuing the water turbid with
sand and shingle reaches the sea.

And the sand is deposited on the sea-shores by the back-
wash of the salt waves, until the sand becomes so fine as to
seem almost like water. And it will not remain on the sea-
shores but returns with the wave by reason of its lightness,
being formed of rotten leaves and other very light things.
And consequently being, as has been said, almost of the
nature of water, it afterwards, when the weather is calm,
drops down and settles at the bottom of the sea, where by
reason of its fineness it becomes compressed and resists the
waves which pass over it on account of its smoothness; and
in this shells are found; and this is white earth fit for pot-
tery.[37]

All the outlets of the water flowing from the mountain
to the sea carry stones from the mountain with them to
the sea; and by the backwash of the sea water against the
mountains, these stones were thrown back towards the
mountain; and as the waters moved towards the sea and
returned from it the stones turned with them and as they

rolled their corners struck together; and as the parts of least resistance to the blows were worn away, the stones ceased to be angular and became round in form, as may be seen on the shores of Elba. And those remained larger which were less removed from their native spot; and they became smaller the farther they were carried from that place; so that in the process they were converted into small pebbles and then into sand and at last into mud. After the sea had receded from the aforesaid mountains the salt deposit left by the sea with the other moisture from the earth made a compound with this shingle and this sand, so that the shingle was converted into rock and the sand into tufa. And of this we see an example in the Adda, where it emerges from the mountains of Como, and in the Ticino, the Adige, the Oglio and Adria from the German Alps, and likewise the Arno from the Monte Albano near Monte Lupo and Capraia where the largest rocks are all formed of solidified shingle of different stones and different colours.[38]

The first and most essential thing is stability. As to the foundations of the component parts of temples and other public buildings, their depths should bear the same relation one to another, as do the weights which are to rest upon them. Every part of the depth of the earth in a given space is composed of layers, and each layer is composed of heavier and lighter parts; the lowest being the heaviest. And the reason for this is that these layers are formed by the sediment from the water discharged into the sea by the current of the rivers which flow into it. The heaviest part of this sediment was the part that was discharged first, and so on by degrees: And this is the action of the water when it becomes stationary, while when it first moves it is carrying away. These layers of soil are visible in the banks of rivers which in their continuous course have cut through and divided one hill from another in a deep defile, wherein the waters have receded from the shingle of the banks; and this has caused

the substance to become dry and to turn into hard stone, especially such mud as was of the finest texture.[39]

(c) The Mediterranean

Every valley has been made by its river, and the proportion between valleys is the same as that between river and river. The greatest river in our world is the Mediterranean river, which moves from the sources of the Nile to the Western Ocean.[40]

The bosom of the Mediterranean, as an inland sea, received the principal waters of Africa, Asia, and Europe that flowed towards it; and its waters came up to the foot of the mountains that surrounded it and formed its banks.

And the peaks of the Apennines stood up in this sea like islands surrounded by salt water. Nor did Africa as yet, behind its Atlas mountains, reveal the earth of its great plains uncovered to the sky some 3,000 miles in extent. And Memphis stood on the shore of this sea, and above the plains of Italy where flocks of birds are flying today, fishes were wont to wander in large shoals.[41]

Of the consumption or evaporation of the water of the Mediterranean Sea

The Mediterranean Sea, a vast river placed between Africa, Asia, and Europe, gathers within itself about three hundred principal rivers, and in addition to that it receives the rains which fall upon it over a space of three thousand miles. It returns to the mighty ocean its own waters and those that it has received; but doubtless it returns less to the sea than what it receives; for from it descend many springs which flow through the bowels of the earth and vivify this terrestrial machine. This is so because the surface of this Mediterranean is farther from the centre of the world than the surface of this ocean . . . and in addition to this the heat of the sun is continually evaporating a portion of the water

of the Mediterranean, and as a consequence this sea can acquire but little increase from the aforesaid rains.[42]

How the flow and ebb of the tide is not uniform, for on the coast of Genoa there is none; at Venice it makes a variation of two braccia; between England and France of eighteen braccia. How the current that flows through the straits of Sicily is very powerful because through these there pass all the waters of the rivers which discharge themselves into the Adriatic.[43]

The Danube or Donau flows into the Black Sea, which formerly extended almost to Austria and covered all the plain where the Danube flows today. And the evidence of this is shown by the oysters and cockle shells, and scollops and bones of great fishes which are still found in many places in the high slopes of those mountains; and this sea was formed by the filling up of the spurs of the Adula range which extended to the east, and joined the spurs of the Taurus range extending to the west. And near Bithynia the waters of this Black Sea poured into the Propontis falling into the Aegean Sea, that is the Mediterranean Sea, where at the end of a long course the spurs of the Adula range were separated from those of the Taurus range; and the Black Sea sank down and laid bare the valley of the Danube with the above-named provinces, and the whole of Asia Minor beyond the Taurus range to the north, and the plain that stretches from Mount Caucasus to the Black Sea to the west, and the plain of the Don this side of the Ural Mountains, that is at their feet. So the Black Sea must have sunk about 1,000 braccia to uncover such vast plains.[44]

It is not denied that the Nile is always turbid as it enters the Egyptian Sea and that this turbidness is caused by the soil that this river carries away continually from the places through which it passes; which soil never returns back, nor does the sea receive it except it throws it on its shores.

Behold the ocean of sand beyond Mount Atlas where it was once covered with salt water.[45]

How the river Po in a short time might dry up the Adriatic Sea in the same way as it has dried up a large part of Lombardy.[46]

3. WATER AND AIR

Write how the clouds are formed and how they dissolve, and what it is that causes vapour to rise from the water of the earth into the air, and the causes of mists and of the air becoming thickened, and why it appears more blue or less blue at one time than at another; and describe also the regions of the air, and the cause of snow and hail, and how water contracts and becomes hard in ice, and write of the new shapes that snow forms in the air, and of the new shapes of leaves on the trees in cold countries, and of the pinnacles of ice and hoar-frost making strange shapes of herbs with various leaves, the hoar-frost making as if it might serve as dew ready to nourish and sustain the said leaves.[47]

The movement of water within water proceeds like that of air within air.[48]

Acoustics

Although the voices which penetrate the air proceed from their sources in circular motion, nevertheless the circles which are propelled from their different centres meet without any hindrance and penetrate and pass across one another keeping to the centre from which they spring.

Since in all cases of movement water has great conformity with air, I will cite it as an example of the above-mentioned proposition. I say: if at the same time you throw two small stones on a sheet of motionless water at some distance from one another, you will observe that round the

two spots where they have struck, two distinct sets of circles are formed, which will meet as they increase in size and then penetrate and intersect one another, while always keeping as their centres the spots which were struck by the stones. And the reason of this is that although apparently there is some show of movement there, the water does not leave its places because the openings made there by the stones are instantly closed again, and the motion occasioned by the sudden opening and closing of the water causes a certain shaking which one would describe as a tremor rather than a movement. And that what I say may be more evident to you, watch the pieces of straw which on account of their lightness are floating on the water and are not moved from their original position by the wave that rolls beneath them as the circles reach them. The impression on the water therefore, being (in the nature of) a tremor rather than a movement, the circles cannot break one another as they meet, and as the water is of the same quality all through its parts, transmit the tremor from one to another without changing their place. For as the water remains in its position it can easily take this tremor from the adjacent parts and pass it on to other adjacent parts, its force steadily decreasing until the end.*⁴⁹

Just as the stone thrown into the water becomes the centre and cause of various circles, and the sound made in the air spreads out in circles, so every body placed within the luminous air spreads itself out in circles and fills the surrounding parts with an infinite number of images of itself, and appears all in all and all in each part.⁵⁰

Air

Its onset is much more rapid than that of water, for the occasions are many when its wave flees from the place of

* Compare Vitruvius, *De Architectura*, v, c. iii. 6–8 and Helmholtz, 'Über die physiologischen Ursachen der musikalischen Harmonie', *Vorträge und Reden*, 1896, p. 129.

its creation without the water changing its position; in the likeness of the waves which the course of the wind makes in cornfields in May, when one sees the waves running over the fields without the ears of corn changing their place.[51]

The elements are changed one into another, and when the air is changed into water by the contact it has with its cold region this then attracts to itself with fury all the surrounding air which moves furiously to fill up the place vacated by the air that has escaped; and so one mass moves in succession behind another, until they have in part equalized the space from which the air has been separated, and this is the wind. But if the water is changed to air, then the air which first occupied the space into which the aforesaid increase flows must needs yield place in speed and impetus to the air which has been produced, and this is the wind.

The cloud or vapour that is in the wind is produced by heat and it is smitten and banished by the cold, which drives it before it, and where it has been ousted the warmth is left cold. And because the cloud which is driven cannot rise because the cold presses it down and cannot descend because the heat raises it, it therefore must proceed across; and I consider that it has no movement of itself, for as the said powers are equal they confine the substance that is between them equally, and should it chance to escape the fugitive is dispersed and scattered in every direction just as with a sponge filled with water which is squeezed so that the water escapes out of the centre of the sponge in every direction. So therefore does the northern wind become the origin of all the winds at one and the same time.[52]

That wind will be of briefer movement which is of more impetuous beginning; and this the fire has taught us as it bursts forth from the mortars, showing us the form and speed by the smoke which penetrates the air in brief and scattered motion. But fitful impetuosity of the wind is shown by the dust that it raises in the air in its various twists

and turns. One perceives also between the chains of the Alps how the clashing together of the winds is caused by the impetus of various forces; one sees how the flags of ships flutter in different currents; how on the sea one part of the water is struck and not another; and the same thing happens in the piazzas and on the sandbanks of rivers, where dust is swept away furiously in one part and not in another. And since these effects show us the nature of their causes we can say with certainty that the wind which has the more impetuous origin will have the briefer movement; and this is borne out by the aforesaid experiment showing the brief movement of the smoke from the mouth of the mortar. And this arises from the resistance that the air makes on being compressed by the percussion of this smoke which in itself also suffers compression in offering resistance to the wind. But if the wind is of slow movement it will extend over a very long way in a straight course, because the air penetrated by it will not become condensed in front of it and will not thwart its movement, but will readily expand spreading its course over a very long space.[53]

4. EARTH, WATER, AIR, AND FIRE

Leonardo is here making the ascent of the Monte Rosa on a fine summer's day with an intensely blue sky overhead. His desire is to peer into those upper regions which are beyond the atmosphere—the sphere of the Element of Fire. His surmise that they are regions of 'immense darkness' and that the blue colour of the sky is due to the reflection of light by small particles in the air has been confirmed by recent investigations in the stratosphere.

Of the colour of the Atmosphere

I say that the blue which is seen in the atmosphere is not its own colour but is caused by warm humidity evaporated in minute and imperceptible atoms on which the solar rays

fall rendering them luminous against the immense darkness
of the region of fire that forms a covering above them. And
this may be seen, as I myself saw it, by anyone who ascends
the Monte Rosa, a peak of the Alps that divides France from
Italy. . . .

There I saw the dark atmosphere overhead and the sun
as it shone on the mountain was far brighter here than on
the plains below because a smaller extent of atmosphere
lay between the summit of the mountain and the sun. [See
p. 333.]

As a further illustration of the colour of the atmosphere,
we may take the smoke of old and dry wood, which as it
comes out of the chimneys seems to be a pronounced blue
when seen against a dark space. But as it rises higher and is
seen against the luminous atmosphere it turns immediately
to an ashen grey hue. And this happens because it no longer
has darkness beyond it. . . . If the smoke comes from young
green wood it will not assume a blue colour, because as it
is not transparent and is heavily charged with moisture it
will produce the effect of a dense cloud which takes distinct
lights and shadows as though it were a solid body. The
same occurs with atmosphere which excessive moisture
renders white, while little moisture acted upon by heat
renders it dark, of a dark blue colour. . . . If this transparent
blue were the natural colour of the atmosphere it would
follow that wherever a greater quantity of the atmosphere
intervened between the eye and the element of fire the
shade of blue would be deeper; as we see in blue glass and
in sapphires, which are darker in proportion as they are
thicker. But the atmosphere in such circumstances acts in
exactly the opposite way, since where a greater quantity of
it comes between the eye and the sphere of fire, there it
appears much whiter. This happens towards the horizon.
And the less the extent of atmosphere between the eye and
the sphere of fire of so much the deeper blue does it appear,
even when we are in the low plains. It follows therefore,

as I say, that the atmosphere assumes this azure hue by reason of the particles of moisture which catch the luminous rays of the sun.[54]

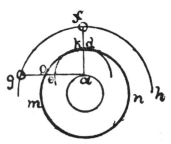

Prove that the surface of (the sphere of) the air where it borders on the fire, and the surface of the (sphere of) fire where it ends are penetrated by the solar rays which transmit the images of the heavenly bodies, large when they rise and small when they are on the meridian.

Let *a* be the earth and *ndm* the surface of the air bordering on the sphere of fire; *hfg* is the orbit of the sun; then I say that when the sun appears on the horizon *g* its rays are seen passing through the surface of the air at a slanting angle—*om*; this is not the case at *dk*. And so it passes through a greater mass of air.[55]

Of the heat that is in the world

Where there is life there is heat, and where vital heat is, there is movement of vapour. This is proved inasmuch as we see that the element of fire by its heat always draws to itself damp vapours and thick mists as opaque clouds which it raises from seas as well as lakes and rivers and damp valleys; and these being drawn by degrees as far as the cold region, the first portion stops, because heat and moisture cannot exist with cold and dryness; and where the first portion stops, the rest settle, and thus one portion after another being added, thick and dark clouds are formed.

They are often wafted about and borne by the winds

from one region to another, where by their density they
become so heavy that they fall in thick rain; and if the heat
of the sun is added to the power of the element of fire, the
clouds are drawn up higher still and find a greater degree
of cold, in which they form ice and fall in storms of hail.
Now the same heat which holds up so great a weight of
water as is seen to rain from the clouds, draws them from
below upwards, from the foot of the mountains, and leads
and holds them within the summits of the mountains, and
these finding some fissures, issue continuously and cause
rivers.[56]

As water flows in different ways out of a squeezed sponge,
or air from a pair of bellows, so it is with the thin trans-
parent clouds that are driven up on high through the reflec-
tion occasioned by the heat; the part which finds itself
uppermost is that which first reaches the cold region and
there halted by the cold and dryness awaits its companion.
The part below ascending towards the part that is stationary
treats the air that is in between as though it were a syringe,
and this then escapes crosswise and downwards; it cannot
go upwards because it finds the cloud so thick that it cannot
penetrate it.

And for this reason all the winds that make war upon
the earth's surface descend from above, and when they
strike upon the resisting earth they produce a movement of
recoil, which as it tries to rise meets the descending wind,
and thereby the ascent is constrained to break its natural
order, and taking a transverse route pursues a violent course
which grazes incessantly the surface of the earth.

And when the aforesaid winds strike upon the salt waters,
then their direction becomes clearly visible, in the angle that
is formed by the lines of incidence and of recoil; and from
these result the proud and menacing and engulfing waves,
of which one is the cause of the other.

As the natural warmth spread through the human limbs

is driven back by the surrounding cold which is its opposite and enemy flowing back to the lake of the heart and the liver fortifies itself there, making of these its fortress and defence, so the clouds being made up of warmth and moisture, and in summer of certain dry vapours, and finding themselves in the cold and dry region, act after the manner of certain flowers and leaves which when attacked by the cold hoar-frost pressing cold together offer a greater resistance.

So these in their first contact with the cold air begin to resist and not to wish to pass farther forward; the others below continue to rise; the part above being stationary proceeds to thicken; the warmth and dryness recede to the centre; the part above abandoned by the warmth begins to freeze or rather to dissolve; the clouds below continue to rise and press the warmth nearer to the cold; and thus the warmth being constrained to return to its primary element is suddenly transformed into fire and twines itself across the dry vapour, and in the centre of the cloud makes a great increase, and kindling within the cloud which has become cool it makes a noise that resembles that of water falling on boiling pitch or oil, or of molten copper when plunged into cold water; even so, driven out by its opposite it shatters the cloud that would withstand it and dashing through the air breaks and destroys everything that opposes it; and this is the thunderbolt.[57]

Where the flame cannot live no animal that draws breath can live

The bottom part of the flame is the first origin of this flame and through it passes all its nutriment of fat; and it is of less heat than the rest of the flame, just as it is of less brightness; and it is blue in colour and here its nutriment is purged and disposed of. The other part has the brighter flame, but this is the first to come into existence when the flame is created and it is born in spherical shape, and after a span of life produces above itself a very small flame of radiant

colour and shaped like a heart, with its point turned towards the sky; and this continues to multiply towards infinity by absorbing the substance that feeds it.

The blue flame is formed of spherical shape . . . and does not in itself form a pyramidal figure until it has warmed the surrounding air sufficiently; and the principal heat of this blue flame goes upwards in the direction where it is the natural desire of the blue flame to travel, that is the shortest way to the sphere of fire.

The colour of the blue flame does not move of itself. Nor does the nourishment given to the flame by the candle move of itself. The movement must therefore be generated by others. The generator of this movement is the air which rushes to refill the vacuum created by the air that had been previously consumed by the flame. The light generates vacuum, and the air runs to succour this vacuum.[53]

5. MICROCOSM AND MACROCOSM

The organic and inorganic worlds are both of similar nature and subject to the same natural laws. Man is a part of a world, a microcosm included in a macrocosm.

The Beginning of the Treatise on Water

Man has been called by the ancients a lesser world and indeed the term is well applied. Seeing that if a man is composed of earth, water, air, and fire, this body of earth is similar. While man has within himself bones as a stay and framework for the flesh, the world has stones which are the supports of earth. While man has within him a pool of blood wherein the lungs as he breathes expand and contract, so the body of the earth has its ocean, which also rises and falls every six hours with the breathing of the world; as from the said pool of blood proceed the veins which spread their branches through the human body, so

the ocean fills the body of the earth with an infinite number of veins of water. . . .

In this body of the earth is lacking, however, the nerves, and these are absent because nerves are made for the purpose of movement; and as the world is perpetually stable, and no movement takes place here, nerves are not necessary. But in all other things man and the earth are very much alike.[58]

Explanation of the presence of water on the summits of the mountains

I say that just as the natural heat of the blood in the veins keeps it in the head of man, and when the man is dead the cold blood sinks to the lower parts, and as when the sun warms the man's head the amount of blood there increases and grows so much with other humours, that by pressure in the veins it frequently causes pains in the head; in the same way with the springs which ramify through the body of the earth and, by the natural heat which is spread through all the containing body, the water stays in the springs at the high summits of the mountains. And this water that passes through a pent-up conduit within the body of the mountain like a dead thing will not emerge from its low state because it is not warmed by the vital heat of the first spring. Moreover, the heat of the element of fire and by day the heat of the sun have power to stir up the dampness of the low places of the mountains and to draw them up in the same way as it draws the clouds and calls up their moisture from the bed of the sea.[59]

The same cause which moves the humours in all kinds of living bodies against the natural law of gravity also propels the water through the veins of the earth wherein it is enclosed and distributes it through small passages. And as the blood rises from below and pours out through the broken veins of the forehead, as the water rises from the

lowest part of the vine to the branches that are cut, so from the lowest depth of the sea the water rises to the summits of mountains, where, finding the waves broken, it pours out and returns to the bottom of the sea. Thus the movement of the water inside and outside varies in turn, now it is compelled to rise, then it descends in natural freedom. Thus joined together it goes round and round in continuous rotation, hither and thither from above and from below, it never rests in quiet, either in its course or in its own nature. It has nothing of its own but seizes hold on everything, changing into as many different natures as there are different places on its course, acting just like the mirror which takes in as many images as there are things passing in front of it. So it changes continually, now as regards place, now as regards colour, now it absorbs new smells or tastes, now it detains new substances or qualities, now it brings death, now health, sometimes it mixes with air or lets itself be drawn on high by heat, and on reaching the cold region, the heat that guided it upward is squeezed by the cold. And as the hand presses the sponge under water where the water flowing out makes an inundation into the other water, so the cold presses the air that is mingled with water, making it flee in fury and drive the other air; this then is the cause of the wind.[60]

That which to the utmost admiration of those who contemplate it raises itself from the lowest depth of the sea to the highest summits of the mountains and pouring through the broken veins returns to the deep sea and again rises with swiftness and descends again, and so in course of time the whole element circulates. So from high to low, so passing in and out, now with natural movement, now with fortuitous movement it proceeds, together and united. So it goes ranging round in continual circulation after the manner of the water of the vine, which as it pours through its cut branches and falls upon its roots rises again through

the passages and falling again returns in continual circulation.

The water which sees the air through the broken veins of the high mountain summits is suddenly abandoned by the power which brought it there, and escaping from these forces resumes its natural course in liberty.

Likewise the water that rises from the low roots of the vine to its lofty head falls through the cut branches upon the roots and mounts anew to the place whence it fell.[61]

6. A SPIRIT AMID THE ELEMENTS: ITS LIMITATIONS

Of Spirits

We have said that the definition of a spirit is a power united to a body, because of itself it can neither rise nor take any kind of movement in space, and if you say that it does rise of itself this cannot be within the elements. For if the spirit is an incorporeal quantity, this quantity is called a vacuum, and the vacuum does not exist in nature; and granting that one were formed it would be immediately filled up by the rushing in of the element in which such a vacuum had been generated. Therefore, by the definition of weight, which says that gravity is an accidental power, created by one element being drawn or impelled towards another, it follows that any element without weight in one element acquires weight by passing into the element above it, which is lighter than itself. One sees that a part of water has neither gravity nor levity when merged in the other water, but will acquire weight if drawn up into the air; and if you were to draw the air beneath the water, then the water on finding itself above this air acquires weight, which weight it cannot support by itself, and hence its collapse is inevitable; and it will fall into the water at the spot where there is a vacuum. The same thing would happen to a spirit if it were amid the elements where it

would continually generate a vacuum in whatever element it might find itself and for this reason it would be continually flying towards the sky until it had quitted those elements.

Whether the spirit has a body amid the elements

We have proved that a spirit cannot of itself exist amid the elements without a body, nor can it move of itself by voluntary motion except to rise upwards. We now say that such a spirit in taking a body of air must of necessity mingle with this air; because if it remained united the air would be separate and fall when the vacuum is generated, as is said above; therefore it is necessary if it is to be able to remain suspended in the air, that it should absorb a certain quantity of air; and if it were mingled with the air, two difficulties ensue, namely that it rarefies that portion of the air wherewith it mingles and for this reason the rarefied air will fly upwards of its own accord and will not remain among the air that is heavier than itself; and, moreover, that as this spiritual essence is spread out it becomes separated and its nature becomes modified, and it thereby loses some of its first power. Added to these there is a third difficulty, and that is that this body of air taken from the spirit is exposed to the penetrating winds, which are incessantly sundering and tearing to pieces the united portions of the air, revolving and whirling them amid the other air; therefore the spirit which is infused in this air would be dismembered or rent and broken up with the rending of the air into which it was incorporated.[62]

Whether the spirit having taken a body of air, can move of itself or no

It is impossible that the spirit infused into a certain quantity of air should have power to move this air; and this is proved above where it is said that the spirit rarefies that portion of the air wherein it has entered; therefore such air will rise above the other air, and this movement will

be made by the air through its own lightness, and not through the voluntary movement of the spirit, and if this air is encountered by the wind, by the third part of this discourse, the air will be moved by the wind and not by the spirit diffused in it.

Whether the spirit can speak or no

Wishing to prove whether or no the spirit can speak it is necessary first to define what voice is, and how it is generated; and we shall describe it thus: The voice is movement of air in friction against a dense body, or of a dense body in friction against the air—which is the same thing; and this friction of the dense with the rare condenses the rare and causes resistance; moreover the rare when in swift motion, and the rare moving slowly condense each other at their contact, and make a noise or great uproar; and the sound or murmur caused by one rare moving through another rare at a moderate speed is like a great flame which creates noises in the air. And the loudest uproar made by one rare with another is when the one moving swiftly penetrates the other which is motionless; as for instance the flame of fire issuing from a big gun striking the air; and also like the flame issuing from the cloud which strikes the air and so produces thunderbolts.

Therefore we may say that the spirit cannot produce a voice without movement of the air, in it there is none and it cannot emit what it has not; and if it desires to move the air in which it is diffused it becomes necessary that the spirit should multiply itself, and that cannot multiply which has no quantity. And in the fourth part it is said that nothing rare can move unless it has a stable spot whence to take its motion; and much more so in the case of an element moving in its own element, which does not move of itself, except by uniform evaporation at the centre of the thing evaporated: as occurs with a sponge squeezed in the hand which is held under water; the water escapes from it in

every direction with equal movement through the openings that come between the fingers of the hand in which it is squeezed.

Whether the spirit has articulate voice, and whether the spirit can be heard, and what hearing is and seeing, and how the wave of the voice passes through the air and how the images of objects pass to the eye.[63]

There can be no voice where there is no motion or percussion of the air; there can be no percussion of the air where there is no instrument; there can be no instrument without a body; this being so a spirit can have neither voice, nor form, nor force; and if it were to assume a body it could not penetrate nor enter where the doors are closed. And if any should say that through air collected together and compressed a spirit may assume bodies of various forms, and by such instrument may speak and move with force—to him I reply that where there are neither nerves nor bones there can be no force exerted in any movement made by imaginary spirits.[64]

7. THE VAULT OF HEAVEN

According to ancient traditions, universally accepted in Leonardo's time, the Earth with its elements (compare p. 13) was enclosed and surrounded by the heavenly world with bodies that were neither heavy, nor light, nor corruptible. Looking beyond the phenomena of this Earth, Leonardo tried to apply similar methods of observation and deduction to the vault of heaven. He erected a sort of observatory by placing an optical instrument under the skylight of his roof and speculated on the nature of the moon.

Doubts arose in his mind regarding the Ptolemaic system. Did the sun revolve around the Earth? On a page of mathematical notes he wrote in large letters 'The sun does not move'.

In order to see the nature of the planets, open the roof and note at the base one planet singly: the reflected movement on this base will show the nature of this planet; but arrange that the base reflects only one at a time.[65]

Construct glasses in order to see the moon large.[66]

It is possible to find means whereby the eye does not see remote objects as much diminished as they are in natural perspective where they are diminished by reason of the convexity of the eye which necessarily intersects at its surface the pyramids of every image conveyed to the eye between spherical right angles. But the method that I show here cuts these pyramids at right angles close to the surface of the pupil. The convex pupil of the eye takes in the whole of our hemisphere while this will show only a single star; but where many small stars transmit their images to the surface of the pupil those stars are extremely small; here only one star is seen but it will be large. And so the moon will be larger and its spots more distinct. You should place close to the eye a glass filled with water . . . for this water makes objects which are congealed in balls of crystalline glass appear as though they were without glass.

Of the eye. Of bodies less than the pupil of the eye that which is nearest to it will be least discerned by the eye. And from this experience it is made known to us that the power of sight is not reduced to a point. . . . But the images of the objects conveyed to the pupil of the eye are distributed on this pupil exactly as they are distributed in the air: and the proof of this is shown to us when we look at the starry sky without sighting more fixedly one star than another; the sky then appears all strewn with stars; and their proportions in the eye are the same as in the sky and likewise the spaces between them.[67]

Of the Moon

The moon has no light of itself, but so much of it as the sun sees it illuminates. And of that illuminated part we see as much as faces us. And its night receives as much light as our waters lend it as they reflect upon it the image of the sun, which is mirrored in all those waters that face the sun and the moon.

The surface of the waters of the moon and of our earth is always ruffled more or less, and this ruggedness is the cause of the expansion of numberless images of the sun which are reflected in the hills and hollows and sides and crests of the innumerable waves; that is in as many different spots on each wave as there are eyes in different positions to see them. This could not happen if the sphere of water which in great part covers the moon were uniformly spherical, for then there would be an image of the sun for every eye, and its reflections would be distinct and its radiance would always be spherical, as is clearly shown in the gilded balls placed on the tops of high buildings. But if the gilded balls were rugged or composed of globules like mulberries which are a black fruit composed of minute balls, then each part of these little balls visible to the sun and to the eye will display to the eye the lustre produced by the reflection of the sun. And, thus, in one and the same body there will be seen many minute suns; and these often will blend at a long distance and appear continuous.[68]

Nothing light remains among less light things. Whether the moon has its seat within its elements or not. And if the moon has not its special seat like the earth in the midst of its elements, how is it that it does not fall in the midst of our elements? And if it is not in the midst of its elements and does not fall down, it must be lighter than all other elements. And if it is lighter than all other elements why is it solid and not transparent?[69]

Demonstration that the earth is a star

In your discourse you must prove that the earth is a star
much like the moon, and the glory of our universe; and
then you must treat of the size of various stars according
to the authors.[70]

The sun does not move.*

The sun has substance, shape, motion, radiance, heat, and
generative power: and these qualities all emanate from it
without its diminution.

The sun has never seen any shadow.[71]

Praise of the sun

If you look at the stars without their rays (as may be done
by looking at them through a small hole made with the
extreme point of a fine needle and placed so as almost to
touch the eye), you will see these stars to be so minute
that it would seem as though nothing could be smaller; it
is in fact the great distance which is the reason of their
diminution, for many of them are very many times larger
than the star which is the earth with the water. Think,
then, what this star of ours would seem like at so great a
distance, and then consider how many stars might be set
in longitude and latitude between these stars which are
scattered throughout this dark expanse. I can never do
other than blame many of those ancients who said that the
sun was no larger than it appears; among these being
Epicurus; and I believe that he reasoned thus from the
effects of a light placed in our atmosphere equidistant from
the centre; whoever sees it never sees it diminished in size
at any distance. . . .

But I wish I had words to serve me to blame those who

* A similar statement by Galilei more than a hundred years later
was condemned as heresy.

would fain extol the worship of men above that of the sun; for in the whole universe I do not see a body of greater magnitude and power than this, and its light illumines all the celestial bodies which are distributed throughout the universe. All vital force descends from it since the heat that is in living creatures comes from the soul (vital spark); and there is no other heat nor light in the universe. . . . And certainly those who have chosen to worship men as gods such as Jove, Saturn, Mars, and the like have made a very great error, seeing that even if a man were as large as our earth he would seem like one of the least of the stars which appears but a speck in the universe; and seeing also that men are mortal and subject to decay and corruption in their tombs.

The Spera and Marullo and many others praise the sun.*72

II. THE FOUR POWERS OF NATURE

Weight, force, together with percussion, are to be spoken of as the producers of movement as well as being produced by it. Of these three accidental powers two have one and the same nature in their birth, their desire, and their end.73

Weight, force, a blow, and impetus are the children of movement because they are born from it. Weight and force always desire their death and each is maintained by violence. Impetus is frequently the cause why movement prolongs the desire of the thing moved.74

Gravity force together with percussion are not only inter-changeably to be called mother and daughters the one of the other and all sisters together, because they may all be produced by movement, but they are both producers and daughters of this movement; because without these within

* *Spera* by Goro Dati, Florence, 1482. Lines 16–22 are in praise of the sun. The hymn on the sun by Marullus was published in M. Tarcaniota's *Hymni et epigrammata*, Florence, 1487.

us movement cannot create, nor can such powers be revealed without movement.[75]

PLANS FOR A BOOK ON THEORETICAL MECHANICS

Deal first with weight [gravitation]
 then with its supports [statics]
 then with friction
 then with motion [kinetics]
 and lastly with percussion.[76]

First deal with weight, then with movement, which creates force, then with this force and lastly with the blow.[77]

Arrange that the book of the Elements of mechanics with its examples shall precede the demonstration of the movement and force of man and other animals and by means of these you will be able to prove all your propositions.[78]

Your Treatise on the movement of heavy bodies deals with heavy liquids, with air, and with the motions of fire. Compare the motion of this fire with the whirls in air and in water and you will find whirls in the fire which enable it to combine its revolutions. This experiment you will make with registers and with boiling waters.[79]

On Machines

Why nature cannot give the power of movement to animals without mechanical instruments, as is shown by me in this book on movement which nature has created in the animals. And for this reason I have drawn up the rules of the four powers of nature without which nothing can give local movement to these animals. We shall, therefore, first describe this local movement and how it produces and is produced by each of the three other powers. Then we shall describe the natural weight, for though no weight can be

said to be other than accidental, it has pleased us to style it thus in order to distinguish it from force, which in all its operations is of the nature of weight and is for this reason called accidental weight, and this is the force which is produced by the third power of nature, that is the inherent and natural power. The fourth and last power will be called percussion, that is the end and restraint of movement. And we shall begin by saying that every local insensible movement is produced by a sensible move, just as in a clock the counterpoise is raised up by man, who is its mover. Moreover the elements repel or attract each other, for one sees water expelling air from itself, and fire entering as heat under the bottom of a boiler and afterwards escaping in the bubbles on the surface of the boiling water. And again the flame draws to itself the air, and the heat of the sun draws up the water in the form of moist vapour which afterwards falls down in thick heavy rain. Percussion, however, is the immense power which is generated within the elements.[80]

I. WEIGHT

Heat and cold proceed from the nearness or remoteness of the sun. Heat and cold cause the movement of the elements. No element has of itself weight or lightness. . . .

The motion originates from the fact that what is thinner can neither resist nor support what is more dense.

Lightness is born of weight and weight of lightness; and they give birth one to another at the same time; repaying in the same instant the boon of their creation they grow in power as they grow in life, and have more life as they have more motion; and they destroy one another in the same instant in the common vendetta of their death.

For so it is proved; lightness is not created unless it is joined to weight, nor is weight produced unless it is placed above lightness. Nor has lightness any existence unless it is underneath weight. . . .

And so it is with the elements. If for instance a quantity of air lay beneath water, the water would immediately acquire weight; not because it has itself changed, but because it does not meet with the due amount of resistance; it therefore descends into the position occupied by the air beneath it while the air fills up the vacuum which the weight has left.[81]

No element has weight or lightness unless it moves. The Earth is in contact with the Water and the Air and has of itself neither weight nor lightness. It has no consciousness of the Water and Air that surround it except when they happen to move. And this is shown by the leaves of plants which grow upon the earth in contact with water and air, and which do not bend except to the movement of air and water.

From this it follows that weight is an incident created by the movement of the lower elements in the higher.

Lightness is an incident created when the thinner element is drawn beneath the less thin . . . which then acquires weight and meets with insufficient resistance from the thinner element below which then acquires lightness.

Lightness is not produced except in conjunction with weight, nor is weight produced without lightness. This may be shown: Let air be introduced under water by blowing a pipe, then this air will acquire lightness and the water will acquire weight from having beneath it the air which is a body thinner and lighter than itself. . . .

Levity and gravity are caused by immediate motion. Motion is created by heat and cold.

Motion is an incident created by inequality of weight and force. . . .

The motion of the elements arises from the sun.

The heat of the universe is produced by the sun.

The light and heat of the universe come from the sun and its cold and darkness from the withdrawal of the sun.

Every movement of the elements arises from heat and cold.

Gravity and levity are created in the elements.[82]

Weight comes into being when an element is placed above another element thinner than itself.

Weight is caused by one element having been drawn within another.[83]

Weight is caused by one element being situated in another; and it moves by the shortest line towards its centre, not by its own choice, not because the centre draws it to itself; but because the other intervening element cannot withstand it.[84]

Gravity, force, and accidental movement together with percussion, are the four accidental powers with which all the visible works of mortals have their existence and their end.

Gravity
Gravity is accidental power, which is created by movement and infused in bodies standing out of their natural position.

Heavy and Light
Gravity and Lightness are equal powers created by one element being transferred into the other; in every function they are so alike, that they may be named a single power. For they have merely variation in the bodies in which they are infused, and in the movement of their creation and deprivation.

That body is said to be heavy which being free directs its movement to the centre of the world by the shortest way.

That body is said to be light which being free flees from the centre of the world; and each is of equal power.[85]

The centre of every gravity
Every gravity weighs through the central line of the universe because it is drawn to this centre from all parts.

A central line of the universe is that which arises from the centre of the world and ends in the centre of gravity of every body.[86]

The centre of magnitude of bodies is placed in the middle of their length, width, and depth. The centre of accidental gravity of these bodies is placed in the middle of those parts which resist and balance one another. The centre of natural gravity is that which divides a body into two parts of equal weight and quantity.[87]

By the ninth of the second of the Elements which says that the centre of every suspended gravity stops below the centre of its support, therefore:—The central line is the name given to what one imagines to be the straight line from the thing to the centre of the world. The centre of all suspended gravity desires to unite with the central line of its support. And that suspended gravity which happens to be farther removed from the central line of its support will acquire more force in excess of that of its natural weight. Now, in conclusion, I affirm that the water·of the spiral eddy gives the centre of its gravity to the central line of its pole and every small weight that is added on one of its sides is the cause of its movement.[88]

2. FORCE AND WEIGHT

Here one asks whether gravity is produced by itself or by force, or whether force is produced by itself or by gravity.[89]

What difference there is between force and weight

Force is spiritual essence which by accidental violence is united to weighty bodies, restraining them from following their natural inclination; and here although of short duration it often shows itself of marvellous power.[90]

Force and weight have much in common in all their powers, and they differ only in the motion of their birth and death.

For weight simply dies with the arrival at its native place, but force is born and dies with every motion.

Weight is a power created by the motion that transports one element into another by means of force, and the length of its life corresponds to its effort to regain its native place.

Force is the product of dearth and profusion. It is the child of material motion and the grandchild of spiritual motion, and the mother and origin of weight. Weight is confined to the elements of water and earth, but force is unlimited; for by it infinite worlds can be set in motion if it were possible to make instruments by which this force could be generated.

The spirit of the sentient animals moves through the limbs of their bodies and when the muscles it has entered are responsive it causes them to swell, and as they swell they shorten and in shortening they pull the tendons that are joined to them. And from this arises the force and movement of human limbs. Consequently material movement springs from spiritual.

The quality and quantity of the force in man will have the power of giving birth to other force, and this will be greater in proportion as the movement is longer.

Weight and force together with the motion of bodies and percussion are the four powers of nature by which the human race in its marvellous and various works seems to create a second nature in this world; for by the use of such powers all the visible works of mortals have their being and their death.[91]

That force will be more feeble which is more distant from its source.[92]

What is Force?

Force I define as an incorporeal agency, an invisible power, which by means of unforeseen external pressure is caused by the movement stored up and diffused within bodies

which are withheld and turned aside from their natural uses; imparting to these an active life of marvellous power it constrains all created things to change of form and position, and hastens furiously to its desired death, changing as it goes according to circumstances. When it is slow its strength is increased, and speed enfeebles it. It is born in violence and dies in liberty; and the greater it is the more quickly it is consumed. It drives away in fury whatever opposes its destruction. It desires to conquer and slay the cause of opposition, and in conquering destroys itself. It waxes more powerful where it finds the greater obstacle. Everything instinctively flees from death. Everything when under constraint itself constrains other things. Without force nothing moves. The body in which it is born neither grows in weight nor in form. None of the movements that it makes are lasting.

It increases by effort and disappears when at rest. The body within which it is confined is deprived of liberty. Often also by its movement it generates new force.[93]

Force is the same throughout and the whole is in every part of it.

Force is a spiritual energy, an invisible power which is imparted by violence from without to all bodies that are without their natural balance.

Force is nothing but a spiritual energy, an invisible power, which is created and imparted, through violence from without, by animated bodies to inanimate bodies, giving to these the similarity of life, and this life works in a marvellous way, constraining and transforming in place and shape all created things. It speeds in fury to its undoing and continues to modify according to the occasion.

Retardation strengthens, and speed weakens it.

It lives by violence and dies from liberty.

It transmutes and compels all bodies to a change of place and form.

Great power gives it great desire of death.

It drives away with fury whatever opposes its destruction.

Transmuter of various forms.

Always lives ill at ease with whoever holds it.

Always in opposition to natural desires.

It grows slowly from small beginnings and makes itself a terrible and marvellous power and by compression of itself constrains all things . . . it dwells in bodies which are out of their natural course and use . . . willingly it consumes itself.

Force is the same throughout and through all the body where it is generated.

Force is only a desire of flight.

Always it desires to weaken and to spend itself.

Itself constrained it constrains everybody.

Without it nothing moves.

No sound or voice is heard without it.

Its true seed lies in living bodies.

Weight is transmitted to the full by perpendicular resistance, and is all in every part of the resistance.

If an oblique resistance opposed to the weight be loosened and freed, it will make no resistance to the weight; on the contrary it will descend with it to ruin.

It is in the nature of weight to transmit itself of its own accord to the desired place.

Every part of force contains the whole—contrary to weight. Often they are victors one over the other.

They are of similar nature as regards pressure and the stronger overpowers the weaker. Weight does not change of its own accord, while force is always fugitive.

Weight is corporeal and force is incorporeal.

Weight is material and force is spiritual.

One desires flight from itself and death, the other seeks stability and permanence.

Often one generates the other.

If weight creates force, force is weight.

If weight conquers force, force is weight.
And if they are of equal strength they make long company.
If one is eternal the other is mortal.[94]

If you are on a boat, and you there exert your utmost force the boat will never move from its position unless the said force is greater in an obstacle outside the boat than that made within it. Again if you are all wrapped in a sack, and within it make efforts to move yourself, you will find it impossible to move from your place; but if you draw a foot out of the sack, and use it as a lever on the ground putting your head to the bottom of the sack, then you will draw it backwards.

The flame also does the same with its desire to multiply and extend itself in the bombard, for while it is entirely inside the bombard does not recoil. But when this flame strikes and pushes the resisting air while remaining united to that which pushes on the bottom, it is the cause that the bombard recoils; for that portion of the flame that strikes, not being able to find in the air that instant passage that it requires, throws its force upon the opposite side.[95]

3. MOVEMENT

Definition of Movement

Direct movement is that which extends from one point to another by the shortest line.

Curved movement is that in which no direct movement is to be found in any part.

Spiral movement is composed of an oblique and curved line which is such that the lines drawn from the centre to the circumference are all found to be of various lengths. And it is of four kinds, convex spiral, plane spiral, concave spiral, and the fourth is columnar spiral.

Then there still is the circular movement made always

around one point at an equal distance and this is called circumvolution. There are also the irregular movements which are infinite and are composed of a mixture of the aforesaid movements.[96]

Of movement in general

What is the cause of movement. What movement is in itself. What it is which is most adapted for movement. What is impetus; what is the cause of impetus; the medium in which it is created. What is percussion; what is its cause. What is rebound. What is the curve of straight movement and its cause.[97]

A point has no part; a line is the transit of a point; points are the boundaries of a line. An instant has no time. Time is made of movement of the instant, and instants are the boundaries of time.[98]

Of movement

I find that force is infinite together with time; and that weight is finite together with the weight of the whole globe of the terrestrial machine. I find that the stroke of indivisible time is movement, and that this movement is of many varieties, namely natural, accidental, and participating; and this participating movement ends in its greatest power when it changes from the accidental to the natural, that is in the middle of its course; and the natural is more powerful at the end than at any other place; the accidental is strongest in the third and weakest at the close.[77]

No movement can ever be so slow that a moment of stability is found in it.

That movement is slower which covers less distance in the same time.

And that movement is swifter which covers more distance in the same time.

Movement can acquire infinite degrees of slowness.

It is in the power of movement to extend to infinite slowness and likewise to infinite velocity.

Movement has the power to extend to infinite velocity.[98]

4. MOVEMENT AND WEIGHT

Of Movement and Weight

In equal movements made in equal time the mover will always have more power than the thing which is moved; and the mover will be so much the more powerful than the thing moved in proportion as the movement of this moved thing exceeds the length of movement of its mover; and the difference of the power of the mover over that of the thing moved will be so much less in proportion as the length of the movement made by the thing moved is less than the movement of this mover. . . .

And this we see with an arrow from a bow, when its point is resting on the wood; for though the cord drive it with all the force of the bow it only penetrates the wood very little, but does the contrary if it has some movement.

Some say that the arrow in moving propels a wave of air in front of itself, and that this wave by means of its movement prevents the course of the arrow from being impeded. This is incorrect, however, because everything which is moved exhausts and impedes its mover. The air therefore which passes in waves in front of the arrow does so because of the movement of this arrow, and it lends little or no help of movement to its mover, which has to be moved by the same mover, but rather checks and shortens the movement of the thing moved.[99]

Every heavy substance moves on the side where it weighs most. And the movement of the heavy substances is made where it encounters least resistance.

The heaviest part of bodies that move in the air becomes guide of the movements.

That heavy substance descends more slowly through the air which has greater width.

It follows that that heavy substance will descend more swiftly which has the least width.

The free descent of every substance is made along the line of its greatest diameter.[100]

The movements of weight are of three kinds, of which two are contrary and the third participates in one and the other.

The reason is that the movement made from below upwards becomes feebler the more it rises; the other on the contrary grows stronger the farther it descends. While the first leaves its highest contact unharmed the second, on the contrary, inflicts great damage to itself and to others; the third movement is transverse and half of it resembles the weight that descends and the other half is like the weight that rises.[90]

Proof of the proportion of the time and movement together with the speed made in the descent of heavy bodies in the shape of pyramids, because the aforesaid powers are all pyramidal seeing that they commence in nothing and proceed to increase in degrees of arithmetical proportion.

If you cut the pyramid at any stage of its height by a line equidistant to its base, you will find that the proportion of the height of this section from its base to the total height of the pyramid will be the same as the proportion between the breadth of this section and the breadth of the whole base.[101]

Now we have found that the discontinuous quantity when moving acquires at each stage of its movement a degree of speed; and so in each stage of harmonic time they acquire a length of space from each other and this acquisition is in arithmetical proportion.[102]

Of movement

The weight which descends freely acquires a degree of movement with every degree of time, and with every degree of movement it acquires a degree of velocity.

Although the equal division of the movement of time cannot be stated by degrees as is the movement made by bodies, nevertheless I must in this case make the degrees after the manner in which they are made among musicians.

Let us say that in the first degree of time the weight acquires a degree of movement and a degree of velocity, then it will acquire two degrees of movement and two of velocity in the second degree of time and so it continues in succession. . . .[103]

The wave of the air that is produced by a body moving through the air will be much swifter than the body that moves it.

This happens because the air is very volatile and when a body moves through it, it makes the first wave in its first movement, and that first wave cannot be made without at the same time causing another after it and that causing another. And so this body moving through the air creates beneath it in each stage of time multiplications of waves which in their flight prepare the path for the movement of their mover.[103]

If two bodies of equal weight and shape fall one after another from an equal altitude one will be a degree more distant than the other in each degree of time.[104]

The weight which has a free descent acquires a degree of weight with every degree of movement. . . .[105]

The weight which descends freely gains a degree of speed with every stage of movement.

And the part of the movement which is made in each degree of time grows longer successively.[106]

If many bodies of equal weight and shape are allowed to fall one after the other at equal times the excesses of their intervals will be equal to each other.

The experiment of the aforesaid conclusion as to movement ought to be made in this way: One takes two balls of equal weight and shape and lets them drop from a great height in such a way that at the beginning of their movement they touch one another; and the experimenter should station himself on the ground below in order to watch whether in their fall they have maintained contact with each other or not. And this experiment should be made repeatedly so that no accident may occur to hinder or falsify the proof—for the experiment may go wrong and may or may not deceive the experimenter.[107]

Of the descent of weight

Every natural action is made by the shortest way; and this is why the free descent of the weight is made towards the centre of the world; because it is the shortest distance between the movable thing and the ultimate depth of the universe.[108]

Every weight desires to descend to the centre by the shortest way; and where there is greater weight there is greater desire, and that thing which weighs the most if left free falls most rapidly. The less the slant of the opposing substance the greater its resistance. The weight passes by nature into whatever supports it and thus penetrating from support to support it grows heavier as it passes from body to body until it realizes its desire. . . .

In its action of pressing and weighting it is like force. Weight is subdued by force as force is by weight. One can see weight without force, but not force without weight. If weight has no neighbour it seeks one with fury, while force drives it away with fury.

If weight desires a permanent position, force readily flies from it.

If weight desires stability, force always desires flight; weight of itself is without fatigue, while force is never exempt from it. The more weight falls the more it increases and the more force falls the more it diminishes. If one is eternal the other is mortal. Weight is natural and force is accidental. Weight desires stability and permanence, and force is desirous of flight and death.

Weight, force, and a blow resemble each other as regards pressure.[109]

5. MOVEMENT AND FORCE

First. If a power move a body a certain distance in a certain time, the same power will move half of this body in the same time twice this distance.

Second. If any force move any movable thing a certain distance in a certain time the same force will move half this movable thing the whole distance in half this time.

Third. If a force move a body in a certain time a certain distance the same force will move half of this body half the distance in the same time.

Fourth. If a power move a body in a certain time a certain distance, half the force will move in the same time half the body half the distance.

Fifth. If a force move a body in a certain time a certain distance it is not necessary that such power move twice this weight in twice the time twice this distance, because it might be that this force could not move this body.

Sixth. If a force move a body in a certain time a certain distance, it is not necessary that half of this force move this same body in the same time half this distance, for perhaps it would not be able to move it.

Seventh. If two separate forces move two separate bodies the same forces united will move in the same time the two

movable things joined together for the same distance, because the proportion remains the same.[110]

Nothing that can be moved is more powerful in its simple movement than its mover.[111]

Of the mover or the movable thing

The power of the mover is always greater than the resistance of the thing moved.[112]

Of the movement made by things proportionately to the power which drives them

One ought to make the experiment with a cross-bow or other power which does not grow weaker, and also with balls of equal shape and of different substances and weight to test which goes farthest away from its motive power, and to test with various shapes of various sizes, breadths and lengths and to make a general rule. I wish to know what weight the power will have which shall drive to a greatest distance from itself a weight of a pound spherical in shape.[113]

Of the power of the cross-bow

The weight that charges the cross-bow has the same proportion to the weight of the arrow as the movement of the arrow of this cross-bow has to the movement of its cord.

Here one ought to deduct three resistances made by the air, that is the percussion of the bow of the cross-bow made upon the air, and that of the cord; the third is that made against the arrow.[114]

If the cord of the cross-bow draws four hundred pounds weight upon its notch with the movement of a third of a braccio, as it discharges itself, it will draw two hundred pounds with two-thirds of a braccio distance from its notch; and one hundred pounds will be removed from its

position by such power for a space of one braccio and a third.

And as much as you diminish the weight of the movable thing so the power will cause it to make a greater movement, so that you will always find that the movement of the cord and the movement of the thing propelled will be in the same proportion as the weight that drew the cord to the notch was to the weight that was driven by the cord (if the air did not restrain it).[115]

A man who wants to make a bow carry a very long way must be standing entirely on one foot and raising the other so far from the foot he stands on as to afford the requisite counterpoise to his body which is thrown forward on the first foot. And he must not hold his arm fully extended, and in order that he may be more able to bear the strain he must hold a piece of wood which as used in cross-bows extends from the hand to the breast, and when he wishes to shoot he should suddenly leap forward and at the same instant extend his arm with the bow and release the cord. And if by dexterity he does everything at once it will go a very long way.

The reason given for this is as follows: know that as the leap forward is swift it lends one degree of fury to the arrow, and the extending of the arm because swifter lends a second; the push of the cord being also swifter gives a third. Therefore, if other arrows are driven by three degrees of fury and this by dexterity is driven by six it should travel double the distance. And I must remind you to leave the bow relaxed so that it will spring forward and remain taut.[116]

I have ten measures of time and ten measures of force and ten measures of movement and ten of weight, and I wish to raise up this weight.

If I double the weight and not the force in the movement, it becomes necessary to double the time.

If I double the weight and not the time or the force it becomes necessary to halve the movement.

If I double the weight and not the movement or the time it becomes necessary to double the force.

If I halve the weight and not the movement or the time, the force is halved.[117]

6. IMPETUS AND PERCUSSION

What is primary movement

Primary movement is that which is made by the movable thing during the time when it is joined to its mover.

Of derived movement

Derived movement is that which the movable thing makes through the air after it is separated from its mover. Derived movement has its origin in primary movement and it never has swiftness or power equal to the swiftness or power of this primary movement. The course of this movable thing will conform to the direction of the mover's course when all the parts of this movable thing have movement equal to the primary movement of their mover.[118]

Definition of impetus

Impetus is a power created by movement and transmitted from the mover to the movable thing; and this movable thing has as much movement as the impetus has life.[119]

Of impetus

Impetus is the impression of movement transmitted by the mover to the movable thing.

Impetus is a power impressed by the mover on the movable thing.

Every impression tends to permanence or desires permanence. This is shown in the impression made by the sun in the eye of the spectator and in the impression of the sound made by the clapper as it strikes the bell.

Every impression desires permanence as is shown by the image of the movement impressed upon the movable thing.[120]

What is impetus

Impetus under another name is called derived movement, which arises out of primary movement, that is to say when the movable thing is joined to its mover.

In no part of the derived movement will one ever find a velocity equal to that of the primary movement. For instance at every stage of movement of the cord of the bow there is a loss of the acquired power which has been communicated to it by its mover. And since every effect partakes of its cause the derived movement of the arrow lessens its power by degrees, and thus participates in the power of the bow which as it was produced by degrees is so destroyed.[121]

Simple impetus is that which moves the arrow or dart through the air. Compound impetus is that which moves the stone when it issues from the sling.[122]

I ask why field-lances or hunting-whips have a greater movement than the arm. I say that this happens because the hand describes a much wider circle as the arm moves than does the elbow; and in consequence moving at the same time the hand covers twice as much space as does the elbow, and therefore it may be said to be of a speed double that of the movement of the elbow, and so it sends things when thrown a greater distance from itself.

Thus you see clearly that the circuit described by the elbow is less by half and its speed is slower by half.

It is true that if one subtracts from the movement made

by the hand an amount equal to that made by the elbow the movements are of equal slowness.[123]

There are two different kinds of percussion, simple and complex. The simple is made by the movable thing in its falling movement upon its object. Complex is the name given when this first percussion passes beyond the resistance of the object which it strikes first, as in the blow given to the sculptor's chisel which is afterwards transferred to the marble that he is carving. This blow also is divided into two others, namely a simple and a double blow. The simple blow has been sufficiently described. The double one occurs when the hammer descends with force in its natural movement and flies back rebounding from the greater blow and creates an inferior blow and makes this percussion in two places, with the two opposite sides of the hammer. And this blow grows less and less in proportion to the number of the obstacles which are interposed between the final resistance, just as if someone were to strike a book on its front pages, even though its pages were all touching, the last page would feel the damage slightly.[124]

Of movement and percussion

If someone descends from one step to another by jumping from one to the other and you add together all the forces of the percussions and the weights of these jumps, you will find that they are equal to the entire percussion and weight that such a man would produce if he fell by a perpendicular line from the top to the bottom of the height of this staircase.

Furthermore, if this man were to fall from a height, striking stage by stage upon objects which would bend in the manner of a spring, in such a way that the percussion from the one to the other was slight, you will find that at the last part of his descent this man will have his percussion as much diminished by comparison with what it would

have been in a free and perpendicular line, as it would be if there were subtracted all the percussions that were given at each stage of the said descent upon the aforesaid springs[125]

Every spherical body of thick and resisting surface when moved by an equal force will make as much movement in the rebounds caused by its impact upon a concrete ground as if it were thrown freely through the air.

How admirable Thy justice, O Thou First Mover! Thou hast not willed that any power should be deprived of the processes or qualities necessary for its results; for, if a force have the capacity of driving an object conquered by it, a hundred braccia, and this object while obeying it meets with some obstacle, Thou hast ordained that the force of the impact will cause a new movement, which by diverse rebounds will recover the entire amount of the distance it should have traversed.

And if you were to measure the track made by these bounds you will discover it to be of the same length as that made by a similar object impelled freely through the air by the same force.[126]

Why it is first the blow rather than the movement caused by it; the blow has performed its function before the object has started on its course.[127]

The blow is born by the death of motion, and motion is born by the death of force.

Force is caused by motion injected into the weight, and likewise the blow is caused by motion injected into the weight.[128]

Of the blow and the displacement caused by weight or by force.

I maintain that the displacement caused by the weight which falls is equal to the displacement caused by the force.

The body that receives the blow is not injured as much in

the part opposite as it is in the part which is struck. The proof of this is shown when a stone is struck while lying in a man's hands, for the hand is not injured when it is holding the stone as much as it would be injured if it actually received the blow.[129]

Ascertain always the proportion of the blow to the object which receives it.

Since one hundred pounds applied at a single blow makes a greater percussion than a million applied one by one, I advise that when you train the battering ram against the castle you cause the blow to be raised in the air by the weight of the men and then you pull it back after the manner of a catapult or cross-bow, and you will have a good result.[130]

A blow is an end of movement created in an indivisible period of time, because it is caused at the point which is the end of the line of the movement made by the weight which is the cause of the blow.[131]

If a ten-pound hammer drives a nail into a piece of wood with one blow, a hammer of one pound will not drive the nail altogether into the wood in ten blows. Nor will a nail that is less than a tenth part (of the first) be buried more deeply by the said hammer of a pound in a single blow although they may be in equal proportions to one another as those first named, because the hardness of the wood does not diminish the proportion of its resistance, that is it remains as hard as at first. If you wish to treat of the proportions of the movement of the things that have penetrated into the wood when driven by the power of the blow, you have to consider the nature of the weight that strikes and the place where the thing is struck.[132]

I say that every body moved or struck keeps in itself for a time the nature of this blow or movement, and keeps it in

proportion as the power of the force of this blow or move-
ment is greater or less. Observe a blow given on a bell how
it preserves in itself the noise of the percussion.

Observe a stone projected from a bombard how long it
preserves the nature of the movement. . . .

The eye keeps within itself the images of luminous
bodies for a certain time.[133]

I say that percussion is the end of the swift motion of bodies
against resisting objects. It is also the cause of all sounds and
the breaker and transmuter of various things and the pro-
duct of a second motion. There is nothing of greater power
and it goes on transmuting according to circumstance.[134]

The stroke in a bell leaves its likeness behind it impressed
as the sun in the eye or the scent in the air; but we wish to
discern whether the likeness of the stroke remains in the
bell or in the air and this is ascertained by placing your
ear to the surface of the bell after the stroke. The stroke
given in the bell will cause response and some slight move-
ment in another bell similar to itself; and the string of a
lute as it sounds will cause response and movement in
another similar string of like tone in another lute; and this
you will see by placing a straw on the string similar to that
which has sounded.[135]

III. MECHANICS

REFERENCES TO BOOKS ON APPLIED
MECHANICS

Speak first of motion then of weight as produced by motion,
then of the force that proceeds from weight and motion,
then of the percussion that springs from weight, motion
and often from force.

Speak of motion and impetus.

Speak of wheels rotating one way.

You will speak of wheels that turn and return.
Speak of the wheel that augments.
Speak of the perpetual screws.
Speak of mills and other machines that move and throw.
Speak of teeth.
You will first speak of poles.
Then of wheels and battens without teeth.
Then of wheels and battens with rope and with teeth.
And you will say what teeth are most praiseworthy in nature and movement and setting.[136]

Now look in the book on Elements in mechanics and you will find the definition of the screw.[137]

I. FRICTION

Friction

Friction is divided into three parts: these are simple, compound, and irregular.

Simple friction is that made by the thing moved on the place where it is dragged.

Compound friction is that which the thing moved makes between two immovable things.

Irregular friction is that made by the wedge of different sides.[138]

Of friction

The movement of friction is divided into parts of which one is simple and all the others are compound. Simple, when the object is dragged along a plane smooth surface without any intervention. This is the only friction that creates fire when it is powerful—that is to say it generates fire—as can be seen at waterwheels when the water is removed between the whetted iron and the wheel. The other frictions are compound and are divided into two parts; the first is when any greasiness of some thin substance intervenes between the bodies that rub together; and the

second is when an additional friction is introduced, as would be the friction of the poles of the wheels. The first of these is again divided into two parts, namely the greasiness, that is interposed, and the balls and such things.[139]

The resistance created by friction to the movement of weights is separate and remote from this weight.

Reason

This is shown by the things said before, namely that it is obvious that the movement made by weights along horizontal lines does not of itself offer any other resistance to its mover than its own friction which it makes with the surface where it touches it; which movement is more difficult in proportion as the surface is more scoured and rough.[140]

Who knows what weight pulls a hundred pounds upwards over this slope knows the capacity of the screw. In order to know accurately the quantity of the weight required to move a hundred pounds over the sloping road one must know the nature of the contact which this weight has with the surface on which it rubs in its movement, because different bodies have different frictions; thus let there be two bodies with different surfaces, one soft and polished, well greased or soaped, and let it be moved over a surface similar in kind, it will move much more easily than one that is roughened by lime or a rasping file; therefore, always when you wish to know the quantity of force required to drag the same weight over streets of different slope, you have to make the experiment and ascertain what amount of force is required to move the weight along a level road, that is to ascertain the nature of its friction. . . .

Different slopes make different degrees of resistance at their contact; because, if the weight which must be moved is upon level ground and has to be dragged, it undoubtedly

will be in the first strength of resistance, because everything rests on the earth and nothing on the cord which must move it. But if you wish to pull it up a very steep road all the weight which it gives of itself to the cord which sustains it is subtracted from the contact of its friction; but there is another more evident reason: you know that if one were to draw it straight up slightly grazing and touching a perpendicular wall, the weight is almost entirely on the cord that draws it, and only very little rests upon the wall where it rubs.[141]

A thing which is consumed entirely by friction in its long movement will be consumed in part at the start of this movement.

This proves that it is impossible to give or make anything with absolute exactness; for if you want to make a perfect circle by moving one of the points of the compasses, and you admit what is set forth above, that this point tends to be worn away in the course of long movement, then the whole point will necessarily be worn away in a certain space of time and the part will be consumed in part of this time; and the beginning of such consumption will be indivisible in indivisible time.

And likewise the opposite point of these compasses as it rotates over the centre of the circle is being consumed at every stage of the movement while also consuming the place where it rests; we may therefore say that the end of the circumference does not join its beginning, but is imperceptibly nearer the centre of the circle.[142]

2. WEIGHING INSTRUMENTS

Take a beam of uniform weight and thickness, and let it be suspended from a pole at its centre, or at a certain part of its length; and this beam thus suspended we shall call balance or scales, and the parts that protrude from the pole we shall call arms of the balance. . . .[143]

The Commencement of this Book concerning Weights

First. If the weights, arms, and movements slant equally these weights will not move each other. Second. If the weights equal in slant, and equal, move each other then the arms of the balance will be unequal. Third. But if the equal weights in the arm and the balance move one another, then the movements of the weights will be of unequal slant. Fourth. If the weights of the arms of the balance with the slant of the movements of these weights are equal, then these weights will show themselves unequal if their appendices have their slants unequal.[144]

The arrangement of the book will be as follows: First the simple poles, then supported from below, then partly suspended, then entirely, then let these poles support other weights.[145]

Of weight proportioned to the power that moves it. One has to consider the resistance of the medium wherein such a weight is being moved; and a treatise will have to be written on this subject.[146]

In order to test a man and see whether he has true judgement on the nature of weights, ask him where you should divide one of the two equal arms of a balance so that the cut part if added to the end of its remainder, may form an exact counterweight to the arm opposite it. Which thing is not possible; and if he indicates a place he is a sorry mathematician.[147]

Where the Science of weights is led into error by the practice

The science of weights is led into error by its practice, which in many instances is not in harmony with this science nor is it possible to bring it into harmony; and this is caused by the poles of the balances by means of which the science of such weights is formed, which poles according

to the ancient philosophers were placed by nature as poles
of a mathematical line and in some cases in mathematical
points, and these points and lines are devoid of substance,
whereas practice makes them possessed of substance, be-
cause necessity demands this for the support of the weight
of these balances together with the weights which are gauged
upon them. I have found that the ancients were in error in
their reckoning of weights, and that this error has arisen
because in a considerable part of their science they have
made use of poles which had substance and in a considerable
part of mathematical poles, such as exist in the mind and
are without substance; which errors I set down here
below.[148]

The centre of the length of each arm of a balance is the true
centre of its gravity.

Arm of balance is said to be that space which is found
between the weight attached to this balance and its pole.

That proportion which exists between the spaces that
come between the centres of the arms and the pole of the
balance, is as that of the opposite weight which the one
arm gives of itself in counterpoise to the other with its
own arm which is the counterpoise.[149]

The intercentric line is said to be that which starts from the
centre of the world and which rising therefrom in one
continuous straight line passes through the centre of the
heavy substance suspended in an infinite quantity of
space.[150]

The centre of any heavy body whatsoever will stand in a
perpendicular line beneath the centre of the cord on which
it is suspended. I ask if you were to suspend a pole outside
the centre of its length what degree of slant it will assume.

The pole which is suspended outside the centre of its
length by a single cord will assume such a slant, as will make
with its opposite sides together with the perpendicular of

the centre of the cord that supports it, two equal acute angles or two equal obtuse angles.[151]

3. WHEELS AND WEIGHT

The wheel as it turns upon its axle causes part of the axle to become lighter and the other heavier even more than double of what it was at first, when it did not move away from its position.[152]

In a circular balance no heavy body will raise more than its own weight by the force of its simple weight.

I call circular balance the wheel or pulley by which water is pulled from the wells, to which one never applies more weight than that which is attained by the water that is lifted.[153]

If you wish with certainty to understand well the function and the force of the tackle it is necessary for you to know the weight of the thing that moves or the weight of the thing moved; and if you would know that of the thing that moves multiply it by the number of the wheels of the tackle, and the total that results will be the complete weight which will be able to be moved by the moving thing.[154]

If you multiply the number of the pounds that your body weighs by the number of the wheels that are situated in the tackle, you will find that the number of the total that results will be the complete quantity of pounds that it is possible to raise with your weight.[155]

Cause an hour to be divided into three thousand parts, and this you will do by means of a clock by making the counter-weight lighter or heavier.[156]

As the attachment of the heavy body is farther from the centre of the wheel the revolving movement of the wheel round its pivot will become more difficult although the

motive power may not vary. The same is seen with the time of clocks, for, if you place the two weights nearer or farther away from the centre of the timepiece, you make the hours shorter or longer.[157]

The fact that a thing may be either raised or pulled causes great difference of difficulty to its mover; for if it weighs a thousand pounds and one moves it by simply lifting it, it shows itself as a thousand pounds; whereas if it is pulled it becomes less by a third; and if it is pulled with wheels it is diminished by as many degrees in proportion to the sizes of the wheels, and also according to the multiplied number of the wheels. And with the same time and power it can make the same journey, with different degrees of time and power also in the same time and movement; and this is done merely by increasing the number of the wheels on which rest the axles which must be multiplied.[158]

4. THE SCREW

Of the screws of equal thickness that will be most difficult which has most grooves upon it. And among those screws of equal length, thickness, and number of ridges you will find that the easiest to move which has the greatest number of curves of its ridges. That screw will be strongest to sustain weights of which the ridges have the less number of curves; but it will be most difficult to move. [159]

Vitruvius says* that small models are of no avail for ascertaining the effects of large ones; and I here propose to prove that this conclusion is a false one. And chiefly by bringing forward the very same argument which led him to this conclusion; that is, by an experiment with an auger. For he proves that if a man, by a certain exertion of strength, makes a hole of a given diameter, and afterwards another hole of double the diameter, this cannot be made with

* De Architectura, x. 16. 5.

only double the exertion of the man's strength, but needs much more. To this one may very well reply that an auger of double the diameter cannot be moved by double the exertion because the surface of a body similar in shape and of double the width has four times the quantity and power of the smaller one.[160]

III

FLIGHT

Vasari reports that Leonardo used to buy caged birds in order to release them, for he had pity for their plight. An additional motive may have been his admiration for their flight, which was a continuous source of inspiration to him. He loved to watch them moving through the air, soaring, gliding, sailing, and flapping and compared their behaviour with that of flying insects and bats while drawing their instantaneous actions in his notebooks. Here also we find representations of the structure of wings and tails with accounts of their co-operation in steering the body.

This interest went hand in hand with a study of the medium wherein flights took place. How did the air react? Here was an opportunity to study the Powers of Nature, i.e. weight, movement, and impetus at work within one of the four elements, and to compare and contrast its properties with those of another element that he had studied—Water. How were bodies heavier than air able to sustain and propel themselves therein? Man should be able to do likewise if provided with the requisite apparatus. His designs show various machines with the aviator in horizontal and vertical positions, while using his limbs to operate fabricated wings and windlass; also an aerial screw heralding the helicopter of the present day, a parachute, a hydrometer to determine humidity, and an instrument to indicate the direction and to measure the force and velocity of the wind.

While absorbed in these studies, he once jotted down in his notebook that he must have been predestined to write on this because one of the earliest recollections of his

babyhood was a dream of a kite paying a visit to his
cradle and opening his lips with its tail (see p. 286).

His booklet on the flight of birds, written and illustrated
in 1505, is now one of the treasures of the Royal Library
at Turin and has recently been claimed by the exiled royal
family as their private property.

I. MOVEMENT THROUGH WIND AND WATER

The instrumental or mechanical science is the noblest and
useful above all others, since by means of it all animated
bodies which have movement perform all their actions;
and these movements have their origin from the centre of
their gravity which is placed in the middle beside unequal
weights, and it has scarcity and abundance of muscles, and
also lever and counter-lever.[1]

Before you write about creatures which can fly make a
book about insensible things which descend in the air
without the wind and another on those which descend
with the wind.[2]

In order to give the true science of the flight of birds through
the air you must first give the science of the winds, which
we shall prove by the motion of the waters; and the under-
standing of this science, which can be studied through the
senses, will serve as a ladder to arrive at the perception of
flying things in the air and the wind.[3]

Divide the treatise on birds into four books, of which the
first deals with their flight by flapping their wings; the
second of flight without flapping wings and with the help
of the wind; the third of flight in general such as that of
birds, bats, fishes, animals, insects; the last of the mechanism
of motion.[4]

First define the motion of the wind and then describe in what way the birds steer through it with only the simple balancing of the wings and tail; and this you will describe after the description of their anatomy.[5]

Of the bird's movement

To speak of this subject you must in the first book explain the nature of the resistance of the air, in the second the anatomy of the bird and its wings, in the third the method of working the wings in their various movements, in the fourth the power of the wings and of the tail when the wings are not being moved and when the wind is favourable to serve as guide in various movements.[6]

What is impetus?

Impetus is a power transmitted from the mover to the movable thing, and maintained by the wave of the air within the air which this mover produces; and this arises from the vacuum which would be produced contrary to the natural law, if the air which is in front of it did not fill up the vacuum, so causing the air which is driven from its place by the aforesaid mover to flee away. And the air that goes before it would not fill up the place from which it is separated if it were not that another body of air filled up the place from which this air was separated. . . . And this movement would continue to infinity if the air were capable of being compressed to infinity.[7]

Impetus is the impression of local movement transmitted from the mover to the movable thing and maintained by the air or by the water as they move in order to prevent the vacuum.

The impetus of the movable thing within the water is different from the movable thing within the air, and these differences result from the dissimilarities of these elements, because air is condensable to infinity and water is not.

The impetus of the water is divided into two parts through its being of two natures, one simple and the other complex. The simple is entirely beneath the surface of the water, the complex is between the air and the water, as with boats.

The simple impetus does not compress the water in front of the movement of the fish, but moves the water backwards with the same speed that the mover has; and the wave of the water will never be swifter than its mover.

But the movement of the boat, called complex movement since it is shared by the water and the air, is divided into three chief parts because it is carried on in three directions, namely against the course of the river, in the direction of its current, and crosswise, that is across the breadth of the river.[8]

Every movement will retain its course or rather every body when moved will continue on its course as long as the power of the impulse is maintained therein.[9]

The impetus generated in still water has a different effect from that generated in still air. This is shown by the fact that water is never compressed in itself by any movement below its surface, as the air is within itself when struck by a moving object. And this we may see from the bubbles with which the water is encumbered from its surface to its bed, which cluster around where the water fills up the vacuum that the fish leaves behind it as it penetrates; and the movements of this water strike and drive the fish, because water only has weight within water when it has movement, and this is the primary cause of the increase of movement for its mover.[10]

Of the wind

The air moves like a river and carries the clouds with it; just as running water carries all the things that float upon it.[11]

The movement of the air against a fixed thing is as great as the movement of the moving thing against an air which does not move.

And it is the same with water which a similar circumstance has shown me to act in the same way as does the air, as with the sails of ships when accompanied by the lateral resistance of their helm.[12]

When the heavy substance descends in the air, and the air moves in a contrary direction in order to fill up continuously the space evacuated by this heavy substance, the movement of this air is a curve, because when it desires to rise by the shortest line it is prevented by the heavy substance which descends upon it, and so it is obliged to bend and then return above this heavy substance in order to fill up the vacuum that has been left by it. And if the air would not be compressed beneath the speed of the heavy substance, the birds would not be able to support themselves upon the air that is struck by them; but it is here necessary to affirm that the air is compressed beneath that which strikes it and it becomes rarefied above in order to fill up the void left by that which has struck it.[13]

Of the science of the weight proportioned to the powers of their movers

The force of the mover ought always to be proportionate to the weight of the thing to be moved and to the resistance of the medium in which the weight moves. But one cannot deduce the law of this action unless one first gives the quantity of the condensation of the air when struck by any movable thing; and this condensation will be of greater or less density according to the greater or less speed of the movable thing pressing on it; as is shown in the flight of birds, for the sound that they make with their wings in beating the air is deeper or shriller according to whether the movement of the wings is slower or swifter.[14]

II. STRUCTURE OF BIRDS' WINGS

First do the anatomy of the bird's wing; and then of its
feathers deprived of fluff and then with the fluff.[15]

You will study the anatomy of the wings of a bird together
with the muscles of the breast which are the movers of
these wings. And you do the same for man in order to show
the possibility that there is in man to sustain himself amid
the air by the flapping of wings.[16]

A plea for the undertaking that disposes of the objections.

You will perhaps say that the sinews and muscles of a
bird are incomparably more powerful than those of a man,
because all the strength of so many muscles and flesh of the
breast goes to aid and increase the movement of the wings,
while the bone in the breast is all in one piece and conse-
quently affords the bird very great power, the wings being
all covered with a network of thick sinews, and other very
strong ligaments of cartilage and the skin being very thick
with various muscles.

The reply to this is that such great strength is given as a
reserve of power beyond what it ordinarily uses to support
itself on its wings, since it is necessary for it whenever it
may desire either to double or to treble its motion, in order
to escape from its pursuer or follow its prey. Therefore in
such a case it becomes necessary for it to put forth double
or treble the amount of effort and in addition to this to
carry through the air in its talons a weight corresponding
to its own weight; so one sees a falcon carrying a duck and
an eagle carrying a hare, which circumstance shows well
enough where the excess of strength is spent; for they need
but little force in order to sustain themselves and to balance
themselves on their wings and flap them in the pathway of
the wind, and to direct their course a slight movement of
the wings is sufficient, and the movement will be slower
in proportion as the bird is greater in size.[17]

The feathers that offer a feeble resistance are set beneath those that offer a strong resistance, and their extremities are turned towards the tail of the bird; because the air underneath flying things is thicker than it is above them, and thicker in front than it is behind; and the necessity of flight requires that these lateral extremities of the wings are not found by the stroke of the wind because they would immediately be spread out and separated, and would be instantly penetrated by the wind. Therefore, the resistances are so placed that the parts with a convex curve are turned towards the sky so that the more they are struck by the wind the more they lower themselves drawing closer to the lower resistances underneath them and so preventing the entry of the wind beneath the front. . . .[18]

The wing of the bird is always concave in its lower part extending from the elbow to the shoulder, and the rest is convex. In the concave part of the wing the air is whirled round, and in the convex it is pressed and condensed.[19]

The longest feathers of the wings will be flexible since they are not covered by other feathers from their centre to their tip.

The helms placed on the shoulders of wings are extremely necessary for they keep the bird poised and motionless in the air as it faces the course of the wind.

[With drawing]
This helm is placed near where the feathers of the wings bend, and because of its strength it bends but little or not at all, being situated in a very strong place and supplied with powerful sinews and being of hard bone and covered with very strong feathers, protecting and supporting one another.[20]

Birds with short tails have very wide wings; which by their width take the place of the tail; and they make considerable

use of the helms set on the shoulders when they wish to turn
to any spot.[21]

Why the sinews beneath the birds' wings are more powerful
than those above. It is done for the movement. The shoulder,
being the helm of the wing, is hollow below like a spoon;
and being concave below, it is convex above. It is fashioned
thus in order that the process of going up may be easy, and
that of going down difficult and meeting with resistance;
and it is especially adapted for going forward drawing
itself back in the manner of a file.[22]

The helms formed on the shoulders of the wings of birds
are provided by resourceful nature as a convenient means
of deflecting the direct impetus, which often takes place
during their headlong flight. For a bird finds it much more
convenient to bend by direct force one of the smallest parts
of the wings than the whole of them; and the reason why
their feathers are made very small and very strong is that
they may serve as cover for one another and in doing so
arm and fortify each other with marvellous power. And
these feathers are based in small and very strong bones,
which are moved and bent over the massive joints of these
wings by sinews.

The movement and position of these bones on the
shoulders of the wings resemble that of the thumb in the
human hand, which being surrounded by four sinews
equidistant from one another at the base, makes therewith
an infinite number of movements both circular and straight.

We may say the same of the rudder placed behind the
movement of the ship, imitated from the tails of the birds;
as to which experience teaches us how much more readily
this small rudder is turned during the rapid movements of
great ships than the whole ship itself. . . .[23]

Bats when they fly must of necessity have their wing

completely covered with a membrane, because the creatures of the night whereon they feed seek to escape by means of confused revolutions and this confusion is enhanced by their various twists and turns. So the bats must sometimes follow their prey upside down, sometimes in a slanting position or in various other ways, which they could not do without causing their own destruction if their wings were of feathers that let the air pass through them.[24]

III. SWIMMING AND FLIGHT

When two forces strike against each other it is always the swiftest which leaps backwards. So it is with the hand of the swimmer when it strikes and presses upon the water and makes his body glide forward in a contrary movement; so it is also with the wing of the bird in the air.[25]

Swimming upon water teaches man how birds do upon the air.[26]

Swimming illustrates the method of flying and shows that the largest weight finds most resistance in the air.

Observe the goose's foot: if it were always open or always closed the creature would not be able to make any kind of movement. While with the curve of the foot outwards it has more perception of the water in going forward than the foot would have as it is drawn back; this shows that the same weight the wider it is the slower is its movement. Observe the goose moving through the water, how as it moves its foot forward it closes it occupying but little water and consequently acquiring speed; and as it pushes it back it spreads it out and so makes itself slower, and then the part of the body that has contact with the air becomes swifter.[27]

Why is the fish in the water swifter than the bird in the air when it ought to be the contrary since the water is heavier and thicker than the air and the fish is heavier and has smaller

wings than the bird? For this reason the fish is not moved from its place by the swift currents of the water as is the bird by the fury of the winds amid the air; also we may see the fish speeding upwards on the very course down which the water has fallen abruptly with very rapid movement like lightning amid incessant clouds, which seems a marvellous thing. And this is caused by the immense speed with which it moves which so exceeds the movement of the water as to cause it to seem motionless in comparison with the movement of the fish. . . .

This happens because the water is of itself thicker than the air and consequently heavier, and it is therefore swifter in filling the vacuum which the fish leaves behind it in the place whence it departs; and also the water which it strikes ahead is not compressed as is the air in front of the bird, but rather makes a wave that by its movement prepares the way and increases the movement of the fish; and therefore it is swifter than the bird which has to meet compressed air ahead.[28]

In what way a man ought to learn to swim. Of the way in which a man should rest upon the water. How a man ought to defend himself against the whirlpools or eddies of the waters which suck him to the bottom. How a man when sucked down to the bottom has to seek the reflex current which will cast him out of the depths. How he ought to propel himself with his arms. How he ought to swim on his back. How he can only remain underwater as long as he can hold his breath.

Submarine

How by an appliance many are able to remain for some time under water. How and why I do not describe my method of remaining under water for as long a time as I can remain without food; and this I do not publish or divulge on account of the evil nature of men who would practise

assassinations at the bottom of the seas by breaking the ships in their lowest parts and sinking them together with the crews who are in them; although I will furnish particulars of others which are not dangerous, for above the surface of the water emerges the mouth of a tube by which they draw breath, supported upon wine skins or pieces of cork.[29]

The lines of movements made by birds as they rise are of two kinds, of which one is always spiral in the manner of a screw, and the other is rectilinear and curved.

That bird will rise on high which by means of a circular movement in the shape of a screw makes its reflex movement against the coming of the wind and against the flight of this wind, turning always upon its right or left side.[30]

The bird which takes longer strokes with one wing than with the other will progress with a circular movement.

If the bird which does not beat its wings should not wish to descend rapidly to a depth, then after a certain amount of slanting descent it will set itself to rise by a reflex movement and to revolve in a circle mounting after the manner of the cranes when they break up the ordered lines of their flight and gather into a troop and proceed to raise themselves by many turns after the manner of a screw, and then, having gone back to their first line, they follow their first movement again which drops with a gentle descent, and then return again to a troop and moving in a circle raise themselves.[31]

When the bird is flying to the east with the wind from the north and finds its left wing above the said wind it will be turned over, unless at the onset of the wind it puts its left wing under the wind and by some such movement plunges towards the north-east and under the wind.[32]

Why the bird sustains itself upon the air

The air which is struck with greater swiftness by the movable thing is compressed to a greater degree within itself. . . .

The atmosphere is an element capable of being compressed within itself when it is struck by something moving at a greater rate of speed than that of its own velocity and it then forms a cloud within the rest of the air. . . .

When the bird finds itself within the wind it can sustain itself without flapping its wings, because the function which they have to perform against the air requires no motion. The motion of the air against the motionless wings sustains them, while the movement of the wings sustains them when the air is motionless.[33]

The wind in passing the summits of mountains becomes swift and dense and as it blows beyond the mountains it becomes thin and slow, like water that issues from a narrow channel into the wide sea.

When the bird passes from a slow to a swift current of the wind it lets itself be carried by the wind until it has devised a new assistance for itself. . . .

When the bird moves with impetus against the wind it makes long quick beats with its wings with a slanting movement, and after thus beating its wings it remains for a while with all its members contracted and low. The bird will be overturned by the wind when in less slanting position it is so placed as to receive beneath it the percussion of any lateral wind. But if the bird that is struck laterally by the wind on the point of being overturned folds its upper wing it immediately goes back to the position of having its body turned towards the ground, while if it folds its lower wing it will immediately be turned upside down by the wind.[34]

The wind exercises the same force on a bird as a wedge lifting a weight.[35]

Nature has so provided that all large birds can stay at so great an elevation, that the wind which increases their flight may be of straight course and powerful. For if their flight were low among mountains where the wind goes round and is perpetually full of eddies and whirls and where they cannot find any spot of shelter in the fury of the wind compressed in the hollows of the mountains, nor so guide themselves with their great wings as to avoid being dashed upon the cliffs and the high rocks and trees, would not this sometimes be the cause of their destruction? Whereas at great altitudes whenever through some accident the wind turns in any way, the bird has always time to redirect its course and in safety adjust its flight which will always proceed entirely free. . . . Inasmuch as all beginnings of things are often the cause of great results, so we may see a small almost imperceptible movement of the rudder to have power to turn a ship of marvellous size and loaded with a very heavy cargo, and that, too, amid such a weight of water as presses on its every beam, and in the teeth of the impetuous winds which are enveloping its mighty sails. Therefore we may be certain in the case of those birds which can support themselves above the course of the winds without beating their wings, that a slight movement of wing or tail which will serve them to enter either below or above the wind, will suffice to prevent the fall of the said birds.[36]

The birds which fly swiftly, keeping at the same distance above the ground beat their wings downwards and behind them; downwards to the extent needed to prevent the bird from descending, backwards according as it wishes to advance with greater speed.

The speed of the bird is checked by the opening and spreading out of its tail.[37]

In all the changes which birds make in their directions they spread out their tail.

The spreading and lowering of the tail and the opening of the wings at the same time to their full extent arrests the swift movement of birds. When birds are descending near the ground and the head is below the tail, they lower the tail, which is spread wide open, and take short strokes with the wings; consequently the head is raised above the tail, and the speed is checked so that the bird can alight on the ground without a shock.[38]

Many birds move their wings as swiftly when they raise them as when they let them fall; such are the magpies and birds like them.

There are some birds which are in the habit of moving their wings more swiftly when they lower them than when they raise them, and this is seen to be the case with doves and such birds. There are others which lower their wings more slowly than they raise them, and this is seen with crows and similar birds.[39]

The kite and the other birds which beat their wings only a little go in search of the current of the wind; and when the wind is blowing at a height they may be seen at a great height, and if it is blowing low they remain low. When there is no wind in the air, then the kite beats its wings more often in its flight, in such a way that it rises on high and acquires an impetus; with which impetus, dropping then gradually it can travel for a great distance without beating its wings. And when it has descended it does the same over again and so continues in succession, and this descent without beating the wings serves it as a means of resting in the air after the previous fatigue of the beating of the wings.

All the birds which fly in spurts rise on high by beating their wings; and during their descent they proceed to rest, for while descending they do not beat their wings.[40]

When the kite in descending turns itself right over and

pierces the air head downwards, it is forced to bend the tail as far as it can in the opposite direction to that where it wants to go; and then bending the tail swiftly in the direction in which it wishes to turn the change in the bird's course will correspond to the turn of the tail—like the rudder of a ship which when turned turns the ship but in the opposite direction.[41]

A bird supporting itself upon the air against the movement of the winds has a power within itself that desires to descend, and there is another similar power in the wind that strikes it which desires to raise it up. And if these powers are equal so that one cannot conquer the other, the bird will not be able either to raise or lower itself, and consequently will remain steady in its position in the air.[42]

Why the flight of birds when they migrate is made against the approach of the wind

The flight of birds when they migrate is made against the movement of the wind not in order that their movement may be made more swiftly but because it is less fatiguing. And this is done with a slight beating of their wings whereby they enter the wind with a slanting movement from below and then place themselves slantwise upon the course of the wind. The wind enters under the slant of the bird like a wedge and raises it upwards during the time that the acquired impetus consumes itself, after which the bird descends again under the wind. . . . Then it repeats the above-mentioned reflex movement upon the wind until it has regained the elevation that it lost, and so it continues in succession.

Why birds seldom fly in the direction of the current of the wind

It very seldom happens that the flight of the birds is made in the direction of the current of the wind, and this is due to the fact that this current envelops them and separates the

feathers from the back and also chills the bared flesh. But the greatest drawback is that after the slantwise descent its movement cannot enter the wind and by its help be thrown upwards to its former elevation unless it turns backwards which would delay its journey.

The bird spreads out the feathers of its wings more and more as its flight becomes slower and this is according to the law—which says: That body will become lighter which acquired greater breadth.[43]

The bird weighs less when it spreads itself out more, and conversely it weighs more when it draws itself together more tightly; and the butterflies make experiments of this in their descent.[44]

When the bird desires to rise by beating its wings it raises its shoulders and beats the tips of the wings towards itself, and comes to condense the air which is interposed between the points of the wings and the breast of the bird, and the pressure from this air raises the bird.

When the bird desires to turn to the right or left side by beating its wings, it will beat lower with the wing on the side on which it wishes to turn, and thus the bird will twist its movement behind the impetus of the wing which moves most and it will make the reflex movement under the wing from the opposite side.[40]

When a bird flies against the wind its progress should be made in a slanting line towards the earth, entering underneath the wind . . . but when this bird wishes to rise to a height it will enter above the wind, and it will retain enough of the impetus it has acquired in the descent we have spoken of, so that by means of the speed thus gained it will lower its tail and the elbows of its wings and it will raise its helm. It will then be above the wind. . . .[45]

The butterfly and like insects all fly with four wings,

those behind being smaller than those in front. Those in front form a partial covering to those behind.

All insects of this clan have power to rise with straight movement, for as they raise themselves these wings remain perforated with the front wings much higher than those behind. And this continues as long as the impulse which urges them upwards; and then as they lower their wings the larger become joined to the smaller, and so as they descend they again acquire fresh impulse.[46]

[*With drawing of a dragonfly*]
The pannicola flies with four wings, and when those in front are raised those behind are lowered.

But it is necessary for each pair to be sufficient of itself to sustain the whole weight.

When one pair is raised the other is lowered.

In order to see the flying with four wings go into the moats and you will see the black 'pannicole'.[47]

Animal as it plunges from one Element into another.[48]

This note accompanies a drawing of a flying gurnard with its tail turned, its wings outspread on the point of launching from water into air. On the same sheet are drawings of a butterfly, an ant lion, and a bat, all with outspread wings.

IV. FLYING-MACHINE

The genius of man may make various inventions, encompassing with various instruments one and the same end; but it will never discover a more beautiful, a more economical, or a more direct one than nature's, since in her inventions nothing is wanting and nothing is superfluous.[49]

A bird is an instrument working according to mathematical law, which instrument it is in the capacity of man to reproduce with all its movements but not with as much strength, though it is deficient only in power of maintaining

equilibrium. We may therefore say that such an instrument constructed by man is lacking in nothing except the life of the bird, and this life must needs be imitated by the life of man. The life which resides in the bird's members will without doubt better obey their needs than will that of man which is separated from them and especially in the almost imperceptible movements which preserve equilibrium. But since we see that the bird is equipped for many sensitive varieties of movement, we are able from this experience to deduce that the most obvious of these movements will be capable of being comprehended by man's understanding, and that he will to a great extent be able to provide against the destruction of that instrument of which he has made himself life and guide.[50]

A substance offers as much resistance to the air as the air to the substance. See how the beating of its wings against the air supports a heavy eagle in the highly rarefied air close to the sphere of elemental fire. Observe also how the air in motion over the sea fills the swelling sails and drives heavily laden ships.

From these instances, and the reasons given, a man with wings large enough and duly attached might learn to overcome the resistance of the air, and conquering it succeed in subjugating it and raise himself upon it.

If a man has a tent 12 braccia wide and 12 high covered with cloth he can throw himself down from any great height without hurting himself.*[51]

 The man in flying machines must be free from the waist upwards in order to be able to balance himself as he does in a boat, so that his centre of gravity and that of his machine may counterbalance each other and shift where necessity demands through a change in the centre of its resistance.[52]

* This project of a parachute is accompanied by a drawing.

Remember that your bird must imitate no other than the bat, because its membranes serve as framework or rather as a means of connecting the framework, that is the frame of the wings.

If you imitate the wings of feathered birds these are more powerful in structure because they are penetrable, that is their feathers are separate and the air passes through them. But the bat is aided by its membrane which binds the whole and is not penetrated by the air.[53]

Dissect the bat, and concentrate on this, and on this model arrange the machine.[54]

Suppose that there is a body suspended, which resembles that of a bird, and that its tail is twisted to an angle of different degrees; you will be able by means of this to deduce a general rule as to the various twists and turns in the movements of birds occasioned by the bending of their tails. In all the various movements the heaviest part of the body which moves becomes the guide of the movement.[55]

When the mover of a body has power divisible in four through its four chief ministering members, it will be able to employ them equally and unequally, and also all equally and all unequally, according to the dictates of the various movements of the flying body.

If they are all moved equally the flying body will be in regular movement.

If they are used unequally in continuous proportion, the flying body will be in circling movement.[56]

The bird I have described ought by the help of the wind to rise to a great height and this will be its safety; since even if all the above-mentioned revolutions were to befall it it would still have time to regain a position of equilibrium provided that its parts have a great resistance; so that they can safely withstand the fury and impetus of the descent by aid of the defences which I have mentioned, and of its joints made of strong tanned leather and its rigging made of cords of very strong raw silk; and let no one encumber himself with iron bands for these are very soon broken at the joints and they become worn out; and for this reason it is well not to encumber oneself with them.[57]

IV

THE ARTS

I. THE ARTIST'S COURSE OF STUDY

Leonardo's notes for a Treatise on Painting may be arranged under the following headings: A student must learn how the eye functions; how the shapes, sizes, and recessions of objects that are put in its way can be co-ordinated; and how they are revealed by the play of light on their surfaces; he must also study their structure and life. He must understand these fundamentals in order to create in a conforming manner and spirit.

I. THE EYE AND THE APPEARANCE OF THINGS

How do we observe nature, and what is the proper analysis of our observation? These are initial questions for both painters and scientists.

Nature is perceived through the senses, mainly through the sense of sight. The art of painting is embedded in the process of seeing. Fields of views are conveyed through visual rays into the eye. The painter must analyse this experience in order to reproduce the visual image appearing in the eye on his picture plane. His painting should give the impression of a window through which we look out into a section of the visible world.

He was enabled to achieve this by the science of perspective, which provided a mathematical method of constructing a three-dimensional space which included any number of individual objects, on to a two-dimensional surface, a method which met not only the requirements of verisimilitude but also those of unification and harmony (compare p. 204).

(a) The Five Senses

The ancient speculators have concluded that the faculty of judgement which is given to man is quickened by an instrument with which the five senses are connected by means of the organ of perception (*imprensiva*); and to this instrument they have given the name of 'sensus communis'.* And this name is used simply because it is the common judge of the other five senses, namely seeing, hearing, touch, taste, and smell. The 'sensus communis' is activated by the organ of perception (*imprensiva*) which is situated midway between it and the senses. The organ of perception works by means of the images of the things transmitted to it by the five senses, which are placed on the surface midway between the external things and the organ of perception. . . .

The images of the surrounding things are transmitted to the senses, and the senses transmit them to the organ of perception, and the organ of perception transmits them to the 'sensus communis', and by it they are imprinted on the memory, and are retained there more or less distinctly according to the importance or power of the thing given. The sense which is nearest to the organ of perception functions most quickly; and this is the eye, the chief and leader of all others; of this only will we treat and leave the others in order not to be too long.

Experience tells us that the eye takes cognizance of ten different qualities of objects; namely: light and darkness—the first serves to reveal the other nine—the other serves to conceal them—colour and substance, form and position, distance and nearness, movement and rest.*

How the five senses are the ministers of the soul

The soul apparently resides in the seat of judgement, and judgement apparently resides in the place called 'sensus communis' where all the senses meet; and it is in this place

Theory originally propounded in Aristotle's *De Anima*.

and not throughout the body as many have believed; for if
that were so it would not have been necessary for the in-
struments of the senses to meet in one particular spot; it
would have sufficed for the eye to register its perception on
its surface instead of transmitting the images of the things
seen to the 'sensus communis' by way of the optic nerves; for
the soul would have comprehended them upon the surface
of the eye.

Similarly with the sense of hearing, it would suffice merely
for the voice to resound in the arched recesses of the rock-
like bone which is within the ear, without there having to be
another passage from this bone to the 'sensus communis',
whereby the voice must address the common judgement.

The sense of smell is also forced of necessity to have re-
course to this same judgement.

The touch passes through the perforated tendons and is
transmitted to this same place; these tendons spread out with
infinite ramifications into the skin . . . and carry impulse
and sensation to the limbs; and passing between muscles and
sinews dictate their movement to them; and they obey and
in the act of obeying they contract because the swelling of
the muscles reduces their length drawing the nerves with it.
These nerves are interwoven amid the limbs and spread out
to the extremities of the fingers transmitting to the 'sensus
communis' the impression of what they touch.

The nerves with their muscles serve the tendons even as
soldiers serve their leaders; and the tendons serve the 'sensus
communis' as the leaders their captain, and this 'sensus com-
munis' serves the soul as the captain serves his lord.

So, therefore, the articulation of the bones obeys the
nerve, and the nerve the muscle, and the muscle the tendon
and the tendon the 'sensus communis' and the 'sensus com-
munis' is the seat of the soul, and the memory is its monitor,
and its faculty of receiving impressions serves as its standard
of reference.

How the sense waits on the soul, and not the soul on the

sense, and how, where the sense that should minister to the soul is lacking, the soul in such a life lacks conception of the function of this sense, as is seen in the case of a mute or one born blind.[2]

Of the ten functions of the eye which all concern the painter

Painting extends over all the ten functions of the eye; that is, darkness, light, body, colour, shape, location, remoteness, nearness, motion, and rest. My little work will be woven together of these functions, reminding the painter according to what rules and in what fashion he should imitate with his art all these things, the work of nature and ornament of the world.[3]

(*b*) The Eye

The eye which is the window of the soul is the chief organ whereby the understanding can have the most complete and magnificent view of the infinite works of nature.[4]

Now do you not see that the eye embraces the beauty of the whole world? . . . It counsels and corrects all the arts of mankind . . . it is the prince of mathematics, and the sciences founded on it are absolutely certain. It has measured the distances and sizes of the stars; it has discovered the elements and their location . . . it has given birth to architecture and to perspective and to the divine art of painting.

Oh excellent thing, superior to all others created by God! What praises can do justice to your nobility? What peoples, what tongues will fully describe your function? The eye is the window of the human body through which it feels its way and enjoys the beauty of the world. Owing to the eye the soul is content to stay in its bodily prison, for without it such bodily prison is torture.[5]

O marvellous, O stupendous necessity, thou with supreme reason compellest all effects to be the direct result of their

causes; and by a supreme and irrevocable law every natural
action obeys thee by the shortest possible process. Who
would believe that so small a space could contain the images
of all the universe? O mighty process! What talent can
avail to penetrate a nature such as these? What tongue will
it be that can unfold so great a wonder? Verily none! This
it is that guides the human discourse to the considering of
divine things. Here the forms, here the colours, here all the
images of every part of the universe are contracted to a
point. What point is so marvellous? O wonderful, O
stupendous necessity—by thy law thou constrainest every
effect to be the direct result of its cause by the shortest path.
These are miracles . . . forms already lost, mingled together
in so small a space it can recreate and recompose by expan-
sion. Describe in thy anatomy what proportion there is
between the diameters of all the lenses (*spetie*) in the eye and
the distance from these to the crystalline lens.[6]

The eye whereby the beauty of the world is reflected is of
such excellence that whoso consents to its loss deprives
himself of the representation of all the works of nature.
The soul is content to stay imprisoned in the human body
because thanks to our eyes we can see these things; for
through the eyes all the various things of nature are
represented to the soul. Whoso loses his eyes leaves his soul
in a dark prison without hope of ever again seeing the sun,
light of all the world; How many there are to whom the
darkness of night is hateful though it is of but short duration;
what would they do if such darkness were to be their
companion for life?[7]

The air is full of an infinite number of images of the things
which are distributed through it, and all of these are re-
presented in all, all in one, and all in each. Accordingly if
two mirrors be placed so as to exactly face each other, the
first will be reflected in the second and the second in the
first. Now the first being reflected in the second carries to it

its own image together with all the images reflected in it, among these being the image of the second mirror; and so it continues from image to image on to infinity, in such a way that each mirror has an infinite number of mirrors within it, each smaller than the last, and one inside another. By this example it is clearly proved that each thing transmits its image to all places where it is visible, and conversely this thing is able to receive into itself all the images of the things which are facing it.

Consequently the eye transmits its own image through the air to all the objects which face it, and also receives them on its own surface, whence the 'sensus communis' takes them and considers them, and commits to the memory those that are pleasing.

So I hold that the invisible powers of imagery in the eyes may project themselves to the object as do the images of the object to the eyes.

An instance of how the images of all things are spread through the air may be seen if a number of mirrors be placed in a circle, and so that they reflect each other for an infinite number of times. For as the image of one reaches another it rebounds back to its source, and then becoming smaller rebounds again to the object and then returns, and so continues for an infinite number of times.

If at night you place a light between two flat mirrors which are a cubit's space apart, you will see in each of these mirrors an infinite number of lights, one smaller than another in succession.

If at night you place a light between walls of a room every part of them will become tinged by the images of this light, and all those parts which are directly exposed will be lit by it. . . . This example is even more apparent in the transmission of solar rays, which pass through all objects and into the minutest part of each object, and each ray conveys to its object the image of its source.

That each body alone of itself fills all the surrounding air

with its images, and that this same air at the same time is able to receive into itself the images of the countless other bodies which are within it, is proved by these instances; and each body is seen in its entirety throughout the whole of this atmosphere, and each in each minutest part of it, and all throughout the whole and all in each minutest part; each in all, and all in every part.[8]

If the object in front of the eye sends its image to it, the eye also sends its image to the object; so of the object no portion whatever is lost in the images proceeding from it for any reason either in the eye or the object. Therefore we may rather believe that it is the nature and power of this luminous atmosphere that attracts and takes the images of the objects that are within it, than that it is the nature of the objects which send their images through the air. If the object opposite the eye were to send its image to it, the eye would have to do the same to the object; whence it would appear that these images were incorporeal powers. If it were thus it would be necessary that each object should rapidly become smaller; because each object appears by its image in the atmosphere in front of it; that is the whole object in the whole atmosphere and all in the part; speaking of that atmosphere which is capable of receiving in itself the straight and radiating lines of the images transmitted by the objects. For this reason then it must be admitted that it is the nature of this atmosphere which finds itself among the objects to draw to itself like a magnet the images of the objects among which it is situated.

Prove how all objects, placed in one position, are all everywhere and all in each part.

I say that if the front of a building or some piazza or field which is illuminated by the sun has a dwelling opposite to it, and if in the front which does not face the sun you make a small round hole all the illuminated objects will transmit their images through this hole and will be visible inside the

dwelling on the opposite wall which should be made white, and they will be there exactly, but upside down; and if in several places on the same wall you make similar holes you will have the same result from each.

Therefore, the images of the illuminated objects are all everywhere on this wall and all in each minutest part of it. The reason is this—we know clearly that this hole must admit some light to the said dwelling and the light admitted by it is derived from one or many luminous bodies. If these bodies are of various shapes and colours the rays forming the images are of various colours and shapes and the representation on the wall will be of various colours and shapes.[9]

The circle of light which is in the centre of the white of the eye is by nature adapted to apprehend objects. This same circle contains a point which seems black. This is a nerve bored through, which penetrates to the seat of the powers within where impressions are received and judgement formed by the 'sensus communis'.

Now the objects which are over against the eyes send the rays of their images after the manner of many archers who aim to shoot through the bore of a carbine. The one among them who finds himself in a straight line with the direction of the bore of the carbine will be more likely to hit its bottom with his arrow. Likewise of the objects opposite to the eye those will be more directly transferred to the sense which are more in line with the perforated nerve.

That liquid which is in the light that surrounds the black centre of the eye acts like hounds in the chase, which start the quarry for the hunters to capture. Likewise the humour that is derived from the power of the 'imprensiva' and sees many things without seizing hold of them, suddenly turns thither the central beam which proceeds along the line to the sense and this seizes on the images and confines such as please it within the prison of its memory.[10]

All bodies together, and each by itself, give off to the sur-

rounding air an infinite number of images which are all in all and all in each part, each conveying the nature, colour, and form of the body which produces it. It can clearly be shown that all bodies pervade all the surrounding atmosphere with their images all in each part as to substance, form, and colour; this is shown by the images of many and various bodies which are reproduced by transmittance through one single perforation, where the lines are made to intersect causing the reversal of the pyramids emanating from the objects, so that their images are reflected upside down on the dark plane (opposite the perforation).[11]

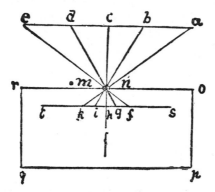

An experiment, showing how objects transmit their images or pictures, intersecting within the eye in the crystalline humour.

This is shown when the images of illuminated objects penetrate into a very dark chamber by some small round hole. Then you will receive these images on a white paper placed within this dark room rather near to the hole; and you will see all the objects on the paper in their proper forms and colours, but much smaller; and they will be upside down by reason of that very intersection. These images, being transmitted from a place illuminated by the sun, will seem as if actually painted on this paper, which must be extremely thin and looked at from behind. And

let the little perforation be made in a very thin plate of iron.

Let *abcde* be the objects illuminated by the sun and *or* the front of the dark chamber in which is the hole *nm*. Let *st* be the sheet of paper intercepting the rays of the images of these objects and turning them upside down because since the rays are straight *a* on the right becomes *k* on the left, and *e* on the left becomes *f* on the right; and the same takes place inside the pupil.[12]

Necessity has provided that all the images of objects in front

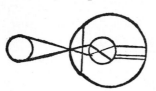

of the eye shall intersect in two planes. One of these intersections is in the pupil, the other in the crystalline lens; and if this were not the case the eye could not see so great a number of objects as it does. . . . No image, even of the smaller object, enters the eye without being turned upside down; but as it penetrates into the crystalline lens it is once more reversed and thus the image is restored to the same position within the eye as that of the object outside the eye.*[13]

It is impossible that the eye should project from itself, by visual rays, the visual power,† since as soon as it opens, the front portion (of the eye) which would give rise to this emanation would have to go forth to the object, and it could not do this without time. And this being so, it could not travel so high as the sun in a month's time when the eye wanted to see it. And if it could reach the sun it would necessarily follow that it should perpetually remain in a continuous line from the eye to the sun and should always

* The image formed on the retina is upside down, but it is the brain and not the lens which transposes the image and enables us to see things in their correct position. In the figure Leonardo conceives the lens as a ball in the centre of the eyeball.

† Compare Plato, *Timaeus*, 45, 'light-bearing eyes'.

diverge in such a way as to form between the sun and the eye the base and the apex of a pyramid. This being the case, if the eye consisted of a million worlds, it would not prevent its being consumed in the projection of its power; and if this power would have to travel through the air as perfumes do, the winds would bend it and carry it into another place. But we do (in fact) see the mass of the sun with the same rapidity as (an object) at the distance of a braccio, and the power of sight is not disturbed by the blowing of the winds nor by any other accident.[14]

I say that the power of vision extends through the visual rays to the surface of non-transparent bodies, while the power possessed by these bodies extends to the power of vision. Likewise each body pervades the surrounding air with its image; each separately and all together do the same; and not only do they pervade it with the semblance of the shape, but also with that of their power.

Example

You will see when the sun is over the centre of our hemisphere that wherever it reveals itself there are semblances of form; and you will also perceive the reflections of its radiance as well as the glow of its heat; and all these powers proceed from the same source by means of radiant lines that issue from its body and they end in the opaque objects without entailing any diminution at the source.

Confutation

Those mathematicians then who argue that no spiritual power can emanate from the eye, because this could not be without greatly impairing the power of vision, and therefore maintain that the eye takes in but does not send forth anything from itself.

Example

What will they say of the musk which always keeps a great quantity of its surrounding atmosphere charged with odour, and which when carried miles will permeate a thousand miles with that perfume without diminution of itself?

Or will they say that the ringing of the bell by its clapper, which daily fills the whole countryside with its sound, must of necessity consume this bell?

Certainly it seems, there are such men as these—but enough! Is not that snake called lamia seen daily by the rustics attracting to itself with fixed gaze as the magnet attracts iron, the nightingale which hastens to her death with mournful song? . . . Maidens are said to have power in their eyes to attract to themselves the love of men. . . .[15]

(c) Perspective

Perspective is the bridle and rudder of painting.[16]

Painting is based upon perspective which is nothing else than a thorough knowledge of the function of the eye. And this function simply consists in receiving in a pyramid the forms and colours of all objects placed before it. I say in a pyramid, because there is no object so small that it will not be larger than the spot where these pyramids are received into the eye. Therefore if you extend the lines from the edges of each body as they converge you will bring them to a single point, and necessarily the said lines must form a pyramid.[17]

There are three branches of perspective; the first deals with the reasons of the (apparent) diminution of objects as they recede from the eye, and is known as Perspective of Diminution; the second contains the way in which colours

vary as they recede from the eye; the third and last explains
how objects should appear less distinct in proportion as
they are more remote. And the names are as follows:
Linear perspective, the perspective of colour, the perspective of disappearance.* [18]

The science of painting deals with all the colours of the
surfaces of bodies and with the shapes of the bodies thus
enclosed; with their relative nearness and distance; with the
degrees of diminution required as distances gradually
increase; and this science is the mother of perspective, that
is the science of visual rays. Perspective is divided into three
parts, of which the first deals only with the line-drawing of
bodies; the second with the toning down of colours as they
recede into the distance; the third with the loss of distinctness of bodies at various distances. Now the first part
which deals only with lines and boundaries of bodies is
called drawing, that is to say the figuration of any body.
From it springs another science that deals with shade and
light, also called chiaroscuro which requires much explanation. [19]

Perspective is nothing else than the seeing a place behind
a sheet of glass, smooth and quite transparent, on the surface of which all the things may be marked that are behind
this glass. The things approach the point of the eye in
pyramids, and these pyramids are intersected on the glass
plane. [20]

* In modern painting the last two of the three subjects are
described by the terms 'values' and 'envelopment'.

A method of drawing an object in relief at night

Place a sheet of not too transparent paper between the object and the light and you can draw it very well.[20]

Every bodily form, so far as it affects the eye, includes three attributes; namely mass, shape, and colour; and the mass is recognizable at a greater distance from its source than either colour or shape. Again colour is discernible at a greater distance than shape, but this law does not apply to luminous bodies.[21]

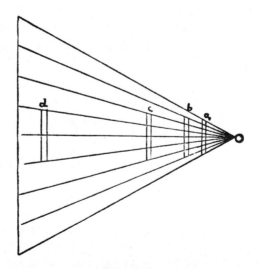

Perspective

Among objects of equal size that which is most remote from the eye will look smallest.[22]

Of several bodies of equal size and tone, that which is farthest will appear lightest and smallest.[23]

Of several bodies, all equally large and equally distant, that which is most brightly illuminated will appear to the eye nearest and largest.[24]

Among shadows of equal depth those nearest to the eye will look least deep.[25]

A dark object will appear bluer in proportion as it has more luminous atmosphere between it and the eye, as may be seen in the colour of the sky.[26]

I ask to have this much granted me (as axiom)—to assert that every ray passing through air of equal density travels in a straight line from its cause to the object or place where it strikes.* [27]

The air is full of infinite straight and radiating lines intersected and interwoven with one another, without one occupying the place of another. They represent to whatever object the true form of their cause.[28]

The body of the atmosphere is full of infinite radiating pyramids produced by the objects existing in it. These intersect and cross each other with independent convergence without interference with each other and pass through all the surrounding atmosphere.[29]

[For figure see R. No. 85]

The vertical plane is represented by a perpendicular line and it is imagined as being placed in front of the common point where the concourse of the pyramid converges. And this plane bears the same relation to this point as a plane of

* This corresponds to the first axiom in Euclid's Optics.

glass would, upon which you drew the various objects that you saw throught it. And the objects thus drawn would be so much smaller than the originals as the space between the glass and the eye was smaller than that between the glass and the objects.[30]

If the eye be in the middle of a course with two horses running to their goal along parallel tracks, it will seem to it as if they were running to meet one another. This, as has been stated, occurs because the images of the horses which impress themselves upon the eye are moving towards the centre of the surface of the pupil of the eye.[31]

As regards the point in the eye it may be comprehended with greater ease if you look into the eye of anyone you will see your image there. Now imagine two lines starting from your ears and going to the ears of that image which you see of yourself in the eye of the other person. You will clearly recognize that these lines converge in such a way that they would meet in a point a little way beyond your own image mirrored in the eye.[32]

[*For figure see R. No. 57*]
 And if you want to measure the diminution of the pyramid in the air which occupies the space between the object seen and the eye, you must do it according to the diagram figured below. Let *mn* be a tower, and *ef* a rod which you must move backwards and forwards till its ends correspond with those of the tower; then bring it nearer to the eye, at *cd* and you will see that the image of the tower seems smaller as at *to*. Then bring it still closer to the eye, and you will see the rod project far beyond the image of the tower, . . . and so you will discern that, a little farther within the lines must converge in a point.[32]

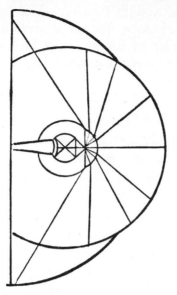

Only one line of all those that reach the visual power has no intersection and this has no sensible dimensions because it is a mathematical line which originates from a mathematical point which has no dimension.[33]

[For figure see R. No. 56]

Let *ab* be the vertical [picture] plane and *r* the point of the pyramids terminating in the eye and *n* the point of diminution which is always in a straight line opposite the eye and always moves as the eye moves—just as when a rod is moved its shadow moves, precisely as the shadow moves with a body. And each of the two points is the apex of pyramids having common bases at the intervening vertical planes. But, although their bases are equal, their angles are not equal because the point of diminution is the termination of a smaller angle than that of the eye. If you ask me: 'By what practical experience can you show me these points?' I reply—so far as concerns the point of diminution which moves with you—when you walk by a ploughed

field look at the straight furrows which come down with their ends to the path where you are walking, and you will see that each pair of furrows will look as though they tried to get nearer and meet at the [farther] end. . . .[34]

2. THE SURFACE OF THINGS AND LIGHT

In so far as the Art of Painting is concerned with the representation of the surfaces of objects it is allied to spatial geometry. The surfaces are conceived as without substance like geometric planes; and the axioms of Euclid's Elements defining the point, the line, the plane apply to them.

Moreover, the places and colours of objects are revealed by rays of light which radiate from their source in pyramidal formation. At the bases of these pyramids are the objects which the rays strike at different angles as they drive away the surrounding darkness; and through this interplay of light and shadow the objects emerge into view.

Leonardo excelled in modelling by gradations of light and dark, and was a protagonist of the clair-obscur, *of the* sfumato. *Yet, by his interest in the contrasts, reflections, neutralizations of colours and in their sparkle, and by his observation of atmospheric effects he may also be considered a forerunner of the Impressionists, though the theory of primary colours of the solar spectrum, which influenced them so greatly, was as yet unknown in his times.*

His treatise on painting was imbued with the conception which he had formed of nature. The four simple colours, red, blue, green, and yellow were related to the four elements, fire, air, water, and earth, the way in which objects were enveloped in space was similar to the way in which the elements came in contact with one another.

(a) The Geometric Foundation

Let no man who is not a mathematician read the Elements of my work.[35]

The science of painting begins with the point, then comes the line, the plane comes third, and the fourth the body in its vesture of planes. This is as far as the representation of objects goes. For painting does not, as a matter of fact, extend beyond the surface; and it is by its surface that the body of any visible thing is represented.[36]

A point is that which has no centre. It has neither breadth, length, nor depth. A line is a length produced by the movement of a point, and its extremities are points. It has neither breadth nor depth. A surface is an extension made by the transversal movement of a line, and its extremities are lines. (A surface has no depth.) A body is a quantity formed by the lateral movement of a surface and its boundaries are surfaces. A body is a length, and it has breadth with depth formed by the lateral movement of its surface.[37]

1. The surface is a limitation of the body. 2. The limitation of the body is no part of that body. 3. That which is not part of any body is a thing of naught. 4. A thing of naught is that which fills no space. The limitation of one body is that which begins another.[38]

The limiting surface is the beginning of another. The limits of two coterminous bodies are interchangeably the surface of the one and of the other, as water with air. None of the surfaces of bodies are parts of these bodies.[39]

The boundaries of bodies are the boundaries of their planes, and the boundaries of the planes are lines. Which lines do not form part of the size of the planes, nor of the atmosphere which surrounds these planes; therefore that which is not part of anything is invisible as is proved in geometry.[40]

The boundary of one thing with another is of the nature of a mathematical line, but not of a drawn line, because the end of one colour is the beginning of another colour—the boundary is a thing invisible.[41]

Empty space begins where the object ends. Where empty space ends the object begins and where the object ends emptiness begins.[42]

The point has no centre, but is itself a centre and nothing can be smaller. The point is the minimum. The point is indivisible by the mind. The point has no parts. The point is the end which nothingness and the line have in common. It is neither nothingness nor line, nor does it occupy a space between them. Therefore the end of nothingness and the beginning of the line are in contact with one another, but they are not joined together, for between them, dividing them, is the point. . . .

And from this it follows that many points imagined in continuous contact do not constitute the line and therefore many lines in continuous contact along their sides do not make a surface, nor do many surfaces in continuous contact make a body, because among us bodies are not formed of incorporeal things. . . .

The contact of the liquid with the solid is a surface common to the liquid and the solid. Similarly the contact between a heavier and a lighter liquid is a surface common to them both. The surface does not form part of either—it is merely the common boundary.

Thus the surface of water does not form part of the water nor does it form part of the air. . . . What is it therefore that divides the air from the water? There must be a common boundary which is neither air nor water but is without substance. . . . A third body interposed between two bodies would prevent their contact and here water and air are in contact without interposition of anything between them. Therefore they are joined together and the

air cannot be moved without the water nor the water raised without drawing it through the air. Therefore a surface is the common boundary of two bodies, and it does not form part of either; for if it did it would have divisible bulk. But since the surface is indivisible, nothingness separates these bodies the one from the other.[42]

The cylinder of a body is columnar in shape and its two opposite ends are two circles enclosed between parallel lines, and through the centre of the cylinder is a straight line passing through the middle of the thickness of the cylinder, ending at the centres of these circles, and called by ancients axis.[43]

Propositions

Every body is surrounded by an extreme surface.
 Every surface is full of infinite points.
 Every point makes a ray.
 The ray is made up of infinite separating lines.
 In each point on any line, there intersect lines proceeding from the points on the surfaces of bodies, and they form pyramids. At the apex of each pyramid there intersect lines proceeding from the whole and from the parts of the bodies, so that from this apex one may see the whole and the parts.
 The air that is between bodies is full of the intersections formed by the radiating images of these bodies.
 The images of the figures and their colours are transferred from one to the other by a pyramid.
 Each body fills the surrounding air with its infinite images by means of these rays.
 The image of each point is in the whole and in each part of the line caused by this point.
 Each point of the one object is by analogy capable of uniting the whole base of the other.
 Each body becomes the base of innumerable and infinite

pyramids. One and the same base serves as the cause of innumerable and infinite pyramids turned in various directions and of various degrees of length.

The point of each pyramid has in itself the whole image of its base.

The centre line of each pyramid is full of an infinite number of points of other pyramids.

One pyramid passes through the other without confusion. . . .[44]

And as the geometrician reduces every area circumscribed by lines to the square and every body to the cube; and arithmetic does likewise with the cubic and square roots, those two sciences do not extend beyond the study of continuous and discontinuous quantities; but they do not deal with the quality of things which constitute the beauty of the works of nature and the ornament of the world.[45]

(b) Light and Shade and Colour

Among the various studies of natural processes that of light gives most pleasure to those who contemplate it. And among the chief features of mathematics that of the certainty of its demonstrations elevates the minds of the investigators most powerfully. Perspective, therefore, is to be preferred to all the discourses and systems of the schoolmen. In its province the beam of light is explained by methods of demonstration, wherein is found the glory not only of mathematical but also of physical science, adorned as it is with the flowers of both. And, whereas its propositions have been laid down at great length, I shall abridge them with conclusive brevity, with demonstrations drawn either from nature or from mathematics according to the nature of the subject; sometimes deducing the effects from the causes, and at other times the causes from the effects: adding also to my own conclusions some which are not contained in these but which nevertheless may be inferred

from them. Even as the Lord who is the Light of all things shall vouchsafe to enlighten me I will treat of light.[46]

Look at the light and consider its beauty. Blink your eye and look at it again: what you see was not there at first, and what was there is no more.

Who is it who makes it anew if the maker dies continually?[47]

Light is the chaser away of darkness. Shade is the obstruction of light.[48]

The scientific and true principles of painting first determine what is a shaded object, what is direct shadow, what is cast shadow, and what is light, that is to say, darkness, light, colour, body, figure, position, distance, nearness, motion, and rest. These are understood by the mind alone and do not entail manual operation; and they constitute the science of painting which remains in the mind of its contemplators; and from it is then born the actual creation, which is far superior in dignity to the contemplation or science which precedes it.[49]

In the practice of perspective the same rules apply to light and to the eye.[50]

Shadow is the obstruction of light. Shadows appear to me to be of supreme importance in perspective, because without them opaque and solid bodies will be ill defined; that which is contained within its outlines and the outlines themselves will be ill understood unless it is shown against a background of a different tone. Therefore, I state as my first proposition concerning shadows that every opaque body is surrounded and its whole surface enveloped in shadow and light. And to this I shall devote the first book.

Moreover these shadows are of varying degrees of darkness, because they have been abandoned by a varying quantity of luminous rays; and these I call primary shadows,

because they are the first shadows to form a covering to the bodies concerned. And to this I shall devote the second book.

From these primary shadows there issue certain dark rays, which are diffused through the air and vary in intensity according to the density of the primary shadows from which they are derived; and consequently I shall call these shadows derived shadows, because they have their origin in other shadows. And of this I will make the third book.

Moreover these derived shadows in striking upon anything create as many different effects as there are different places where they strike; and of this I will make the fourth book.

And since where the derived shadow strikes, it is always surrounded by the striking of the luminous rays, it leaps back with these in a reflex stream towards its source and mingles with and becomes changed into it altering thereby somewhat of its nature; and to this I shall devote the fifth book.

In addition to this I will make a sixth book to contain an investigation of the many different varieties of the rebound of the reflected rays, which modify the primary shadow by as many different colours as there are different points from whence these luminous reflected rays proceed.

Furthermore I will make the seventh book treat of the various distances that may exist between the point where each reflected ray strikes and the point whence it proceeds, and of the various different shades of colour which it acquires in striking against opaque bodies.[51]

As regards all visible objects, three things must be considered. These are the position of the eye which sees, that of

the object seen, and the position of the light which illumi-
nates the object. *b* is the eye, *a* is the object seen, *c* is the light.
a is the eye, *b* the illuminating body, *c* is the illuminated
object.[52]

Of the nature of shadow

Shadow partakes of the nature of universal matter. All such
matter is more powerful in its beginning and grows weaker
towards the end; I say at the beginning, whatever their
form or condition, whether visible or invisible. It is not
from small beginnings that it grows to a great size in time,
as a great oak from the small acorn. But on the contrary
like the oak which is most powerful at its beginning at its
stem where it springs from the earth and is largest. Dark-
ness, then, is the strongest degree of shadow and light is its
least. Therefore, O Painter, make your shadows darker
close to the object that casts it, and make the end of it
fading into light, seeming to have no end.[53]

Shadow is the diminution alike of light and of darkness,
and stands between light and darkness.

A shadow may be infinitely dark, and also of infinite
degrees of absence of darkness.

The beginnings and ends of shadow lie between the
light and the darkness and may be infinitely diminished
and infinitely increased.[54]

Shadow is the diminution of light by the intervention of an
opaque body, shadow is the counterpart of the luminous
rays which are cut off by an opaque body.[55]

What is the difference between light and the lustre [high-light] which appears on the polished surface of opaque bodies? The lights that are on the polished surface of opaque bodies will be stationary even if the eye which sees them moves. But the reflected light on those same objects will appear in as many different places on the surface as different positions are taken by the eye.[56]

 The highlight or lustre on an object is not necessarily situated in the middle of the illuminated part, but moves as the eye moves in looking at it.[57]

Suppose the body to be the round object figured here and 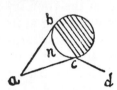 let the light be at the point *a*, and let the illuminated side of the object be *bc* and the eye at the point *d*: I say then that as lustre is everywhere and in each part, if you stand at point *d* the lustre will appear at *c*, and as the eye moves from *d* to *a*, the lustre will move from *c* to *n*.[58]

Of the difference between lustre and light

Lustre [or highlight] does not partake of the colours but is a sensation of white as derived from the surface of wet bodies; light partakes of the colours of the object which reflects it.[58]

A single and distinct luminous body causes stronger relief in the object than a diffused light; as may be seen by comparing one side of a landscape illuminated by the sun, and one overshadowed by clouds, and illuminated only by the diffused light of the atmosphere.[59]

In an object in light and shade, the side which faces the light transmits the images of its details more distinctly and immediately to the eye than the side which is in shadow.[60]

The more brilliant the light of a luminous body, the deeper the shadows cast by the illuminated object.[61]

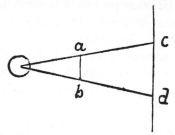

If the rays of light proceed, as experience shows, from a single point, and are diffused in a sphere round this point, radiating and dispersed through the air, the farther they spread the wider they spread; and an object placed between the light and a wall is always imaged larger in its shadow, because the rays that strike it will have spread by the time they have reached the wall.[62]

The way in which shadows cast by objects should be defined. If the object is the mountain here figured and the light is at the point *a*, I say that from *bd* and from *cf* there will be no light but from reflected rays. And this is because the rays of light can only act in straight lines; and the same is the case with the secondary or reflected rays.[58]

Where the shadow should be on the face.[63]

Very great charm of shadow and light is to be found in the faces of those who sit in the doors of dark houses. The eye of the spectator sees that part of the face which is in shadow lost in the darkness of the house, and that part of the face which is lit draws its brilliancy from the splendour of the sky. From this intensification of light and shade the face gains greatly in relief and beauty by showing the subtlest shadows in the light part and the subtlest lights in the dark part.[64]

The lights which illumine opaque bodies are of four kinds, namely, universal, as that of the atmosphere within our horizon; and particular, like that of the sun or of a window or door or other space; the third kind is the reflected light; and there is also a fourth kind which passes through substances that are semi-transparent to a certain degree like linen, paper, or such-like things; but not those transparent like glass or crystal or other diaphanous bodies where the effect is the same as if nothing was interposed between the body and the light.[65]

Of the three kinds of lights which illumine opaque bodies

The first of the lights with which opaque bodies are illumined is called particular, and it is the sun or the light from a window or a flame. The second is called universal and is seen in cloudy weather or in mist or the like. The third is the subdued light when the sun in the evening or the morning is entirely below the horizon.[66]

The atmosphere is so adapted as to gather up instantaneously and display every image and likeness of whatever body it sees. When the sun appears in the eastern horizon it at once permeates the whole of our hemisphere and fills it with its luminous semblance.

All the surfaces of solid bodies turned towards the sun or towards the atmosphere illumined by the sun, become

clothed and dyed by the light of the sun or of the atmosphere.

Every solid body is surrounded and clothed with light and darkness. You will get only a poor perception of the details of a body when the part that you see is all in shadow, or all illumined.

The distance between the eye and the bodies determines how much the part that is illumined increases and that in shadow diminishes.

The shape of a body cannot be accurately perceived when it is bounded by a colour similar to itself, and the eye is between the part in light and that in shadow.[67]

What portion of a coloured surface ought in reason to be the most intense? If *a* is light and *b* illuminated by it in a direct line, then *c* on which the light cannot strike is light only by reflection from *b*, which let us say is red. Then the light reflected from this red surface will tinge the surface at *c* with red. And if *c* is red also it will appear much more intense than *b*; and if it were yellow you would see there a colour between red and yellow.[58]

The surface of an object partakes of the colour of the light which illuminates it, and of the colour of the air that is interposed between the eye and this object, that is to say of the colour of the transparent medium interposed between the object and the eye.[68]

Colours seen in shadow will reveal more or less of their natural beauty in proportion as they are in fainter or deeper

shadow. But colours seen in a luminous space will reveal greater beauty in proportion as the light is more intense.

Colours seen in shadow will display less variety in proportion as the shadows in which they lie are deeper. And evidence of this is to be had by looking from an open space through the doorways of dark churches, where the pictures painted in various colours all appear covered by darkness. Therefore at a considerable distance all shadows of different colours will appear of the same darkness. In an object in light and shade the light side shows its true colour.[69]

Of the nature of contrasts

Black garments make the flesh tints of the representations of human beings whiter than they are, and white garments make the flesh tints dark, and yellow garments make them seem coloured, while red garments shows them pale.[70]

Of the juxtaposition of one colour next to another so that one sets off the other

If you wish the proximity of one colour to make attractive another which it borders, observe that rule which is seen in the rays of the sun that compose the rainbow, otherwise called the Iris. Its colours are caused by the motion of the rain, because each little drop changes in the course of its descent into each one of the colours of that rainbow, as will be set forth in the proper place.[71]

Of secondary colours produced by mixing other colours

The simple colours are six, of which the first is white, although some philosophers do not accept white or black in the number of colours, because one is the cause of colours and the other is the absence of them. Yet, because painters cannot do without them, we include them in their number, and say that in this order white is the first among the simple,

and yellow is second, green the third, blue is the fourth, red is the fifth, and black is the sixth.

White we shall put down for the light, without which no colour can be seen, yellow for the Earth, green for the Water, blue for the Air, red for Fire, and black for the darknesses which are above the element of Fire; for there is no matter of any density there, which the rays of the sun must penetrate, and, in consequence, illuminate. If you wish briefly to see all the varieties of composed colours, take panes of coloured glass and look through them at all the colours of the country, which are seen beyond them. Then you will see that the colours of things seen beyond the glasses are all mixed with the colour of the glass and you will see which colour is strengthened or weakened by this mixture. For example, if the glass is yellow in colour, I say that the visual images of objects which pass through that colour to the eye can either be impaired or improved, and the deterioration will happen to blue, black, and white more than to all the others; and the improvement will occur with yellow and green more than with all the others. Thus you will examine with the eye the mixtures of colours, which are infinite in number; and thus you can make a choice of colours for new combinations of mixed and composed colours. You may do the same with two glasses of different colours held before the eye and thus continue experimenting by yourself.[72]

Make the rainbow in the last book on Painting but first write the book on colours produced by the mixture of the other colours, so that you may be able to prove by those painters' colours the genesis of the rainbow colours.[73]

Every object that has no colour in itself is tinged either entirely or in part by the colour set opposite to it. This may be shown for every object which serves as a mirror is tinged with the colour of the thing that is reflected in it. And if the object is white, the portion of it that is illumined by red

will appear red; and so with every other colour whether it be light or dark.

Every opaque and colourless object partakes of the colour of what is opposite to it: as happens with a white wall.[74]

Any white and opaque surface will be partially coloured by reflections from surrounding objects.[75]

Since white is not a colour but is capable of becoming the recipient of every colour when a white object is seen in the open air all its shadows are blue . . . that portion of it which is exposed to the sun and atmosphere assumes the colour of the sun and the atmosphere, and that portion which does not see the sun remains in shadow and partakes only of the colour of the atmosphere. And if this white object did neither reflect the green fields all the way to the horizon nor yet face the brightness of the horizon itself it would undoubtedly appear simply of the same hue as the atmosphere.[76]

Of colours of equal whiteness that will seem most dazzling which is on the darkest background, and black will seem most intense when it is against a background of greater whiteness. Red also will seem most vivid when set against a yellow background, and so will all the colours when set against those which present the sharpest contrasts.[77]

How white bodies should be represented

If you are representing a white body let it be surrounded by ample space, because as white has no colour of its own it is tinged and altered in some degree by the colour of the objects surrounding it. If you see a woman dressed in white in the midst of a landscape that side which is towards the sun is bright in colour, so much so that in some portions it will dazzle the eyes like the sun itself; and the side which is towards the atmosphere,—luminous through being interwoven with the sun's rays and penetrated by them—since

the atmosphere itself is blue, that side of the woman's figure will appear steeped in blue. If the surface of the ground about her be meadows and if she be standing between a field lighted up by the sun and the sun itself, you will see every portion of those folds which are towards the meadows tinged by the reflected rays with the colour of that meadow. Thus the white is transmuted into the colours of the luminous and of the non-luminous objects near it.[78]

Every body that moves rapidly seems to tinge its parts with the impressions of its colour. This proposition is proved from experience; thus when the lightning moves among the dark clouds its whole course through the speed of its sinuous flight resembles a luminous snake. In like measure if you move a lighted brand its whole course will seem a circle of flame. This is because the organ of perception acts more rapidly than the judgement.[79]

The art of painting shows by means of its science, wide landscapes with distant horizons on a flat surface.[80]

The painter can suggest to you various distances by a change in colour produced by the atmosphere intervening between the object and the eye. He can depict mists through which the shapes of things can only be discerned with difficulty; rain with cloud-capped mountains and valleys showing through; clouds of dust whirling about combatants; streams of varying transparency, and fishes at play between the surface of the water and its bottom; and polished pebbles of many colours deposited on the clean sand of the river bed surrounded by green plants seen beneath the water's surface. He will represent the stars at varying heights above us.[81]

Of aerial perspective

There is another kind of perspective which I call aerial, because by the difference in the atmosphere one is able to distinguish the various distances of different buildings,

which appear based on a single line; as for instance when we
see several buildings beyond a wall, all of which are seen
above the top of the wall look to be the same
size; and if in painting you wish to represent
one more remote than another you must
make the atmosphere somewhat dense. You
know that in an atmosphere of equal density
the remotest things seen through it, such as mountains in
consequence of the great quantity of atmosphere between
your eye and them, will appear blue and almost of the same
hue as the atmosphere itself when the sun is in the East.
Therefore you should make the building which is nearest
above the wall of its natural colour, but make the more
distant ones less defined and bluer . . .[82]

The density of smoke from the horizon downwards is
white and from the horizon upwards it is dark; and although
this smoke is in itself of a uniform colour, this uniformity
shows itself as different, on account of the difference of the
space in which it is found.[83]

Of trees and lights on them

The best method of practice in representing country scenes,
or I should say landscapes with their trees, is to choose
them when the sun in the sky is hidden; so that the fields
receive a diffused light and not the direct light of the sun,
which makes the shadows sharply defined, and very differ-
ent from the lights.[84]

Of the accidental colours of trees

The accidental colours of the leaves of trees are four, namely
shadow, light, lustre, and transparency.
 The accidental parts of the leaves of plants will at a great
distance become a mixture, in which the colour of the most
extensive part will predominate.[85]

Landscapes are of a more beautiful azure when in fine weather the sun is at noon, than at any other time of the day, because the air is free from moisture; and viewing them under such conditions you see the trees of a beautiful green towards their extremities and the shadows dark towards the centre; and in the farther distance the atmosphere which is interposed between you and them looks more beautiful when there is something dark beyond, and so the azure is most beautiful.

Objects seen from the side on which the sun is shining will not show you their shadows. But if you are lower than the sun you can see what is not seen by the sun, and that will be all in shadow.

The leaves of the tree which are between you and the sun are of three principal colours, namely a green most beautiful shining and serving as a mirror for the atmosphere which lights up objects that cannot be seen by the sun, and the parts in shadow that only face the earth, and those darkest parts which are surrounded by something other than darkness.

The trees in a landscape which are between you and the sun are far more beautiful than those which have you between the sun and themselves; and this is so because those which are in the same direction as the sun show their leaves transparent towards their extremities and the parts that are not transparent, that is at the tips are shining; and the shadows are dark because they are not covered by anything. The trees, when you place yourself between them and the sun, will only display their light and natural colour, which in itself is not very strong, and besides this certain reflected lights which, owing to their not being against a background that offers a strong contrast to their brightness, are but little in evidence. And if you are situated lower down than they such parts of them may be visible as are not exposed to the sun, and these will be dark.

In the wind.

But if you are on the side whence the wind is blowing you will see the trees looking much lighter than you would see them on the other sides; and this is due to the fact that the wind turns up the reverse side of the leaves which in all trees is much whiter than the upper side; and, more especially, they will be very light if the wind blows from the quarter where the sun is, and if you have your back turned to it.[86]

Describe the landscapes with wind and water and at the setting and rising of the sun.

All the leaves which hang towards the earth as the twigs bend with branches turned over, straighten themselves in the current of the winds; and here their perspective is inverted, for if the tree is between you and the quarter from which the wind is coming, the tips of the leaves pointing towards you take their natural position, while those on the opposite side which should have their tips in a contrary direction have, by being turned over, their tips pointing towards you.

The trees of the landscape do not stand out distinctly one from another; because their illuminated parts border on the illuminated parts of those beyond them and so there is little difference in lights and shades.

When clouds come between the sun and the eye all the edges of their round masses are light and they are dark towards the centre and this happens because towards the top these edges are seen by the sun from above while you are looking at them from below, and the same happens with the position of the branches of the trees; and also the clouds, like the trees, being somewhat transparent are partly bright and at the edges show thinner.

But when the eye is between the cloud and the sun the appearance of the cloud is the contrary of what it was before, for the edges of its rounded mass are dark and it is light to-

wards the centre. And this comes about because you see the same side as faces the sun and because the edges have some transparency and reveal to the eye the part which is hidden beyond them; and which, as it does not catch the sunlight like that portion turned towards it, is necessarily somewhat darker. Again, it may be that you see the details of those rounded masses from the underside, while the sun sees them from above, and since they are not so situated as to reflect the light of the sun, as in the first instance, they remain dark.

The black clouds which are often seen higher up than those that are bright and illuminated by the sun, are thrown into shadow by the other clouds that are interposed between them and the sun.

Again, the rounded forms of the clouds that face the sun show their edges dark because they lie against the light background; and to see that this is true you should observe the prominence of the whole cloud that stands out against the blue of the atmosphere which is darker than itself.[87]

The colours in the middle of the rainbow mingle together. The bow in itself is not in the rain nor in the eye that sees it; though it is generated by the rain, the sun, and the eye. The rainbow is always seen by the eye that is between the rain and the body of the sun; hence if the sun is in the east and the rain is in the west it will appear on the rain in the west.[90]

At the first hour of the day the atmosphere in the south near to the horizon has a dim haze of rose-flushed clouds; towards the west it grows darker, and towards the east the damp vapour of the horizon shows brighter than the actual horizon itself, and the white of the houses in the east is scarcely to be discerned; while in the south, the farther distant they are, the more they assume a dark rose, flushed hue, and even more so in the west; and with the shadows it is the contrary, for these disappear before the white. . . .[88]

If you take a light and place it in a lantern tinted green or

some other transparent colour you will see by experiment
that all objects thus illuminated seem to take their colour
from the lantern.

You may also have seen how the light that penetrates
through stained glass windows in churches assumes the
colour of the glass of these windows. If this is not enough
to convince you watch the sun at its setting when it appears
red through the vapour, and dyes red all the clouds that
reflect its light.[89]

3. THE LIFE AND STRUCTURE OF THINGS

*Although the painter's eye sees but the surface of things
it must in rendering the surface discern and interpret the
organic structure that lies beneath. The representation of
the human figure entails a knowledge of its anatomy and
its proportions. Landscapes entail a study of the mor-
phology of plants, of the formation of the earth, of the
movements of water and wind.*

This work must begin with the conception of man, and
describe the nature of the womb and how the foetus lives
in it, up to what stage it resides there and in what ways it
quickens into life and feeds. Also its growth and what
interval there is between one stage of growth and another.
What it is that forces it out from the body of the mother,
and for what reasons it sometimes comes out of the mother's
womb before due time.

Then I will describe which are the members which after
the boy is born, grow more than the others, and determine
the proportions of a boy of one year. Then describe the
fully grown man and woman, with their proportions, and
the nature of their complexions, colour, and physiognomy.

Then how they are composed of veins, tendons, muscles,
and bones. Then in four drawings represent four universal
conditions of men. That is, mirth with various acts of
laughter; and describe the cause of laughter. Weeping in

various aspects with its causes. Strife with various acts of killing: flight, fear, ferocity, boldness, murder, and everything pertaining to such conditions. Then represent Labour with pulling, thrusting, carrying, stopping, supporting, and such-like things.

Further, I would describe attitudes and movements. Then perspective concerning the function of the eye; and of hearing—here I will speak of music—and treat of the other senses—and describe the nature of the five senses. This mechanism of man we will demonstrate with [drawings of] figures.[91]

(a) Proportion

The theory of proportions had a great fascination for Renaissance artists. Their canons were not only intended as a means of artistic workmanship, they were meant to achieve harmony. Proportions in painting, sculpture, and architecture were like harmony in music and gave intense delight.

Proportion is not only found in numbers and measurements but also in sounds, weights, time, and position, and whatever power there may be.

The Roman architect Vitruvius had transmitted some data of a Greek canon for the proportions of the human figure and these were revived in Renaissance time. A drawing by Leonardo, now in the Academy at Venice, was reproduced in an edition of Vitruvius' book, published in 1511, in order to illustrate the statement that a well-made human body with arms outstretched and feet together can be inscribed in a square; while the same body spread-eagled occupies a circle described around the navel. The proportions of the human body are here related to the most perfect geometric figures and may be said to be integrated

into the spherical cosmos. Leonardo endeavoured to verify and elaborate Vitruvius' mathematical formulae in order to put them on a scientific basis by empirical observations, and for this purpose he collected data from living models.

Geometry is infinite because every continuous quantity is divisible to infinity in one direction or the other. But the discontinuous quantity commences in unity and increases to infinity, and as it has been said the continuous quantity increases to infinity and decreases to infinity. And if you give me a line of twenty braccia I will tell you how to make one of twenty-one.[92]

Every part of the whole must be in proportion to the whole ... I would have the same thing understood as applying to all animals and plants.[93]

From painting which serves the eye, the noblest sense, arises harmony of proportions; just as many different voices joined together and singing simultaneously produce a harmonious proportion which gives such satisfaction to the sense of hearing that listeners remain spellbound with admiration as if half alive. But the effect of the beautiful proportion of an angelic face in painting is much greater, for these proportions produce a harmonious concord which reaches the eye simultaneously, just as a chord in music affects the ear; and if this beautiful harmony be shown to the lover of her whose beauty is portrayed, he will without doubt remain spellbound in admiration and in a joy without parallel and superior to all other sensations.[94]

The painter in his harmonious proportions makes the component parts react simultaneously so that they can be seen at one and the same time both together and separately; together, by viewing the design of the composition as a whole;

and separately by viewing the design of its component
parts.[95]

Vitruvius, the architect, says in his work on architecture*
that the measurements of the human body are distributed
by nature as follows: 4 fingers make 1 palm; 4 palms make
1 foot; 6 palms make 1 cubit; 4 cubits make a man's height;
and 4 cubits make one pace; and 24 palms make a man; and
these measures he used in buildings.

If you open your legs so much as to decrease your height
by $\frac{1}{14}$ and spread and raise your arms so that your middle
fingers are on a level with the top of your head, you must
know that the navel will be the centre of a circle of which
the outspread limbs touch the circumference; and the space
between the legs will form an equilateral triangle.

The span of a man's outspread arms is equal to his
height.

From the roots of the hair to the bottom of the chin is the
tenth part of a man's height; from the bottom of the chin to
the crown of the head is the eighth of the man's height;
from the top of the breast to the crown of the head is the
sixth of the man; from the top of the breast to the roots of
the hair is the seventh part of the whole height; from the
nipples to the crown of the head is a fourth part of the man.
The maximum width of the shoulders is the fourth part of
the height; from the elbow to the tip of the middle finger
is the fifth part; from the elbow to the end of the shoulder
is the eighth part. The complete hand is the tenth part. The
penis begins at the centre of the man. The foot is the seventh
part of the man. From the sole of the foot to just below
the knee is the fourth part of the man. From below the
knee to where the penis begins is the fourth part of the man.

The distance between the chin and the nose and that be-
tween the eyebrows and the beginning of the hair is equal
to the height of the ear and is a third of the face.[96]

* *De Architectura*, III, 1.

The head *a f* is $\frac{1}{6}$ larger than *nf*.[97]

The foot from where it is attached to the leg to the tip of the great toe, is as long as the space between the upper part of the chin and the roots of the hair *ab*; and equal to five-sixths of the face.[98]

For each man respectively the distance between *ab* is equal to *cd*.[99]

The length of the foot from the end of the toes to the heel goes twice into that from the heel to the knee, that is, where

the leg-bone joins the thigh bone. The hand to the wrist goes four times into the distance from the tip of the longest finger to the shoulder-joint.[100]

A man's width across the hips is equal to the distance from the top of the hip to the bottom of the buttock, when he stands equally balanced on both feet; and there is the same distance from the top of the hip to the armpit. The waist, or narrower part above the hips, will be half-way between the armpits and the bottom of the buttock.[97]

Every man at three years is half the full height he will grow to at last.[101]

There is a great difference in the length between the joints in men and boys. In man the distance from the shoulder joint to the elbow, and from the elbow to the tip of the thumb, and from one shoulder to the other, is in each instance two heads, while in a boy it is only one head; because Nature forms for us the size which is the home of the intellect before forming what contains the vital elements.

Remember to be very careful in giving your figures limbs that they should appear to be in proportion to the size of the body and agree with the age. Thus a youth has limbs that are not very muscular nor strongly veined, and the surface is delicate and round and tender in colour. In man the limbs are sinewy and muscular; while in old men the surface is wrinkled, rugged and knotty, and the veins very prominent.[102]

(b) The Anatomy and Movement of the Body

The human body is a complex unity within the larger field of nature, a microcosm wherein the Elements and

Powers of the universe were incorporated. In order to study its structure Leonardo dissected corpses and examined bones, joints, and muscles separately and in relation to one another, making drawings from many points of view and taking recourse to visual demonstration since an adequate description could not be given in words. According to him such visual demonstrations gave 'complete and accurate conceptions of the various shapes such as neither ancient nor modern writers have ever been able to give without an infinitely tedious and confused prolixity of writing and of time'. Moreover, there are not only the various points of view, the infinity of aspects to be considered, there are also the continuous successions of phases in movements. The circular movements of shoulder, arm, and hand, for instance, is suggestive of a pictorial continuity such as we may see on a strip of film.

The study of structure included that of function, of the manner in which actions and gestures were performed, how the various muscles work together in bending and straightening the joints; how the weight of a body is supported and balanced. Leonardo looked upon anatomy with the eye of a mechanician. Each limb, each organ was believed to be designed and perfectly adapted to perform its special function. Thus the muscles of the tongue were made to produce innumerable sounds within the mouth enabling man to pronounce many languages. In his time divisions between the various branches of anatomy did not exist. He investigated problems of physiology and embryology, the systems of nerves and arteries. He anticipated the principle of blood circulation and prepared the ground for further analyses on many subjects.

You who say that it is better to watch an anatomical demon-

stration than to see these drawings, you would be right if it were possible to observe all the details shown in such drawings in a single figure, in which with all your cleverness you will not see or acquire knowledge of more than some few veins, while in order to obtain a true and complete knowledge of these, I have dissected more than ten human bodies, destroying all the various members and removing the minutest particles of the flesh which surrounded these veins, without causing any effusion of blood other than the imperceptible bleeding of the capillary veins. And as one single body did not suffice for so long a time, it was necessary to proceed by stages with so many bodies as would render my knowledge complete; this I repeated twice in order to discover the differences. And though you should have a love for such things you may perhaps be deterred by natural repugnance, and if this does not prevent you, you may perhaps be deterred by fear of passing the night hours in the company of these corpses, quartered and flayed and horrible to behold; and if this does not deter you, then perhaps you may lack the skill in drawing, essential for such representation; and if you had the skill in drawing, it may not be combined with a knowledge of perspective; and if it is so combined you may not understand the methods of geometrical demonstration and the method of estimating the forces and strength of muscles; or perhaps you may be wanting in patience so that you will not be diligent.

Concerning which things, whether or no they have all been found in me, the hundred and twenty books which I have composed will give verdict 'yes' or 'no'. In these I have not been hindered either by avarice or negligence, but only by want of time. Farewell.[103]

How it is necessary for the painter to know the inner structure of man

The painter who has a knowledge of the nature of the sinews, muscles, and tendons will know very well in the

movement of a limb how many and which of the sinews are the cause of it, and which muscle by swelling is the cause of the contraction of that sinew; and which sinews expanded into most delicate cartilage surround and support the said muscle.

Thus he will in divers ways and universally indicate the various muscles by means of the different attitudes of his figures; and will not do like many who, in a variety of movements, still display the same things in the arms, the backs, the breasts, and legs. And these things are not to be regarded as minor faults.[104]

In fifteen entire figures there shall be revealed to you the microcosm on the same plan as before me was adopted by Ptolemy in his cosmography; and I shall divide them into limbs as he divided the macrocosm into provinces; and I shall then define the functions of the parts in every direction, placing before your eyes the representation of the whole figure of man and his capacity of movements by means of his parts. And would that it might please our Creator that I were able to reveal the nature of man and his customs even as I describe his figure.[105]

Remember, in order to make sure of the origin of each muscle to pull the tendon produced by this muscle in such a way as to see this muscle move, and its attachment to the ligaments of the bones. You will make nothing but confusion in demonstrating the muscles and their positions, origins and ends, unless you first make a demonstration of thin muscles after the manner of threads; and in this way you will be able to represent them one over the other as nature has placed them; and thus you can name them according to the limb they serve, for instance the mover of the tip of the big toe, and of its middle bone or of the first bone, etc. And when you have given this information you will draw by the side of it the true form and size and position of each muscle; but remember to make the threads

which denote the muscles in the same positions as the central line of each muscle; and so these threads will demonstrate the shape of the leg and their distance in a plain and clear manner.[106]

Of the hand from within

When you begin the hand from within first separate all the bones a little from each other so that you may be able quickly to recognize the true shape of each bone from the palm side of the hand and also the real number and position in each finger; and have some sawn through lengthwise, so as to show which is hollow and which is full. And having done this replace the bones together at their true contacts and represent the whole hand from within wide open. The next demonstration should be of the muscles around the wrist and the rest of the hand. The fifth shall represent the tendons which move the first joints of the fingers. The sixth the tendons which move the second joints of the fingers. The seventh those which move the third joints of these fingers. The eighth shall represent the nerves which give them the sense of touch. The ninth the veins and the arteries. The tenth shall show the whole hand complete with its skin and its measurements; and measurements should also be taken of the bones. And whatever you do for this side of the hand you should also do for the other three sides—that is for the palmar side, for the dorsal side, and for the sides of the extensor and flexor muscles. And thus in the chapter on the hand you will give forty demonstrations; and you should do the same with each limb. And in this way you will attain thorough knowledge. You should afterwards make a discourse concerning the hands of each of the animals, in order to show in what way they vary. In the bear for instance the ligaments of the tendons of the toes are attached above the ankle of the foot.[107]

Weight, force, and the motion of bodies and percussion

are the four elemental powers in which all the visible actions of mortals have their being and their end.[108]

After the demonstration of all the parts of the limbs of men and of the other animals you will represent the proper way of action of these limbs, that is in rising from lying down, in moving, running, and jumping in various attitudes, in lifting and carrying heavy weights, in throwing things to a distance, and in swimming; and in every action you will show which limbs and which muscles perform it, and deal especially with the play of the arms.[109]

As regards the disposition of the limbs in movement you will have to consider that when you wish to represent a man who for some reason has to turn backwards or to one side you must not make him move his feet and all his limbs towards the side to which he turns his head. Rather must you make the action proceed by degrees and through the different joints, that is those of the foot, the knee, the hips, and the neck. If you set him on the right leg, you must make his left knee bend inwards and his left foot slightly raised on the outside; and let the left shoulder be somewhat lower than the right; and the nape of the neck is in a line directly over the outer ankle of the left foot. And the left shoulder will be in a perpendicular line above the toes of the right foot. And always set your figures so that the side to which the head turns is not the side to which the breast faces, since nature for our convenience has made us with a neck which bends with ease in many directions as the eye turns to various points and the other joints are partly obedient to it.[110]

On the grace of the limbs

The limbs should be adapted to the body with grace and with reference to the effect that you wish the figure to produce. If you wish to produce a figure that shall look light and graceful in itself you must make the limbs elegant

and extended, and without too much display of the muscles; and the few that are needed you must indicate softly, that is, not very prominently and without strong shadows; the limbs and particularly the arms easy, so that they should not be in a straight line with the adjoining parts. If the hips, which are the pole of a man, are placed so that the right is higher than the left, then let the right shoulder be lower than the left and make the joint of the higher shoulder in a perpendicular line above the highest prominence of the hip. Let the pit of the throat always be over the centre of the ankle of that foot on which the man is leaning. The leg which is free should have the knee lower than the other, and near the other leg. The positions of head and arms are infinitely varied and I shall therefore not enlarge on any rules for them. Let them, however, be easy and pleasing, with various turns and twists and the joints gracefully bent, that they may not look like pieces of wood.[111]

That is called simple movement in a man when he simply bends forward, or backwards, or to the side.[112]

That is called a compound movement in a man when some purpose required bending down and to the side at the same time. . . .[113]

Of human movement

When you wish to represent a man in the act of moving some weight reflect that these movements are to be represented in different directions. A man may stoop to lift a weight with the intention of lifting it as he straightens himself; this is a simple movement from below upwards; or he may wish to pull something backward, or push it forward or draw it down with a rope that passes over a pulley. Here you should remember that a man's weight drags in proportion as the centre of his gravity is distant from that of his support, and you must add to this the force exerted by his legs and bent spine as he straightens himself.[114]

The sinew which guides the leg, and which is connected
 with the patella of the knee, feels it
a greater labour to carry the man up-
wards in proportion as the leg is more
bent; the muscle which acts upon the
angle made by the thigh where it
joins the body has less difficulty and
less weight to lift, because it has not
the weight of the thigh itself. And
besides this its muscles are stronger
being those which form the buttock.[115]

The first thing that the man does when he ascends by steps
is to free the leg which he wishes to raise from the weight
of the trunk which is resting upon this leg, and at the same
time he loads the other leg with his entire weight including
that of the raised leg. Then he raises the leg and places the
foot on the step where he wishes to mount; having done
this he conveys to the higher foot all the weight of the
trunk and of the leg and leaning his hand upon his thigh,
thrusts the head forward and moves towards the point of
the higher foot, while raising swiftly the heel of the lower
foot; and with the impetus thus acquired he raises himself
up; and at the same time by extending the arm which was
resting upon his knee he pushes the trunk and head upwards
and thus straightens the curve of his back.[116]

Man and every animal undergoes more fatigue in going
upwards than downwards, for as he ascends he bears his
weight with him and as he descends he simply lets it go.[117]

A man, in running, throws less of his weight on his legs than
when he is standing still. In like manner the horse, when
running, is less conscious of the weight of the man whom it
is carrying; consequently many consider it marvellous that
a horse in a race can support itself on one foot only. There-
fore we may say regarding weight in transverse movement

that the swifter the movement, the less the weight towards the centre of the earth.[118]

How a man proceeds to raise himself to his feet when he is sitting on level ground.[119]

It is impossible that any memory can hold all the aspects and mutations of any limb of any animal. We shall demonstrate this by taking the hand for an example. Since every continuous quantity is divisible *in infinitum* the movement of the eye, which observes the hand, travels through a space, which is also a continuous quantity and there divisible *in infinitum*. And in every stage of the movement the aspect and shape of the hand varies when it is seen, and will continue to vary as the eye moves in a complete circle. And the hand in turn will act in a similar way as it is raised in its movement, that is to say it will travel through space which is a continuous quantity.[120]

There are [four] principal simple movements in the flexion performed by the joint of the shoulder, namely when the arm attached to the same moves upward or downwards or forward or backward. One might say, though, that such movements are infinite. For if we turn our shoulder towards a wall and describe a circular figure with our arm we shall have performed all the movements contained in the said shoulder. And, since [every circle is] a continuous quantity, the movement of the arm [has produced] a continuous quantity. This movement would not produce a continuous quantity were it not guided by the principle of continuation. Therefore, the movement of that arm has been through all the parts of the circle. And as the circle is divisible *in infinitum* the variations of the shoulder have been infinite.[121]

One and the same action seen from various places

One and the same attitude is shown in an infinite number of variations, because it can be viewed from an infinite number of places and these places are of a continuous quantity, and a continuous quantity is divisible into an infinite number of parts. Consequently every human action shows itself in an infinite variety of situations.[122]

The movements of man performed on one single occasion or for one single purpose are infinitely varied in themselves. This can be proved thus. Let us assume that a man strikes some object. Then I say that his stroke is made up of two states. Either he is lifting the thing which must descend in order to bring about the stroke, or this thing is already descending. Whichever may be the case, it is undeniable that the movement occurs in space and that space is a continuous quantity, and that every continuous quantity is divisible *in infinitum*. The conclusion is that every movement of the thing which descends is variable *in infinitum*.[123]

(c) Physiology

Where there is life there is heat; where there is heat there is movement of the watery humours.[124]

The cause which moves the water through its springs against the natural course of its gravity is like that which moves the humours in all the shapes of animated bodies.[125]

[With a drawing of heart showing veins and arteries]
O writer, with what words will you describe with a like perfection the whole arrangement of that of which the drawing is here? For lack of knowledge you will describe it confusedly so as to convey but little perception of the true shapes of things; and deceiving yourself you believe that you can satisfy the listener completely when you speak

of the figure of anything that has body and is surrounded by surfaces.

I recommend that you do not cumber yourself with words unless you are speaking to the blind, or if you wish to demonstrate to the ears with words rather than to the eyes of men speak of things of substance or of nature and do not busy yourself in making enter by the ears things which have to do with the eyes for in this you will be far surpassed by the work of the painter.

With what words can you describe this heart without filling a whole book? Yet the more detail you write concerning it the more you will confuse the mind of the hearer. And you will always need commentators or to go back to experience, and this with you is very brief and only deals with a few things as compared with the extent of the subject concerning which you desire complete knowledge.[126]

Of the human eye

The pupil of the eye changes to as many different sizes as there are differences in the degrees of brightness and obscurity of the objects which present themselves before it. . . . In this case nature has provided the visual faculty, when irritated by excessive light, with the contraction of the pupil and here nature works like one who, having too much light in his habitation, blocks up the window more or less according to necessity, and who, when night comes, throws open the whole of this window in order to see better. . . .

Nature is here providing for perpetual adjustment and continual equilibrium by dilation and contraction of the pupil according to the obscurity or brightness which presents itself before it. You can observe the process in nocturnal animals such as cats, screech owls, long-eared owls, which have the pupil small at midday and very large at night . . . and if you wish to make the experiment with a man look intently at the pupil of his eye while holding a lit candle at a short distance away and make him look at

this light as you bring it gradually nearer, and you will see that the nearer the light approaches to his pupil the more it will contract.[127]

The pupil is situated in the centre of the cornea [luce] which is of the shape of a part of a sphere which takes the pupil at the centre of its base. This 'luce' forming part or a sphere takes all the images of the objects and transmits them through the pupil within to the place where the vision is formed.

In the anatomy of the eye, in order to be able to see the inside well without spilling its watery humour, you should place the whole eye in white of egg and make it boil and become solid; and then cut the egg and the eye transversely so that no part of the middle portion be poured out.[128]

Make two air holes in the horns of the great ventricles and insert melted wax by means of a syringe, making a hole in the ventricle of the memoria, and through this hole fill the three ventricles of the brain; and afterwards when the wax has set take away the brain and you will see the shape of the three ventricles exactly.[129]

(d) The Tongue

Of the muscles which move the tongue [illustrated by drawings] No organ needs so great a number of muscles as the tongue, —of these twenty-four were already known apart from the others that I have discovered; and of all the members moved by voluntary action this exceeds all the rest in the number of its movements. . . . The present task is to discover in what way these twenty-four muscles are divided or apportioned in the service of the tongue in its necessary movements which are many and varied; and in addition it has to be seen in what manner the nerves

descend to it from the base of the brain, and how they pass into this tongue distributing themselves and breaking into ramifications. And it must further be noted how these twenty-four muscles convert themselves into six in the formation they make in the tongue. Moreover, you should show whence these muscles have their origin, that is some in the vertebrae of the neck . . . some in the maxilla, and some on the trachea. . . . And similarly how the veins nourish them and how the nerves give them sensation. . . . The tongue works in the pronunciation and articulation of the syllables which constitute the words. This tongue is also employed during the necessary revolutions of the food in the process of mastication and in the cleansing therefrom of the inside of the mouth and teeth. Its principal movements are seven. . . .

Consider well how by the movement of the tongue, with the help of the lips and teeth, the pronunciation of all the names of things is known to us; and how the simple and compound words of a language reach our ears by means of this instrument; and how these, if there were a name for all the effects of nature, would approach infinity, together with the countless things which are in action and in the power of nature; and these man does not express in one language only but in a great number, and these also tend to an infinity; because they vary continually from century to century, and from one country to another, through the intermingling of the peoples who by wars and other mischances continually mix with one another; and the same languages are liable to pass into oblivion, and they are mortal like all created things; and if we grant that our world is everlasting, we shall say that these languages have been, and still will be, of infinite variety, through the infinite centuries which constitute infinite time. And this is not the case with any other sense; for these are concerned only with such things as nature continually produces; and the ordinary shapes of things created by nature do not

change, as from time to time do the things created by man, who is nature's greatest instrument.[130]

I have so many words in my mother-tongue that I ought rather to complain of the lack of a right understanding of things than of a lack of words with which fully to express the conception that is in my mind.[131]

(e) The Lips

Of the muscles which move the lips of the mouth

The muscles which move the lips of the mouth are more numerous in man than in any other animal; and this is necessary for him on account of the many actions in which these lips are continually employed, as in the four letters of the alphabet *bfmp*, in whistling, laughing, weeping, and similar actions. Also in the strange contortions used by clowns when they imitate faces.

What muscle is that which so tightens the mouth that its lateral boundaries come near together?

The muscles which tighten the mouth thus lessening its length are in the lips; or rather these lips are the actual muscles which close themselves. In fact this muscle alters the size of the lip below other muscles, which are joined to it and of which one pair distends it and moves it to laughter, . . . and the muscle which contracts it is the same of which the lower lip is formed; and a similar process goes on simultaneously in the upper lip. There are other muscles which bring the lips to a point; others that flatten them; others which cause them to curl back, others that straighten them; others which twist them all awry; and others which bring them back to the first position. So there always are as many muscles as correspond to the various attitudes of these lips and as many others that serve to reverse these attitudes; and these it is my purpose here to describe and represent in full, proving these movements by means of my mathematical principles.[132]

I once saw in Florence a man who had become deaf who, when you spoke very loud, did not understand you, but if you spoke gently and without making sound of the voice, understood merely from the movement of the lips. Now perhaps you will say that the lips of a man who speaks loudly do not move like those of one speaking softly, and that if they were to move them alike they would not be alike understood. As to this argument I leave the decision to experiment; make a man speak to you gently and note his lips.[133]

(f) The Embryo

Though human ingenuity may make various inventions answering by different machines to the same end, it will never devise an invention more beautiful, more simple, more direct than does Nature; because in her inventions nothing is lacking, and nothing is superfluous. She needs no counterpoise when she creates limbs fitted for movement in the bodies of animals, but puts within them the soul of the body which forms them, that is the soul of the mother which first constructs within the womb the shape of man, and in due time awakens the soul that is to be its inhabitant. And this at first lay dormant, under the tutelage of the soul of the mother who gives it nourishment and life through the umbilical vein with all its spiritual members; and this will continue as long as the said umbilical cord is joined to it by the secundines and the cotyledons by which the child is attached to the mother. These are the reasons why a wish, strong desire, a fright experienced by the mother is felt more powerfully by the child than by the mother; for there are many cases when the child loses its life from it. . . .[134]

As one mind governs two bodies, inasmuch as the desires, the fears, and the pains of the mother are one with the pains, that is the bodily pains, and desires of the child which is in the body of the mother, in like manner the nourishment

of the food serves for the child and it is nourished from the same cause as are the other parts of the mother, and its vital powers are derived from the air which is the common living principle of the human race and of other living creatures.

The black races of Ethiopia are not the product of the sun; for if black gets black with child in Scythia, the offspring is black; but if a black gets a white woman with child the offspring is grey. And this shows that the seed of the mother has power in the embryo equally with that of the father.[135]

I reveal to men the origin of their second—second or perhaps first—cause of existence. Division of the spiritual from the material parts. And how the child breathes and how it is nourished through the umbilical cord; and why one soul governs two bodies, as when one sees that the mother desires a certain food and the child bears the mark of it. And why the child [born] at eight months does not live. Here Avicenna contends that the soul gives birth to the soul and the body to the body and every member, but he is in error.*[136]

(g) Comparative Anatomy

You will represent here for comparison the legs of a frog, which have a great resemblance to the legs of man, both as regards bones and muscles. Then, in continuation, the hind legs of the hare which are very muscular, with strong active muscles, because they are not encumbered with fat.[137]

Note on the bendings of joints and on the way the flesh swells in their flexions or extensions; and of this most important study write a separate treatise: the description of the movements of animals with four feet; among which is man, who likewise in his infancy crawls on all fours.[138]

The walking of men is always after the universal manner of

* *De Anima* by Avicenna, Arab philosopher, 979–1037

walking of animals with four legs inasmuch as just as they move their feet crosswise after the manner of the trot of the horse, so man moves his four limbs crosswise; that is if he puts forward his right foot in walking he with it puts forward his left arm and vice versa, invariably.[139]

The frog instantly dies when the spinal cord is pierced; and before this it lived without head, without heart or any bones or intestines or skin, and here therefore it would seem lies the foundation of movement and life. All the nerves of the animals derive from here: when this is pricked they instantly die.[140]

I have found in the composition of the human body that the organs of sense are duller and coarser as compared with those of the constitutions of animals. Thus it is composed of an instrument less ingenious and of parts less capable of receiving the power of the senses. I have seen in the Lion tribe how the sense of smell forming part of the substance of the brain descends down the nostrils which form a large receptacle for the sense of smell. This enters among a great number of cartilaginous cells with many passages leading up to the above-mentioned brain. The eyes in the Lion tribe have a large part of the head for their sockets and the optic nerves are in immediate communication with the brain; with men the contrary is seen to be the case for the sockets of the eyes occupy but a small part of the head, and the optic nerves are thin and long and weak; and by the weakness of their action we see by day, but badly at night; whereas the aforesaid animals see better by night than by day; and the proof of this is seen in the fact that they prowl for prey by night and sleep by day as do also nocturnal birds.[141]

The eyes of animals

The eyes of all animals have their pupils adapted to dilate and diminish of their own accord in proportion to the

greater or less light of the sun, or other luminary. But in birds the variation is much greater and especially with nocturnal birds of the owl species such as the horned owl, the white and the brown owls. With these the pupil dilates until it almost occupies the whole eye, or diminishes to the size of a grain of millet, preserving always its circular shape.

But in the Lion tribe such as panthers, leopards, ounces, tigers, wolves, lynxes, Spanish cats, and other similar animals, the pupil as it diminishes changes from the perfect circle to an elliptical figure.

Man, however, having a more feeble sight than any other animal is less hurt by excessive light and his pupil undergoes less increase in dark places. But in the eyes of the above-mentioned nocturnal animals, in the horned owl, which is the largest nocturnal bird, the power of vision is so much increased that in the faintest glimmer of night (which we call darkness) it can see more distinctly than we in the splendour of noon, when these birds stay hidden in dark places; or if they are compelled to come out into the sunlit air the pupil contracts so much that their power of sight diminishes together with the quantity of the light.

Study the anatomy of the various eyes and see which are the muscles which open and close the said pupils of the eyes of animals.[142]

If at night your eye is placed between the light and the eye of a cat, it will see the eye look like fire.[143]

When the bird closes its eye with its two coverings it first closes the secondina, and this it does sidewards from the lachrymal gland towards the outer corner of the eye, and the outer covering closes from below upwards. And these two movements intersect and first cover the eye from the direction of the lachrymal gland because the bird has already seen that it is safe in front and below; it reserves only the upper part of the eye because of the dangers from birds of prey descending from above and behind; and it

will first uncover the membrane in the direction of the outer corner, for if the enemy comes behind the bird has opportunity of flying forward. Also if it keeps the membrane called secondina which is of transparent texture it does so because if it did not possess this shield it could not keep its eyes open against the wind which strikes the eye in the fury of its swift flight.[144]

Analyse the movement of the tongue of the woodpecker.[145]

Describe the tongue of the woodpecker and the jaw of the crocodile.[146]

After an artist had mastered anatomy he was at liberty to create organisms according to his own ideas. He might, for instance, fit together parts of different animals to form a chimerical structure. Leonardo's monsters are a curious instance of the way in which his mind united science and fantasy. They are usually either ideas for masquerades or emblems.

How to make an imaginary animal appear natural

You know that you cannot make any animal without it having its limbs such that each bears some resemblance to that of some one of the other animals. If therefore you wish to make one of your imaginary animals appear natural— let us suppose it to be a dragon—take for its head that of a mastiff or setter, for its eyes those of a cat, for its ears those of a porcupine, for its nose that of a greyhound, with the eyebrows of a lion, the temples of an old cock and the neck of a water-tortoise.[147]

(h) Draperies

The draperies thin, thick, new, old, with folds broken and pleated, soft light, shadows obscure and less obscure, with or without reflections, definite or indistinct according to

distances and colours; and the garments according to the rank of those who wear them, long or short, fluttering or stiff according to the movements; so encircling the figures as to bend or flutter with ends streaming upwards or downwards, according to the folds; clinging close to the feet or separated from them, according as the legs within are shown at rest or bending, or twisting or striding; fitting closely or separating from the joints, according to the step or movement or whether the wind is represented.

And the folds should correspond to the quality of the draperies whether transparent or opaque. . . .

On the thin clothes of the women in walking, running, and jumping, and their variety.[148]

How draperies should be drawn from nature: that is to say, if you want to represent woollen cloth draw the folds from that, and if it is to be silk, or fine cloth or coarse, or linen or crape, vary the folds in each and do not represent dresses, as many do, from models covered with paper or thin leather which will deceive you greatly.[149]

Everything by nature tends to remain at rest. Drapery of equal density and thickness has a tendency to lie flat; therefore when you give it a fold or plait forcing it out of its flatness, note the effect of the restraint in the part where it is strongest; and the part farthest away from the restraint will be seen to relapse most into the natural state; that is to say it spreads out freely.[150]

You must not give to drapery a great confusion of many folds, but rather introduce only those held by the hands or arms; the rest you may let fall simply where its nature makes it flow; and do not let the nude forms be traversed by too many lines and broken folds.[151]

Figures dressed in a cloak should not show the shape so much that the cloak looks as if it were next to the flesh.

For surely you would not wish that the cloak should be next to the flesh since you must realize that between the cloak and the flesh are other garments which prevent the shapes of the limbs from being visible and appearing through the cloak. And those limbs which you show make thick of their kind so that there may seem to be other garments under the cloak. The limbs of a nymph or an angel should be shown in almost their original state, for these are represented clad in light draperies, which are driven and pressed against the limbs of the figures by the blowing wind.[152]

(i) Botany

The following pages contain a selection of Leonardo's notes on plants. Other notes bearing on landscape, such as inquiries into the formation of rocks, the movements of water and clouds, are given in Chapter II. Notes on atmosphere, light, and colour in landscape are given in Chapter IV, pp. 139 ff.

Numerous drawings of trees and flowering plants indigenous to Italy are to be found in his manuscripts. He was interested in the influence of sunlight and water on their growth. He watched the process of ripening of a gourd (see p. 371). He observed the gravitational attraction of the earth on certain plants (geotropism) and the habit of others to turn towards the sun (heliotropism). He examined the sap of trees and discovered that their age corresponds to the number of rings in the cross-sections of the stems. His observation of the order according to which the leaves occupy various positions on the stem or axis was a first step in establishing the laws of phyllotaxis which were developed centuries later.

He is not universal who does not love equally well all that is comprised in Painting. Some one for instance who does

not care for landscapes and esteems them a matter involving merely cursory and simple investigations. So does our Botticelli, who said that such studies are vain since by merely throwing a sponge soaked with different colour at a wall a stain is formed wherein a lovely landscape might be discerned. I admit as quite true that in such a stain one might detect various inventions if one looks for them, like heads of men, different animals, battles, rocks, seas, clouds, trees, and the like, just as in listening to the chimes of bells one seems to hear whatever one chooses. But although such stains may suggest to you compositions, they do not teach you how to complete any detail.

And this artist painted very poor landscapes![153]

The representation of the four seasons of the year or of the things that participate therein

In the autumn you will make things according to the progress of the season, that is, at the beginning the trees begin to fade in their leaves on the oldest branches, more or less, depending on whether the tree is represented as growing on sterile or fertile soil, and even more pale and reddish those kinds of tree which were first to produce fruit.

Do not, as many do, make all kinds of trees, even though they are equally distant, of the same kind of green. Speaking of fields, and plants and various kinds of ground, and of stones, and trunks of trees, they are always different. Because nature is infinitely variable, not only as regards species but in the same plants different colours are found, that is on the twigs the leaves are more beautiful and larger than on other branches. Nature is so delightful and abundant in its variations that among trees of the same kind there would not be found one which nearly resembles another, and not only the plants as a whole, but among their branches, leaves, and fruit, will not be found one which is precisely like another.

Therefore, observe this and vary them as much as you can.[154]

The tips of the boughs of plants unless they are borne down by the weight of their fruits, turn towards the sky as much as possible. The upper side of their leaves is turned towards the sky that it may receive the nourishment of the dew which falls at night.

The sun gives spirit and life to the plants and the earth nourishes them with moisture.[155]

The lower branches, after they have formed the angle of their separation from the parent stem, always bend downwards so as not to crowd against the other branches which follow above them on the same stem and to be better able to take the air which nourishes them.[156]

Every shoot and every fruit is produced above the insertion (in the axil) of its leaf which serves it as mother, by bringing it water of the rains and moisture of the dew that falls there at night from above and often protects them from the excessive heat of the sun's rays.[157]

Of the birth of leaves upon their branches

The thickness of a branch is never diminished in the space

there is between one leaf and another except by as much as the thickness of the eye that is above the leaf; and this thickness is lacking in the following branch up to the next leaf.

Nature has so placed the leaves of the latest shoots of many plants that the sixth leaf is always above the first and so on in succession if the rule is not impeded.

And this serves two uses for the plants, the first being that as the branch and fruit spring in the following year from the bud or eye which is above in contact with the attachment of the leaf, the water which wets this branch can descend to nourish this bud, the drop being caught in the axil where the leaf springs; and the second use is that as these shoots develop in the following year, one will not cover the other, since the five branches come forth turned in five different directions, and the sixth comes forth above the first at some distance.[158]

All the flowers which see the sun mature their seeds and not the others, that is those which see only the reflection of the sun.[159]

If you take away a ring from the bark of a tree it will wither from the ring upwards and remain alive from the ring downwards, and if you make this ring during a bad moon and then cut the plant from the foot during a good moon,

that of the good moon will survive and the rest will wither.*[160]

The branches always start above the leaf.[161]

The beginning of the branch will always have the central line of its thickness [axis] directed to the central line [axis] of the plant.[162]

In general almost all the upright parts of trees curve somewhat turning the convexity towards the south; and their branches are longer and thicker and more numerous towards the south than towards the north. And this occurs because the sun draws the sap towards that surface of the tree which is nearest to it. And one notices this unless the sun is screened off by other trees.[163]

All the branches of trees at every stage of their height, united together, are equal to the thickness of their trunk.

All the ramifications of the waters at every stage of their length being of equal movement are equal to the size of their parent stream.[164]

Of the insertion of the branches on plants

The beginning of the ramification of plants upon their principal branches is the same as the beginning of the leaves upon the shoots of the same plant. These leaves have four ways of growing one above another; the first and most usual is that the sixth always originates over the sixth below; the second is that the two-thirds above are over the two-thirds below; the third way is that the third above is over the third below; and the fourth is the fir tree which is arranged in tiers.[157]

All seeds have the umbilical cord when the seed is ripe. And in like manner they have matrix and secundina, as is

* For Leonardo's experiments on the sap of plants see giambattista de Toni, *Le piante & animali in L. d. V.*, p. 9 (1922).

seen in herbs and all the seeds which grow in pods. But those which grow in shells, such as hazel-nuts, pistachio-nuts and the like have the umbilical cord long and this shows itself in their infancy.[165]

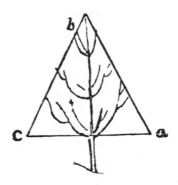

The cherry-tree is of the character of the fir-tree as regards its ramification which is placed in stages round its stem; and its branches spring in fours, fives, or sixes opposite one another; and the tips of the topmost shoots form a pyramid from the centre upwards; and the walnut and the oak from the centre upwards form a half-sphere.[166]

A leaf always turns its upper side towards the sky so that it may the better be able to receive over its whole surface the dew which drops gently from the atmosphere; and these leaves are so distributed on the plants that one covers another as little as possible, but they lie alternately one above another as is seen in the ivy which covers the walls. And this alternation serves two ends; that is in order to leave spaces so that the air and the sun may penetrate between them,—and the second purpose of it is that the drops which fall from the first leaf may fall on to the fourth, or on to the sixth in the case of other trees.[167]

In representing wind, besides showing the bending of the

boughs and the inverting of their leaves at the approach of the wind, you should represent the clouds of fine dust mingled with the troubled air.[168]

Young plants have more transparent leaves and more lustrous bark than old ones; and particularly the walnut is lighter coloured in May than in September.[169]

The rings on the cross-section of the branch of a tree show the number of its years, and the greater or smaller width of these rings show which years were wetter and which drier. They also show the direction in which the branch was turned, for the part that was turned towards the north grows thicker than that turned towards the south so that the centre of the stem is nearer to the bark that faces south than to that on the north side.

Although this is of no importance in painting I want nevertheless to describe it in order to leave out as little as possible of what I know about trees.[170]

4. THE EXPRESSION OF THE SPIRIT

The knowledge of anatomy is not enough. The artist must penetrate deeper. Actions must be suggestive of the motives which incited them; faces and gestures must reveal frames of mind. The human body was an outward and visible expression of the soul. It was shaped by its spirit. The painter must reverse the process and by constructing a body give expression to a spirit.

Leonardo considered this the artist's highest purpose and he himself excelled therein. His portrait of the Mona Lisa has always been considered a masterpiece for its expression of an inner life, and his other paintings are in the same category. While among the drawings that have survived are some caricatures of faces.

The hands and arms in all their actions must display the intention of the mind that moves them, as far as possible, because by means of them whoever has a sympathetic judgement follows mental intentions in all their movements. Good orators, when they wish to persuade their hearers of something, always accompany their words with movements of their hands and arms, although some fools do not take care of such ornaments, and on the tribune seem statues of wood, through whose mouths the voice of some man concealed in the tribune, is conducted by a speaking tube. This practice is a great defect in the living, and even more in painted figures, which, if they are not endowed by their creator with lively actions according to the intention that you imagine to be in such a figure, will be judged twice dead; dead because it is not alive, and dead in its action.

But to return to our subject, here below will be represented and discussed many emotions; that is: the motion of anger, of pain, of sudden fright, of weeping, of flight, of desire, of command, of negligence, of solicitude, and the like.[171]

A good painter has two chief objects to paint, man and the intention of his soul; the former is easy, the latter hard, because he has to represent it by the attitudes and movements of the limbs. The knowledge of these should be acquired by observing the dumb, because their movements are more natural than those of any other class of persons.[172]

The most important consideration in painting is that the movements of each figure expresses its mental state, such as desire, scorn, anger, pity, and the like.[173]

In painting the actions of the figures are in every case expressive of the purpose in their minds.[174]

Every action must necessarily be expressed in movement.

To know and to will are two operations of the human mind. To discern, to judge, to reflect are actions of the human mind.

Our body is subject to heaven, and heaven is subject to the spirit.[175]

A picture or rather the figures therein should be represented in such a way that the spectator may easily recognize the purpose in their minds by their attitudesas is the case with a deaf and dumb person who, when he sees two men in conversation—although he is deprived of hearing, can nevertheless understand the nature of their discussion from the attitudes and gestures of the speakers.[176]

The limbs which are subject to labour must be muscular, and those which are not you must make without muscles and soft.

Represent your figures in such action as may be fitted to express what purpose in their minds; otherwise your art will not be good.[177]

How a figure is not worthy of praise unless such action appears in it as expresses the passion of his sentiment. That figure is most worthy of praise which by its action best expresses the passion which animates it.[178]

Old men ought to be represented with slow and heavy movements, their legs bent at the knees, when they stand still, and their feet placed parallel and apart; bending low with the head leaning forward, and their arms but little extended. Women must be represented in modest attitudes, their legs close together, their arms folded, their heads inclined and somewhat on the side. Old women should be represented with eager, swift, and furious gestures, like infernal furies; but the action should be more violent in their arms and head than in their legs. Little children, with

lively and contorted movements when sitting, and, when standing, in shy and timid attitudes.[179]

The subject with its form

The lover is moved by the thing loved, as the sense is by that which it perceives, and it unites with it and they become one and the same thing. The work is the first thing born of the union; if the thing that is loved be base, the lover becomes base. When the thing taken into union is in harmony with that which receives it, there follow delight, pleasure, and satisfaction. When the lover is united to the beloved it finds rest there; when the burden is laid down there it finds rest. . . .[180]

5. COMPOSITION

When an artist was commissioned to paint a picture in commemoration of a certain event he did not copy a given scene; he composed it. The figures were grouped and set against a suitable background and had to be adapted to a certain space. Leonardo's advice to a painter seeking inspiration for a composition to look at a wall spotted with stains shows how much he valued a free play of the imagination in fitting things into two-dimensional patterns. Nevertheless, he required a scene to be life-like. The rendering of bodies in space, their relative positions, illumination, colour, proportions, structure, and poses must be co-ordinated into a harmonious ensemble.

Of the order of study

I say that first you ought to learn the limbs and their mechanism, and after having completed this study you should then learn their actions according to the circumstances in which they occur in man; and thirdly the composition of subjects, the studies for which should be taken from natural

actions and made from time to time, as circumstances allow; and pay attention to them in the streets and piazze and fields, and note them down with a brief indication of the forms; thus for a head make a O, and for an arm a straight or a bent line, and the same for the legs and the body and when you return home work out these notes in a complete form. And adverse opinion says that to acquire practice and do a great deal of work it is better that the first period of study should be employed in drawing from various compositions done by divers masters on paper or on walls. And that in this way practice and good methods are rapidly acquired; to which I reply that this method will be good, if based on works of good composition done by skilled masters. But since such masters are so rare that but few of them are to be found, the surer way is to go to the objects of nature rather than to those which are imitated from nature with great deterioration, and so acquire bad habits; for he who can go to the fountain does not go to the water jar.[181]

How to represent someone who is speaking among a group of people

When you wish to represent a man speaking among a group of persons consider the matter of which he has to treat and adapt his action to the subject. That is, if the subject be persuasive let his action be in keeping, if the matter is to set forth an argument, let the speaker with the fingers of the right hand hold one finger of the left hand keeping the two smaller ones closed; and his face alert and turned towards the people, with mouth slightly open to look as though he spoke; and if he is seated let him appear as though about to rise, with his head forward. If you represent him standing, make him leaning slightly forward with head and shoulders towards the people. These you should represent silent and attentive and all watching the face of the orator with gestures of admiration; and make some old men in astonishment at what they hear, with the corners of their mouths pulled

down drawing back the cheeks in many furrows with their eyebrows raised where they meet, making many wrinkles on their foreheads; some sitting with their fingers clasped over their weary knees; and some bent old man, with one knee crossed over the other and one hand resting upon it and holding his other elbow and the hand supporting the bearded chin.[182]

Notes on the Last Supper

One who was drinking and has left the glass in its position and turned his head towards the speaker.

Another twisting the fingers of his hands, turns with stern brows to his companion. Another with his hands spread shows the palms, and shrugs his shoulders up to his ears, making a mouth of astonishment. Another speaks into his neighbour's ear and he, as he listens, turns towards him to lend an ear while holding a knife in one hand, and in the other the loaf half cut through. Another as he turns with a knife in his hand upsets a glass on the table. Another lays his hands on the table and is looking. Another blows his mouthful. Another leans forward to see the speaker shading his eyes with his hands. Another draws back behind the one who leans forward, and sees the speaker between the wall and the man who is leaning.*[183]

The painter ought always to consider, when he has a wall on which he has to represent a story, the height at which he will locate his figures, and when he draws from nature for this composition, he ought to take a position with his eye as much below the object that he is drawing, as the object, when inserted into the composition, will be above the eye of the observer. Otherwise the work will be reprehensible.[184]

* In comparing these notes with the finished picture it will be seen that in some cases they are descriptive of the attitudes of the apostles.

Why groups of figures one above another are to be avoided

This practice, which is universally adopted by painters on the walls of chapels, is by reason strongly to be condemned seeing that they represent one scene at one level with its landscape and buildings, and then they mount to the stage above this to represent another scene and so vary the point of sight from that of the first, and then make a third and a fourth scene in such a way that on one wall there are four points of sight, which is extreme folly on the part of such masters.

We know that the point of sight is opposite the eye of the spectator of the scene, and if you were to ask how I should represent the life of a saint divided into several scenes on one end of the same wall I answer to this that you must set the foreground with its point of sight on a level with the eye of the spectator of the scene. And on this plane represent the first episode on a large scale. And then by diminishing gradually the figures and buildings upon the various hills and plains you can represent all the events of the story. And on the rest of the wall up to the top you will make trees of sizes proportioned according to the figures or angels if these are appropriate to the story, or birds or clouds or similar things; otherwise do not put yourself to the trouble for all your work will be wrong.[185]

I cannot refrain from mentioning among these precepts a new device for study, which although it may seem trivial and almost ludicrous is nevertheless extremely useful in arousing the mind to various inventions. And this is, that when you look at a wall spotted with stains or with a mixture of stones, if you are about to devise some scene, you will be able to see in it a resemblance to various landscapes adorned with mountains, rivers, rocks, trees, plains, wide valleys and various groups of hills; or again you may see battles and figures in action; or strange faces and costumes,

and an infinite number of things which you can then reduce into separate and well-drawn forms. And these appear on such walls confusedly, like the sound of bells in whose clanging you may find any name and word you choose to imagine.[186]

How to increase your talent and stimulate various inventions

. . . Look at walls splashed with a number of stains, or stones of various mixed colours. If you have to invent some scene, you can see there resemblances to a number of landscapes, adorned with mountains, rivers, rocks, trees, great plains, valleys and hills, in various ways. Also you can see various battles, and lively postures of strange figures, expressions on faces, costumes and an infinite number of things, which you can reduce to good integrated form. This happens on such walls and varicoloured stones, (which act) like the sound of bells, in whose pealing you can find every name and word that you can imagine.

Do not despise my opinion, when I remind you that it should not be hard for you to stop sometimes and look into the stains of walls, or ashes of a fire, or clouds, or mud or like places, in which, if you consider them well, you may find really marvellous ideas. The mind of the painter is stimulated to new discoveries, the composition of battles of animals and men, various compositions of landscapes and monstrous things, such as devils and similar things, which may bring you honour, because by indistinct things the mind is stimulated to new inventions.[187]

The way to represent a battle

Represent first the smoke of the artillery, mingled in the air with the dust tossed up by the movement of horses and combatants. And this mixture you must express thus: the dust, being a thing of the earth, has weight; and although by reason of its fineness it may easily rise and mingle with

the air, will nevertheless readily fall down again. It is the
first part that rises highest; hence that part will be least seen
and will seem almost of the colour of the air. The smoke
which is mingled with the dust-laden air will, as it rises to a
certain height, look like a dark cloud; and at the top the
smoke will be more distinctly visible than the dust. The
smoke will assume a bluish tinge, and the dust will keep to
its colour. This mixture of air, smoke, and dust will look
much lighter from the side whence the light comes than
from the opposite side. The more the combatants are in this
turmoil the less will they be seen, and the less will be the
contrast between their lights and shadows. You should give
a ruddy glow to the faces and figures and the air around
them, and to the gunners and those near them. And this
glow will grow fainter as it is farther remote from its cause.
The figures which are between you and the light, if far
away, will appear dark against a light background, and the
nearer the legs are to the ground the less will they be visible,
for there the dust is coarsest and densest. And if you make
horses galloping away from the throng, make the little
clouds of dust distant from each other as is the space between
the strides made by the horse, and that cloud which is
farthest away from the horse should be least visible, for it
should be high and spread out and thin, and the nearer
should be more conspicuous, smaller and denser. Let the air
be full of arrows in every direction, some shooting upwards,
some falling, some flying level. The balls from the guns
must have a train of smoke following their course. The
figures in the foreground you must make with dust on their
hair and eyebrows and on such other flat places likely to re-
tain it. You will make the conquerors rushing onwards with
their hair and other light things streaming in the wind, with
brows bent down; and they should be thrusting forward
the opposite limbs; that is if a man advances the right foot,
the left arm should also come forward. And if you make
anyone fallen you must make the mark where he has slipped

on the dust turned into blood-stained mire; and round about in the half-liquid earth show the print of the trampling of men and horses who have passed that way. Make a horse dragging the dead body of his master, and leaving behind him in the dust and mud the track where the body was dragged along. Make the conquered and beaten pale, with brows raised and knit, and the skin above their brows furrowed with pain; the sides of the nose with wrinkles going in an arch from the nostrils and ending where the eye begins; the nostrils drawn high up—which is the cause of these lines; the lips arched displaying the upper teeth; and the teeth apart as with crying out in lamentation. Show someone using one hand as a shield for his terrified eyes with the palm turned towards the enemy; while the other rests on the ground to support his half-raised body. Represent others shouting with their mouths wide open, and running away. Put all sorts of arms between the feet of the combatants, such as broken shields, lances, broken swords, and other such objects. Make the dead partly or entirely covered with dust, which is mingled with the oozing blood and changed into crimson mire, and let the blood be seen by its colour flowing in a sinuous stream from the corpse to the dust. Others in the death agony grinding their teeth, rolling their eyes, with their fists clenched against their bodies, and the legs distorted. Some might be shown disarmed and beaten down by the enemy turning upon the foe, with teeth and nails to take a cruel and bitter revenge. You might see a riderless horse charging with mane streaming in the wind among the enemy and doing him great mischief with his hoofs. You may see some maimed warrior fallen on the ground, covering himself with his shield, and the enemy bending down over him and trying to give him the death-stroke. There might also be seen a number of men fallen in a heap on top of a dead horse. You will see some of the victors leaving the combat and issuing from the crowd, and with both hands wiping their eyes and cheeks covered

with mud caused by smarting of their eyes from the dust.

You will see the squadrons of the reserves standing full of hope and watchful with eyebrows raised, shading them with their hands peering into the thick and confusing mist in readiness for the command of the captain; and so too the captain, with staff raised, hurrying to the reserves, pointing out to them the quarter where they are needed. And show a river wherein horses are galloping stirring up the water all around with turbulent waves, and foam, and broken water, leaping into the air and over the legs and bodies of the horses. And see to it that you paint no level spot of ground that is not trampled with blood.[188]

The way to represent Night

That which is entirely bereft of light is all darkness; since such is the condition of night, if you wish to represent a scene herein, arrange to introduce a great fire. Then the thing which is nearest to this fire will be most tinged with its colour. For whatever is nearest to the element partakes most of its nature; and making the fire a red colour you must make all the objects illuminated by it of a ruddy hue; while those that are farther from the fire are more tinted by the black hue of the night. The figures which are seen against the fire look dark in the glare of the fire-light because that part of the object which you see is tinged by the darkness of the night, and not by the fire; those who stand by the sides should be half dark and half and half in ruddy light; while those visible beyond the edges of the flames will be all lit up by the ruddy glow against a black background. As for their gestures, make those who are near it screen themselves with their hands and cloaks as a defence against the intense heat, and with faces turned away as though about to retire. Of those farther off represent a great number as raising their hands to screen their eyes hurt by the intolerable glare.[189]

Describe a wind on land and at sea.
Describe a storm of rain.[190]

How to represent a tempest

If you wish to represent a tempest consider and arrange its effects when the wind blowing over the face of the sea and of the land lifts and carries with it everything that is not fixed firmly in the general mass. And in order to represent this tempest you must first show the clouds riven and torn and flying with the wind, together with storms of sand blown up from the sea-shores, and boughs and leaves swept up by the strength and fury of the gale and scattered with other light objects through the air. Trees and plants should be bent to the ground, almost as if they would follow the course of the winds, with their branches twisted out of their natural growth and their leaves tossed and inverted. Of the men who are there, some should have fallen and be lying wrapped round by their garments, and almost indistinguishable on account of the dust, while those who remain standing should be behind some tree with their arms thrown round it that the wind may not tear them away; others should be shown crouching, their hands over their eyes because of the dust, their clothes and hair streaming in the wind. Let the sea be wild and tempestuous, and full of foam whirled between the big waves, and the wind should carry the finer spray through the stormy air resembling a dense and all-enveloping mist. Of the ships that are there, some should be shown with sails rent and the shreds fluttering in the air in company with the broken ropes and some of the masts split and fallen, and the vessel itself lying disabled and broken by the fury of the waves, with the men shrieking and clinging to the fragments of the wreck. Make the clouds driven by the impetuous winds, hurled against the high mountain tops, and there wreathing and eddying like waves that beat upon rocks; the very air should strike

terror through the deep darkness caused by the dust and mist and heavy clouds.[191]

DESCRIPTION OF THE DELUGE

The underlying theme is man's impotence when face to face with the relentless laws of nature. Leonardo is inspired by his study of the movement of water in mountain valleys, on watercourses, and by the sea-side to write a consecutive narrative consisting of various scenes, vividly portrayed, following one upon the other as effect follows cause. As a torrent rises from a small source, so here a seemingly small accident on a mountainside gradually leads to a catastrophe whereby the whole landscape is finally submerged. He may have wanted to show how the destruction of the world, foretold in the Apocalypse, and believed to be impending, may be consummated.

The original manuscript is illustrated with marginal pen drawings of waves, eddies, waterfalls, &c., to make clearer the description of the movement. (See R. Plates XXXIV–XXXIX.)

First let there be presented the summit of a rugged mountain with valleys that surround its base, and on its sides let the surface of the soil be seen to slide together with the little roots of small shrubs; and leaving bare a great portion of the surrounding rocks. Descending in devastation from these precipices let it pursue its headlong course striking and laying bare the twisted and gnarled roots of the great trees overturning them in ruin; and let the mountains as they become bare reveal the deep fissures made in them by ancient earthquakes; and let the bases of the mountains be in great part covered and clad with debris of shrubs which have fallen from the sides of the lofty mountain peaks; and let these be mingled with mud, roots, branches of trees with different kinds of leaves thrust in among the mud and earth and

stones. And let the fragments of some of the mountains descend into the depth of some valley and there form a bank to the swollen waters of its river; which having already burst its banks is rushing on with enormous waves, striking and destroying the walls of the cities and farms of the valley. And let the ruins of the high buildings of these cities throw up much dust rising up in shapes of smoke or wreathing clouds against the descending rain. And as great masses of debris falling from the high mountains or large buildings strike the waters of the big lakes, great quantities of water rebound in the air in the opposite direction; that is to say the angle of reflection will be equal to the angle of incidence. Of the objects borne along by the currents of the waters, that will appear at a greater distance from the opposite banks which is heavier or of larger bulk. But the swollen waters should be sweeping round the lake which confines them and striking with whirling eddies against the different obstacles, and leaping up into the air in muddy foam; then falling back and causing the beaten water to dash up again into the air. And the circling waves which recede from the place of concussion are impelled across the course of other circling waves which move in a contrary direction and after striking against these they rise up into the air without becoming detached from their base.

And where the water issues from the lake the spent waves are seen spreading out towards the outlet; thence the water falling or descending through the air acquires weight and impetus and on striking the water below it penetrates and tears it open and drives down in fury to reach its depth; and then recoiling, it leaps up again to the surface of the lake, accompanied by the air that has been submerged with it; and this air remains in the foam mingled with logs and other things lighter than the water; and around these are formed the beginnings of waves which increase the more in circumference as they acquire more movement; and this movement makes them lower in proportion as they acquire a wider base;

and therefore they are little in evidence as they die away. But if the waves rebound against various objects they then leap back against the approach of the other waves observing the same law of development in their curve as they have already shown in their original movement. The rain as it falls from the clouds is of the same colour as these clouds, that is on its shaded side, unless indeed the sun's rays should penetrate there, in which case the rain will appear less dark than the cloud. And if the great weight of the debris of the huge mountains or of big buildings strike in their descent the great pools of water, then a great quantity of water will rebound in the air and its course will be in the opposite direction to that of the substance which struck the water; that is to say the angle of reflection will be equal to the angle of incidence. Of the objects borne along by the current that which is heavier, of larger bulk, will keep at a greater distance from the two opposite banks. The water in the eddies revolves more swiftly in proportion as it is nearer to their centre. The crests of the waves of the sea fall forward to their bases beating with friction on the bubbles which form their face; and by this friction the falling water is ground into minute particles and becomes converted into a dense mist and is mingled with the gale in the manner of wreathing smoke and winding clouds and at last rises into the air and is converted into clouds. But the rain which falls through the air, being buffeted and tossed by the currents of the winds becomes rare or dense according to rarity or density of these winds, and thus there is generated in the atmosphere a flood of transparent clouds which is formed by the aforesaid rain and is seen through the lines made by the falling rain which is near the eye of the spectator.

The waves of the sea which break on the slope of the mountains that confine it will foam from the velocity with which they fall against these hills and in turning back meet the onset of the next wave and after loud roaring return in a great flood to the sea whence they came.

Let a great number of inhabitants, men and animals of all kinds, be seen driven by the rising deluge towards the peaks of the mountains which border on these waters.[192]

Of a Deluge and the Representation of it in Painting

Let the dark and gloomy air be seen buffeted by the rush of opposing winds and dense from the continued rain mingled with hail and bearing hither and thither an infinite number of branches torn from the trees mixed together with numberless leaves. All around let there be seen ancient trees uprooted and stripped by the fury of the winds; let there be seen fragments of mountains which have already been scoured bare by their torrents fall into these very torrents and choke up their valleys; until the swollen rivers overflow and submerge the wide lands with their inhabitants. Again you might see on many of the mountain-tops many different kinds of animals huddled together, terrified and subdued to tameness in company with men and women who had fled there with their children. And the waters which cover the fields with their waves are in great part strewn with tables, bedsteads, boats, and various other contrivances improvised through necessity and fear of death, on which are women and men with their children uttering lamentations and cries terrified by the fury of the winds which are causing the waters to roll over and over in mighty hurricane, bearing with them the bodies of the drowned; nor was there any object lighter than the water but was covered with different animals who had made a truce and stood together in terror, among them being wolves, foxes, snakes, and creatures of every kind—fugitives from death. And all the waves that beat against their sides were striking them with blows from various bodies of the drowned, blows which killed those in whom life remained.

You might see groups of men with weapons in their hands defending the small spots that remained to them from

the lions, wolves, and beasts of prey which sought safety there. Ah! what dreadful screams were heard in the dark air rent by the fury of the thunder and the lightning it flashed forth which darted through the clouds bearing ruin and striking down all that withstood its course! Ah, you might see many stopping their ears with their hands in order to shut out the tremendous sounds made in the darkened air by the fury of the winds mingling with the rain, the thunders of heaven, and the fury of the thunderbolts! Others, not content to shut their eyes, laid their hands over them, one above the other to cover them more securely in order not to see the pitiless slaughter of the human race by the wrath of God. . . . Ah, how many laments! How many in their terror flung themselves from the rocks! Huge branches of great oaks loaded with men were seen borne through the air by the impetuous fury of the winds. How many boats were capsized, some whole, others broken in pieces with people on them labouring to escape with gestures and actions of grief foretelling a fearful death! Others with gestures of despair were taking their own lives, hopeless of being able to endure such anguish; some of these were flinging themselves from lofty rocks, others were strangling themselves with their own hands; others seized their own children and with violence slew them at one blow; some with their own weapons wounded and killed themselves; others falling upon their knees recommended themselves to God. Ah! how many mothers were weeping over their drowned sons, supported upon their knees, with arms open and raised towards heaven, and with cries and shrieks declaiming against the wrath of the gods! Others with hands clasped and fingers clenched gnawed them and devoured them with bites that ran blood, crouching with their breasts on their knees in their intense and unbearable anguish.

Herds of animals were to be seen, such as horses, oxen, goats, and sheep, already hemmed in by the waters and left

isolated on the high peaks of the mountains huddled together, and those in the middle climbing to the top and treading on the others, and fighting fiercely with each other; and many dying from lack of food.

And the birds had already begun to settle on men and on other animals no longer finding any land left unsubmerged that was not occupied by living creatures; already had hunger, the minister of death, taken the lives of the greater number of the animals when the dead bodies now inflated began to rise from the bottom of the deep waters to the surface among the buffeting waves; and there lay beating one against the other; and, like balls puffed up with wind, rebound from the spot where they strike, these lay upon the bodies of the dead.

And above these judgement scenes the air was seen covered with dark clouds, riven by the jagged course of the raging bolts of heaven, lighting up now here, now there, the depth of the gloom.[192]

Amid the whirling courses of the winds were seen a great quantity of companies of birds coming from distant lands, and these appeared to be almost indistinguishable, for in their circling movements at one time all the birds of one company were seen edgewise, that is showing their narrowest side, and at another time showing their greatest breadth, that is in full face; and at their first appearance they were shaped like an indistinguishable cloud, and then the second and third groups became more defined as they approached nearer to the eye of the spectator.

And the nearest of these companies descended with a slanting movement, and settled upon the dead bodies, which were borne along by the waves of the great deluge, and fed upon them; and this they did until the buoyancy of the inflated dead bodies came to fail, so that with slow descent they sank down to the bottom of the waters.[193]

The divisions

Darkness, wind, tempest at sea, deluge of water, forests on
fire, rain, bolts from heaven, earthquakes, and destruction
of mountains, levelling of cities.

Whirlwinds which carry water and branches of trees, and
men through the air. Branches torn away by the winds
crashing together at the meeting of the winds, with people
upon them.

Broken trees laden with people.

Ships broken to pieces dashed upon the rocks.

Flocks of sheep.

Hailstones, thunderbolts, whirlwinds.

People on trees which cannot support them, trees and
rocks, towers and hills crowded with people, boats, tables,
troughs and other contrivances for floating,—hills covered
with men, women and animals, with lightning from the
clouds which illuminates the scene.[192]

II. COMPARISON OF THE ARTS

I. PAINTING, MUSIC, AND POETRY

*Leonardo's ability to practise several arts led him to com-
pare what they had in common and wherein they differed,
and this deepened his understanding of the distinctive
qualities of the realm of painting. He challenged the pre-
vailing scholastic classification of human knowledge
according to which the seven Liberal Arts represented the
highest form of human effort. Poetry and Music were
included among these; but Painting was relegated to the
'Mechanical Arts' or crafts which included manual work of
various kinds and was considered inferior.**

* The following quotation from the work of an original mem-
ber of the Académie Royale de Peinture et Sculpture founded in
Paris in 1648 shows that the ancient prejudice against painting as
an 'Ars Mechanica' was then still prevalent. In the preface to his

The poet's art resembles the musician's in that the syllables of his words are the equivalent of the musician's notes. Both verse and voice proceed through time in rhythmical formation. The painter, on the other hand, does not express himself in rhythmical divisions of time but he may infuse rhythm into the contours of his figures. Plutarch had compared contours to rhythmic movement: 'Dancing resembles the lines by which figures are defined—Dancing is like silent poetry, while poetry is the dance of speech.'

However, rhythm was but a secondary consideration. It was the harmonic combination, the variation of pitch that seemed all-important to Leonardo. The painter's art resembles the musician's in that proportions are the equivalent of the variations of pitch in musical sounds. Beautiful proportions in painting are like a musical chord with different notes sounded all at one time. These simultaneous harmonies give intense pleasure. Here the poet's art falls short, since it cannot sound more than one note at a time. It follows from these considerations that harmony and rhythm pass beyond the limits of one art. They respond to a feeling for beauty in our very being and reveal themselves in different attire according to the conditions of each art. 'Do you not know that our soul is composed of harmony.'

The painter is lord of all types of people and of all things. If the painter wishes to see beauties that charm him it lies

Entretiens sur les vies et les ouvrages des plus excellens peintres anciens et modernes (1666) André Félibien writes: 'Il faudrait diviser ce long et laborieux ouvrage en trois parties principales. La Première qui traiterait de la composition comprendrait presque toute la théorie de l'art. Les deux autres parties qui parleraient du dessin et du coloris ne regardent que la pratique et appartiennent à l'ouvrier, ce qui les rend moins nobles que la première qui est toute libre et que l'on peut savoir sans être peintre.'

in his power to create them, and if he wishes to see monstrosities that are frightful, buffoonish or ridiculous, or pitiable he can be lord and god thereof; if he wants to produce inhabited regions or deserts or dark and shady retreats from the heat, or warm places in cold weather, he can do so. If he wants valleys, if he wants from high mountain tops to unfold a great plain extending down to the sea's horizon, he is lord to do so; and likewise if from low plains he wishes to see high mountains. . . . In fact whatever exists in the universe, in essence, in appearance, in the imagination, the painter has first in his mind and then in his hand; and these are of such excellence that they can present a proportioned and harmonious view of the whole, that can be seen simultaneously, at one glance, just as things in nature.[194]

He who despises painting loves neither philosophy nor nature. If you despise painting, which is the sole imitator of all the visible works of nature, you certainly will be despising a subtle invention which brings philosophy and subtle speculation to bear on the nature of all forms—sea and land, plants and animals, grasses and flowers, which are enveloped in shade and light. Truly painting is a science, the true-born child of nature, for painting is born of nature, but to be more correct we should call it the grandchild of nature; since all visible things were brought forth by nature and these her children have given birth to painting. Therefore we may justly speak of it as the grandchild of nature and as related to God.*[195]

Painting cannot be taught to those not endowed by nature, like mathematics where the pupil takes in as much as the master gives. It cannot be copied like letters where the copy has the same value as the original. It cannot be moulded as in sculpture where the cast is equal in merit to the original; it cannot be reproduced indefinitely as is done in the printing of books.

* Dante, *Inf.* xi. 105, 'Si che vostr' arte a Dio quas è nepote.'

It remains peerless in its nobility; alone it does honour to its author, remaining unique and precious; it never engenders offspring equal to it; and this singleness makes it excel over sciences which are published everywhere. Do we not see great kings of the East go about veiled and covered because they think they might diminish in fame by showing themselves in public and divulging their presence. Do we not see that pictures representing Deity are kept constantly concealed under costly draperies and that before they are uncovered great ecclesiastical rites are performed with singing to the strains of instruments; and at the moment of the unveiling the great multitudes of peoples who have flocked there throw themselves to the ground worshipping and praying to Him whose image is represented for the recovery of their health and for their eternal salvation, as if the Deity were present in person. The like does not happen with any other work of man; and if you assert that it is not due to the merit of the painter but to the subject represented we answer that, if that were so, men might remain peacefully in their beds provided their imagination were satisfied, instead of going to wearisome and perilous places as we see them doing constantly on pilgrimages. And what necessity impels these men to go on pilgrimages? You surely will agree that the image of the Deity is the cause and that no amount of writing could produce the equal of such an image either in form or in power. It would seem, therefore, that the Deity loves such a painting and loves those who adore and revere it and prefers to be worshipped in this rather than in another form of imitation; and bestows grace and deliverance through it according to the belief of those who assemble in such a place.[196]

Music may be called the sister of painting, for she is dependent upon hearing, the sense which comes second,* and her

* According to ancient traditions the five senses ranked in order of nobility. Sight came first and then hearing. These two were con-

harmony is composed of the union of its proportional parts sounded simultaneously, rising and falling in one or more harmonic rhythms. These rhythms may be said to surround the proportionality of the members composing the harmony just as the contour bounds the members from which human beauty is born.

But painting excels and ranks higher than music, because it does not fade away as soon as it is born, as is the fate of unhappy music. On the contrary, it endures and has all the appearance of being alive, though in fact it is confined to one surface. Oh wonderful science which can preserve the transient beauty of mortals and endow it with a permanence greater than the works of nature; for these are subject to the continual changes of time which leads them towards inevitable old age! And such a science is in the same relation to divine nature as its works are to the works of nature, and for this it is to be adored.[197]

The musician claims that his art is equal to that of the painter, for it, too, is a body composed of many parts—the graces of which may be contemplated by the observer in as many harmonic rhythms as there are, and with these rhythms which are born and die it delights the soul of man within him. But the painter answers and says that the human body composed of many members does not give pleasure through harmonic rhythms in which beauty has to vary and create new forms, nor is it composed in rhythms which constantly require to be born and to die, but he makes it to last a great number of years and of such excellence that it keeps alive that harmony of proportion which nature with all its force could not keep. How many paintings have preserved the image of divine beauty of which time or sudden death have destroyed Nature's original; so that the

nected with the arts of painting and music, and were superior to the senses of smell, taste, and touch.

work of the painter has survived in nobler form than that of Nature, his mistress.[198]

Tymbals to be played like a monochord, or the soft flute.[199]

Music has two ills, one of which is mortal and the other wasting; the mortal is ever linked to the instant which follows that of its utterance; the wasting lies in its repetition making it hateful and vile.[200]

There is the same difference between the poet's and the painter's representation of the human figure as there is between dismembered and united bodies. Because the poet in describing the beauty or ugliness of any figure can only show it to you consecutively, bit by bit, while the painter will display it all at once. . . . And the poet's way may be compared to that of the musician who all by himself undertakes to sing a composition which is intended for four voices and first sings the part of the soprano, then that of the tenor, then the contralto, and finally the bass. Such performances cannot produce the beauty of harmonious proportions set in harmonious divisions of time. . . . Also music when setting her suave melodies in rhythmic divisions of time, composes them in her various voices. But the poet is debarred from such harmonious discrimination of voices—he is unable to give an equivalent of musical harmony, because it is beyond his power to say different things simultaneously as the painter does in his harmonious proportions where the component parts are made to react simultaneously and can be seen at one and the same time both together and separately. . . . For these reasons the poet ranks far below the painter in the representation of visible

things, and far below the musician in that of invisible things.[201]

If the poet knows how to describe and write down the appearance of forms, the painter can make them so that they appear enlivened with lights and shadows which create the very expression of the faces. Herein the poet cannot attain with the pen what the painter attains with the brush.[202]

And if the poet serves the understanding by way of the ear, the painter does so by the eye—the nobler sense; but I will ask no more than that a good painter should represent the fury of a battle and that a poet should describe one and that both these battles be put before the public; you will soon see which will draw most of the spectators, and where there will be most discussion, to which more praise will be given and which will satisfy the more. Undoubtedly the painting being by far the more intelligible and beautiful will please more. Inscribe the name of God and set up His image opposite, and you will see which will be more revered. Painting embraces within itself all the forms of nature, while you have nothing but their names which are not universal as form is. If you have the effects of demonstrations we have the demonstrations of the effects. Take the case of a poet who describes the beauties of a lady to her love and a painter who portrays her; and you will see whither nature will the more incline the enamoured judge. Surely the proof of the matter should be allowed to rest on the verdict of experience.

You have set painting among the mechanical arts. Truly were painters as ready as you are to praise their own works in writing, I doubt whether it would endure the stigma of so base a name. If you call it mechanical because it is by manual work that the hands design what is in the imagination, your writers set down with the pen by manual work what originates in your mind. And if you call it mechanical because it is done for money, who fall into this error—if error it can be called—more than you yourselves?

If you lecture for instruction, do you not go to whoever pays you the most? Do you do any work without some pay? And yet I do not say this in blame of such views, for every labour looks for its reward. And if a poet should say I will write a story which signifies great things, the painter can do likewise, for even so Apelles painted the Calumny. If you were to say that poetry is more lasting, I say the works of a coppersmith are more lasting still, for time preserves them longer than your works or ours; nevertheless they display little imagination; and a picture can be made more enduring if painted upon copper in enamel colours.

We by our art may be called the grandchildren of God.

If poetry treats of moral philosophy, painting has to do with natural philosophy. If poetry describes the working of the mind, painting considers the working of the mind as reflected in the movements [of the body]. If poetry can terrify people by fictions of hell, painting can do as much by placing the same things before the eye. Suppose the poet is set against the painter to represent beauty, terror or a base, ugly monstrous thing, whatever the forms he may in his way produce, the painter will satisfy the more. Have we not seen pictures so closely resembling the actual thing that they have deceived both men and beasts.[203]

How Painting surpasses all human works by the subtle speculations connected with it

The eye which is called the window of the soul is the chief means whereby the understanding can most fully and abundantly appreciate the infinite works of nature; and the ear is the second, which acquires dignity by hearing of the things the eye has seen. If you, historians, or poets, or mathematicians had not seen the things with your eyes, you could report but imperfectly of them in writing. And if you, O poet, tell a story with your pen, the painter with his

brush can tell it more easily, with simpler completeness, and less tedious to follow. If you call painting dumb poetry, the painter may call poetry blind painting. Consider then which is the more grievous defect, to be blind or dumb? Though the poet is as free as the painter in the invention of his fictions his creations do not give so great a satisfaction to men as paintings do; for though poetry attempts to describe forms, actions, and places in words, the painter employs the actual similitude of the forms, in order to reproduce them. Consider, then, which is nearer to the actual man, the name of the man, or his image? The name of the man changes with change of country; but his form is not changed except by death.[204]

On King Mathias's* birthday a poet brought him a poem composed in praise of the event which he said was for the benefit of the world; and a painter presented him with a portrait of his beloved. The King quickly closed the book of the poet and turning to the picture fixed his eyes on it with great admiration. Then the poet very indignantly said: 'Oh King, read, but read, and you will learn matter of far weightier substance than a mute picture.' And the King, resenting the reproach that he was admiring mute things, said: 'Silence, oh poet, you do not know what you are saying; this picture serves a nobler sense than your work which might be for the blind. Give me something that I can see and touch and not merely hear, and do not blame my choice when I put your book under my arm and am holding the painting with both hands for my eyes to enjoy; because my hands chose of their own accord to serve the nobler sense and not the sense of hearing. I myself am of the opinion that the painter's art is as far above the poet's as the sense he serves is nobler. Do you not know that our soul is composed of harmony and that harmony is only produced

* Mathias Corvinus, King of Hungary, a friend of the Sforza and patron of art and literature.

when proportions of things are seen or heard simultaneously? And do you not see that in your art there is no simultaneous reaction of proportions, but one part produces another in succession so that the latter is not born before the former has died. Therefore, in my opinion, your invention is much inferior to the painter's for the sole reason that there is no composition of harmonious proportions. It does not satisfy the mind of the listener or beholder like the proportions of the beautiful forms that compose the divine beauties of this face here before me, which being all joined together and reacting simultaneously give me so much pleasure with their divine proportions that I think there is no other work of man on earth that can give greater pleasure.'[205]

2. TIME AND SPACE

Proportion in all things

Proportion is not only found in numbers and measurements but also in sounds, weights, times, spaces, and in whatsoever power there may be.[206]

Describe the nature of time as distinguished from the geometrical definitions. The point has no part; a line is the transit of a point; points are the boundaries of a line.

An instant has no time. Time is made by the movement of the instant, and instants are the boundaries of time.[207]

Although time is numbered among continuous quantities,* yet through its being invisible and without substance it does not altogether fall under the head of Geometry, which represents its divisions by means of figures and bodies of infinite variety, as may constantly be seen to be the case with things visible and things of substance; but it harmonizes with these only as regards its first principles, namely as to the point and the line. The point as viewed in terms of

* See page 146.

time is to be compared with the instant and the line may be likened to the length of a quantity of time. And just as points are the beginning and end of the said line so instants form the end and the beginning of any given space of time. And whereas a line is divisible to infinity, a space of time is not unlike such a division; and as the divisions of the line may bear a certain proportion to each other, so may the parts of time.[208]

3. SOUND AND SPACE

Just as a stone flung into the water becomes the centre and cause of many circles, and as sound diffuses itself in circles in the air; so any object, placed in the luminous atmosphere, diffuses itself in circles, and fills the surrounding air with infinite images of itself.[209]

I say that the sound of the echo is reflected to the ear after it has struck, just as the images of objects striking the mirrors are reflected into the eyes. And as the image falls from the object into the mirror and from the mirror to the eye at equal angles, so sound will also strike and rebound at equal angles as it passes from the first percussion in the hollow and travels out to meet the ear.[210]

Every impression continues for a time in the sensitive object that receives it, and that which was of greater power will continue in its receiver for a longer time, and the less powerful for a shorter time. . . .

The sensitive impression is that of a blow received on a resounding substance such as bells and like things, or like the note in the ear, which, indeed, unless it preserved the impression of the notes, could never derive pleasure from hearing a voice alone; for when it passes straight from the first to the fifth note the effect is as though one heard these two notes simultaneously, and thus one perceived the true harmony which the first makes with the fifth; for if the

impression of the first note did not remain in the ear for some space of time the fifth which follows immediately after the first would seem alone; and a single note cannot create any harmony, and therefore any note sung alone would seem devoid of charm.

Likewise the radiance of the sun or other luminous body remains in the eye for some time after it has been seen, and the motion of a single firebrand whirled rapidly in a circle causes this circle to seem one continuous uniform flame.

The drops of rain seem continuous threads descending from the clouds; and herein one may see how the eye preserves the impressions of the moving things which it sees. . . .

The voice impresses itself through the air without displacement of air, and strikes upon objects and returns back to its source.[211]

The painter measures the distance of things as they recede from the eye by degrees just as the musician measures the intervals of the voices heard by the ear. Although the objects observed by the eye touch one another as they recede, I shall nevertheless found my rule on a series of intervals measuring 20 braccia each, just as the musician who, though his voices are united and strung together, has created intervals according to the distance from voice to voice calling them unison, second, third, fourth, and fifth and so on, until names have been given to the various degrees of pitch proper to the human voice.*[212]

* A reference to Leonardo's theory that objects of equal size placed so as to recede at regular intervals of say, 20 braccia, each diminish to $\frac{1}{2}$, $\frac{1}{3}$, $\frac{1}{4}$ of their size and so on in harmonious progression. There is therefore a close analogy with the divisions of the string on the monochord producing the octave, fifth, and fourth, &c. Leon Battista Alberti recommends the use of these proportions in architecture: 'The numbers through which the consensus of voices appeal most agreeably to the ears of men, are the very same which also fill men's eyes and soul with marvellous pleasure.'

4. PAINTING AND SCULPTURE

Comparison between Painting and Sculpture

Painting requires more thought and skill and is a more marvellous art than sculpture, because the painter's mind must of necessity enter into nature's mind in order to act as an interpreter between nature and art; it must be able to expound the causes of the manifestations of her laws, and the way in which the likenesses of objects that surround the eye meet in the pupil of the eye transmitting the true images; it must distinguish among a number of objects of equal size, which will appear greater to the eye; among colours that are the same, which will appear darker and which lighter; among objects all placed at the same height, which will appear higher; among similar objects placed at various distances, why they appear less distinct than others.

The art of painting includes in its domain all visible things, and sculpture with its limitations does not, namely the colours of all things in their varying intensity and the transparency of objects. The sculptor simply shows you the shapes of natural objects without further artifice. The painter can suggest to you various distances by a change in colour produced, by the atmosphere intervening between the object and the eye. He can depict mists through which the shapes of things can only be discerned with difficulty; rain with cloud-capped mountains and valleys showing through; clouds of dust whirling about the combatants who raised them; streams of varying transparency, and fishes at play between the surface of the water and its bottom; and polished pebbles of many colours deposited on the clean sand of the river bed surrounded by green plants seen underneath the water's surface. He will represent the stars at varying heights above us and innumerable other effects whereto sculpture cannot aspire.[213]

The sculptor cannot represent transparent or luminous substances.[214]

How the eye cannot discern the shapes of bodies within their boundaries were it not for shadows and lights; and there are many sciences which would not exist but for the science of shadows and lights—as painting, sculpture, astronomy, a great part of perspective and the like.

It may be shown that the sculptor does not work without the help of shadows and lights, since without these the material carved would remain all of one colour. . . . A level surface illumined by a steady light does not anywhere vary in the clearness and obscurity of its natural colour; and this sameness of the colour indicates the uniform smoothness of the surface. It would follow therefore that if the material carved were not clothed by shadows and lights, which are produced by the prominences of the muscles and the hollows interposed, the sculptor would not be able uninterrupted to watch the progress of his work, as he must do, else what he fashions during the day would look almost as though it had been made in the darkness of the night.

Of painting

Painting, however, by means of shadows and lights presents upon level surfaces, shapes with hollowed and raised portions in diverse aspects, separated from each other at various distances.[215]

The sculptor may claim that *basso relievo* is a kind of painting; this may be conceded as far as drawing is concerned because relief partakes of perspective. But as regards the shadows and lights it errs both as sculpture and as painting because the shadows of the *basso relievo* in the foreshortened parts, for instance, have not the depth of the corresponding shadows in painting or sculpture in the round. But this art is a mixture of painting and sculpture.[216]

*That sculpture is less intellectual than painting and lacks many of
its inherent qualities*

As I practise the art of sculpture as well as that of painting,
and am doing both in the same degree, it seems to me that
without being suspected of unfairness I may venture to give
an opinion as to which of the two is of greater skill and of
greater difficulty and perfection.

In the first place, a statue is dependent on certain lights,
namely those from above, while a picture carries its own
light and shade with it everywhere. Light and shade are
essential to sculpture. In this respect, the sculptor is helped
by the nature of the relief, which produces them of its own
accord; while the painter has to create them by his art in
places where nature would normally do so.

The sculptor cannot differentiate between the various
natural colours of objects; the painter does not fail to do so
in every particular. The lines of perspective of sculptors do
not seem in any way true; those of painters may appear to
extend a hundred miles beyond the work itself. The effects
of aerial perspective are outside the scope of sculptors'
work; they can neither represent transparent bodies nor
luminous bodies nor reflections, nor shining bodies such as
mirrors and like things of glittering surface, nor mists, nor
dull weather, nor an infinite number of things which I for-
bear to mention lest they be wearisome.

The one advantage which sculpture has is that of offering
greater resistance to time. . . .

Painting is more beautiful, more imaginative and richer
in resource, while sculpture is more enduring, but excels in
nothing else.

Sculpture reveals what it is with little effort; painting
seems a thing miraculous, making things intangible appear
tangible, presenting in relief things which are flat, in
distance things near at hand.

In fact, painting is adorned with infinite possibilities which sculpture cannot command.[217]

III. ARCHITECTURAL PLANNING

Leonardo's manuscripts contain a number of architectural designs for domed cathedrals built on a central plan where structural problems are dealt with theoretically and from an artistic point of view. He also designed forts, villas, castellos, pavilions, and stables for his patrons. His advice was sought regarding the completion of the cathedrals of Milan and Pavia.

He was interested in theoretical questions of practical importance—in problems such as what form of a church would best answer the requirements of acoustics. He wrote on arches and beams and the pressure which they sustain; on the origin and progress of cracks in walls and how to avoid them.

His ideas on town-planning and on arrangement of houses and gardens combine art with technical knowledge, and provide for plenty of light, air, and open space, noise-proof rooms, and two-level highways, etc.

M

The diagrams reproduced from one of his notebooks indicate the rules as given by Vitruvius and by Leon Battista Alberti for the proportions of the Attic base of a column.

What is an arch?

An arch is nothing else than a strength caused by two weaknesses; for the arch in buildings is made up of two segments of a circle, and each of these segments being in itself very weak desires to fall, and as one withstands the downfall of the other the two weaknesses are converted into a single strength.

Of the nature of the weight in arches

When once the arch has been set up it remains in a state of equilibrium, for the one side pushes the other as much as the other pushes it; but if one of the segments of the circle weighs more than the other the stability is ended and destroyed, because the greater weight will subdue the less.[218]

Here it is shown how the arches made in the side of the octagon thrust the piers of the angles outwards as is shown

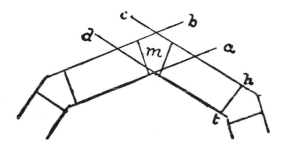

by the lines *hc* and *td* which thrust out the pier *m*; that is they tend to force it away from the centre of such an octagon.[219]

An experiment to show that a weight placed on an arch does not discharge itself entirely on its columns; on the contrary the greater the weight placed on the arches, the less the arch transmits the weight to the columns. The experiment is the following: Let a man be placed on a steelyard in the middle of the shaft of a well, then let him spread out his hands and feet between the walls of the well, and you will see him weigh much less on the steel-

yard. Give him a weight on the shoulders, you will see by experiment that the greater the weight you give him the greater effort he will make in spreading his arms and legs and in pressing against the wall, and the less weight will be thrown on the steelyard.[220]

A new tower founded partly on old masonry.[221]

Water stairs

When the descent from the floodgates has been so hollowed out that at the end of its drop it is below the bed of the river, the waters which descend from them will never form a cavity at the foot of the bank, and will not carry away soil in their rebound, and so they will not proceed to form a fresh obstacle but will follow the transverse course along the length of the base of the floodgate from the under side. Moreover, if the lowest part of the bank which lies diagonally across the course of the waters be constructed in deep broad steps after the manner of a staircase, the waters which as they descend in their course are accustomed to fall perpendicularly from the beginning of this lowest stage, and dig out the foundations of the bank, will not be able any longer to descend with a blow of too great a force. And I give as an example of this the stair down which the water falls from the meadows of the Sforzesca at Vigevano, for the running water falls down it for a height of fifty braccia.[222]

The water should be allowed to fall from the whole circle *ab*.[223]

Town planning

Let the street be as wide as the universal height of the houses.[224]

[With plan of town showing high- and low-level roads. Plate LXXVII in R.]

The high-level roads are six braccia higher than the low-level roads, and each road should be twenty braccia wide and have a fall of half a braccio from the edges to the centre. And in this centre at every braccio there should be an opening of the width of a finger one braccio long, through which rainwater may drain off into holes made on the lower-level roads. And on each side of this road there should be an arcade six braccia broad resting on columns.

And if anyone wishes to go through the whole place by the high-level roads he will be able to use them for this purpose, and so also if anyone wishes to go by the low-level roads. The high-level roads are not to be used by wagons or like vehicles but are solely for the convenience of the gentle-folk. All carts and loads for the service and convenience

of the common people should be confined to the low-level roads. One house has to turn its back on another, leaving the low-level road between them. The doors serve for the bringing in of provisions such as wood and wine, &c. The privies, stables, and noisome places are emptied by underground passages situated at a distance of three hundred braccia from one arch to the rest, each passage receiving light through openings in the street above, and at every arch there should be a spiral staircase. . . . At the first turn there should be a door of entry into the privies, and this staircase should enable one to descend from the high-level to the low-level road.

The high-level roads begin outside the gates at the height of six braccia. The site should be chosen near to the sea, or some large river, in order that the impurities of the city may be carried far away by water.[225]

Plan of house

A building ought always to be detached all round in order that its true shape can be seen.[226]

[With architectural drawings.]

Large room for the master, room, kitchen, larder, guardroom, large room for the family, and hall.

The large room for the master and that for the family should have the kitchen between them, and in both the food may be served through wide and low windows or by tables that turn on swivels. The large room of the family is on the other side of the kitchen so that the master of the house may not hear the clatter.

The wife should have her own apartment and hall apart from that of the family, so that she may set her serving maids to eat at another table in the same hall. She should have two other apartments as well as her own, one for the serving maids, the other for the nurses, and ample space for their utensils. And the apartment will be in communica-

tion with the various conveniences; and the garden and stable in contact.

He who is stationed in the buttery ought to have behind him the entrance to the kitchen, in order to be able to do his work expeditiously; and the window of the kitchen should be facing the buttery so that he may extract the wood. And let the kitchen be convenient for cleaning pewter so that it may not be seen being carried through the house. I wish to have one door to close the whole house.[227]

A water mill

By means of a mill I shall be able at any time to produce a current of air; in the summer I shall make the water spring up fresh and bubbling, and flow along in the space between the tables which will be arranged thus [drawing]. The channel may be half a braccio wide, and there should be vessels there with wines, always of the freshest. Other water should flow through the garden moistening the orange and citron trees according to their needs. These citron trees will be permanent, because their situation will be so arranged that they can easily be covered over and the continuous warmth which the winter season produces will be the means of preserving them far better than fire, for two reasons: one is that this warmth of the springs is natural and is the same as warms the roots of all the plants; the second is that fire gives warmth to these plants in accidental manner, because it is deprived of moisture and is neither uniform nor continuous, being warmer at the start than at the end and is very often overlooked through the carelessness of those in charge of it.

The herbage of the little brooks ought to be cut frequently so that the clearness of the water may be seen upon its shingly bed, and only those plants should be left which serve the fishes for food, such as watercress and like plants. The fish should be such as will not make water muddy, that

is to say eels must not be put there nor tench, nor yet pike because they destroy the other fish.

By means of the mill you will make many water conduits through the house, and springs in various places, and a certain passage where, when anyone passes, from all sides below the water will leap up, and so it will be there ready in case anyone should wish to give a shower bath from below to the women or others who shall pass there.

Overhead we must construct a very fine net of copper which will cover over the garden and shut in beneath it many different kinds of birds. So you will have perpetual music together with the scents of the blossoms of the citrons and the lemons.

With the help of the mill I will make continuous sounds from all sorts of instruments, for so long as the mill shall continue to move.[228]

IV. THE ARTIST'S LIFE

The painter strives and competes with nature.[229]

The painter ought to be solitary and consider what he sees, discussing it with himself in order to select the most excellent parts of whatever he sees. He should act as a mirror which transmutes itself into as many colours as are those of the objects that are placed before it. Thus he will seem to be a second nature.[230]

The life of the painter in his studio

In order that the well-being of the body may not sap that of the mind the painter or draughtsman ought to remain solitary, and especially when intent on those studies and reflections of things which continually appear before his eyes and furnish material to be well kept in the memory. While you are alone you are entirely your own; and if you have but one companion you are but half your own, or even less in proportion to the indiscretion of his conduct.

And if you have more companions you will fall deeper into the same trouble. If you should say, 'I will go my own way, I will withdraw apart the better to study the forms of natural objects', I tell you that this will work badly because you cannot help often lending an ear to their chatter; and not being able to serve two masters you will badly fill the part of a companion, and carry out your studies of art even worse. And if you say, 'I will withdraw so far that their words shall not reach me nor disturb me', I can tell you that you will be thought mad; but bear in mind that by doing this you will at least be alone; and if you must have companionship find it in your study. . . . This may assist you to obtain advantages which result from different methods. All other company may be very mischievous to you.[231]

Small rooms or dwellings discipline the mind, large ones distract it.[232]

Denial of the assertion that painters should not work on feast days
For painting is the way to learn to know the maker of all marvellous things—and this is the way to love so great an inventor. For in truth great love springs from the full knowledge of the thing that one loves; and if you do not know it you can love it but little or not at all.

And if you love Him for the sake of the good benefits that you expect to obtain from Him, you are like the dog wagging its tail, welcoming and jumping up at the man who may give him a bone. But if the dog knew and would be capable of understanding the virtue of this man how much greater would be his love![233]

The life of the painter in the country

A painter needs such mathematics as belong to painting, and the severance from companions who are not in sympathy with his studies; and his brain should have the power

of adapting itself to the variety of objects which present themselves before it; and he should be free from other cares. And if, while considering and defining one case, a second should intervene, as happens when an object occupies the mind, then he must decide which of these cases is the more difficult to work out, and follow that until it becomes entirely clear, and then work out the explanation of the other; and above all he should keep his mind as clear as the surface of a mirror, which becomes changed to as many different colours as are those of the objects; and his companions should resemble him as to their studies, and if he fail to find any he should keep his speculations to himself alone, for in the end he will find no more useful company.[234]

Studying when you wake, or before you go to sleep in the dark
I have found in my own experience that it is of no small benefit when you lie in bed in the dark to go over again in the imagination the outlines of the forms you have been studying or of other noteworthy things conceived by subtle speculation; and this is certainly a praiseworthy exercise and useful in impressing things on the memory.[235]

The mind of a painter should be like a mirror, which always takes the colour of the object it reflects and is filled by the images of as many objects as are in front of it. Therefore you must know that you cannot be a good painter unless you are universal master to represent by your art every kind of form produced by nature. And this you will not know how to do unless you see them and retain them in your mind. Therefore as you walk through the fields turn your attention to the various objects and look now at this thing and now at that, collecting a store of divers facts selected and chosen from those of less value. And do not do like some painters who, when tired in their mind, dismiss their work from their thoughts and take exercise by walking for relaxation keeping, however, such

weariness of mind as prevents them from apprehending the objects they see; but often when they meet friends or relatives and being saluted by them although they may see and hear them take no more cognizance of them than if they had met so much air.[236]

What induces you, oh man, to depart from your home in town, to leave parents and friends, and go to the country-side over mountains and valleys, if it is not the beauty of the world of nature which, if you consider well, you can only enjoy through the sense of sight; and since the poet in this claims to compete with the painter, why do you not take the poet's descriptions of such landscapes and stay at home without exposing yourself to the excessive heat of the sun? Would that not be more expedient and less fatiguing, since you could stay in a cool place without moving about and exposing yourself to illness? But your soul could not enjoy the pleasures that come to it through the eyes, the windows of its habitation, it could not receive the reflections of bright places, it could not see the shady valleys watered by the play of meandering rivers, it could not see the many flowers which with their various colours compose harmonies for the eye, nor all the other things which may present themselves to the eye. But if a painter on a cold and severe winter's day shows you his paintings of these or other country-sides where you once enjoyed yourself beside some fountain, and where you can see yourself again in flowery meadows as a lover by the side of your beloved under the cool, soft shadows of green trees, will it not give you much greater pleasure than listening to the poet's description of such a scene?[237]

The time for studying selection of subjects

Winter evenings should be spent by young students in study of the things prepared during the summer; that is, all the drawings from the nude which you have made in

the summer should be brought together and a choice made
of the best limbs and bodies from among them to apply
in practice and commit to memory.

Of attitudes

Afterwards, in the following summer you should select
someone who is well grown, and has not been brought up
in doublets and whose figure has therefore lost its natural
bearing, and make him go through some graceful and
elegant movements; and if his muscles do not show plainly
within the outlines of his limbs this is of no consequence. It
is enough for you to obtain good attitudes from the figure,
and you can correct the limbs by those which you have
studied in the winter.

Of the way of learning aright how to compose groups of figures in historical pictures

When you have well learnt perspective and have fixed in
your memory all the parts and forms of objects, you should
go about and often as you go for walks observe
and consider the circumstances and behaviour of
men as they talk and quarrel, or laugh or come
to blows with one another; the actions of the men
themselves and of the bystanders, who intervene
or look on. And take a note of them with rapid strokes
thus—in a little book which you should always carry
with you; and let this be of tinted paper; and so that it
may not be rubbed out, change the old for a new one; since
these things should not be rubbed out but preserved with
great care; for the forms and positions of objects are so
infinite that the memory is incapable of retaining them,
wherefore keep these as your guides and masters.[231]

Whether it is better to draw in company or no

I say and insist that drawing in company is much better
than alone, for many reasons. The first is that you would be

ashamed of being seen among a number of draughtsmen if you are weak, and this feeling of shame will lead you to good study; secondly a wholesome envy will stimulate you to join the number of those who are more praised than you are, for the praise of others will spur you on; yet another is that you can learn from the drawings of those who do better than yourself; and if you are better than the others, you can profit by your contempt for their defects, and the praise of others will incite you to further efforts.[235]

Of judging your own pictures

We know very well that errors are better recognized in the works of others than in our own; and often by reproving little faults in others, we may ignore great ones in ourselves. ... I say that when you paint you should have a flat mirror and often look at your work as reflected in it, when you will see it reversed, and it will appear to you like some other painter's work, so you will be better able to judge of its faults than in any other way. Again it is well that you should often leave off work and take a little relaxation, because when you come back to it you are a better judge; for sitting too close at work may greatly deceive you. Again it is good to retire to a distance because the work looks smaller and your eye takes in more of it at a glance and sees more easily the lack of harmony and proportion in the limbs and colours of the objects.[238]

As the body with great slowness produced by the extent of its contrary movement turns in greater space and thereby gives a stouter blow, whereas shorter movements have little strength, so the study of the same subject made at long intervals of time causes the judgement to become more perfect and more able to recognize its own mistakes. And the same is true of the eye of the painter as it draws farther away from the picture.[239]

Of the choice of beautiful faces

It seems to me no small grace in a painter to be able to give a pleasing air to his figures, and this grace, if he have it not by nature, he may acquire it by incidental study in this way: Look about you and take the best parts of many beautiful faces, of which the beauty is established rather by public fame than by your own judgement; for you may deceive yourself and select faces which bear a resemblance to your own, since it would often seem that such resemblance pleases us; and if you were ugly you would select faces that are not beautiful, and you would then create ugly faces as many painters do. For often a master's shapes resemble himself; so therefore select beauties as I tell you and fix them in your mind.[231]

Of selecting the light which gives most grace to faces

If you should have a courtyard that you can at pleasure cover with a linen awning that light will be good. Or when you want to take a portrait do it in dull weather, or as evening falls, placing the sitter with his back to one of the walls of the courtyard. Note the faces of the men and women in the streets as evening falls and when the weather is dull, what softness and delicacy you may perceive in them. Therefore, O Painter! have a court arranged with the walls tinted black and a narrow roof projecting within the walls. It should be 10 braccia wide and 20 braccia long and 10 braccia high and covered with a linen awning when the sun is shining; or else paint a portrait towards the evening or when it is cloudy or misty; and this is perfect lighting.[240]

Rule to be given to boys learning to paint

We know clearly that vision is one of the swiftest actions that there is, and in one instant we see infinite forms; nevertheless, we understand only one thing at a time.

Suppose that you, reader, were to glance rapidly at all this written page, and you will quickly perceive that it is full of various letters, but in this time you could not recognize what letters they are nor what they were meant to tell. Hence you need to proceed word by word, line by line, to be able to understand these letters. Again, if you wish to mount to the top of an edifice you must go up step by step; otherwise it will be impossible to reach the top. So I say to you, whom nature turns to this art, if you wish to have knowledge of the forms of things, you will begin with their details, and not go on to the second until you have the first well fixed in memory and in practice. And if you do otherwise, you will waste your time, or certainly you will prolong your study a good deal; and remember to acquire diligence first, rather than rapidity.[238]

That diligence should first be learnt rather than rapid execution

If as draughtsman you desire to study well and to good purpose, accustom yourself to work slowly when you are drawing, and discriminate in the lights which have the highest degree of brightness, and likewise in the shadows, which are those that are darker than the others and in what way they join one another; and then their dimensions and the relative proportions of one to another; and note in the outlines which way they are tending, and in the lines what part of them is curved to one side or the other, and where they are more or less conspicuous and where they are broad or fine; and finally that your shadows and lights blend like smoke without strokes or borders: And when you shall have schooled your hand and your judgement by such diligence, you will acquire rapid execution before you are aware.[231]

These rules are to be used only in testing the figures; since every man makes certain mistakes in his first compositions and he who knows them not cannot amend them.

Therefore, you being aware of errors test your work and where you find mistakes amend them, and remember never to fall into them again. But if you try to apply these rules in composition you would never make a beginning and would cause confusion in your work.

These rules are intended to give you a free and good judgement; since good judgement proceeds from clear understanding, and a clear understanding comes from reason derived from sound rules, and sound rules are the daughters of sound experience—the common mother of all the sciences and arts. Therefore bearing in mind the precepts of my rules, you will be able, merely by your amended judgement to judge and recognize everything that is out of proportion in a work, whether it is in the perspective or in the figures or other things.[241]

Many who have not studied the theory of shade and light and of perspective turn to nature and copy her; they thus acquire a certain practice simply by copying without studying or analysing nature further. There are some who look at the objects of nature through glass or transparent paper or veils* and make tracings on the transparent surface; and they then adjust their outlines, adding on here and there to make them conform to the laws of proportion, and they introduce chiaroscuro by filling in the positions, sizes, and shapes of the shadows and lights. These practices may be praiseworthy in him who knows how to represent effects of nature by his imagination and only resorts to them in order to save trouble and not to fail in the slightest particular in the truthful imitation of a thing whereof a precise likeness is required; but they are reprehensible in him who cannot portray without them nor use his own

* Devices to facilitate the correct placing of objects on the picture plane were recommended by Leon Battista Alberti, *Della Pittura*, ii; by Lomazzo, *Trattato dell' Arte*, vi. 14 and 15; and by Dürer, *Unterweisung der Messung*, &c., who illustrated the subject by four woodcuts (Bartsch 146–9).

mind in analyses, because through such laziness he destroys
his own intelligence and he will never be able to produce
anything good without such contrivance. Men like this
will always be poor and weak in imaginative work or
historical composition.[242]

The painter who draws by practice and judgement of the
eye without the use of reason is like a mirror which copies
everything placed in front of it without knowledge of the
same.[243]

Those who are enamoured of practice without science are
like the pilot who gets into a ship without rudder or com-
pass and who never has any certainty where he is going.
Practice should always be based on sound theory, of which
perspective is the guide and gateway, and without it
nothing can be done well in any kind of painting.[244]

How the painter is not worthy of praise unless he is universal

It may be frankly admitted that certain people deceive them-
selves who call a painter a 'good master' who can only do
the head or the figure well. Surely it is no great achievement
if after studying one thing only during his whole lifetime
he attain to some perfection. But since we know that paint-
ing embraces and contains within itself all things which
nature produces, or which result from the fortuitous actions
of man, and in short whatever can be comprehended by the
eyes, it would seem to me that he is but a poor master who
makes only a single figure well. For do you not see how
many and how varied are the actions performed by men
alone? Do you not see how many different animals there
are, and also trees and plants and flowers? What variety of
mountainous regions and plains, of springs, rivers, cities with
public and private buildings, instruments fitted for man's
use; of divers costumes, ornaments, and arts? All these
things should be rendered with equal facility and perfection
by whomever you wish to call a good painter.[245]

How in works of importance a man should not trust so entirely to
his memory as to disdain to draw from nature

Any master who should venture to boast that he could re-
member all the forms and effects of nature would certainly
appear to me to be graced with great ignorance, in as much
as these effects are infinite and our memory is not of so great
capacity as to suffice thereto. Hence, O painter, beware lest
the greed of gain should supplant in you the renown in art,
for to gain this renown is a far greater thing than is the re-
nown of riches. Hence for these and other reasons which
might be given, you should first strive in drawing to present
to the eye in expressive form the purpose and invention
created originally in your imagination, then proceed by
taking off and putting on until you satisfy yourself; then
have men arranged as models draped or nude in the way in
which you have disposed them in your work; and make the
dimensions and size as determined by perspective, so that
nothing remains in the work that is not so counselled by
reason and by the effects in nature. And this will be the way
to make yourself renowned in your art.[235]

That painting declines and deteriorates from age to age, when
painters have no other standard than paintings already done

Hence the painter will produce pictures of small merit if he
takes for his standard the pictures of others, but if he will
study from natural objects he will bear good fruit. As was
seen in the paintings after the Romans who always imitated
each other and so their art constantly declined from age to
age. After these came Giotto, the Florentine, who was not
content with imitating the works of Cimabue his master,
being born in mountain solitudes inhabited only by goats
and such beasts and being guided by nature to his art, he
began by drawing on the rocks the movements of the goats
which he was tending; and thus he began to draw all the
animals which were to be found in the country, and in such

a way that after much study he excelled not only the masters
of his time but all those of many bygone ages. Afterwards
this art declined again, because everyone imitated the pic-
tures that were already done; thus it went on deteriorating
. . . until Tomaso of Florence, nicknamed Masaccio, showed
by his perfect works how those who take for their standard
anyone but nature—the mistress of all masters—weary
themselves in vain. And similarly, I would say about these
mathematical studies that those who study only the authori-
ties and not the works of nature are descendants but not sons
of nature, the mistress of all good authors. Oh how great is
the folly of those who blame those who learn from nature,
leaving uncensured the authorities who were themselves
the disciples of this same nature.[246]

Therefore, O painter, who do not know these laws, if you
would escape the censure of those who have studied them,
be zealous to represent everything according to nature and
not to disparage such study as do those who work only for
gain.[247]

He is a poor disciple who does not excel his master.[248]

V

TALES AND ALLEGORIES

Leonardo's notebooks contain a number of tales, fables, epigrams, riddles, &c., some of which may have been composed for recital at social gatherings. His language is simple and lucid, his humour terse and trenchant.

We give below a selection of tales dealing with animal life derived from ancient books which were in his possession. Then follow fables and epigrams of his own invention, based on observations of nature and made, according to ancient usage, to serve as moral examples in order to expose ingratitude, vice, and ignorance, and to extol humility, virtue, and truth. After this come a selection of his 'prophecies' and a few tales entitled 'jests'.

The last part of this chapter is devoted to imaginative descriptions of nature.

I. BESTIARY

The following thirteen tales are transcriptions from a medieval bestiary entitled Fior di Virtù *which was very popular from the thirteenth century onwards.*

Love of virtue

The lark is a bird of which it is told that when it is taken into the presence of a sick person, if the sick man is going to die, the bird turns away its head and never looks at him. But if the sick person is going to recover the bird never loses sight of him and is the cause of curing all his sickness.

Like unto this is the love of virtue. It never looks at any vile or base thing, but rather dwells always on things honest and virtuous and takes up its abode in a noble heart, like the

birds do in green woods upon flowery branches. And this
love shows itself more in adversity than in prosperity, as
light does which shines most where it finds the darkest spot.[1]

Sadness

Sadness resembles the raven which, when it sees its young
ones born white, departs with great grief and abandons
them with sad lamentations, and does not feed them until it
sees on them some few black feathers.[2]

Peace

Of the beaver one reads that when it is pursued, knowing
this to be on account of the virtue of its testicles for medi-
cinal uses and not being able to escape, it stops; and in order
to be at peace with its pursuers bites off its testicles with its
sharp teeth and leaves them to its enemies.[3]

Anger

It is said of the bear that when he goes to the beehives to
take their honey the bees begin to sting him so that he leaves
the honey and rushes to avenge himself; and wishing to take
vengeance on all those who sting him he fails to take ven-
geance on any; in such a wise that his rage is turned to mad-
ness, and he flings himself on the ground in exasperation
vainly trying to defend himself by his hands and feet.[3]

Avarice

The toad feeds on earth and always remains lean, because it
never satisfied itself—it is so afraid lest it should be without
earth.[4]

Blandishments

The siren sings so sweetly that she lulls the mariners to sleep;
then she climbs upon the ships and kills the sleeping
mariners.

Prudence

The ant, by natural foresight, provides in the summer for the winter, killing the seeds she harvests that they may not germinate, and on them it feeds in due time.

Folly

The wild bull having a dislike of red colour, the hunters cover the trunk of tree with red and the bull runs at it and with great fury digs into it with its horns, and forthwith the hunters kill it.[5]

Justice

We may liken the virtue of justice to the king of the bees who orders and arranges everything with judgement. For some bees are ordered to go to the flowers, others are ordered to labour, others to fight with the wasps, others to clear away all dirt, others to accompany and escort the king; and when he is old and has no wings they carry him. And if one of them fails in his duty, he is punished without reprieve.[6]

Falsehood

The fox, when it sees a flock of jackdaws or magpies or birds of that kind, suddenly flings himself on the ground with his mouth open to look as if he were dead; and these birds want to peck at his tongue and he bites off their heads.[7]

Lies

The mole has very small eyes and always lives underground; and it lives as long as it remains in the dark, but when it emerges into the light it dies immediately because it becomes known. So it is with lies.

Fear or cowardice

The hare is always frightened; and the leaves that fall from the trees in the autumn always keep him in terror and generally put him to flight.[8]

Constancy

Constancy may be symbolized by the phoenix which understanding by nature its renewal, it has the constancy to endure the burning flames which consume it, and then it is reborn anew.[9]

The following tales are transcriptions from Cecco d'Ascoli's Acerba. *The author was an astrologer, a contemporary of Dante.*

The crocodile—hypocrisy

This animal catches a man and straightway kills him; after he is dead, it weeps over him with a lamentable voice and many tears. Then, having done with lamenting, it cruelly devours him. It is thus with the hypocrite, who for the smallest matter has his face bathed in tears, but shows the heart of a tiger and rejoices in his heart at the woes of others, while wearing a pitiful face.[10]

The oyster—for treachery

This opens completely when the moon is full; and when the crab sees it it throws a piece of stone or seaweed into it and the oyster cannot close again so that it serves the crab for a meal. So it is with him who opens his mouth to tell a secret and thereby puts himself at the mercy of the indiscreet listener.[11]

The caterpillar—for virtue in general

The caterpillar, which through the care exercised in weaving round itself a new habitation with admirable design and fine workmanship, comes out of it afterwards with painted and beautiful wings, rising on these towards heaven.

The spider

The spider brings forth out of herself the delicate and ingenious web, which makes her a return by the prey it takes.[12]

The following description is an adaptation from Pliny's Natural History.

The elephant

The great elephant has by nature qualities which are rarely found in man, namely honesty, prudence, a sense of justice, and of religious observance. Consequently when the moon is new they go down to the rivers and there solemnly cleansing themselves bathe, and after having thus saluted the planet they return to the woods. And when they are ill, lying down they fling up plants towards heaven as though they wished to offer sacrifice. They bury their tusks when they drop out from old age. Of these two tusks they use one to dig up roots for food but they save the point of the other for fighting; when they are taken by hunters, worn out by fatigue, they strike off their tusks and having drawn them out ransom themselves therewith. They are merciful and know the dangers, and if one of them finds a man alone and lost it kindly puts him back in the path he has missed. If it finds the footprints of the man before it sees him, it fears betrayal, and so it stops and blows, as it shows them to the other elephants and they form into a troop and go warily.

These animals always go in troops, and the oldest goes in front and the second in age remains the last; and thus they enclose the troop. They fear shame and only pair at night and secretly, nor do they then rejoin the herd but first bathe in the river. They never fight with females as other animals do. It is so peaceable that it is unwilling by nature ever to hurt those weaker than itself; and if it meets a drove or flock of sheep it puts them aside with its trunk so as not to trample them underfoot; and it never injures óthers unless it is provoked. When one of them has fallen into a pit the others fill the pit with branches, earth, and stones, thus raising the bottom, that it may easily get out. They greatly dread the grunting of swine and retreat hastily doing no less

harm with their feet to themselves than to their enemies. They delight in rivers and are always wandering about them; but on account of their great weight they cannot swim. They devour stones, and the trunks of trees are their favourite food. They hate rats. Flies delight in its smell and as they settle on its back it wrinkles up its skin making its folds deep and tight and kills them. When they are crossing rivers they send their young ones towards the fall of the stream, and standing themselves up stream they break the united current of the water so that the current may not carry them away. The dragon flings itself under the elephant's body and with its tail it ties its legs; with its wings and claws it squeezes its ribs, and with its teeth bites its throat; the elephant falls on top of it and the dragon bursts. Thus in its death it is revenged on its foe.[13]

II. FABLES

Leonardo's fables give a picture of the Italian country-side. Willow-trees are planted in ordered rows, and pollarded just above the crotch of the main branches. The vines are trained on these trees and arboured between them. Willow shoots are used to bind the vines to the trees. The fruit-trees are loaded with walnuts, chestnuts, peaches, figs, and the big lemon-like citrons. Huge gourds lie in the sun with their big leaves spreading out on the ground. The manner of agriculture in Tuscany and Lombardy has not notably changed since Leonardo's time and is a work of art.

The privet and the blackbird

In this fable Leonardo ridicules those who think that everybody and everything exists only to be of service to them.

The privet feeling its tender boughs, loaded with young fruit, pricked by the sharp claws and beak of the insolent blackbird complained to the blackbird with piteous

remonstrance entreating it that since it stole the delicious fruits it should at least spare the leaves which served to protect them from the burning rays of the sun, and desist from scratching the tender bark with its sharp claws. To this the blackbird replied with angry upbraiding: 'Oh, be silent uncultured shrub! Do you not know that nature made you produce these fruits for my nourishment; do you not see that you are in this world to serve me with food; do you not know, base creature, that next winter you will be food and prey for the fire?' To these words the tree listened patiently. and not without tears. Shortly afterwards the blackbird was caught in a net and boughs were cut to make a cage to imprison it. Branches were cut from the pliant privet among others, to serve for the plaited twigs of the cage; and seeing that it was the cause of the blackbird's loss of liberty the privet rejoicingly said: 'O blackbird, I am here and am not yet burnt as you have foresaid. I shall see you in prison before you see me burnt.'

The laurel, the myrtle, and the pear tree

The proud pear tree is shown to disdain the pity of the laurel and the myrtle because its wood is the favourite material of woodcarvers and lends itself for artistic purposes—while the laurel and myrtle are used for wreaths and the like, and serve no lasting practical purpose.

The laurel and the myrtle seeing the pear-tree cut down cried out with loud voices: 'O pear-tree, whither are you going? Where is the pride you displayed when you were covered with ripe fruit? Now you will no longer shade us with your dense foliage.' The pear-tree replied: 'I am going with the husbandman who has cut me down and who will take me to the workshop of a good sculptor and he will by his art give me the form of Jove, the god; and I shall be dedicated in a temple, and shall be adored by men in place of Jove, while you are bound continually to be maimed and stripped of your boughs which will be placed around me to do me honour.'

The chestnut and the fig tree

Those who are pleased with themselves and look down on others are put in their place.

The chestnut, seeing a man upon the fig-tree, bending the boughs towards him and plucking the ripe fruit which he put into his open mouth to destroy and gnaw with his hard teeth, tossed its long boughs and with tumultuous rustle exclaimed: 'O fig! How much less are you protected by nature than I. See how with me my sweet offspring are set in close array: first clothed in soft wrappers over which is the hard but softly lined husk; and not content with taking this care of me, and giving them so strong a shelter, she has placed over this sharp and close-set spines so that the hand of man cannot hurt me'. Then the fig-tree and its offspring began to laugh and after the laughter it said: 'You know man to be of such ingenuity that he will bereave you of your fruits by means of rods and stones and stakes; and when they are fallen, he will trample them with his feet or hit them with stones so that your offspring will emerge from their armour crushed and maimed; while I am touched carefully by his hands and not like you with sticks and stones and...'

The willow and the gourd

The weak are used for the benefit of the strong; and on trying to free themselves are liable to become the prey of worse parasites.

The hapless willow, finding that she could not enjoy the pleasure of seeing her slender branches grow and attain the height she wished, and point to the sky, because she was always being maimed and lopped and spoiled for the sake of the vine and any trees that grew near, collected her spirits and opened wide the portals of her imagination; and remaining in continual meditation she sought in the world of plants for one wherewith to ally herself which had no need of the help of her withes. Having stood for some time in this prolific imagination the gourd presented itself to her thoughts with

a sudden flash, and tossing all her branches with extreme delight she thought that she had found the companion suited to her purpose, since the gourd is more apt to bind others than to need binding. Having come to this conclusion the willow straightened her branches towards the sky awaiting some friendly bird who should be the mediator of her wishes. Seeing the magpie among others near to her she said to it: 'O gentle bird! By the refuge that you found among my branches during these days in the morning, when the hungry, cruel, and rapacious falcon wanted to devour you, and by the rest which you have always found in me when your wings craved repose, and by the pleasure you have enjoyed among my boughs when playing with your companions and making love I entreat you to find the gourd and obtain from her some of her seeds, and tell her that those that are born of them will be treated by me as though they were my own offspring; and in this way use all such words for the same persuasive purport; though indeed, since you are master of language, there is no need for me to teach you. And if you do me this service I shall be happy to have your nest in the fork of my boughs for all your family free of rent.' Then the magpie after making and confirming certain new stipulations with the willow—and principally that she should never give admittance to any snake or polecat, cocked its tail, lowered its head and flung itself down from the bough throwing its weight on its wings; and beating the fleeting air with these bearing about inquisitively now here now there while its tail served as a rudder to steer, it came to the gourd. There, with a few polite words and a handsome bow, it obtained the required seeds and carried them to the willow who received it with cheerful looks. And having with its claws scraped the earth near the willow, it planted the grains in a circle around it with its beak.

In a short time these started to sprout, and the branches grew and spread out and began to occupy all the boughs of

the willow while their broad leaves deprived it of the beauty of the sun and sky. But this evil was not enough; the gourds then began to drag down towards the earth by their big weight the ends of the tender shoots inflicting strange twisting and discomfort.

Then the willow shook itself in vain to throw off the gourd. After raving in vain for some days because the grasp of the gourd was sure and firm as to forbid such plans, it saw the wind go by and commended itself to him. The wind blew hard and the old and hollow stem of the willow opened up in two parts down to the roots and fell; and it bewailed itself in vain and recognized that it was born to no good fate.

The legend of the wine and Mohammed

Leonardo describes the pride of the wine and its effect on drunkards, and he approves of its prohibition as enforced by Mohammed.

Wine, the divine juice of the grape, finding itself in a golden and richly wrought cup on Mohammed's table, was puffed up with pride at so much honour; when suddenly it was struck by a contrary mood saying to itself: 'What am I about, that I rejoice, not perceiving that I am now nearing my death and that I shall leave my golden abode in this cup in order to enter into the foul and fetid caverns of the human body and be transmuted from a fragrant and delicious liquor into foul and base fluid. And as though so much evil were not enough, I shall for a long time have to lie in hideous receptacles, together with other fetid and corrupt matter cast out from human intestines.' And it cried to Heaven imploring vengeance for so much damage, and that an end be henceforth put to so much insult, and that since this country produced the finest and best grapes in the whole world these at least should not be made into wine. Then Jove caused the wine drunk by Mohammed to rise in spirit to his brain; contaminating it and making him mad, and giving birth to so many follies that when he had recovered, he made a law

that no Asiatic should drink wine; and henceforth the vine was left free with its fruit.

As soon as wine enters the stomach it begins to ferment and swell; then the spirit of that man begins to abandon his body, rising towards heaven and the brain finds itself parting from the body. Then it begins to degrade him, and makes him rave like a madman, and then he commits irreparable errors, killing his friends.

The ant and the grain of millet

Long discussions are superfluous when reason dictates the course of action.

The ant found a grain of millet. The seed, feeling itself caught, cried out: 'If you do me the kindness to allow me to accomplish my function of reproduction, I will give you a hundred such as I am.' And so it was.

The spider and the bunch of grapes

The unscrupulous self-seeker who abuses the hospitality of others ends by being punished.

A spider found a bunch of grapes which for its sweetness was much resorted to by bees and divers kinds of flies. It seemed that it had found a most convenient spot to spread its net and having settled on its delicate web it entered into its new habitation. Every day, hiding in the spaces between the grapes, it fell like a thief on the wretched animals which were unaware of the danger. But after a few days had passed the vintager came, and cut the bunch of grapes and placed it with others that were trodden, and thus the grapes were a snare and pitfall both for the deceitful spider and the deceived flies.

The nut and the campanile

The artfulness and ingratitude of those who insinuate themselves into favours for their own benefit.

A nut found itself carried by a crow to the top of a tall campanile, and by falling into a crevice was released from

its deadly beak; and it besought the wall by that grace which God had bestowed upon it in allowing it to be so high and great, and so rich in having bells of such beauty and of such noble tone, that it would give help; that as it had not been able to drop beneath the green branches of its old father and lie in the fallow earth covered by his fallen leaves, the wall would not abandon it, for when it found itself in the beak of the cruel crow it had vowed that if it escaped thence it would end its life in a little hole. At these words the wall, moved with compassion, was content to shelter it in the spot where it had fallen; and within a short time the nut began to burst open and to put its roots in between the crevices of the stones, and push them apart, and throw up shoots from its hollow; and these soon rose above the building, and as the twisted roots grew thicker they began to thrust the walls apart and force the ancient stones from their old places. Then the wall too late and in vain bewailed the cause of its destruction, and in a short time it was torn asunder and a great part of it fell in ruin.

The moth and the candle

A warning to those who forsake the true light in order to pursue transient glories.

The vain and wandering moth, not content with its power to fly through the air at its ease, and overcome by the seductive flame of the candle, decided to fly into it; but its joyous movement was the cause of instant woe; for in the flame its delicate wings were consumed. And the hapless moth dropped all burnt at the foot of the candlestick. After much lamentation and repentance it wiped the tears from its streaming eyes and raising its face exclaimed: 'O false light! how many like me must thou have miserably deceived in times past; and if my desire was to see light ought I not to have distinguished the sun from the false glimmer of dirty tallow?'[14]

The citron

The consequences of pride and haughtiness.

The tongue bitten by teeth

The citron, puffed up with pride of its beauty, separated itself from the trees around it and in so doing it turned towards the wind; which, not being broken in its fury, flung it uprooted to the ground.

The consequences of vanity and ignorance.

The citron, desirous of producing a fine and noble fruit high up on its topmost shoot, set to work with all the strength of its sap. But when this fruit had grown it caused the tall, straight top of the tree to bend down.

The peach, envious of the great quantity of fruit on the walnut tree nearby, determined to do likewise, and loaded itself with its own fruit to such an extent that the weight pulled it down to the ground, uprooted and broken.

The walnut tree standing by the roadside and displaying the wealth of its fruit was stoned by every man who passed.

When the fig-tree was without fruit nobody would look at it; then wishing to be praised by men for its production of fruit, it was bent and broken by them.

The fig-tree standing by the side of the elm and seeing that its boughs were without fruit and that it nevertheless had the audacity to keep the sun from its own unripe figs said reprovingly: 'O elm, are you not ashamed to stand in front of me? But wait till my offspring are ripe and you will see where you are!' But when her fruit was ripe a troop of soldiers passing by fell upon the fig-tree and tore off the figs, cutting and breaking the boughs. And as the fig-tree stood thus maimed in all its limbs, the elm-tree asked it: 'O fig-tree, how much better it is to be without offspring than to be brought through them into so miserable a plight.'[15]

The lily on the banks of a torrent

Proud things of beauty may find the soil on which they have established a foothold slipping away beneath them.

The lily set itself by the shores of the Ticino and the current carried away the river bank and the lily with it.[16]

The vine and the willow

One's fate is determined by the fate of one's companions and associates.

The vine that has grown old on an old tree falls with the collapse of the tree and perishes through its bad companionship.

The willow which as it grows hopes to outstrip every other plant by its long shoots, is crippled every year because of its association with the vine.[17]

The stone by the roadside

Love for solitude and country life.

A stone of good size recently uncovered by the waters lay on a certain spot perched on the edge of a delightful grove, above a stony road, surrounded by plants and various

flowers of divers colours, and looked upon the great quantities of stones which had collected together in the roadway below. And it began to wish to let itself down there, saying within itself: 'What am I doing here with these plants? I want to live in the company of those my sisters.' And letting itself fall it ended its rapid descent among those desired companions. When it had been there some time it found itself in continual distress from the wheels of the carts, the iron hoofs of horses, and the feet of the passers-by. One rolled it over, another trod upon it; sometimes it raised itself up a little as it lay covered with mud or the dung of some animal, but it was in vain that it looked up at the spot whence it had come as a place of solitude and tranquil peace.

So it happens to those who leaving a life of solitary contemplation choose to come to dwell in cities among people full of infinite evil.

The razor

The rusty blade is compared to the lazy mind.

One day the razor emerging from the handle which served it as a sheath and placing itself in the sun, saw the sun reflected in its body, at which thing it took great pride, and turning it over in its thoughts it began to say to itself: 'And shall I return again to that shop from which I have just come? Certainly not! It cannot be the pleasure of the gods that such splendid beauty be turned to such base uses! What folly it would be that should lead me to shave the lathered beards of rustic peasants and perform such menial service? Is this body destined for such work? Certainly not! I will hide myself in some retired spot and there pass my life in tranquil repose.' And so having hidden itself for some months, returning one day into the open and coming out of its sheath, it saw that it had acquired the appearance of a rusty saw and that its surface no longer reflected the

resplendent sun. With useless repentance it deplored in vain the irreparable mischief, saying to itself: 'Oh, how much better was it to use at the barber that lost edge of mine of such exquisite keenness! Where is that lustrous surface? In truth this vexatious and unsightly rust has consumed it!'

The same thing happens with minds which instead of exercise give themselves up to sloth; these like the razor lose the keenness of their edge, and the rust of ignorance spoils their form.[18]

As the colourful butterfly was idly wandering and flitting about through the dark a light came within sight, and thither it immediately directed its course, and flew round about it in varying circles marvelling greatly at such radiant beauty. And not content merely to behold, it began to treat it as was its custom with fragrant flowers, and directing its flight approached with bold resolve to close the light, which thereupon consumed the tips of its wings and legs and other extremities; then dropping to the foot of it, it began to wonder how this accident had been brought about; for it could not so much as entertain a thought that any evil or hurt could possibly come to it from a thing so beautiful; and then having in part regained the strength which it had lost, it took another flight and passed right through the body of the flame, and in an instant fell down burned into the oil which fed the flame, preserving only so much life as sufficed it to reflect upon the cause of its destruction, saying: 'O accursed light: I thought that in you I had found my happiness! Vainly do I lament my mad desire, and by my ruin I have come to know your rapacious and destructive nature.'

To which the light replied: 'Thus do I treat whoever does not know how to use me aright.'

This applies to those who, when they see before them carnal and worldly delights, hasten to them like the butterfly,

without ever taking thought as to their nature, which they will learn to know to their shame and loss.

The flint, on being struck by the stick, marvelled greatly and said to it in a stern voice: 'What arrogance prompts you to annoy me? Trouble me not, for you have chosen me by mistake; I have never done harm to anyone.' Whereto the stick answered: 'If you will be patient you will see what a marvellous result will issue forth from you.' At these words the flint was pacified and patiently endured its martyrdom; and it saw itself giving birth to the marvellous Element of Fire which by its potency became a factor in innumerable things.

This applies to those who are dismayed at the beginning of their studies and then set out to gain mastery over themselves and to devote themselves in patience to those studies with marvellous results.[19]

III. PROPHECIES

The sayings entitled 'Profetie' do not deal with future events. In answer to enigmatic pronouncements well-known facts and proceedings of everyday life are cited; and these interpretations are imbued with a dramatic quality.

The first text here quoted contains a plan for their grouping and the subsequent transcriptions are arranged as much as possible in the sequence here proposed.

The divisions of the prophecies

First of the things which relate to the reasoning animals, second of those which have not the power of reason, third of plants, fourth of ceremonies, fifth of customs, sixth of propositions, decrees or disputes, seventh of propositions contrary to nature—as to speak of a substance which the more is taken from it the more it grows, eighth of philosophical things. And reserve the weighty cases until the

end and begin with those of less import. And first show
the evils and then the punishments.[20]

Many there will be who will flay their own mother and
fold back her skin;—the tillers of the ground.[21]

Men will deal bitter blows to that which is the cause of
their life: they will thrash the grain.[22]

Of sawyers

There will be many who will move one against another,
holding in their hands a cutting iron. These will not do
each other any injury beyond that caused by fatigue; for
as one pushes forward the other draws back. But woe to
him who comes between them; for in the end he will be
left cut in pieces.

Of a man's shadow which moves with him

Shapes and figures of men and animals will be seen pursuing
these men and animals wherever they flee. And exactly as
one moves the other moves; but what seems so wonderful
is the variety of height they assume.

Of our shadow cast by the sun and our reflection in the
water at one and the same time.

Many a time will one man be seen as three and all three
move together, and often the one that is most real abandons
him.[23]

Oxen will be to a great extent the cause of the destruction
of cities, and in the same way horses and buffaloes.

By drawing guns.[24]

Of asses which are beaten

O indifferent nature, wherefore art thou so partial, being to
some of thy children a tender and benignant mother, and
to others a most cruel and pitiless stepmother? I see thy
children given into slavery to others, without any sort of

advantage, and instead of remuneration for the services they have done, they are repaid by the severest suffering, and they spend their whole life in benefiting their oppressor.

Of bees

And many will be robbed of their stores and their food, and will be cruelly submerged and drowned by folks devoid of reason. O justice of God! Why dost thou not awake to behold thy creatures thus abused?

Of sheep, cows, goats, and the like

From countless numbers will be taken away their little children and the throats of these shall be cut, and they shall be quartered most barbarously.

Of food which has been alive

A large part of the bodies which have had life will pass into the bodies of other animals, that is the houses no longer inhabited will pass piece-meal through those which are inhabited, ministering to their needs and bearing away with them what is waste; that is to say, the life of man is made by things which he eats, and these carry with them that part of man which is dead.[20]

The rat was being besieged in its little dwelling by the weasel which with continual vigilance was awaiting its destruction, and through a tiny chink was considering its great danger. Meanwhile the cat came and suddenly seized hold of the weasel and forthwith devoured it. Whereupon the rat, profoundly grateful to its deity, having offered up some of its hazel-nuts in sacrifice to Jove, came out of its hole in order to repossess itself of the lately lost liberty, and was instantly deprived of this and of life itself by the cruel claws and teeth of the cat.[14]

The thrushes rejoiced greatly at seeing a man take the

owl and deprive her of liberty, tying her feet with strong bonds. But this owl was afterwards by means of bird-lime the cause of the thrushes losing not only their liberty but their life. This is said for those countries which rejoice at seeing their governors lose their liberty, in consequence of which they themselves lose all succour and remain in bondage in the power of their enemy, losing their liberty and often life.[25]

Of ants

These will form many communities, which will hide themselves and their young ones and victuals in dark caverns, and they will feed themselves and their families in dark places for many months without any light, either artificial or natural.[20]

Of the water which flows in a turbid stream mingled with Earth and Mist; and of mist mingling with Air, and of the Fire which is mingled by its heat with each.

All the Elements shall be seen mixed together surging in huge rolling mass, now borne towards the centre of the world, now towards the sky, at one time coursing in fury from the southern regions towards the icy north, at another time from the east to the west, and then again from this hemisphere to the other.[23]

The greatest mountains, even though they are remote from the sea-shores, will drive the sea from its place:

That is by the rivers which carry down the soil they wash away from the mountains and deposit it upon the sea shores; and where the earth comes the sea retires.[24]

Of men who sleep upon planks made from trees

Men will sleep and eat and make their dwelling among trees grown in the forests and the fields.

Of nuts and olives and acorns and chestnuts and the like

Many children shall be torn with pitiless beatings from the very arms of their mothers, and flung upon the ground and then maimed.[20]

The olives which fall from the olive-trees give us the oil which makes light

And things will descend with fury from above, and will give us nourishment and light.[23]

Of sailing ships

The trees of the great forests of Taurus, and of Sinai and of the Apennines and of Atlas shall be seen speeding by means of the air from east to west and from north to south; and transporting by means of the air great multitudes of men. Oh, how many vows! Oh, how many deaths! Oh, how many partings between friends and relations! How many will there be who shall nevermore see their own country or their own native lands! and who shall die unburied and their bones scattered in divers parts of the world.[26]

Of the lamentations made on Good Friday

In all parts of Europe there shall be lamentations by great nations for the death of one man who died in the East.[23]

Of Christians

Many who hold the faith of the son only build temples in the name of the mother.

Of funeral rites, and processions, and lights, and bells, and followers

The greatest honours and ceremonies will be paid to men without their knowledge.[20]

Of churches and the habitations of friars

Many will there be who will give up work and labour and poverty of life and of goods, and will go to live among wealth in splendid buildings, declaring that this is the way to make themselves acceptable to God.

Of friars who spending nothing but words receive great gifts and bestow paradise

Invisible money will procure the triumph of many who will spend it.

Of friars who are confessors

And unhappy women will, of their own free will, reveal to men all their sins and shameful and most secret deeds.[26]

Of sculpture

Alas, whom do I see? The saviour crucified anew![22]

Of crucifixes that are sold

I see Christ sold and crucified afresh, and his saints suffering martyrdom.[27]

Of the worshipping of pictures of saints

Men shall speak with men who hear not; their eyes shall be open and they shall not see; they will speak to them and there shall be no reply; they will ask pardon from one who has ears and does not hear, they will offer light to one who is blind, and to the deaf they will appeal with loud clamour.

Of the sale of paradise

A vast multitude will sell, publicly and unhindered, things of the very highest price, without leave from the Master of those things, which never were theirs nor within their power; and human justice will not prevent it.[28]

Of the religion of monks who live on their saints, who have been dead quite a time

Those who have been dead a thousand years will defray the cost of living of many living men.[29]

Of doctors, who live upon the sick

Men will come to such a state of misery that they will be grateful that others should profit by their sufferings, or by the loss of their true wealth, which is health.[29]

Of the dowries of maidens

And whereas at first maidens could not be protected from the lust and violence of men, either by the watchfulness of parents or by the strength of walls, the time will come when it will be necessary for the fathers and relatives of these maidens to pay a great price to whoever is willing to marry them, even if they are rich, noble, and very beautiful. Certainly it seems that nature desires to exterminate the human race, as a thing useless to the world, and the destroyer of all created things.[26]

Of children wrapped in swaddling bands

O cities of the Sea! In you I see your citizens both females and males, tightly bound, arms and legs, with strong bands by folks who will not understand your language. And you will only be able to assuage your sorrows and lost liberty by means of tearful complaints and sighing and lamentation among yourselves; for those who will bind you will not understand you, nor will you understand them.[20]

The water fallen from the clouds will so change its nature as to remain a long time upon the slopes of the mountains without making any movement. And this will happen in many and diverse lands:
The snow falling in flakes which is water.[24]

Many there will be who will wax great in their destruction:
The ball of snow rolling over the snow.

A great part of the sea will fly towards the sky and for a
long time it will not return:
That is in the clouds.

The great rocks of the mountains will dart forth fire, such
as will burn up the timber of many vast forests and many
beasts both wild and tame:
The flint of the tinder-box, which makes a fire that
consumes the loads of faggots cleared from the forests, and
with this fire the flesh of beasts is cooked.[24]

Of tinder

With stone and iron things will be rendered visible which
were not previously seen.[23]

Of metals

These shall come forth out of dark and gloomy caves;
that which will put the whole human race in great anxiety,
peril, and death. To many that follow it, after many sorrows
it will give delight, but whosoever does not side with it
will die in want and misfortune. It shall lead to the com-
mission of an endless number of crimes; it shall increase the
number of bad men and encourage them to assassinations,
robberies, and enslavement; it shall hold its own followers
in suspicion; it shall deprive free cities of their happy con-
dition; it shall take away the life of many; it shall make
men torment each other with many frauds, deceits, and
treacheries. O monster! How much better were it for men
that thou shouldst return to your cave! By this the vast
forests shall be stripped of their trees, by this an infinite
number of animals shall lose their lives.

Of fire

One shall arise from small beginnings that will rapidly become great; it shall have respect for no created thing; but by its power it shall transform almost everything from its natural condition into another.[23]

The fear of poverty

A malignant and terrifying thing will spread so much fear among men that, in their panic desire to flee from it, they will hasten to increase its boundless powers.[30]

The struggle for property, the greed for money are here shown to be a basic social evil.

Of money and gold

Out of cavernous pits a thing shall come forth which will make all the nations of the world toil and sweat with the greatest torments, anxiety and labour, that they may gain its aid.[30]

Of great guns, which come out of the pit and the mould

There shall come forth from beneath the ground that which with its terrific noise will stun all who are near and with its breath will kill men and destroy cities and castles.[31]

Of swords and spears which of themselves never do any harm to anyone

That which of itself is gentle and void of all offence will become terrible and fierce by reason of evil companionship, and will take the lives of many people with the utmost cruelty; and it would slay many more if it were not that these are protected by bodies which are themselves without life, and have come forth out of pits—that is by cuirasses of iron.[23]

The dead will come from underground and their fierce
movements will send numberless human beings out of the
world:
 Iron, which comes from underground, is dead, but the
weapons are made of it which kill so many men.[24]

Oh, how many great buildings will be ruined by reason of
Fire: The fire of great guns.[24]

The bones of the dead shall be seen by their rapid move-
ment to govern the fortunes of their mover: By dice.
 Feathers shall raise men towards heaven, even as they do
birds: That is by the letters written with their quills.[32]

The dead shall be seen carrying the living in various places:
In carts and ships.[33]

Of dreaming

Men shall walk and not stir, they shall speak with those
who are not present, they shall hear those who do not
speak.[23]

It shall seem to men that they see destructions in the sky,
and flames descending therefrom shall seem to fly away in
terror; they shall hear creatures of every kind speaking
human language; they shall run in a moment to diverse
parts of the world without movement; they shall see the
most radiant splendours amidst darkness.
 O marvel of mankind! What frenzy has thus impelled
you! You will speak with animals of every species and they
with you in human speech. You shall behold yourselves
falling from great heights without suffering any injury;
torrents will accompany you, and will mingle in their rapid
course.[20]

Of plan whereby paper is formed out of rags

That shall be revered and honoured and its precepts shall
be listened to with reverence and love, which was at first

despised and mangled and tortured with many different blows.[23]

Of the cruelty of men

Creatures shall be seen on the earth who will always be fighting one with another, with the greatest losses and frequent deaths on either side. There will be no bounds to their malice; by their strong limbs a great portion of the trees in the vast forests of the world shall be laid low; and when they are filled with food the gratification of their desire shall be to deal out death, affliction, labour, terror, and banishment to every living thing; and from their boundless pride they will desire to rise towards heaven, but the excessive weight of their limbs will hold them down. Nothing shall remain on the earth, or under the earth, or in the waters that shall not be pursued, disturbed, or spoiled, and that which is in one country removed into another. And their bodies shall be made the tomb and the means of transit of all the living bodies which they have slain.

O earth, why dost thou not open and hurl them into the deep fissures of thy vast abysses and caverns, and no longer display in the sight of heaven so cruel and horrible a monster.[23]

Of the desire for wealth

Men out of fear shall pursue the thing they most fear: That is they will be miserable lest they should fall into misery.[32]

IV. JESTS

A jest

A priest going the round of his parish on Saturday before Easter, sprinkling holy water in the houses as was his custom, came to a painter's room and there sprinkled the water upon some of his pictures. The painter, turning round somewhat annoyed, asked him why this sprinkling

had been bestowed on his pictures; then the priest said that
it was the custom and that it was his duty to do so, that he
was doing good, and that whoever did a good deed might
expect a return as good and better; for so God had promised
that every good deed that was done on earth shall be
rewarded a hundredfold from on high. Then the painter,
having waited until the priest had walked out, stepped to
the window above, and threw a large bucket of water on
to his back, saying: Here is the reward a hundredfold from
on high as you said would come from the good you did me
with your holy water with which you have damaged half
my pictures.[34]

The Franciscan friars are wont to keep certain periods of
fasting when they do not eat meat in their monasteries, but
on journeys as they are living on charity they have licence
to eat whatever is set before them. Now a couple of these
friars travelling under these conditions stopped at an inn
in company of a certain merchant, and sat down with him
at the same table, where on account of the poverty of the
inn nothing was served except a small roasted cockerel.
At this the merchant, as he saw that this would be little for
himself, turned to the friars and said: 'If I remember rightly
you do not eat any kind of meat in your monasteries at this
season.' At these words the friars were constrained by their
rule to admit without further cavil that this was the case;
so the merchant had his desire and ate the chicken, and the
friars fared as best they could.

Now after having dined thus, the table-companions
departed all three together, and after travelling some dis-
tance they came to a river of considerable width and depth,
and as they were all three on foot—the friars by reason of
their poverty, and the other from avarice—it was necessary,
according to the custom of company, that one of the friars,
being barefoot, should carry the merchant on his shoulders;
and so the friar, having given him his clogs to hold, took

up the man. But as it so happened the friar, when he found himself in the middle of the river, remembered another of his rules, and stopping short like St. Christopher raised his head towards him who was weighing upon him and said: 'Just tell me, have you any money about you?' 'You know quite well that I have,' answered the other. 'How do you suppose a merchant like me could go about otherwise?' 'Alas,' said the friar, 'our rule forbids us to carry any money on our persons', and forthwith he dropped him into the water. As the merchant perceived that this was done as a jest and in revenge for the injury he had done them, he with a smiling face, and blushing somewhat from shame endured the revenge peaceably.[35]

A man wishing to prove on the authority of Pythagoras that he had been in the world on a former occasion, and another not allowing him to conclude his argument, the first said to the second: 'This is a token that I was formerly here, I remember that you were a miller.' The other feeling stung by these words agreed that it was true for he remembered as a token that the speaker had been the ass which had carried the flour for him.[36]

A man gave up associating with one of his friends because the latter had a habit of talking maliciously against his other friends. This neglected friend, one day reproached him and with many complaints besought him to tell him the reason why he had forgotten so great a friendship as theirs; to which he replied: I do not wish to be seen in your company any more because I like you, and if you talk to others maliciously of me, your friend, you may cause them to form a bad impression of you, as I did when you talked maliciously of them to me. If we have no more to do with each other it will seem as though we had become enemies, and the fact that you talk maliciously of me, as is your habit, will not be blamed so much as if we were constantly in each other's company.[37]

V. SYMBOLISM

Short liberty.[38]

Prudence—Strength.[39]

This shall be placed in the hand of Ingratitude. Wood nourishes the fire that consumes it.[40]

Not to disobey.[41]

A simile for patience

Patience serves us against insults precisely as clothes do against cold. For if you put on more garments as the cold increases, the cold cannot hurt you; in the same way increase your patience under great injuries, and they cannot vex your mind.[42]

A felled tree which is shooting again.
I am still hopeful.
A falcon. Time.[43]

Nothing is so much to be feared as Evil Report.
This evil report is born of Vices.[41]

Pleasure and pain

(With a drawing reproduced in R., Plate LIX)

Pleasure and pain are represented as twins, since there never is one without the other; and as if they were joined together back to back since they are contrary to each other.

If you choose pleasure, know that he has behind him one who will deal you tribulation and repentance.

This is pleasure together with pain and they are represented as twins because one is never apart from the other. They are made with their backs turned to each other because they are contrary to one another; they exist in one and the same body because they have one and the same foundation, for the origin of pleasure is labour with pain, and the origins of pain are vain and wanton pleasures. And

therefore it is represented here with a reed in his right hand, which is useless and without strength, and the wounds made with it are poisoned. In Tuscany reeds are placed to support beds, to signify that here vain dreams come and here a great part of life is consumed, here much useful time is wasted, namely that of the morning, when the mind is composed and rested and the body therefore is fitted to resume new labours. Here also many vain pleasures are taken, both with the mind imagining impossible things, and with the body taking those pleasures which are often the cause of the failing of life.[44]

Truth and falsehood

Truth the sun
Falsehood a mask.

Fire destroys falsehood, that is sophistry, and restores truth, driving out darkness. Fire is to be put for the destroyer of every sophistry, as the discoverer and demonstrator of truth; because it is light, the banisher of darkness, which is the concealer of all essential things.

Truth

Fire destroys all sophistry, that is deceit; and maintains truth alone, that is gold. Truth in the end cannot be hidden. Dissimulation is useless, Dissimulation is frustrated before so great a judge.

Falsehood puts on a mask.

Nothing is hidden under the sun.

Fire is put for truth because it destroys all sophistry and lies; and the mask is for falsehood and lying, the concealer of truth.[45]

Truth was the only daughter of Time.*[36]

* Cf. A. Gellius, *Noctes Atticae*, 12. 11. 2, 'Veritas filia Temporis'.

[With a drawing of two figures, one pursuing the other with bow and arrow]

A body may sooner be without its shadow than virtue without envy.[44]

When Fortune comes, seize her in front with a sure hand, because behind she is bald.

Just as iron rusts from disuse, and stagnant water putrefies, or when cold turns to ice, so our intellect wastes unless it is kept in use.[46]

[With a drawing of butterflies fluttering round a flame]

Blind ignorance misleads us thus and delights with the results of lascivious joys.

Because it does not know the true light.

Because it does not know what the true light is.

Vain splendour takes from us the power of being. . . .

Behold how owing to the glare of the fire we walk where blind ignorance leads us.

O wretched mortal, open your eyes![47]

[With drawings of compass and plough]

He turns not back who is bound to a star.

Obstacles do not bend me.

Every obstacle yields to stern resolve.[48]

[With a drawing of a plough reproduced in R., Plate LXII]

Obstinate rigour.[49]

VI. IMAGINATIVE DESCRIPTION OF NATURE

I. THE WHALE

The discovery of the fossilized remains of a whale gives rise to reflections on the transitoriness of even the strongest creature.

Like a whirling wind scouring through a sandy and hollow valley which with speeding course drives into its vortex everything that opposes its furious course. . . .

Not otherwise does the northern blast whirl round in its tempestuous progress. . . .

Nor does the tempestuous sea roar so loud, when the northern blast dashes it in foaming waves between Scylla and Charybdis; nor Stromboli nor Mount Etna when their pent-up sulphurous flames send and burst open the mountain fulminating stones and earth mingled together in the issuing flames. Nor when Mount Etna's inflamed caverns vomiting the ill-restrained element and thrusting it back to its own region, driving before it whatever obstacle withstands its impetuous rage. . . .

And drawn on by my eager desire, anxious to see a great multitude of varied and strange shapes made by formative nature, having wandered for some distance among over-hanging rocks, I came to the entrance of a great cavern before which for a time I remained stupefied having been unaware of its existence, my back bent and my left hand supported on my knee while with my right I made a shade over my lowered and contracted eyebrows. And repeatedly bending first one way and then another, to see whether I could discern anything inside, from this I was prevented by the deep darkness within. And after remaining there for a time, suddenly there arose within me two emotions, fear and desire—fear of the threatening dark cavern, desire to

see whether there might be any marvellous thing there-
in. . . .[50]

O powerful and once-living instrument of formative nature,
thy great strength not availing thee thou must needs aban-
don thy tranquil life to obey the law which God and time
gave to creative nature. To thee availed not the branching,
sturdy dorsal fins wherewith pursuing thy prey thou wast
wont to plough thy way, tempestuously tearing open the
briny waves with thy breast.

Oh, how many a time the terrified shoals of dolphins and
big tunny fish were seen to flee before thy insensate fury,
and thou lashing with swift, branching fins and forked tail,
didst create in the sea mist and sudden tempest with great
buffeting and submersion of ships: with great wave thou
didst heap up the uncovered shores with terrified and
desperate fishes which escaping from thee, were left high
and dry when the sea abandoned them, and became the
plenteous and abundant spoil of the neighbouring
people.

O time, consumer of things, by turning them into thyself
thou givest to the taken lives new and different habita-
tions.

O time, swift despoiler of created things, how many
kings, how many peoples hast thou undone, how many
changes of states and of circumstances have followed since
the wondrous form of this fish died here in this cavernous
and winding recess. Now destroyed by time thou liest
patiently in this closed place with bones despoiled and bare
serving as a support and prop for the mountain placed over
thee.[51]

2. MOUNT TAURUS

*The following drafts of letters gave rise to the belief that
Leonardo may have journeyed in the Near East and have*

gone to Armenia on a special mission for the Defterdar of Syria, representative of Kait Bey, Sultan of Egypt. Other notes referring to the Near East seemed to confirm this surmise. There is, however, no definite proof and the passages here quoted may have been drafts for an imaginary tale.

The divisions of the book

The preaching and persuasion of faith.

The sudden inundation to its end.

The destruction of the city.

The death of the people and their despair.

The hunt for the preacher and his release and benevolence.

Description of the cause of this fall of the mountain.

The havoc that it made.

The avalanche of snow.

The finding of the prophet.

His prophecy.

The inundation of the lower parts of Western Armenia, the draining of which was effected by the cutting of Mount Taurus. How the new prophet showed that this destruction occurred as he had foretold.

Description of the Taurus Mountain and of the river Euphrates.

Why the mountain shines at its summit half or a third of the night and looks like a comet after sunset to those who dwell in the West, and before day to those who dwell in the East.

Why this comet appears of variable forms, so that at one time it is round, at another long, at another divided into two or three parts, at another united, and sometimes invisible and sometimes becoming visible again.

To the Defterdar of Syria, lieutenant of the sacred Sultan of Babylon.* The recent disaster which has occurred in these our northern parts which I am certain will strike terror not only into you but into the whole world shall be related to you in due order showing first the effect and then the cause.

Finding myself in this part of Armenia in order to discharge with devotion and care the duties of that office to which you sent me; and making a beginning in those parts which seemed to me to be most suitable for our purpose, I entered into the city of Calindra near to our frontiers. This city is situated at the base of that part of the Taurus Mountains which is separated from the Euphrates and looks westward towards the peaks of the great Mount Taurus. These peaks are of such a height that they seem to touch the sky and in the whole world there is no part of the earth higher than this summit, and they are always struck by the rays of the sun in the East four hours before day; and being of the whitest stone it shines resplendently and performs the same office for these Armenians as the beautiful light of the moon would in the midst of the darkness; and by reason of its great height it outstretches the highest level of the clouds for a space of four miles in a straight line. This peak is visible from a great part of the west, illuminated by the sun after its setting until the third part of the night. And it is this which among you in calm weather was formerly supposed to be a comet and which appears to us in the darkness of night to change into various shapes, sometimes dividing into two or three parts, sometimes long and sometimes short; and this is caused by the clouds on the horizon that come between part of this mountain and the sun, and by their cutting these solar rays the light on the mountain is intercepted by various spaces of clouds and therefore its brightness varies in shape.

* The name of Babylon was commonly applied to Cairo in the Middle Ages.

Of the shape of Mount Taurus

I am not to be accused of idleness, O Defterdar, as your chidings seem to intimate; but your unbounded affection which caused these benefits to be conferred upon me has constrained me to seek out with the utmost care and to investigate diligently the cause of so great and stupendous an effect. And this could not be done without time; now, in order to satisfy you fully as to the cause of so great an effect it is necessary that I shall describe the form of the place, and then I will proceed to the effect by which process I believe you will be satisfied. . . .

Do not be aggrieved, O Defterdar, by my delay in replying to your urgent request, for those matters which you require of me are of such a nature as cannot well be expressed without a lapse of time; and especially because in wishing to explain the cause of so great an effect, it is necessary to describe with accuracy the nature of the place; and by means of this you will afterwards easily be able to satisfy yourself as to the above-mentioned request.

I will pass over any description of the shape of Asia Minor, and what seas or lands form the limits of its outline and extent, because I know that you have not remained in ignorance of these matters through your diligence and care in your studies; and I pass on to describe the true form of Mount Taurus which is the cause of this so stupendous and destructive a marvel, for this will serve to advance our purpose. It is this Mount Taurus which, according to many, is said to be the ridge of the Caucasus Mountains; but wishing to be quite clear about this, I wanted to speak to some of the inhabitants of the shores of the Caspian Sea, who inform me that although their mountains bear the same name, these are of greater height, and they confirm that this must be the true Caucasus, for Caucasus in the Scythian tongue means 'supreme height'. And in fact we have no information that either the east or the west has any mountain of so

great a height; and the proof of this is that the inhabitants of the countries which are to the west see the sun's rays illuminating a great part of the summit for as much as a fourth part of the longest night; and similarly with the countries which are to the east.

Of the structure and size of Mount Taurus

The shadow of this ridge of the Taurus is of such a height that when in the middle of June, the sun is at its meridian, it reaches to the borders of Samartia, which are twelve days' journey, and in mid-December it extends as far as the Hyperborean Mountains, which are a month's journey to the north. And the side that faces the way the wind blows is always full of clouds and mists because the wind which is cleft as it strikes against the rock closes up again on the further side of the rock, and in this way carries with it the clouds from all parts, and leaves them where it strikes. And it is always full of thunderbolts through the great number of clouds which accumulate there whence the rock is all fissured and filled with huge debris.

This mountain at its base is inhabited by very rich people and abounds in most beautiful springs and rivers; it is fertile and abounds in everything that is good and especially in those parts which face south. But after an ascent of about three miles we come to where begin the forests of great firs and pines and beeches and other similar trees. Beyond for a space of another three miles there are meadows and vast pastures; and all the rest, as far as the beginning of the peak of the Taurus, is eternal snow which never disappears at any time, and extends to a height of about fourteen miles in all. From this beginning of the Taurus up to the height of a mile the clouds never pass; thus we have fifteen miles, that is, a height of about five miles in a straight line. And as much or about that are the peaks of the Taurus, and here half-way up we begin to find the air grow warm and there is no breath of wind; but nothing can live there long. Nothing is

brought forth here save a few birds of prey which breed in the high fissures of Taurus and descend below the clouds to seek their prey on the wooded hills; here all is bare rock, from above where the clouds are, and the rock is the purest white; and it is not possible to go to the lofty summit on account of its rough and perilous ascent.[52]

Having many times rejoiced with you in my letters over your prosperous fortunes, I know now that you as a friend will share my sorrow at the miserable state in which I find myself; for the fact is that in the last few days I have been in so many anxieties, fears, dangers, and losses together with the wretched peasants here that we have come to envy the dead; and certainly I do not believe that since first the elements by their separation made order out of chaos, they should ever have reunited in their force and fury to do so much damage to mankind, as has now been seen and experienced by us here; so that I cannot imagine what could further increase so great a misfortune as we have experienced in a space of ten hours. First we were assailed and buffeted by the violence and fury of the winds; and then followed the avalanches from the great mountains of snow which filled up all these valleys and destroyed a great part of our city. And, not content with this, the tempest with a sudden deluge of water has submerged all the lower part of this city; added to this there came a sudden rain, or rather a ruinous storm full of water, sand, mud, and stones all mingled together with roots, stems, and branches of various trees; and every kind of thing came hurtling through the air and descended upon us; finally a great fire—not brought by the wind but carried, it would seem, by thirty thousand devils—completely burnt up and destroyed the country— and has not yet ceased. And those few of us who remain are left in such dismay and terror that as if stunned we hardly have courage to speak one with another. Having left all our business, we stay here together in the ruins of some churches,

men and women, small and great, all mingled together like herds of goats. The neighbours out of pity have helped us with provisions, and they had previously been our enemies. And but for certain people who helped us with provisions we should all have died of hunger. Now you see the state we are in. And all these evils are as nothing compared with those which threaten us shortly. I know that you as a friend will grieve for my misfortunes, as I, in former letters have shown my joy at your prosperity.[53]

3. THE GIANT

Leonardo ridicules man's feeling of self-importance by contrasting his puny efforts with the forces of nature which are here personified by a giant. Perhaps Leonardo had the giant Antaeus in his mind of whom Lucan (Pharsalia, iv. 617) relates that he renewed his strength whenever he fell by coming in contact with mother earth. Benedetto Dei, to whom this account is addressed, is the author of the diary of a journey made through France, the Netherlands, and Switzerland in 1476 in the interests of the Florentine merchants Portinari.

Dear Benedetto Dei, To give you news of things here from the East you should know that in the month of June there appeared a giant who comes from the Libyan desert. This giant was born on Mount Atlas; and was black, and he fought against Artaxerxes with the Egyptians and Arabs, Medes and Persians; he lived in the sea on whales, grampuses, and ships.

The black face at first sight is very horrible and terrifying to look at, and especially the swollen and red eyes set beneath the awful, dark eyebrows which might cause the sky to be overcast and the earth to tremble. And, believe me, there is no man so brave but that when the fiery eyes were turned

upon him he would not willingly have put on wings in order to flee, for infernal Lucifer's face would seem angelic when compared with this. The nose was turned up with wide nostrils from which issued many large bristles; beneath these was the arched mouth with thick lips, and with whiskers at the ends like a cat's, and the teeth were yellow. He towered above the heads of men on horseback from the top of his feet upward. When the proud giant fell because of the gory and miry ground it seemed as though a mountain had fallen; whereat the country shook as with an earthquake, with terror to Pluto in hell; and Mars fearing for his life took refuge under the bed of Jove.

And from the violence of the shock the giant lay somewhat stunned on the ground; then suddenly the people, believing that he had been killed by a thunderbolt began to turn his hair and, like ants that scurry hither and thither over an oak struck down by the axe of a strong peasant, rushed over his huge limbs and pierced them with many wounds.

Then the giant being roused and aware that he was covered by the multitude suddenly felt the smarting from their stabs and uttered a roar which sounded like a terrific thunderclap; and placing his hands on the ground he lifted his terrifying face; and raising one hand to his head he found it covered with men sticking to the hair like the minute creatures which are sometimes found harboured there. Then shaking his head he sent the men flying through the air after the manner of hail when driven by the fury of the winds; and many of these men who had been treading on him were killed. Then he stood erect and stamped with his feet. And they clung to the hairs and strove to hide among it behaving like sailors in a storm who mount the rigging in order to lower the sails and lessen the force of the wind.

And as his cramped position had been irksome, and in order to rid himself of the importunity of the throng, his

rage turned to fury, and he began with his feet to enter among the crowd, giving vent to the frenzy which possessed his legs, and with kicks he threw men through the air, so that they fell on the others, as though there had been a storm of hail; and many were those who in dying brought death; and this cruelty continued until the dust stirred up by his big feet rising into the air, compelled his infernal fury to draw back, while we continued our flight.

Alas, how many attacks were made upon this raging fiend to whom every onslaught was as nothing! O miserable people, for you there avail not the impregnable fortresses, nor the high walls of the city, nor your great numbers, nor your houses or palaces! There remained not any place unless it were the small holes and subterranean caves like those of crabs or crickets and such animals. There you might find safety and a means of escape.

Oh, how many unhappy mothers and fathers were deprived of their sons! how many wretched women were deprived of their companions. In truth, my dear Benedetto, I do not believe that ever since the world was created there has been seen a lamentation, and a wailing of people, caused by so great terror. In truth, in this case the human species must envy every other creature; for though the eagle has strength to defeat the other birds, they at least remain unconquered through the rapidity of their flight, and so swallows through their speed escape from the prey of the falcon; dolphins by their swift flight escape from the prey of the whales and grampuses; but for us wretched beings there avails not any flight, since this monster, advancing with slow step, far exceeds the speed of the swiftest courser.

I do not know what to say or do and everywhere I seem to find myself swimming with bent head through the mighty throat, and remaining buried within a huge belly, confused with death.[54]

The following lines are a variation of a verse in Antonio Pucci's Historia della Reina d'Oriente.

He was blacker than a hornet, and his eyes were as red as a burning fire. He rode on a big stallion six spans across and more than twenty long, with six giants tied to his saddle bow and one in his hand who gnawed him with his tooth; and behind him came boars with tusks sticking out of their snouts perhaps ten spans.[55]

VI

REFLECTIONS ON LIFE

*These reflections inspired by Leonardo's experience of life
and of the ways of men were written down at random among
other notes.*

I. LIFE PASSES

What is fair in men passes
and does not last.[1]

One pushes down the other. By these square blocks are
meant the life and the states of men.[2]

We are deceived by promises and deluded by time, and
death derides our cares; life's anxieties are nought.[3]

That man is extremely foolish who always is in want for
fear of wanting; and his life flies away while he is still hop-
ing to enjoy the good things which he has acquired with
great labour.[4]

He who possesses most is most afraid to lose.[5]

O Time, consumer of all things! O envious age, thou de-
stroyest all things and devourest all things with the hard
teeth of the years little by little, in slow death. Helen, when

she looked in her mirror and saw the withered wrinkles which old age had made in her face wept and wondered why she had twice been carried away. O Time, consumer of all things! O envious age, whereby all things are consumed!*[6]

... The miserable life should not pass without leaving some memory of ourselves in the minds of mortals.

... Lead: Leather—a weight of lead pressing forwards and backwards a little bag of leather filled with air, the descent will show you the hour. We do not lack ways and means to divide and measure these miserable days of ours which it should be our pleasure not to spend and pass away in vain and without praise, and without leaving record of themselves in the minds of men; so that this our miserable course should not be sped in vain.[7]

O thou that sleepest, what is sleep? Sleep resembles death. Oh, why not let thy work be such that after death thou mayst retain a resemblance to perfect life, rather than during life make thyself resemble the hapless dead by sleeping.[8]

Shun those studies in which the work that results dies with the worker.[9]

I obey thee, Lord, first for the love which I ought reasonably to bear thee; secondly, because thou canst shorten or prolong the lives of men.[10]

In rivers, the water that you touch is the last of what has passed and the first of that which comes: so with time present. Life if well spent is long.[11]

* Cf. Ovid's *Metamorphoses*, xv. 228-33:
'Helen also weeps when she sees her aged wrinkles in the looking glass, and tearfully asks herself why she should twice have been a lover's prey.
O Time, thou great devourer, and thou envious Age,
Together you destroy all things; and slowly gnawing with your teeth you finally consume all things in lingering death.' (tr. Loeb.)

The age as it flies glides secretly and deceives one and another; nothing is more fleeting than the years, but he who sows virtue reaps honour.[12]

In youth acquire that which may restore the damage of old age; and if you are mindful that old age has wisdom for its food, you will so exert yourself in youth, that your old age will not lack sustenance.[13]

While I thought that I was learning how to live, I have been learning how to die.[14]

To the ambitious, whom neither the boon of life, nor the beauty of the world suffice to content, it comes as penance that life with them is squandered, and that they possess neither the benefits nor the beauty of the world.[15]

As a day well spent brings happy sleep, so a life well used brings happy death.[16]

Every evil leaves a sorrow in the memory, except the supreme evil, death, which destroys this memory together with life.[17]

Wrongfully do men lament the flight of time, accusing it of being too swift, and not perceiving that its period is sufficient. But good memory wherewith nature has endowed us causes everything long past to seem present.[18]

Our judgement does not reckon in their exact and proper order things which have come to pass at different periods of time; for many things which happened many years ago will seem nearly related to the present, and many things that are recent will seem ancient, extending back to the far-off period of our youth. And so it is with the eye, with regard to distant things, which when illumined by the sun seem near to the eye, while many things which are near seem far off.[19]

Behold the hope and the desire of going back to one's country and of returning to the primal state of chaos is like that of the moth to the light, and of the man who with perpetual longing looks forward with joy to each new spring and to each new summer, and to the new months and the new years, deeming that the things he longs for are too slow in coming; and he does not perceive that he is longing for his own destruction. But this longing is in its quintessence, the spirit of the elements, which finding itself imprisoned as the soul within the human body is ever longing to return to its sender; and I would have you know that this same longing is that quintessence inherent in nature, and that man is a type of the world.[20]

Among the great things which are found among us the existence of Nothing is the greatest. This dwells in time, and stretches its limbs into the past and future, and with these takes to itself all works that are past and those that are to come, both of nature and of the animals, and possesses nothing of the indivisible present. It does not, however, extend to the essence of anything.[21]

Nothingness has no centre, and its boundaries are nothingness.

My opponent says that nothingness and a vacuum are one and the same thing, having indeed two separate names by which they are called, but not existing separately in nature. The reply is that whenever there exists a vacuum there will also be the space which surrounds it, but nothingness exists apart from occupation of space; it follows that nothingness and a vacuum are not the same, for the one is divisible to infinity, and nothingness cannot be divided because nothing can be less than it is; and if you were to take part from it this part would be equal to the whole, and the whole to the part.[22]

II. LIFE OF THE BODY

How the body of the animal continually dies and is renewed

The body of anything whatsoever that takes nourishment continually dies and is continually renewed; because nourishment can only enter in those places where the preceding nourishment is exhausted, and if it is exhausted it no longer has life. And unless you supply nourishment equivalent to that which has departed, life will fail in its vigour, and if you deprive it of its nourishment the life is entirely destroyed. But if you restore as much as is destroyed day by day, then as much of the life is renewed as is consumed; just as the light of the candle is formed by the nourishment given to it by the liquid of this candle which light continually renews by swift succour from beneath as much as it consumes in dying above; and in dying changes from a brilliant light into murky smoke; and this death is continuous, as the smoke is continuous; and the smoke continues as long as the nourishment continues; and in the same instant the whole light is dead and is entirely regenerated by the movement of that which nourishes it.[23]

Why nature did not ordain that one animal should not live by the death of another.

Nature being inconstant and taking pleasure in creating and making continually new lives and forms, because she knows that they augment her terrestrial substance, is more ready and swift in creating than time is in destroying; and therefore she has ordained that many animals shall serve as food one for the other; and as this does not suffice for her desire she frequently sends forth certain poisonous and pestilential vapours and continual plagues upon the vast accumulations and herds of animals; and most of all upon men, who increase rapidly because other animals do not feed upon them; and if the causes are removed the effects would cease.

This earth therefore seeks to lose its life while desiring continual reproduction for the reason brought forward and demonstrated by you; effects often resemble their causes. The animals serve as a type of the life of the world.[24]

Here nature appears rather to have been a cruel stepmother to many animals instead of a mother; and to some not a stepmother but a most tender mother.[25]

Our life is made by the death of others. In dead matter insensible life remains, which reunited to the stomachs of living beings, resumes life, both sensual and intellectual.[26]

Man and animals are really the passage and conduit of food, the sepulchre of animals and resting-place of the dead, making life out of the death of the other (taking pleasure in the misery of others), making themselves the covering for corruption.[8]

If nature has ordained that animals which can move should experience pain in order to conserve those parts which through their motion might diminish or waste; plants are not able to move and therefore do not strike against any objects placed in their way; the feeling of pain is not required in plants and therefore they do not feel pain when they are broken, as animals do.[27]

Lust is the cause of generation,
 Appetite is the support of life,
 Fear or timidity is the prolongation of life, and fraud the preservation of its instruments.[28]

He who fears dangers does not perish by them.[29]

Just as courage imperils life, fear protects it.[30]

Fear arises sooner than anything else.[31]

Every man wishes to make money to give to the doctors, destroyers of life; they therefore ought to be rich.[32]

Learn to preserve your health; and in this you will the better
succeed as you shun physicians because their drugs are a
kind of alchemy about which there are no fewer books than
there are medicines.[33]

Medicine is the restoration of discordant elements; sickness
is the discord of the elements infused into the living body.[34]

Make them give you the diagnosis and treatment for the
case from the saint and from the other and you will see that
men are elected to be doctors for diseases they do not
know.[35]

> To keep in health this rule is wise:*
> Eat only when you want and sup light.
> Chew well, and let what you take
> be well cooked and simple.
> He who takes medicine is ill advised.
> Beware of anger and avoid grievous moods.
> Keep standing when you rise from table.
> Do not sleep at midday.
> Let your wine be mixed (with water), take
> little at a time, not between meals
> and not on an empty stomach.
> Go regularly to stool.
> If you take exercise, let it be light.
> Do not be with the belly upwards, or
> the head lowered;
> Be covered well at night.
> Rest your head and keep your mind cheerful.
> Shun wantonness, and pay attention to diet.[36]

It seems to me that coarse men of bad habits and little power
of reason do not deserve so fine an instrument or so great a
variety of mechanism as those endowed with ideas and
great reasoning power, but merely a sack where food is

* The original is written in verse.

received and whence it passes. For in truth they cannot be reckoned otherwise than as a passage for food, because it does not seem to me that they have anything in common with the human race except voice and shape. And all else is far below the level of beasts.[37]

III. LIFE OF THE SPIRIT

And thou, man, who in this work of mine dost look upon the wonderful works of nature, if thou judgest it to be a criminal thing to destroy it, reflect how much more criminal it is to take the life of man; and if this external form appears to thee marvellously constructed, remember that it is as nothing compared with the soul that dwells in that structure; and in truth, whatever this may be, it is a thing divine. Leave it then to dwell in its work at its good pleasure, and let not thy rage and malice destroy such a life—for in truth he who values it not does not deserve it.

For we part from the body with extreme reluctance, and I indeed believe that its grief and lamentation are not without cause.[33]

The potencies are four: memory and intellect, appetite and concupiscence. The two first are of the reason, the others of the senses.[38]

The man who does not restrain wantonness, allies himself with beasts. It is easier to contend with evil at the beginning than at the end. You can have no greater and no smaller dominion than that over yourself.[39]

Ask advice of him who governs himself well.[40]

If you governed your body by the rules of virtue you would have no desire in this world.[41]

Good culture is born of a good disposition; and since the cause is more to be praised than the effect, you will rather

praise a good disposition without culture, than good culture without the disposition.[18]

Where there is most feeling there is the greatest martyr-dom.[42]

The highest happiness becomes the cause of unhappiness, and the fullness of wisdom the cause of folly.[43]

The part always has a tendency to unite with its whole in order to escape from its imperfection.

The soul's desire is to remain with its body, because without the organic instruments of that body it can neither act nor feel.[44]

The soul can never be corrupted with the corruption of the body, but acts in the body like the wind which causes the sound of the organ, where if a pipe is spoiled, the wind would cease to produce a good result.[45]

Whoever would see how the soul dwells within its body let him observe how this body uses its daily habitation, for if this is without order and confused the body will be kept in disorder and confusion by its soul.[18]

Cornelius Celsus*

The highest good is wisdom, the chief evil is suffering of the body. Seeing that we are made up of two things, that is soul and body, of which the first is the better and the body is the inferior, wisdom belongs to the better part; and the chief evil belongs to the worse part and is the worst. The best thing in the soul is wisdom, and even so the worst thing in the body is pain. Therefore just as bodily pain is the chief evil, so wisdom is the chief good of the soul, that is, of the wise man; and nothing else can be compared to it.[46]†

Good men by nature wish to know.‡

I know that many will call this useless work . . . men who

* Ancient Roman physician.
† Quoted from Valturius, see p. 335.
‡ Cf. Dante, *Convivio*, i. 1, 'All men by nature wish to know.'

desire nothing but material riches and are absolutely devoid
of that of wisdom, which is the food and only true riches
of the mind. For so much more worthy as the soul is than
the body, so much more noble are the possessions of the
soul than those of the body. And often, when I see one of
these men take this work in his hand, I wonder that he does
not put it to his nose, like a monkey, or ask me if it is
something good to eat.[47]

If on delight your mind should feed.[48]

Pray hold me not in scorn! I am not poor!
Poor rather is the man who desires many things.
Where shall I take my place? Where in a little time from
hence you shall know.
 Do you answer for yourself! From henceforth in a little
time. . . .[49]

 Thou, O God, dost sell unto us all good things at the price
of labour.*[50]

You do ill if you praise and worse still if you reprove, in
a matter you do not understand.[22]

It is bad if you praise, and worse if you blame matters that
you do not understand.[8]

To speak well of a base man is much the same as to speak
ill of a good man.[51]

Envy wounds with false accusations, that is by detraction.[52]
Reprove your friend in secret and praise him openly.[29]

Man has much power of discourse which for the most part
is vain and false; animals have but little, but it is useful and
true, and a small truth is better than a great lie.[53]

 * Above this is the word *oratio* which may either be translated as
'a prayer' or it may refer to Horace. Horace says: 'Life gave nothing
to mortals without hard work' (*Sat.* i. 9. 56–60).

The greatest deception men suffer is from their own opinions.[54]

He who does not punish evil commends it to be done. Justice requires power, insight, and will; and it resembles the queen-bee.[40]

And many have made a trade of delusions and false miracles, deceiving the stupid multitude.[55]

Pharisees—that is to say holy friars.[11]

The rest of the definition of the soul I leave to the imagination of the friars, those fathers of the people who by inspiration know all secrets. I leave alone the sacred books, for they are supreme truth.[56]

The lie is so vile, that even if it were speaking well of godly things it would take off something of God's grace; and truth is so excellent that if it praises but small things, they become noble.

Beyond a doubt truth bears the same relation to falsehood as light to darkness. And truth is so excellent in itself, that, even if it dwells on humble and lowly matter, it rises infinitely above the uncertainties and lies about high and lofty matters. Because in our minds, even if lying should be the fifth element, the truth about things will remain nevertheless the chief nutriment of superior intellects, though not of wandering wits.

But you who live on dreams are better pleased by the sophistical reasons and frauds of wits in great and uncertain things than by those reasons which are certain and natural and not so exalted.[57]

Conversation between the spirit and the intellect

A spirit finding again the brain whence it had departed, uttered with a loud voice these words:

O blessed and happy spirit, whence hast thou departed?

Well have I known man and he is much against my liking! He is a receptacle of villainy; a perfect heap of the utmost ingratitude combined with every vice. But why do I fatigue myself using vain words? In him every form of sin is to be found. And if there should be found among men any that possess any good, they will not be treated differently from myself by other men; in fact I have come to the conclusion that it is bad if they are hostile, and worse if they are friendly.[58]

IV. ON GOVERNMENT

When besieged by ambitious tyrants I find a means of offence and defence in order to preserve the chief gift of nature, which is liberty; and first I would speak of the position of the walls, and then of how the various peoples can maintain their good and just lords.[59]

Leonardo's advice to the Duke of Milan.

All communities obey and are led by their magnates, and those magnates ally themselves with and are constrained by their lords in two ways, either by blood relationship or by a tie of property; blood relationship when their sons, like hostages, are a surety and a pledge against any suspicion of their faith; the tie of property when you let each of them build one or two houses within your city, from which he may draw some revenue; and he may also draw revenue from ten cities of five thousand houses with thirty thousand habitations; and you will disperse so great a concourse of people who, herding together like goats one upon the back of another filling every part with their stench, sow the seeds of pestilence and death. And the city will be of a beauty equal to its name, and useful to you for its revenues and the perpetual fame of its growth.[60]

VII

LEONARDO'S WAY THROUGH LIFE

Light is here thrown on Leonardo's activities during the various periods of his life by an arrangement in chronological sequence of such notes on his personal affairs as can be dated. Included are reflections, drafts of letters, references to friends, books, and journeys. In order to complete the picture and fill out a background to these disconnected notes, the dates of historical events and of occurrences that affected him personally, though not mentioned by him, have been added, and for these recourse has been taken to contemporary documents and to Vasari.

I. TUSCANY, 1452–81

15 April 1452. *Birth of Leonardo at Vinci, on the western slope of Mount Albano, near Empoli. The birth was recorded by his grandfather Antonio:* 'On Saturday at three o'clock at night on April 15 a grandson of mine was born, son of my son Piero. He was named Lionardo. The priest Piero of Bartolomeo da Vinci baptized him. . . .' *Here follow the names of ten witnesses of his baptism. He was born out of wedlock by a girl of humble station, named Caterina, and his parents were parted after his birth. His mother was married to Accattabriga di Piero del Vacca of Vinci in 1457. His father, Ser Piero, married Albiera di Giovanni Amadori in the same year that Leonardo was born. He sprang from a Florentine family, who owned a house at Vinci, and like his forefathers became a successful notary in Florence. He was married four*

*times and had nine sons and two daughters, all born after
Leonardo had reached his twenty-fourth year. He had
from the first acknowledged Leonardo as his son and
brought him up in his house.*

*In the following note Leonardo recalled a dream of his
infancy.*

Writing about the kite seems to be my destiny since among
the first recollections of my infancy it seemed to me that
as I was in my cradle a kite came to me and opened my
mouth with its tail and struck me several times with its
tail inside my lips.*

*The boy grew up among the vineyards of the Tuscan
country-side, making intimate observations of nature.
Vasari relates that he painted a dragon on the shield of one
of his father's peasants and for this purpose carried into a
room of his own lizards great and small, crickets, serpents,
butterflies, grasshoppers, bats, and other animals, from
which, variously put together, he composed a great and
ugly creature. He grew up into a youth of shining promise,
gifted in many directions. Besides developing his own style
of drawing, he modelled heads of smiling women and
children in clay which showed the hand of a master. He
studied music and was resolved to acquire the art of playing
the lyra. Being by nature of an exalted imagination and*

* This note is the main theme of Freud's psychosexual study of
Leonardo. The bird of Leonardo's dream was a kite (*nibbio* in
Italian) and the same bird figures in his studies of flight. Its deeply
forked tail serves as a powerful rudder enabling it while soaring on
its wide wings to steer its course with scarcely a movement that is
apparent to the spectator below. This accounts for Leonardo's in-
terest in the bird. Freud mistranslates *nibbio* into 'vulture' and bases
his theory on the fact that in Egyptian hieroglyphs the words
'vulture' and 'mother' were both represented by the figure of a vul-
ture for phonetic reasons, since both were pronounced *mut.*

*full of most graceful vivacity, he sang to that instrument
most divinely, improvising at once the verse and the music.
He took lessons in arithmetic and displayed such talent
that his master was confounded by his doubts and questions.
In 1469 his father became notary of the Signoria in
Florence and rented a house on the Piazza S. Firenze, not
far from the Palazzo Vecchio. On arrival in Florence
Leonardo served his apprenticeship in art in the studio of
Andrea Verrocchio, who was working at that time on the
bronze statue of young David, with a head that seems
Leonardesque. The young pupil was allowed to help with
the picture representing the Baptism of Christ for the
Church of San Salvi by painting one of the angels. 'This',
says Vasari, 'was the reason why Andrea would never
again touch colours, being indignant that a boy should
know more of the art than he did.'*

*In 1471 Verrocchio's workshop participated with others
in the decorations for the festivities staged to welcome
Galeazzo Maria Sforza, Duke of Milan.*

*In 1472 Leonardo's name was inscribed as a member of
the Florentine guild, 'Leonardo di Ser Piero da Vinci,
dipintore'.*

*The first dated note in Leonardo's hand is written on a
drawing in pen and ink of a river valley which is now in
the Uffizi.*

August 2, 1473, the day of Santa Maria della Neve.

*About 1474 Verrocchio received a commission to paint
an altar-piece for the chapel of Donato de' Medici in the
cathedral of Pistoia. Leonardo may have assisted in the
execution of this work, and one of its predella pictures
representing the Annunciation, now in the Louvre, has
been attributed to him. Among his fellow students in*

Verrocchio's workshop were Domenico Ghirlandaio, Botticini, Perugino, Lorenzo di Credi, who was seven years younger.

In April 1476 he was living in Verrocchio's house, as indicated by a judicial warrant of that date, which accused him and three other young Florentines of relations with an ill-famed youth. The accusations were made anonymously and dismissed with the condition that they be brought up again on further evidence. In his distress he had addressed a petition to Bernardo di Simone Cortigiani, an influential head of the Florentine guilds.

You know as I have told you before, that I am without any of my friends.²

On the reverse of this sheet is the query:

If there is no love, what then?

In the following note written years later he recalls an unpleasant incident in connexion with a representation of the Infant Christ.

When I made a Christ Child you put me in prison. Now if I represent Him grown up you will treat me worse.³

The following statement appeared in the first edition of Vasari's Life of Leonardo, *and was suppressed in the second:* 'Leonardo was of so heretical a cast of mind, that he conformed to no religion whatever accounting it perchance much better to be a philosopher than a Christian.'

After 1477 Leonardo probably worked as an independent artist under the patronage of Lorenzo de' Medici. According to Anonimo Gaddiano he lived as a youth with the

Magnifico, who in order to employ him set him to work in the gardens of the Piazza San Marco, where he was establishing an academy. In the following note Leonardo mentions the garden and a work on which he may have been engaged. On the same sheet figure calculations about weights and a pair of scales.

The Labours of Hercules for Pier F. Ginori.
The garden of the Medici.[4]

On 10 January 1478 he was commissioned to paint an altar-piece for the chapel of St. Bernard in the palace of the Signoria. This work was never finished; the commission was afterwards transferred to Filippino Lippi.

On 16 April 1478, Giuliano de' Medici was murdered in the Cathedral of Florence during the celebration of High Mass.

The following notes are written on a sheet with drawings of heads now in the Uffizi. The name of the month is obliterated.

. . . ber, *1478* I began the two Madonnas. . . .
Fioravante di Domenico at Florence is my most beloved friend, as though he were my brother.

On 29 December 1479, or on one of the following days, Leonardo stood beneath a window of the Bargello making a drawing of Bernardo Bandini, who had been hanged for the murder of Giuliano de' Medici. He wrote the name of the delinquent and a description of the costume beside the drawing, which is now in the Bonnat Collection at Bayonne.

A tan-coloured small cap.
A doublet of black serge.

A black jerkin, lined, and the collar covered with black and red stippled velvet
 A blue coat lined with fur of foxes' breasts.
 Black hose.
 Bernardo di Bandino Baroncelli.

The following note quotes Florentine money and was therefore written during this period.

The money I have had from Ser Matteo:
 First 20 grossoni, then on three occasions 3S. and then 6 grossoni, then 3, and then 3,3.
 To make a fine green take green and mix it with bitumen and you will make the shadows darker. Then, for lighter (shades) green with yellow ochre, and for still lighter, green with yellow, and for the lights pure yellow; then mix green and turmeric together and glaze everything with it.
 To make a fine red take cinnabar or red chalk or burnt ochre for the dark shadows and for the lighter ones red chalk and vermilion, and for the lights pure vermilion, and then glaze with fine lake.
 To make good oil for painting: One part of oil, one of the first turpentine and one of the second.[5]

The following list throws light on Leonardo's intercourse with distinguished fellow citizens. On the same sheet are reflections on the flight of time (see p. 274), and the drawing of an instrument resembling a sandglass, where water was to take the place of sand.

Quadrant of Carlo Marmocchi.*
 Messer Francesco Araldo.
 On Arithmetic, Benedetto.†
 Maestro Paolo.‡

* Marmocchi, geographer and astronomer.
† Benedetto de l'Abbaco, mathematiciar.
‡ Maestro Paolo Toscanelli, scientist.

Domenicho di Michelino.*
Calvo degli Alberti.
Messer Giovanni Argiropulo.†⁶

In 1481 the Monastery of San Donato at Scopeto near Florence commissioned Leonardo to paint an Adoration of the Magi. The preparation in monochrome for this picture is preserved at the Uffizi, and many preparatory drawings have survived.

On 28 September 1481 *three monks delivered a barrel of wine at his house sent by the monastery. This is the last known date concerning his first stay in Florence.*

A list of works in Leonardo's possession on leaving Florence. On the same sheet are a number of hasty sketches of heads and helmets.

A head, full face, of a young man with fine flowing hair.
Many flowers from nature.
A head, full face, with curly hair.
Various Jeromes.‡
A head of the Duke.§
Many designs for knots.
4 studies for the panel of Sant' Angelo.
A small composition of Girolamo da Fegline.
A head of Christ done with the pen.
Eight Saint Sebastians.
Many compositions of angels.
A chalcedony.
A head in profile with fine hair.
Some bodies in perspective.
Some machines for ships.

* Domenicho di Michelino, painter, pupil of Fra Angelico.
† Argiropulo, famous Greek Aristotelian.
‡ There exists an unfinished monochrome of St. Jerome in the Vatican.
§ Probably Duke Francesco Sforza whose monument Leonardo was planning to carry out.

Some machines for waterworks.
A portrait of Atalante* raising his head.
The head of Geronimo da Fegline.
The head of Gian Francesco Boso.
Many throats of old women.
Many heads of old men.
Many complete nude figures.
Several arms, legs, feet, and poses.
A madonna, finished.
Another almost, which is in profile.†
The head of the Madonna ascending into Heaven.
A head of an old man with very long neck.
A head of a gipsy.
A head with a hat on.
A representation of the Passion made in relief.
A head of a girl with tresses gathered in a knot.
A head with the hair dressed.[7]

II. FIRST PERIOD IN MILAN, 1482–99

October 1481 *probable date of Leonardo's arrival in Milan. At that time Gian Galeazzo Sforza, Duke of Milan, was thirteen years old, and his uncle Ludovico il Moro, Duke of Bari, was virtual ruler. According to the Anonimo Magliabecchiano, Leonardo was thirty when Lorenzo il Magnifico sent him to the Duke of Milan, accompanied by Atalante Migliorotti, to present him with a lyra, as he was unsurpassed in playing that instrument. His companion, then a youth of sixteen, developed into a successful actor, musician, and builder of musical instruments. Also according to Vasari it was Leonardo's accomplishment in music that was the cause of his summons to Milan. He was greeted with great applause in an assembly*

* Atalante Migliorotti who accompanied Leonardo to Milan.
† It has been suggested that this may refer to the Madonna Litta Hermitage, Leningrad. A study for the head is in the Louvre.

of musicians, where he played on a lyra which he had made himself in the shape of a horse's skull and which produced a sound of great volume and clearness.

A description of Leonardo's appearance is given by the Anonimo. He was a beautiful person, well-proportioned, agreeable and lovely to look at. He wore a short rose-coloured tunic reaching down to his knees, at a time when long clothes were being worn. A fine beard, well arranged in ringlets, descended to the middle of his chest.

Soon after his arrival in Milan Leonardo painted the portrait of Cecilia Gallerani, who became the mistress of Ludovico il Moro in 1481. This portrait has been identified with the Lady with an Ermine in the collection of Prince Czartoryski at Cracow. The following note was addressed by the artist to the sitter:

Cecilia, dearest goddess [*amatissima diva*], having read your most gracious. . . .[8]

Compare Cecilia Gallerani's letter on p. 334.

On 25 April 1483 *Leonardo in partnership with Ambrogio de Predis and his half-brother Evangelista negotiated for a commission, which the confraternity of the Immaculate Conception had to offer, concerning an elaborate carved frame in their chapel adjoining San Francesco. The frame had to be gilt, the centrepiece was to be painted by 'the Florentine' and the side panels by Ambrogio. 'The Virgin of the Rocks', now in the National Gallery, London, was Leonardo's contribution. The work on the frame was valued at 700 Lire, Leonardo's work at 100. Somewhat later the artists claimed more pay. The litigation continued for years. The picture was delivered and then reclaimed. See pp. 359 and 368.*

The following letter addressed to Ludovico il Moro

enumerates the services Leonardo was ready to render.
There had been a project before Ludovico came to power to
erect an equestrian monument in bronze in commemoration
of his father, the condottiere Francesco Sforza. Leonardo
at the end of this letter proposed that this task should be
entrusted to him. Had not another citizen of Florence,
Donatello, erected the equestrian statue at Padua of the
Venetian condottiere Gattamelata.

Most illustrious Lord. Having now sufficiently seen and
considered the proofs of all those who count themselves
masters and inventors of instruments of war, and finding
that the invention and working of the said instruments do
not differ in any respect from those in common use, I shall
endeavour without prejudice to anyone else to explain
myself to your Excellency, showing your Lordship my
secrets, and then offering at your pleasure to work with
effect at convenient times on all those things which are in
part briefly recorded below.

1. I have plans of bridges, very light and strong and
suitable for carrying very easily, and with them you may
pursue, and at times flee from, the enemy; and others secure
and indestructible by fire and battle, easy and convenient
to lift and to place in position; and plans for burning and
destroying those of the enemy.

2. When a place is besieged, I know how to remove
the water from the trenches, and how to construct an
infinite number of bridges, covered ways and ladders and
other instruments having to do with such expeditions.

3. Also if a place cannot be reduced by the method of
bombardment either owing to the height of its banks or to
its strength of position, I have plans for destroying every
fortress or other stronghold even it were founded on rock.

4. I have also plans of mortars most convenient and easy

to carry with which to hurl small stones in the manner almost of a storm; and with the smoke of this cause great terror to the enemy and great loss and confusion.

And if it should happen that the fight was at sea I have plans for many engines most efficient for both attack and defence, and vessels which will resist the fire of the largest cannon, and powder and smoke.

5. Also I have means of arriving at a fixed spot by caves and secret and winding passages, made without any noise even though it may be necessary to pass underneath trenches or a river.

6. Also I will make covered cars, safe and unassailable, which will enter among the enemy with their artillery, and there is no company of men at arms so great that they will not break it. And behind these the infantry will be able to follow quite unharmed and without any hindrance.

7. Also, if need shall arise, I can make cannon, mortars, and light ordnance of very useful and beautiful shapes, different from those in common use.

8. Where the operation of bombardment fails, I shall contrive catapults, mangonels, 'trabocchi', and other engines of wonderful efficacy and in general use. In short, to meet the variety of circumstances, I shall contrive various and endless means of attack and defence.

10. In time of peace I believe I can give perfect satisfaction, equal to that of any other, in architecture and the construction of buildings both private and public, and in conducting water from one place to another.

Also I can carry out sculpture in marble, bronze or clay, and also I can do in painting whatever can be done, as well as any other, be he who may.

Moreover, the bronze horse may be taken in hand, which shall endue with immortal glory and eternal honour the happy memory of the Prince your father and of the illustrious house of Sforza.

And if any of the aforesaid things should seem impossible

or impracticable to anyone I offer myself as most ready to make the trial of them in your park, or in whatever place may please your Excellency, to whom I commend myself with all possible humility.[9]

In this long list artistic attainments came second. The stress is on military and naval engineering. Had Leonardo acquired such knowledge in Florence or after his arrival at Milan? At a time when Milan as an ally of Naples, Ferrara and the Pope was facing war with Venice, his services as engineer must have been very acceptable. In 1484 a council of war was held at Milan; in 1487 Milan annexed Liguria and the port of Genoa.

The date of the letter is uncertain; and there are unexplained gaps in the chronology of Leonardo's life between the years 1482 and 1487. It has been suggested that he visited the Near East where Kait Bey, the ruler of Egypt, was engaged in warfare (cf. p. 264). But the extent of his travels is still an open question.

During this period his interest centred in mechanics. He made designs of weapons to co-ordinate the slings and catapults then in use with the more modern ideas of artillery. He invented machine-guns and breech-loading guns, armoured cars, and mechanical bows capable of hurling flaming projectiles. He drew plans of military bridges and of forts and other defensive devices. As regards war at sea, he designed contrivances for attack and defence, a ram for battering, and a double hull so that a damaged ship would keep afloat, diving suits, and swimming belts.

This instrument is employed in the Indian Ocean in pearl fishing. It is made of leather with many rings so that the sea cannot close it up, and the companion stays above in the boat watching, while he fishes for pearls and corals;

and he has goggles of frosted glass and a cuirass with spikes set in front.[10]

The following notes accompanied by drawings of apparatus refer to a mysterious scheme by which Leonardo hoped to destroy enemy ships by piercing them below the water line, and to release prisoners for half the ransom that had been offered.

Do not impart your knowledge and you alone will excel.

Employ a simple youngster and have the coat sewn at home.

Stop the galleys of the captains and sink the others afterwards and fire the cannon on the foot.

. . . When the watch has gone its round bring a small skiff under the poop and set fire to the whole all of a sudden. [With drawing of a figure in a diving suit.]

A breastplate of armour together with hood, doublet, and hose . . . and a wineskin to contain the breath, with half a hoop of iron to keep it away from the chest. If you have a whole wineskin with a valve . . . when you deflate it, you will go to the bottom pulled down by the sacks of sand; when you inflate it, you will return to the surface of the water.

A mask with the eyes protruding made of glass, but let its weight be such that you raise it while you swim.

Carry a knife which cuts well so that you do not get caught in a net.

Carry with you two or three small wine skins, deflated, and to be inflated like balls in case of need.

Take officers to your liking and many chains and hide them on the bank. But first have an understanding about the agreement how half of the ransom is to be yours without any deduction, . . . and payment may be made into the hands of Maneto,* that is of the said ransom.

* Solmi has suggested that Maneto stands for Manetti (Alvise), who when Leonardo was in Venice in 1500 tried unsuccessfully to

Carry a horn in order to give a signal whether or no the attempt has been successful. . . .[11]

His first designs for the construction of a flying-machine were made about this time.

Make trial of the actual machine over the water so that if you fall you do not do yourself any harm.[12]

On 26 March 1485 Leonardo watched the total eclipse of the sun.

Method of seeing the sun eclipsed without pain to the eye

Take a piece of paper and pierce holes in it with a needle, and look at the sun through these holes.[13]

On 13 April 1485 Ludovico il Moro informed his ambassador at the court of Mathias Corvinus, King of Hungary, that he had asked a great painter who happened to be in Milan to paint a picture for the king. He was probably referring to Leonardo (cf. p. 201).

The following memoranda were written on excursions into the romantic regions of the Lake of Como.

Opposite the castle of Bellaggio there is the river Latte which falls from a height of more than 100 braccia from the source whence it springs, perpendicularly, into the lake with an inconceivable roar and noise. This spring flows only in August and September.

obtain the release of the Venetian prisoners taken by the Turks at Lepanto. But according to Calvi these notes were written some fifteen years earlier.

About eight miles above Como is the Pliniana* which rises and falls every six hours, and as it rises it supplies two mills with water and there is a surplus; and as it falls it causes the spring to dry up: two miles higher up there is Nesso, a place where a river falls with great violence through a mighty chasm in the mountain.

These journeys should be made in the month of May.

And the largest bare rocks in these parts are the Mountains of Mandello near Lecco, and of Gravedona towards Bellinzona, thirty miles from Lecco; and those of the valley of Chiavenna. But the Mandello is the largest of all and it has at its base a gully towards the lake that descends two hundred steps, and here at all seasons there is ice and wind.

In Val Sasina between Vimognio and Introbbio, on the right hand where you enter the road to Lecco you come upon the river Troggia which falls from a very high rock and as it falls it goes underground so that the river ends there. Three miles farther on you come to the buildings of the copper and silver mines near to the district known as Prato San Pietro, and the iron mines and various strange things. The highest mountain in these parts is La Grigna, and it is quite bare.

Above Lake Como towards Germany lies the valley of Chiavenna where the river Mera enters the Lake. Here are barren and very high mountains with huge crags. In these mountains the water-birds called cormorants are found; here grow firs, larches, and pines; deer, wild goats, chamois, and savage bears. One cannot go up there without using hands and feet. The peasants go there in time of snow with a great device to make the bears fall over these rocks. The mountains are close together and have the river between

* The Villa Pliniana is near Torno on the eastern shore. Leonardo can hardly have known what Pliny the Elder wrote: 'In Comensi juxta Larium lacum fons largus horis singulis semper intumescit ac residet' (Nat. Hist. ii. 232). Pliny the Younger asks for an explanation of the miracle (Ep. iv. 30).

them. They extend both on the right and on the left in this way for a distance of twenty miles. One may find good inns there from mile to mile. Above the river there are waterfalls four hundred braccia high which are a fine sight; and there is good living at 4 soldi for your bill. A large quantity of timber is brought down by the river.

The Valtellina as has been said is a valley surrounded by lofty and terrible mountains; it produces a great quantity of strong wine, and has so great a stock of cattle that the peasants reckon that it produces more milk than wine. This is the valley crossed by the Adda, which first runs through Germany for more than forty miles. In this river is found the grayling which feeds on silver of which much is to be found in its sands.

Everyone in this district sells bread and wine. And the wine is worth at most one soldo the bottle, veal is a soldo the pound, and salt ten denari and butter the same, and their pound is thirty ounces and eggs are one soldo for a quantity.

At the head of the Valtellina are the mountains of Bormio which are terrible and always covered with snow. Here ermines breed.[14]

In 1487 the Works Department of the Cathedral of Milan was considering the crowning of the central part of the building.

Leonardo was constructing a model for this tiburio *with the help of the carpenter Bernardo Maggi da Abbiate. Payments towards the expenses of the model were made on* 30 July, *on* 8, 18, 27 August, *on* 28 *and* 30 September *and again on* 11 January 1488. *Then the model was submitted to the Works Department with a letter of which the following draft has survived. He compares the building in need of repairs to an ailing body and the architect to a doctor.*

My Lords, Father Deputies, just as for doctors, guardians,

nurses it is necessary that they should understand what man is, what life is, what health is, and how it is maintained by a balance and harmony of elements, while a discord of these is its ruin and undoing; and one with a good knowledge of these conditions will be better able to repair than one who is without it.

You know that medicines when well used restore health to the sick; and they will be well used when the doctor together with the understanding of their nature shall understand also what man is, what life is, what constitution is and what health is. Understanding these well he will also understand well their opposites and when this is the case he will know well how to repair. . . .

You know that medicines well used restore health to the sick, and he who knows them well will use them well if he also understands what man is, and what life and the constitutions are, and what health is. Knowing these well he will know their opposites, and being thus equipped he will be nearer a cure than anyone else. The need of the invalid cathedral is similar—it requires a doctor architect who well understands what an edifice is, and on what rules the correct method of building is based, and whence these rules are derived and into how many parts they are divided, and what are the causes that hold the structure together, and make it last, and what is the nature of weight, and what is the desire of force and in what manner they should be combined and related, and what effect their union produces. Whoever has a true knowledge of these things will satisfy you by his intelligence and his work. . . . Therefore I shall try without detracting and without abusing anyone, to satisfy you partly by arguments and partly by works, sometimes revealing the effects from the causes sometimes the reasoning by experiment . . . fitting with them certain principles of ancient architects and the evidence of buildings they constructed and what were the reasons of their ruin or their survival etc.

And I shall show at the same time what is the first law of weight and what and how many are the causes that bring ruin to buildings and what is the condition of their stability and permanence. But in order not to diffuse to your Excellencies, I will begin by the plan of the first architect of the cathedral and show clearly what was his intention as revealed by the edifice begun by him, and having understood this you will be able clearly to recognize that the model which I have made embodies that symmetry, that harmony and that conformity, which belongs to the building already begun: what is an edifice, and wherefrom do the rules of correct construction derive their origin, and what and how many are the parts that belong to these.

Either I, or others who can expound it better than I, choose him, and set aside all partialities.[15]

The work which was proceeding on the cathedrals of Pavia, Como, and Milan and on Santa Maria delle Grazie inspired him to investigate the problems connected with domes rising from square and octagonal bases and to make numerous architectural drawings.

Here there cannot and ought not to be any campanile; on the contrary it must stand apart like that of the Cathedral and of San Giovanni at Florence, and the Cathedral of Pisa, where the campanile and the dome are quite detached, and each can display its own perfection. If, however, you wish it to be joined to the church make the lantern serve for the campanile as in the church of Chiaravalle.*16

He was also drawing plans for a new city with plenty of light and air and with two-level highways, the lower to be used by carts and loads and the upper to be reserved for the convenience of gentlefolk.

The terrible devastation caused by the plague in Milan in 1483 may have been the inducement to this work.

The following memoranda refer to his interests, activities, and acquaintances in Milan.

An algebra which the Marliani† have, written by their father. . . .

The measurement of Milan and its suburbs. You will draw Milan.‡ Plan of Milan.

* The Abbey of Chiaravalle, a few miles from Milan, has a central tower on the intersection of the cross.

† Girolamo Marliani, author of *Algebra*; celebrated physician. His sons were also physicians.

‡ On another sheet there is a sketch of a view of Milan and a rough plan with indication of the gates (reproduced in R., Plate CIX).

A book treating of Milan and its churches which is to be had at the last stationer's on the way to Cordusio.*

The measurement of the Corte Vecchia, the measurement of the castle.

Of the measurement of San Lorenzo.†

Get the master of arithmetic to show you how to square a triangle.

Get Messer Fazio‡ to show you the book on proportion.

Get the friar of Brera§ to show you de Ponderibus.||

On proportion by Alchino¶ with notes by Marliano from Messer Fazio.

The book on celestial phenomena by Aristotle, in Italian.**

The measurement of the sun promised me by Giovanni the Frenchman.

Memorandum, to ask Giannino Bombardieri†† how the tower of Ferrara is walled without holes.

Ask Maestro Antonio how mortars are placed on bastions by day or by night. The crossbow of Maestro Gianetto.

Ask Benedetto Portinari§§ how people go on the ice in Flanders. The measurement of the canal, locks, and supports, and large boats; and the expense.

Find a master learned in waterworks and get him to

* Cordusio, i.e. *cura ducis*, the name of a piazza near the centre of the town.

† San Lorenzo, an octagonal building dating back to the sixth century. The dome is to this day one of the most wonderful cupolas ever constructed.

‡ Fazio Cardano, a learned jurist, distinguished for his taste in mathematics, father of the famous Girolamo Cardano, mathematician, astronomer, and physician.

§ Brera, now the gallery and library of Milan, was until 1571 a monastery.

|| Liber Jordani Nemorarii, *De Ponderibus*, written at the beginning of the thirteenth century.

¶ Alchino, the Arab philosopher Alkindi.

** *Meteorologica.*

†† Giannino Bombardieri, a maker of cannon, from Ferrara.

§§ The Portinari were one of the great merchant families of Florence and represented the Medici Bank at Milan.

explain the repair and the cost of a repair, and a lock and a canal and a mill in the Lombard fashion.

A grandson of Gian Angelo, the painter, has a book on water from his father.

Paolino Scarpellino, called Assiolo, has great knowledge of waterwork.

'Knots' by Bramante.*[17]

On *the second day of April 1489* book entitled 'Of the Human Figure'.

This is the first date that occurs in Leonardo's notes on anatomy.

On the same sheet are drawings of skulls showing the blood vessels of the face. On the reverse is a list of subjects for consideration:

Which tendon causes the eye to move so that one eye moves the other?

Of frowning the brows. Of raising the brows. Of lowering the brows.

Of closing the eyes. Of opening the eyes.

Of raising the nostrils.

* 'Knots', *Gruppi*, i.e. twisted ornaments such as illustration. Bramante, celebrated architect born in Urbino, active in Milan 1476–99.

Of opening the lips with the teeth shut. Of pouting with the lips.

Of smiling. Of astonishment.

What is sneezing? What is yawning?

Falling sickness, spasms, paralysis, shivering with cold, sweating, fatigue, hunger, sleepiness, thirst, lust.

Describe the beginning of man when it is caused in the womb. . . .[18]

G. P. Lomazzo gives the following description of Leonardo's methods of studying expressions: There is a tale told by his servants, that Leonardo once wished to make a picture of some laughing peasants, though he did not carry it out but only drew it. He chose certain men whom he thought appropriate for his purpose, and, after getting acquainted with them, arranged a feast for them with some of his friends. Sitting close to them he then proceeded to tell the maddest and most ridiculous tales imaginable, making them who were unaware of his intentions laugh uproariously. Whereupon he observed all their gestures very attentively and those ridiculous things they were doing, and impressed them on his mind; and after they had left, he retired to his room and there made a perfect drawing which moved those who looked at it to laughter, as if they had been moved by Leonardo's stories at the feast!

On the *28th of April* (*1489?*) I received from the Marchesino [Stanga, secretary to the duke] 103 lire and 12 soldi.[19]

On 22 July 1489 Pietro Alamanni, the Florentine ambassador at Milan, wrote to Lorenzo de' Medici: 'Prince Ludovico is planning to erect a worthy monument to his father, and in accordance with his orders Leonardo has been asked to make a model in the form of a large horse in bronze ridden by the Duke Francesco in full

armour. As his Highness has in mind something wonderful, the like of which has never been seen, he has directed me to write to you and ask if you would kindly send him one of two Florentine artists who specialize in this kind of work. Moreover, although he has given the commission to Leonardo, it seems to me that he is not confident that he will succeed.'

If Sabba Castiglione is right in saying that Leonardo worked on the model for the horse of the Sforza monument for sixteen years he must have started soon after his arrival at Milan.

The following note written many years later refers to an earthquake that took place about this time at Rhodes.

In eighty nine [the year 1489] there was an earthquake in the sea of Atalia near Rhodes, which opened the sea, that is its bottom; and into this opening such a torrent of water was poured that for more than three hours the bed of the sea lay bare because of the water that had been lost from it; and then it closed to the former level.[20]

On 13 January 1490 Leonardo collaborated with the poet Bernardo Bellincioni in staging the Festa del Paradiso at the Castello at Milan in honour of Gian Galeazzo Sforza, Duke of Milan, and his young wife, Isabel of Aragon. An enormous gilt hemisphere and personifications of the planets figured on the stage.

On 28 March 1490 a contract was signed at Como for the delivery of stone for a pavilion to be constructed by Leonardo at Milan. In his notebook are sketches for an elevation and plan of a small domed edifice.

Pavilion of the garden of the Duchess of Milan.

Ground plan of the pavilion which is in the middle of the Labyrinth of the Duke of Milan.

On the reverse is the plan of a house with the following note:

If you have your family in your house make their habitations in such a way that at night neither they nor the strangers lodging with you are in control of the door of the house; in order that they may not be able to enter the rooms where you live or sleep, close the exit *m*, and you will have closed the whole house.[21]

A new notebook known as M.S.C. begun at this time is devoted to problems of light and shade.

On the 23rd of April 1490 I began this book and recommenced the horse.[22]

While at work on the Sforza monument he was looking out for horses that might serve as models. He found what he liked in the stable of Galeazzo di San Severino, the son-in-law of Ludovico il Moro.

The following notes are written beside sketches from horses:

Messer Galeazzo's big genet.[23]
Messer Galeazzo's Sicilian horse.[24]

Measurement of the Sicilian horse, the leg from behind, in front lifted and extended.[25]

In the mountains of Parma and Piacenza multitudes of shells and corals filled with wormholes may be seen still adhering to the rocks. When I was making the great horse at Milan a large sack of those shells which had been found in these parts was brought to my workshop by some peasants, and among them were many still in their original condition.[26]

On 10 May 1490 the Works Department of Milan Cathedral returned to Leonardo at his own request the model which he had constructed for the tiburio, *asking him to keep it in readiness. Leonardo had expressed the wish to repair it, but a week later he received 12 lire for the construction of a new model.*

On 8 June 1490 Ludovico il Moro wrote to his secretary, Bartolomeo Calco, that the Works Department of the Cathedral of Pavia was in need of the advice of the Sienese architect who was then in Milan and added as a postscript that also Leonardo and the Lombard architect Amadeo should proceed to Pavia.

On 10 June 1490 Bartolomeo Calco replied that the Sienese architect was working hard to complete his model for the tiburio *of Milan Cathedral and that Leonardo would always be at the Duke's disposal.*

In the month of June 1490 Leonardo and the Sienese architect, Francesco di Giorgio Martini, set out together on horseback with a following of engineers and helpers for Pavia. They put up at the inn 'Saracino' and their bill was paid by the Works Department on 21 June, it being stated that they both had been specially called for a consultation about the cathedral.

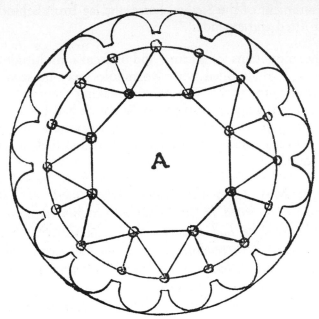

Plan of Santa Maria in Praticha in Pavia.

While at Pavia Leonardo used the notebook known as MS.B. He studied in the famous Sforza library, where the work on perspective by Witelo (Vitolone), Polish physician of the thirteenth century attracted his attention.

Try to get Vitolone which is in the library of Pavia and treats on mathematics.[17]

In Vitolone there are 805 conclusions about perspective.[27]

On the Piazza in front of the Duomo at Pavia stood a bronze equestrian statue known as 'Regisole' which had been removed from Ravenna by Charlemagne. Leonardo, bearing in mind his Sforza monument, studied the action of this horse.

In that of Pavia the movement more than anything else is deserving of praise.

The imitation of antique works is better than that of modern.

Beauty and utility cannot go together as may be seen in fortresses and in men.

The trot has almost the quality of a free horse.

Where natural vivacity is lacking it is necessary to make accidental liveliness.[28]

I have watched the repair of part of the old walls of Pavia which have their foundations in the banks of the Ticino. The piles there were old and were of oak as black as charcoal, those of alder had a red colour like Brazil wood; they were of great weight and hard as iron, without blemish.[29]

On 27 June 1490 a consultation took place at the Castello at Milan in the presence of Ludovico il Moro and the archbishop to decide on the tiburio *of the cathedral. Four models were under consideration, none of which were by Leonardo, and the task of construction was entrusted to two Lombard architects.*

The following note records the entry into Leonardo's household of Giacomo Salai, who grew up in his service, and remained with him until his death.

On St. Mary Magdalene's day [July 22] 1490 Giacomo came to live with me, when ten years of age. Thief, liar, obstinate, glutton. The second day I had two shirts cut out for him, a pair of hose, and a jerkin, and when I put aside money to pay for these things he stole it from the wallet, and it was never possible to make him confess, although I was quite certain of it —lire 4.

The day after I went to sup with Giacomo Andrea,* and

* Giacomo Andrea of Ferrara, architect and engineer, adherent of Lodovico il Moro, was executed when the French took Milan.

the other Giacomo ate supper for two and did mischief for four, as he broke three flagons, spilled the wine, and after this came to sup where I . . .

On the seventh day of September he stole a stile worth 22 soldi from Marco* who was staying with me. It was of silver and he took it from his studio, and when Marco had searched for it a long time he found it hidden in the box of Giacomo—lire 1 soldi 2.[22]

In January 1491 *Beatrice d'Este arrived at Milan as the bride of Ludovico il Moro. She availed herself of her position as mistress of one of the most splendid courts of Italy to surround herself with learned men, poets, and artists, such as Niccolo da Correggio, Bernardo Castiglione, Bramante, and Leonardo da Vinci.*

Leonardo helped to arrange festivals in connexion with the tournament given by Ludovico's son-in-law, Messer Galeazzo di San Severino in celebration of the ducal wedding. The following entry refers to the behaviour of the boy Giacomo Salai.

On the *26th* day *of January* [1491], when I was in the house of Messer Galeazzo da San Severino to arrange the festival for his tournament, and certain footmen had undressed to try on some of the costumes of the savages which were to appear at the festival, Giacomo went to the wallet of one of them as it lay on the bed with other clothes and took out whatever money he found there.—2 lire s. 4.

Item, when I was in the same house Maestro Agostino of Pavia† gave me a Turkish hide in order to make a pair of boots; this Giacomo stole it from me within a month and sold it to a cobbler for 20 soldi and with this money by his own confession, he bought aniseed comfits.—L. 2.

* Probably Leonardo's pupil Marco d'Oggionno (*c.* 1475–1530).
† Agostino Vaprio of Pavia, a painter called to Milan in 1490 to help decorate the ducal castle.

Item. Again on the second day of April Gian Antonio*
having left a silver stile on one of his drawings, this Giacomo
stole from him, and it was worth 24 solidi—L 1 s. 4.

The first year: a cloak Lire 2, 6 shirts Lire 4, 3 jerkins Lire 6,
4 pairs of hose Lire 7 soldi 8, 1 lined doublet Lire 5, 24 pairs
of shoes Lire 6 soldi 5, one cap Lira 1, laces for belt Lire 1.[22]
On the *10th of July 1492.*

in 135 Rhenish florins	l. 445
in dinari of 6 soldi	l. 112.s.16
in dinari of 5½ soldi	l. 201.s.19
in dinari 9 in gold and 3 scudi	l. 53
	l. 811 in all.

That is not riches which may be lost; virtue is our true
wealth and the reward of its possessor. This cannot be lost;
it does not abandon us unless life first leaves us. As for
property and external riches hold them with trembling;
they often leave their possessor in contempt and ignominy
for having lost them.[30]

*This note helps to date the most important of Leonardo's
manuscripts on the practice of painting (B.N. 2038 and A).
Besides dealing with painting, it contains notes on the con-
struction of arches and the beginnings of his treatise on water.*

Thursday *the 27th of September (1492)* Maestro Tommaso
returned and worked for himself until the last day but one
of February.

On the *18th of March 1493* Giulio the German came to live
with me—Antonio, Bartolomeo, Lucia, Piero, Leonardo.

Caterina came on the *16th day of July 1493.*

Messer Mariolo's† Morel the Florentine is a big horse with
a fine neck and a beautiful head.

The white stallion belonging to the falconer has fine hind
quarters; it is behind the Comasina Gate.

* Probably Gian Antonio Boltraffio, portrait painter, pupil of
Leonardo.

† Mariolo da Guiscardi, attendant at Ludovico Sforza's court.

The big horse of Germonino, of Signor Giulio.[31]

Ludovico il Moro issued a decree in 1493 to make the canal of the Martesana near Milan navigable. Leonardo in the following draft has some remunerative suggestions to make on the subject.

To my illustrious Lord, Ludovico, Duke of Bari. Leonardo da Vinci of Florence. . . . Does it please you to see a model which will prove useful to you and to me, and it will also be of use to those who will be the cause of our usefulness. . . . There are here, my Lord, many gentlemen who will undertake this expense between them, if they are allowed to enjoy admission to the waters, the mills, and the passage of vessels, and when their expenses are repaid they will repay for the canal of Martesana. . . .[32]

The heirs of Maestro Ghiringhello have the works of Pelacano.*[33]

Maestro Stefano Caponi, a physician, lives at the piscina and has Euclid, De Ponderibus.[34]

1493 on the first day of November we settled accounts.
Giulio had to pay 4 months and Maestro Tommaso 9 months; Maestro Tommaso afterwards made 6 candlesticks, 10 days' work; Giulio some fire-tongs, 15 days' work. Then he worked for himself till the 27th of May, and worked for me at a lever till 18th of July; then for himself till the 7th of August, and on the 15th for half a day for a lady. Then again for me at two locks until 20th of August.[35]

In 1493 Leonardo had completed the clay model of the horse for the Sforza monument. It measured 23 feet from the top of the horse's head to the base, but was as yet without

* Biagio Pelacani (d. 1416) teacher of philosophy at Pavia, author of works on Aristotle and on Perspective. Giovanni di Ghiringhelli was professor at Pavia 1443-9.

a rider. This model was exhibited on the Piazza del Castello at Milan under a triumphal arch on the occasion of the marriage of Bianca Maria Sforza, niece of Ludovico il Moro, to the Emperor Maximilian. The wedding took place at Innsbruck on 16 March 1494 and the bride was escorted by a distinguished company travelling northwards from Milan, across the Lake of Como and the Valtellina towards the Tyrol. It has been suggested that Leonardo may have been of that company but we know that he was at Vigevano during these months.

Meanwhile the question arose how to cast the colossal clay model of the horse in bronze.

Mould for the horse

Make the horse on legs of iron, strong and well set on good foundations; then grease it and cover it with coating, leaving each coat to dry thoroughly layer by layer; and this will thicken it by the breadth of three fingers. Now fix and bind it with iron as may be necessary.

Moreover, take off the mould and then make the thickness. Then fill the mould by degrees and make it good throughout; encircle and bind it with irons and bake it inside where it has to touch the bronze.[36]

On the 29th day of January 1494.

Cloth for hose	lire 4 s.3
lining	s.16
making	s.8
Salai	s.8
a jasper ring	s.13
a sparkling stone	s.11
to Caterina	s.10
to Caterina	s.10[37]

At the beginning of the year 1494 Leonardo was at Vigevano, the summer seat of the Sforzas on the banks of the Ticino, where Bramante was reconstructing the castle and adding the spacious Palazzo delle Dame. He made the following estimate for the decoration of a hall with scenes from Roman history and portraits of philosophers.

The hall towards the court is 128 paces long and 27 braccia wide.[38]

The narrow moulding above the hall lire 30.

The mouldings underneath this, estimating each picture separately, lire 7; and for the cost of blue, gold, white, plaster, indigo, and glue 3 Lire; time 3 days.

The pictures below these mouldings with their pilaster 12 lire each.

I calculate the cost for smalt, blue and gold and other colours at $1\frac{1}{2}$ lire.

I calculate three days for the invention of a composition, pilaster and other things.

Item for each small vault 7 lire.

Outlay for blue and gold 3½.

Time 4 days.

For the windows 1½.

The cornice below the windows 6 soldi per braccio.

Item for 24 pictures of Roman history 14 lire each.

The philosophers 10 lire.

The pilasters one ounce of blue 10 soldi.

For gold 15 soldi.[39]

How many braccia high is the level of the walls?

123 braccia.

How large is the hall?

How large is the garland?

30 ducats.[37]

In the same notebook (H, 78–79) are drawings and calculations for the construction of a wooden pavilion to be erected in the ducal grounds. He was also interested in the building of stairs and the channelling of water.

On the *second day of February 1494* at the Sforzesca [Vigevano] I have drawn twenty-five steps each of two thirds of a braccio and eight braccia wide.[40]

Stair of Vigevano below the Sforzesca, 130 steps, ½ braccio high and ½ braccio wide, down which the water falls, so as

not to wear anything at the end of its fall; by these steps so much soil has come down that it has dried up a pool; that is to say, it has filled it up and a pool of great depth has been turned into meadows.[41]

Vineyards of Vigevano. On the *20th day of March 1494*. And in the winter they are covered with earth.[42]

Below this note is a sketch showing the alinement of plants in these vineyards, which is much the same as that prevailing at Vigevano and other Lombard vineyards today, but differs from Tuscan vineyards where the winter is not so severe. Leonardo remembered his young days in the country in Tuscany and observed the difference.

On the 23rd day of August 12 lire from Pulisona.

On the *14th of March 1494* Galeazzo came to live with me, agreeing to pay 5 lire a month for his cost, and paying on the 14th day of each month.

His father gave me 2 Rhenish florins.

On the 14th of July I had from Galeazzo 2 Rhenish florins.[43]

On the *15th day of September* Giulio began the lock of my studio, *1494*.[44]

In September 1494 Charles VIII of France entered Lombardy with an army on his way to the kingdom of Naples. He was received as an ally by Ludovico il Moro and entertained at Pavia. Meanwhile the Duc d'Orléans, afterwards Louis XII, who commanded the vanguard of the royal army, occupied Genoa and was menacing Milan. He was already dreaming of asserting his rights on this city based on the marriage of his grandfather with a Visconti.

On 21 October 1494 the young Duke of Milan, Gian Galeazzo, died at Pavia. The manner of his death gave rise to suspicions that poison had been administered by order of his uncle Ludovico. On the following day, at the

*Castello at Milan, Ludovico was proclaimed Duke, super-
seding Gian Galeazzo's infant son, since it was found
necessary to have a man at the helm during these troublous
times.*

*On 17 November 1494, under the pressure of political
events, Duke Ludovico shipped the bronze intended for
casting Leonardo's model of a horse down the Po to Ferrara
to be made into cannon.*

*In the notebooks used by Leonardo at this time we find
the following somewhat obscure entries referring to alle-
gorical representations in connexion with the two dukes.*

Il Moro with spectacles,
 and Envy depicted with False report,
 and Justice black for il Moro.[45]

Ermine with mud.

Galeazzo between calm weather and flight of fortune.[46]

The ermine will die rather than besmirch itself.[47]

*In the same notebook are a series of transcriptions from
a popular medieval bestiary (see p. 228). These were
probably made in connexion with recitations and perfor-
mances at court.*

On Tuesday I bought wine for the morning, on *Friday the
4th day of September (1495)* the same.[48]

*The little notebook which is dated by this entry of the
purchase of wine deals mainly with mechanics.*

 Double floor.

Roof of the flagstaff of the castle.[49]

Have some corn of large size sent from Florence.[50]

Funeral expenses of Caterina

For the 3lbs of tapers	27 s
For the bier	8 s
a pall over the bier	12 s
For bearing and placing the cross	4 s
For bearing the body	8 s
For 4 priests and 4 clerks	20 s
Bell, book and sponge	2 s
For the gravediggers	16 s
To the senior	8 s
For a license from the authorities	1 s
	106 s
'The doctor	5 s
Sugar and candles	12 s
	123 s[51]

Caterina had entered his household in 1493 and had therefore been with him for a few years.

She may have died in hospital, since Leonardo wrote the following note on the next page of the same notebook. It has been suggested that this housekeeper was his mother, who bore the same name (see p. 285). This seems improbable.

Piscin da Mozania at the hospital of Brolio has many veins on arms and legs.[52]

He was interested in a systematic representations of the veins of the human body as is shown by the following notes on a sheet at Windsor datable about this time.

[With drawing of figure showing the anatomy of veins.]

Here shall be represented the tree of the vessels generally, as Ptolemy did with the universe in his Cosmography; here shall be represented the vessels of each member separately from different aspects.

Draw the view of the ramification of the vessels from behind, from the front and from the side; otherwise you do not give true demonstration of their ramification, shape, and position.[53]

The pupil in man dilates and contracts according to the brightness or darkness of the object in view; and since it takes some time to dilate and contract it cannot see immediately on going out of the light into the dark, and similarly out of the dark into the light; and this very thing has once deceived me in painting an eye, and from that I learned it.[54]

In 1495 Leonardo began to work on his painting of the Last Supper on a wall of the refectory of the Dominican friary of Santa Maria delle Grazie. In his notebook are drawings of the socles in the apsis of that church (see p. 322). The following notes in the same book show how he was looking for models for his figure of Christ.

Christ—The young count, the one with the Cardinal of

Mortaro. Giovannina has a fantastic face, lives at Santa
Caterina, at the hospital.[55]
Alessandro Carissimo of Parma, for the hand of Christ.[56]

*Among the apostles represented
in the painting are portraits of
courtiers and men in Milan.
The following description of
Leonardo's methods of studying
is of interest in this connexion.*

*Giovanbatista Giraldi, whose
father knew Leonardo, writes:
When Leonardo wished to paint
a figure he first considered what
social standing and what nature
it was to represent; whether
noble or plebeian, gay or severe,
troubled or serene, old or young,
irate or quiet, good or evil; and
when he had made up his mind, he
went to places where he knew that
people of that kind assembled and
observed their faces, their manners,
dresses, and gestures; and when
he found what fitted his purpose,
he noted it in a little book which he
was always carrying in his belt.
After repeating this procedure
many times, and being satisfied with the material thus
collected for the figure which he wished to paint, he would
proceed to give it shape, and he would succeed marvellously.'*

*Draft of a letter probably dated 1496 addressed to Piacenza
which at that time formed part of the Duchy of Milan.*

Magnificent Commissioners of Buildings! Hearing that Your Magnificences have resolved to make certain great works in bronze, I will put certain things on record for you. First, that you should not be so quick and hasty in awarding the commission that by your speed you put it out of your power to choose a good model and a good master as Italy has a number of men of capacity. Some man may be chosen who by his insufficiency may afford occasion to your successors to blame you and your age, judging that this age was poorly equipped with men of good judgement or good masters; seeing that other cities and especially the city of the Florentines were almost at this very same time endowed with beautiful and great works in bronze; amongst these being the doors of their baptistery. . . . And this Florence, like Piacenza, is a place of intercourse, through which many foreigners pass; who, when they see that the works are fine and good, form the impression that the city must have worthy inhabitants, seeing that the works serve as evidence of their opinion. And on the contrary, I say, that if they see a great expenditure in metal wrought so poorly, it would be less shame to the city if the doors were of plain wood, because the material costing so little, would not seem to merit any great outlay of skill.

Now the principal parts which are sought for in cities are their cathedrals, and as one approaches these the first things which meet the eye are the doors by which one passes into these churches. Beware, gentlemen of the commission, lest the too great speed in wishing with such haste to expedite the commission of so great a work as that which I hear you have ordered, may become the reason why what was intended for the honour of God and of men may prove a great dishonour to your judgements and to your city, where as it is a place of distinction and resort there is a concourse of innumerable foreigners. And this disgrace would befall you if by your negligence you put your trust in some braggart who, by his tricks or by the favour shown to him, were to

be awarded such a commission by you as should bring great and lasting shame to him and to you.

I cannot help feeling angry when I reflect what men those are who have conferred with me wishing to embark on such an undertaking without giving a thought to their capacity for it, not to say more.

One is a maker of pots, another of cuirasses, yet another makes bells and another collars for them, another even is a bombardier. And among them one in his Lordship's service who boasted that he is an intimate acquaintance of Messer Ambrosio Ferere* who has some influence and has made certain promises to him; and if this were not enough he will get on his horse and ride off to his Lord and get such letters from him that you will never refuse him the work. But consider to what straits the poor students who are competent to execute such work are reduced when they have to compete with such men as these.

Open your eyes and look carefully that your money is not so spent as to purchase your own shame. I can assure you that from this district you will get nothing but average works of inferior and coarse masters. There is not a man who is capable—and you may believe me—except Leonardo the Florentine who is making the bronze horse of the Duke Francesco and who has no need to bring himself into notice, because he has work to do which will last him the whole of his life, and I doubt whether he will ever finish it, so great it is.

The miserable students . . . with what hope may they expect a reward. Here is one whom his Lordship has invited from Florence to do this work and he is a capable master, but he has so much, oh! so much, to do that he will never finish it. And what do you imagine is the difference between seeing a beautiful object and an ugly one? Quote Pliny.[57]

* Ambrosio Ferere was Farmer under the Customs of the Duke.

The following notes accompany the drawing of a machine for sharpening needles, with an ingenious system of gears, travelling belts, and an emery wheel, probably the first mass-production machine in history.

Tomorrow morning on *the second day of January 1496* I shall have the strap made and make the test.

100 times an hour and 400 needles every time. That means 40,000 needles per hour, and 480,000 in twelve hours. Let us say 4,000,000 would bring in 20,000 soldi at 5 soldi per 1,000. That is a total of 1,000 Lire for every working day and with twenty working days every month it would be 60,000 Ducats a year.[58]

On 31 January 1496 at the house of Conte di Cajazzo in the presence of the Duke and the people of Milan was performed a play on Danae composed by Baldassare Taccone for which Leonardo designed the stage scenery. A sheet with sketches and a list of dramatis personae is at the Metropolitan Museum, New York.

Acrisius	Gian Cristophano	Mercury	Gian Battista of Osmati (?)
Sirus	Taccone	Jove	Gian Francesco Tantio
Danae	Francesco Romano	A servant.	

Announcer of the performance.

Those who marvel at the new star and kneel and worship it and kneeling down with music close the performance.

A costume for carnival

To make a beautiful costume take a supple cloth and give it an odoriferous varnish made of oil of turpentine and of varnish; ingrain and glue with a pierced stencil, which must be wetted, that it may not stick to the cloth; and this stencil may be made in a pattern of knots which afterwards may be filled in with black and the ground with white millet.[59]

A bird for a comedy.[60]

Leonardo was at this time occupied with the water-supply to the Castle of Milan.

Key of the bath of the Duchess.

Show all the ways of unlocking and releasing. Put them together in their chapter. [With drawing.][61]

To warm the water of the stove of the Duchess add three parts of warm water to four parts of cold water.[62]

A way of flooding the castle [with a plan of the Castle of Milan].[63]

A

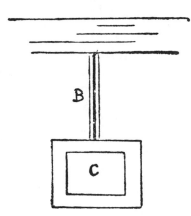

The moat of Milan. Canal 2 braccia wide. The castle with moat full. The filling of the moats of the Castle of Milan.[64]

About this time Duke Ludovico sent to the Emperor Maximilian, his niece's husband, a picture by Leonardo 'which was said by those who were able to judge, to be

*one of the most beautiful and rare works that have been
seen in painting'* (Codice Magliabecchiano).

In July 1496 *Duke Ludovico with a great retinue set
out to pay a brief visit to the Emperor and Empress at
Mals. He travelled through the Valtellina, and on his
return broke his journey at Chiavenna. Leonardo may
have been in the Duke's suite. He probably made more
than one journey to those parts.*

3 January 1497. *Death of Beatrice d'Este, Duchess of
Milan.* 29 June 1497, *the Duke through his secretary, the
Marchesino Stanga, asks Leonardo to finish the Last
Supper and to begin work on the opposite wall of the
refectory, where he was to insert the portraits of the Duke
and the late Duchess with their two sons kneeling on either
side of a Crucifixion by Montorfano.*

*The following account by the novelist Matteo Bandello,
who came to Milan in 1495 at the age of fifteen and was
placed in care of his uncle Vicenzo, the prior of the
monastery of Santa Maria delle Grazie, shows Leonardo
at work in the refectory:* 'Many a time I have seen
Leonardo go to work early in the morning on the platform
before the Last Supper; and he would stay there from
sunrise till darkness, never laying down the brush, but
continuing to paint without eating or drinking. Then three
or four days would pass without his touching the work, yet
each day he would spend several hours examining it and
criticising the figures to himself. I have also seen him,
when fancy took him, leave the Corte Vecchia where he
was at work on the stupendous horse of clay, and go
straight to the Grazie. There climbing on the platform, he
would take a brush and give a few touches to one of the
figures, and then he would leave and go elsewhere.'

Two drafts of letters to the Duke show that Leonardo was in financial difficulties.

I regret very much to be in want, but I regret still more that this has been the cause of the interference with my desire, which has always been to obey your Excellency. I regret very much that having to earn my living has forced me to interrupt the work which your Lordship entrusted to me and to attend to small matters. But I hope in a short time to have earned so much that I may be able with a tranquil mind to carry it out to the satisfaction of your Lordship to whom I commend myself; and if your Lordship thought that I had money, your Lordship was deceived because I had to feed six mouths for thirty-six months and have had 50 ducats.

It may be that your Excellency did not give any further orders to Messer Gualtieri believing that I had money. . . .[65]

[Written on a sheet torn vertically across.]

My Lord, knowing the mind of your Excellency to be occupied. . . . To remind your Lordship of my small matters and . . . I should have maintained silence . . . that my silence should be the cause of making your Lordship angry . . . my life to your service I hold myself ever ready to obey. . . . Of the horse I will say nothing because I know the times . . . to your Lordship how I have still to receive two years' salary . . . with two masters whose salaries and board I have always paid . . . that at last I found I had advanced the work about fifteen lire . . . works of fame by which I could show to those who are to come that what I have been. . . .

Everywhere, but I do not know where I could bestow my work. . . .

I have been working to gain my living. . . .

I not having been informed what it is, I find myself. . . .

Remember the commission to paint the rooms. . . .

I conveyed to your Lordship only requesting. . . .[66]

Plan for a projected altar-piece for San Francesco at Brescia. Leonardo knew Francesco Nani of the Franciscan Order of Brescia and had made a small drawing of his head in profile in 1495 (in notebook S.K.M. II). This connexion probably procured him a commission for this altar-piece, which, however, he did not execute.

The first part of this note is written in two columns across the margin of a rectangle which lies between them and wherein is written 'Our Lady'. The names at the head of the two columns are those of the two patron saints of Brescia.

Jovita	Faustin
Saint Peter	Paul
Elizabeth	Saint Chiara
Bernardino	Our Lady Louis
Bonaventura	Anthony of Padua
Saint Francis	

Anthony: a lily and book
Bernardino: with [the monogram] of Jesus
Louis: with 2 fleur de lys on his breast and the crown at his feet
Bonaventura: with Seraphim
Saint Chiara: with the tabernacle
Elizabeth: with queen's crown.[67]

4th of April 1497. Salai's cloak.

4 braccia of silver cloth	L 15.	s. 4
green velvet to trim it	L 9.	
ribbons		s. 9
loops		s. 12
the making	L 1.	s. 5
ribbon for the front		s. 5
stitching		
here for his grossoni 13		

(26 lire 5 soldi)

Salai steals the soldi.[68]

In 1497 the mathematician Fra Luca Pacioli, who had been invited to Milan by Ludovico il Moro, completed his book De Divina Proportione *for which Leonardo designed the illustrations. In the dedication to Ludovico, dated 9 February 1498, Leonardo is said to have finished the painting of the Last Supper and to have written books on painting and on the movements of the human figure. His participation in a debate at the court between representatives of the Arts and Sciences is also mentioned. Here we should bear in mind Vasari's description that Leonardo with his arguments silenced the learned, confounded the liveliest intellect, and turned every long-established view. '. . . his powers of conversation were such as to draw to himself the souls of listeners.'*

The following description compares the studio of a painter with that of a stone carver. He is describing himself at work:

The sculptor in creating his work does so by the strength or his arm and the strokes of his hammer by which he cuts away the marble or other stone in which his subject is enclosed—a most mechanical exercise often accompanied by much perspiration which mingling with grit turns into mud. His face is smeared all over with marble powder so that he looks like a baker, and he is covered with a snow-storm of chips, and his house is dirty and filled with flakes and dust of stone.

How different the painter's lot—we are speaking of first-rate painters and sculptors—for the painter sits in front of his work at perfect ease. He is well dressed and moves a very light brush dipped in delicate colour. He adorns himself with the clothes he fancies; his home is clean and filled with delightful pictures and he often is accompanied by music or by the reading of various beautiful works to which he can

listen with great pleasure without the interference of ham-
mering and other noises.[69]

During these years Leonardo composed the cartoon of St.
Anne, the Virgin, and the Child which is now in Burling-
ton House. He painted the portrait of Lucrezia Crivelli,
who in 1495 succeeded Cecilia Gallerani as mistress of
Ludovico il Moro. A sheet with Latin epigrams, in praise
of this picture by a court poet, was found among Leonardo's
notes.

How well the master's art answers to nature. Da Vinci
might also have rendered the soul as he has rendered the
rest. But he did not, so that his picture might be a better
likeness. For the soul of his model is possessed by Il Moro,
her lover. The Lady's name is Lucrezia to whom the gods
gave all things lavishly. Beauty of form was bestowed
on her and Leonardo painted her. Il Moro loved her; one
is the greatest of painters the other of princes. By this like-
ness the painter roused the jealousy of nature and of the
goddesses on high. Nature lamented that the hand of man
could attain so much, the goddesses that immortality should
have been bestowed on so fair a form which should have
been perished. But Leonardo did it for Il Moro's sake, and
Il Moro will protect Leonardo. Men and gods alike fear to
injure Il Moro.[70]

In the cathedral at the pulley of the nail of the Cross.[71]

This note is accompanied by a drawing of a pulley. The
nail believed to be of the Cross is still one of the most
precious relics of Milan Cathedral and is kept in the vaulting.
Leonardo supplied a device for lowering it on special
occasions. Ritter Arnold von Harff on his visit to Milan
in 1499 described the nail being suspended above the high
altar.

On 17 March 1498 Leonardo was in Genoa in the escort

of Ludovico il Moro examining the damage done to the breakwater by a tempest. He refers to this visit in the following note, written beside a drawing of an apparatus for shaping metal, the principle of which is embodied in some of the machinery of the modern rolling mill.

The iron bar is to be drawn out into the shape of a rod. In the ruined part of the breakwater at Genoa the iron was drawn out into rods by less power than this.[72]

On these journeys he pursued his studies of nature. The following notes written in Florence some years later record recollections of his travels.

The flow and ebb in our Mediterranean seas does not cause so much variation because in the Gulf of Genoa it does not vary at all. . . .[73]

At Alessandria della Paglia in Lombardy there are no stones for making lime but such as are mixed up with infinite variety of things native to the sea, which is now more than 200 miles away.[74]

At Candia in Lombardy, near Alessandria della Paglia, while making a well for Messer Gualtieri of Candia, the skeleton of a very large boat was found about ten braccia beneath the ground; and as the timber was black and fine it seemed good to the said Gualtieri to have the mouth of the well enlarged in such a way that the ends of the boat should be uncovered.

In the mountains of Verona the red marble is found all mixed with cockle shells turned into stone. Some have been filled at the mouth with the cement that is the substance of the stone; and some have remained separate from the mass of the rock around them because the outer covering of the shell had interposed and had prevented them from uniting with it. In other places this cement had petrified the shells and destroyed the outer skin.[26]

One fine day in July he climbed the Monte Rosa.

And this may be seen, as I saw it, by anyone who goes up the Momboso [Monte Rosa], a peak of the Alps that divide France from Italy. At the base of this mountain spring the four rivers which flow four different ways and water all Europe; and no other mountain has its base at so great an elevation. It lifts itself to so great a height as almost to pass above all the clouds; and snow seldom falls there, but only hail in summer when the clouds are at their greatest height; and there this hail accumulates, so that if it were not that the clouds rarely thus rise and discharge themselves, which does not happen twice in a lifetime, there would be an enormous mass of ice there, piled up by the layers of hail, and in the middle of July I found it very considerable.[73]

He penetrated into Savoy and witnessed the flooding of a valley.

That there are springs which suddenly break forth in earth-quake or other convulsions and suddenly fail; and this happened in a mountain in Savoy where certain forests sank in and left a very deep gap; and about four miles from there the earth opened like a gulf in the mountain, and threw out a sudden and immense flood of water which scoured the whole of a little valley of the tilled soil, vineyards, and houses, and wrought the greatest damage wherever it overflowed.[74]

The river Arna, a quarter of a mile from Geneva in Savoy, where the fair is held on midsummer day in the village of Saint Gervais.[75]

On one occasion above Milan, towards Lago Maggiore, I saw a cloud shaped like a huge mountain full of rifts of fire, because the rays of the sun which was already setting red on the horizon tinged it with its own hue. And this cloud attracted to it all the little clouds which were round about

it, and the great cloud did not move from its place, and it retained on its apex the light of the sun for an hour and a half after sunset, so immense was its size; and about two hours after night had fallen there arose a great wind, a thing stupendous and unheard of.

And this, as it became closed up, caused the air which was pent up within it, being compressed by the condensation of the cloud, to burst and escape by the weakest part, rushing through the air with incessant tumult, acting like a sponge squeezed by a hand under water, from which the water wherein it is soaked escapes between the fingers of the hand that squeezes it escaping by rushing through the other water. So it was with the cloud, driven back and compressed by the cold that clothes it, driving away the air with its own impetus and striking it through the other air, until the heat that is mingled with the moisture of the cloud and has drawn it to so great a height flies back towards the centre of the cloud, fleeing the cold which is its contrary, and gathering in the centre becomes powerful, taking fire and spouting damp steam, which surrounds it and creates a furious wind that moves with the fire thrown out by increasing pressure of the steam ... and this is the thunderbolt which afterwards ruins and smashes to pieces whatever opposes its destined course.[76]

On 21 April 1498 Gualtieri Bascape reports to Ludovico il Moro on the decoration by Leonardo of two rooms in the Castello at Milan—the Saletta Negra and the Sala delle Asse.

On 26 April 1498 Isabella d'Este writes to Cecilia Gallerani Bergamini asking her to send Leonardo's portrait of her to Mantua for inspection (see p. 293).

On 29 April Cecilia replies that the portrait was being sent. She regrets that it was so little like her owing to the fact that it was painted at an age when she was very young

*and her beauty as yet undeveloped. Certainly the master
was not to blame, for his ability was incomparable.*

August 1498.

Canal of Ivrea fed by the river Dora; the mountains of
Ivrea have a wild part, and a fertile one towards the south.

The great weight of the barge which passes through the
river which is supported by the arch of the bridge does not
add weight to this bridge, because the barge weighs exactly
as much as the weight of the water that the barge displaced.[77]

*On 2 October 1498 Ludovico il Moro presented Leonardo
with a vineyard sixteen rods in extent outside Porta
Vercellina. Leonardo refers to the measurements of this
vineyard and gives plans of adjacent plots of ground in
MS. I.*

On the *first of August 1499* I wrote on motion and weight.[78]

What is percussion, what is its cause? What is rebound?

Aristotle, Third of Physics, and Albertus [Magnus] and
Thomas [Aquinas] and others on the rebound, in the
Seventh of the Physics; De Coelo et Mundo.[79]

[With figures.]

I ask in what part of its curving movement will the
cause that moves leave the thing moved or movable.

Speak with Pietro Monti of these ways of throwing
spears.[80]

*List of books in Leonardo's possession before his departure
from Milan.*

Book on Arithmetic [*abbaco*].
Flowers of virtue [a medieval bestiary].
Pliny [*Natural History*].
Lives of Philosophers [by Diogenes Laertius].
The Bible.
Lapidary.
On Warfare [by Robertus Valturius].

Epistles of Filelfo [Francesco Filelfo, humanist].

The first, the third, the fourth Decades [by Livy].

On the preservation of health [by Ugo Benzo of Siena].

Cecco d'Ascoli [*Acerba*, encyclopaedia in verse of the 14th century].

Albertus Magnus [on Aristotelian philosophy and science].

Guido. New treatise on Rhetorics. [Probably Guidotto da Bologna, *Retorica nova.*]

Piero Crescentio [on agriculture].

Cibaldone [*Miscellanea*, a treatise on health translated from a work by the Arab physician Rhazes].

Quadriregio [the four realms, religious scientific poem by the Dominican, Federigo Frezzi].

Aesop [Fables].

Donatus [a short Latin syntax].

Psalms.

Justinus [History].

On the immortality of the soul [Dialogue by Francesco Filelfo].

Guido [Guido Bonatti's treatise on Astronomy?].

Burchiello [Sonnets].

Doctrinale [Italian translation of *Doctrinal de Sapience* by Guy de Roy].

Driadeo [by Luca Pulci].

Morgante [by Luigi Pulci].

Petrarch.

Jehan de Mandeville [Travels].

On honest recreation [by Bartolomeo Sacchi, Platina].

Manganello [a satire on women].

The Chronicle of Isidore [History from the creation to A.D. 615 by Isidore of Seville].

The Epistles of Ovid.

Sphere [by Goro Dati].

The Jests of Poggio.

Chiromancy.

Formulary of letters [by Miniatore Bartolomeo].[81]

Meanwhile Ludovico il Moro's policy was proving disas-
trous, and he had to flee while the French king entered
Milan in October 1499. Louis XII was severe and pitiless
towards his enemies. But their works of art appealed to
him. On seeing Leonardo's painting of the Last Supper
he coveted it so much that he anxiously inquired from
those standing around whether it might be detached from
the wall and transported forthwith to France, though
this would have meant the destruction of the famous
refectory.

Among the French invaders was the Comte de Ligny,
who was planning an exploit on his own account in the
hope of gaining possession of the estate in Naples which
had been the property of his late wife, a Neapolitan
princess. His agent was hoping to get financial support
from Venice. That Leonardo had been asked to help and
was making plans to leave Milan for Naples is revealed
by the following note. He hoped on the way to visit his
native place.

Find Ligny★ and tell him that you will wait for him at
Rome★ and will go with him to Naples★. Have the dona-
tions paid, and take the book by Vitolone, and the measure-
ments of the public building. Have two covered boxes made
ready for the muleteer, bed-covers will be best, there are
three of which you will leave one at Vinci. Take the stoves
from the Grazie. Get from Giovanni Lombardo the theatre
of Verona.

Buy handkerchiefs and towels, hats and shoes, four pair
of hose, a jerkin of chamois and skin to make new ones.
The lathe of Alessandro. Sell what you cannot take with

★ These words were spelled backwards presumably for reasons of
secrecy.

you. Get from Jean de Paris* the method of colouring al
secco, and how to prepare tinted paper, double folded, and
his box of colours. Learn to work flesh colours in tempera,
learn to dissolve gum shellac. . . .[82]

*The following note which is not in Leonardo's hand may
refer to a part of the same exploit. He was to report on the
state of the fortifications of Florence after the death of
Savonarola in 1498.*

Memorandum for Master Leonardo to secure quickly in-
formations on the state of Florence, videlicet, in what
condition the reverend father called friar Girolamo had kept
the fortresses. Item the manning and armament of each
command, and in what way they are equipped, and whether
they are the same now.[83]

*The exploit of the Comte de Ligny came to nothing. On
14 December 1499 Leonardo sent his savings amounting
to 600 florins to be deposited at Santa Maria Nuova in
Florence. He then left Milan for Venice in the company
of Fra Luca Pacioli. They stopped at Mantua on their
way and were welcomed by the Duchess Isabella d'Este,
who sat to Leonardo for the drawing of her profile which
is now at the Louvre. Though her sympathies were with
her defeated brother-in-law, Ludovico, she was anxious
to conciliate the victor and save her husband's little state
and she invited the Comte de Ligny, who was a connexion
of her family, to Mantua.*

*In the first days of February 1500 Ludovico crossed the
Alps and re-entered Milan. His friends rejoiced, but
the struggle was not yet over. Leonardo was awaiting
the outcome in Venice.*

* The French painter Jean Perréal accompanied the French king
to Italy. A portrait drawing of the Comte de Ligny, attributed to
Perréal, is at Chantilly.

III. VENICE, FLORENCE, ROMAGNA,
1500–6

On 15 March 1500 *Lorenzo da Pavia, il Gusnasco, the lutanist, wrote from Venice to Isabella d'Este that he had seen Leonardo's portrait drawing of her and had found it so good, it could not be better.*

Giorgione was twenty-three years old at the time when Leonardo arrived in Venice. The two artists probably met. According to Vasari, Giorgione was influenced by certain works of Leonardo which he admired for their envelopment in light and shade.

On the Piazza of SS. Giovanni e Paolo Leonardo could see the bronze equestrian statue of Bartolommeo Colleoni which was modelled by his master Verrocchio after he had left Florence, and cast in bronze by Al. Leopardi in 1493.

The Venetian Senate availed itself of Leonardo's presence to procure his advice on the defences at Friuli and on the river Isonzo. The Turks, who had defeated the Venetian fleet at Lepanto in August 1499, were now menacing the frontier. In the following draft Leonardo advocates a scheme for inundating the country-side. On the same sheet is a sketch of road and river communications with the inscription:

Bridge of Gorizia, Wippach

My most illustrious Lords—As I have carefully examined the conditions of the river Isonzo, and have been given to understand by the country folk that whatever route on the mainland the Turks may take in order to approach this part of Italy they must finally arrive at this river, I have therefore formed the opinion that even though it may not be possible to make such defences upon this river as would not ultimately be ruined and destroyed by its floods. . . .[84]

*On a later date he recalls the work on a sluice at Friuli
made at this time.*

And let the sluice be made movable like the one I devised
in Friuli, where when the floodgate was open the water
which passed through hollowed out the bottom.[85]

> At Rome
> At old Tivoli, Hadrian's Villa.
> Laus deo. 1500 . . . day of March.[86]

*If the above notes on one and the same sheet were written
at the same time, it may be assumed that Leonardo went to
Rome on a short visit.*

*On 10 April 1500 Ludovico il Moro was finally
defeated and taken prisoner by the French at Novara.*

Leonardo comments on the events at Milan:

The Governor of the castle made a prisoner,
 Visconti carried away and his son killed,
 Giovanni della Rosa deprived of his money. . . .
 The Duke lost the state, his property, and his liberty and
none of his enterprises have been completed.[87]

*On 24 April 1500 Leonardo drew fifty golden florins
from his deposit at Santa Maria Nuova in Florence. On
that date he was therefore again established in that city
which he had left eighteen years ago. During his absence
the Medici had been banished and Florence had become a
republic. His father was now procurator of the monastery
of the Servite brothers. Vasari relates that Filippino Lippi
voluntarily gave up a commission to paint an altar-piece
at Santissima Annunziata for this brotherhood when
Leonardo expressed the wish to undertake such a work.
The friars took Leonardo into their house and bore the*

expense of his household. His cartoon representing the Virgin, St. Anne, and Christ filled all artists with wonder, and was viewed for two days by crowds of people as if attending a solemn festival.

On 11 August 1500 the Marchese of Mantua received from his agent a plan of a small palace drawn by Leonardo for the merchant Angelo del Tovaglia.

A contemporary account of Leonardo's activities occurs in a letter written from Florence in April 1501 by the Vicar General of the Carmelites, Fra Pietro di Novellara, to Isabella d'Este in answer to questions she had put him as to the possibility of persuading him to paint a subject picture for her 'studio', or failing this a 'Madonna and Child' devoto e dolce come è il suo naturale. *It runs as follows: 'As far as I can learn Leonardo's life is so irregular and unsettled that he may be said to live from day to day. He has done one sketch only since he has been in Florence, a cartoon in which Christ is represented as about a year old and as almost leaping from his mother's arms to seize a lamb which he seems to embrace. His mother almost rising from St. Anne's knees takes hold of the Child in order to separate him from the Lamb (a sacrificial creature) which represents the Passion. St. Anne who rises slightly from her seat and seems to restrain her daughter from separating the Child from the Lamb, may represent the Church, who would not that the Passion of Christ were hindered. The figures are as large as life, but occupy a small cartoon, because they are all either seated or bent, one of them is a little in front of the other on the left. This drawing is still unfinished. He has done no other work.' This cartoon corresponds approximately with the picture in the Louvre, and has been lost. In Vasari's time the tradition of the excitement and delighted interest roused*

*by the exhibition of the cartoon was still alive and he gives a vivid description thereof.**

A week later Fra Piero wrote again after having visited Leonardo on the Wednesday of the Passion Week. They had come to the following understanding: If Leonardo should succeed in releasing himself from his engagement with the King of France, he would serve Marchesa Isabella in preference to anyone else in the world. In any case he will paint the portrait at once, for he had finished the small picture for Florimond de Robertet, a favourite of the King of France, representing the Madonna trying to take a yarn winder out of the hands of the Child, who is contemplating its cruciform shape and playfully trying to retain it. This work is now lost. Copies of it are in the collections of the Duke of Buccleugh and of Mr. Reford.

On 19 September 1501 Ercole I of Ferrara, Isabella's father, wrote to his agent to inquire whether the French governor at Milan would cede the colossal horse, which Leonardo had modelled for the Sforza monument, and which was standing neglected and exposed to wind and weather in the castle square. The French governor replied that he could not cede the model without the consent of his king.

On 12 May 1502 Leonardo did Isabella d'Este a small service by examining and reporting on some jewelled vases in Florence, formerly the property of Lorenzo il Magnifico.

In the summer of 1502 Leonardo entered the service of Cesare Borgia who, with the approval of the Pope and the French king, was subduing the local despots in the Romagna to his rule. He witnessed the most brilliant period of that adventurous career; and the notebook which he carried with him that summer and autumn makes interest-

* For an earlier version of the subject see p. 321.

ing reading when viewed against the lurid background of those ferocious and treacherous events.

Made by the sea at Piombino.[88]

Many years later when writing a description of a deluge Leonardo recalled his observations made at this sea-side place.

Waves of the sea at Piombino all of foaming water;
 Of water that leaps up at the spot where the great masses strike the surfaces;
 Of the winds at Piombino;
 The emptying the boats of the rain water.[89]

During his stay at Piombino he planned the draining of its marshes.

A method of drying the marsh of Piombino.[90] [With a slight sketch.]

He studied aerial perspective in a sailing-boat plying between the mainland and the mountainous island of Elba.

When I was in a place at an equal distance from the shore and the mountains, the distance from the shore looked much greater than that of the mountains.[91]

Passing through Siena he examined a famous bell on the tower of the Palazzo Publico, by the side of which stood a wooden statue, coated with brass plates, which struck the hours with a hammer.

Bell of Siena, the manner of its movement and the position of the attachment of its clapper.[92]

In June Leonardo was at Arezzo where Cesare Borgia's condottiere was fighting. He was anxious to secure a book by Archimedes with his help.

Borges shall get for you the Archimedes from the bishop of Padua, and Vitellozzo the one from Borgo San Sepolcro.[93]

Had any man discovered the range of power of the cannon, in all its variety, and had given such a secret to the Romans, with what speed would they have conquered every country, and subdued every army, and what reward would have been great enough for such a service! Archimedes, although he had greatly damaged the Romans in the siege of Syracuse, did not fail to be offered very great rewards by these same Romans. And when Syracuse was taken diligent search was made for Archimedes, and when he was found dead greater lamentation was made in the Senate and among the Roman people than if they had lost all their army; and they did not fail to honour him with burial and statue, their leader being Marcus Marcellus. And after the second destruction of Syracuse the tomb of this same Archimedes was found by Cato in the ruins of a temple; and so Cato had the temple restored and the tomb he so highly honoured . . . and of this Cato is recorded to have said that he did not glory in anything so much as in having paid this honour to Archimedes.[94]

Meanwhile he studied the topography and made maps of the district for military purposes.

From Bonconvento to Casanova 10 miles; from Casanova

to Chiusi 9 miles, from Chiusi to Perugia 12 miles; from Perugia to Santa Maria degli Angeli and then to Foligno.[95]

For a reproduction of a tinted map of the Valle di Chiana see R., Plate CXIII. Leonardo's method of procedure in drawing maps was first to chart the river systems and determine the locality of the towns and then around these watersheds insert the mountains. The result was very suggestive of the nature of the terrain. The following note refers to drawing of maps.

On the tops of the sides of the hills foreshorten the shape of the ground and its division, but give its proper shape to what is turned towards you.[96]

While studying the watersheds of Chiana and the upper Arno he looked for shells in order to ascertain whether these parts had been submerged by the sea in former ages.

Where the valleys have never been covered by the salt water of the sea there shells are never found; as is plainly visible in the great valley of the Àrno above Gonfolina, a rock which was once united with Monte Albano in the form of a very high bank. This kept the river dammed up in such a way that before it could flow into the sea which was then at the foot of this rock, it formed two large lakes, the first of which was where we now see the flourishing city of Florence together with Prato and Pistoia. . . . In the upper part of the Val d'Arno, as far as Arezzo, a second lake was formed which discharged its waters into the above-mentioned lake. It was shut in at about where now we see Girone, and it filled all the valley above for a distance of forty miles. This valley received upon its base all the soil brought down by the turbid waters and it is still to be seen at its maximum height at the foot of **Prat**o Magno for there the rivers have not worn it away.

Across this land may be seen the deep cuts of the rivers which have passed there in their descent from the great mountain of Prato Magno; in which cuts there are no traces of any shells or of marine soil. This lake was joined to that of Perugia.[97]

Pigeon House at Urbino. *30 July 1502*[98]

Passing through Urbino Leonardo saw the magnificent Renaissance castle built for the Condottiere Federigo di Montefeltro. It had been a renowned centre of art and literature. Now young Guidobaldo, Federigo's son and heir, had fled from his home.

The fortress of Urbino.[99]

The following profetia *in the same notebook was probably suggested by the pillage of the palace whose treasures Cesare Borgia had sent to Cesena.*

Of mules which have on them rich burdens of silver and gold. Much treasure and great riches will be laid upon four-footed beasts which will convey them to divers places.[100]

In ascending the staircase of the pillaged palace Leonardo made a hasty sketch of the columned arches on one of the landings.

Another sketch illustrates the unsatisfactory effect of a plinth which is narrower than the wall.

Steps of Urbino.

The plinth must be as broad as the thickness of the wall against which the plinth is built.[101]

First day of August 1502. At Pesaro, the Library.[87]

There is harmony in the different falls of water as you saw at the fountain of Rimini on the *8th day of August 1502*.[102]

The shepherds in the Romagna at the foot of the Apennines make peculiar large cavities in the mountains in the form

of a horn, and on one side they fasten a horn. This little horn becomes one and the same with the said cavity and thus they produce a very loud sound by blowing into it.[103]

In Romagna, the realm of all the dullards, they use carts with four equal wheels, or they have two low in front and two high ones behind and this is a great restraint on movement because more weight is resting upon the front wheels than upon those behind, as I have shown.

... And these first wheels move less easily than the large ones, so that to increase the weight in front is to diminish the power of movement and so to double the difficulty.

[With a drawing.]

Here the larger wheel has three times the leverage of the small wheel; consequently the small one finds three times as much resistance and to add a hundred pounds [necessitates adding] two hundred more to the small [wheel].[104]

[With drawing of castle, R., Vol. II, Plate CX, 4.]

St. Mary's Day, the *middle of August at* Cesena 1502.[105]

[With a sketch of two bunches of grapes hanging on a hook.]

Thus grapes are carried at Cesena.[106]

A visit to Cesare Borgia of a delegation from the Sublime Porte revived Leonardo's interest in the East. The Sultan was planning the construction of a bridge between Pera and Constantinople to replace a wooden structure resting on heavy barges that had been thrown across the Golden Horn.

Leonardo drew a plan for the bridge in his notebook.

Bridge from Pera to Constantinople.

40 ells wide, 70 ells above water, and 600 ells long, 400 ells being above the water and 200 resting on land. In this way it provides its own supports.[107]

On 18 August 1502 Cesare Borgia while conferring at Pavia with the French king appointed Leonardo his chief engineer. He was to supervise the fortresses in the conquered provinces and was given power to requisition whatever was needed.

[With drawing.]

At Porto Cesenatico on the *6th of September 1502* at the 15th hour. How the bastions should project beyond the walls of towns to defend the outer slopes, so that they may not be struck by artillery.[107]

On returning to Romagna Cesare Borgia found himself isolated at Imola, his captains conspiring against him, Urbino in revolt. From this time dates Leonardo's tinted plan of Imola with indication of the distances to places in the neighbourhood (R., Plate CXI). Florence espoused the cause of Cesare and sent Niccolo Macchiavelli with offers of help. He and Leonardo met and became friends. They both were now able to observe the course of events which culminated in Cesare murdering his disaffected captains as they met him in order to be reconciled, on 12 December 1502. Among the victims was Vitellozzo Vitegli (see p. 344). The campaign was over and Cesare left for Rome in February 1503.

Macchiavelli gave to his ideal image of a statesman in the pages of Il Principe *the name of Valentino after Cesare Borgia, the Duke of Valentino. In the following note Leonardo also refers to him by that name.*

Where is Valentino?

Boots, boxes in the customhouse, the monk at Carmine, squares.

Piero Martelli.

Salvi Borghesini.

return the bags.
a support for the spectacles.
the nude of Sangallo.
the cloak. . . .[108]

On his return to Florence Leonardo was probably lodging
at or near the ecclesiastical hospital of Santa Maria Nuova
where he had deposited his money.

Memorandum. That *on the eighth day of April 1503* I,
Leonardo da Vinci, lent to Vante, the miniature painter,
four gold ducats. Salai carried them to him and gave them
into his own hand, and he said he would repay them within
the space of forty days.

Memorandum. How on the same day I paid to Salai
three gold ducats which he said he wanted for a pair of
rose-coloured hose with their trimming. And there remain
nine ducats due to him—excepting that he owes me twenty
ducats; seventeen I lent him at Milan and three at Venice.[109]

This old man, a few hours before his death told me that he
had lived a hundred years, and that he did not feel any
bodily ailment other than weakness, and thus while sitting
on a bed in the hospital of Santa Maria Nuova at Florence
without moving or sign of anything amiss, he passed from
this life. And I examined the anatomy to ascertain the cause
of so sweet a death, and found that it was caused by weak-
ness through failure of blood and of the artery that feeds
the heart and the lower members which I found to be very
parched and shrunk and withered; and the result of this
examination I wrote down very carefully. . . . The other
autopsy was on a child of two years old, and here I found
everything the contrary to what was the case in the old
man. . . .[110]

[With a drawing.]
This is the reverse of the tongue, and its surface is rough
in many animals and especially in the leonine species, such

as lions, panthers, leopards, lynxes, cats and the like which have the surface of their tongues very rough as though covered with minute somewhat flexible nails; and when they lick their skin these nails penetrate to the root of the hairs, and act like combs in removing the small animals which feed upon them.

And I once saw how a lamb was licked by a lion in our city of Florence, where there are always twenty-five to thirty of them, and they bear young. The lion with a few strokes of his tongue stripped off the whole fleece of the lamb, and after having made it bare, ate it.[111]

On 24 July 1503 he visited the camp of the Florentine army besieging Pisa and approved of a plan to straighten the river so as to deprive Pisa of its water and make Florence directly accessible from the sea. The plan had the support of his friend Macchiavelli, and if feasible would end the war between Florence and Pisa which had been dragging on for years. The report from the camp says: 'Yesterday came here accompanied by one of the Signoria, Alessandro degli Albizzi with Leonardo da Vinci and others and after seeing the plan and after many discussions and doubts it was decided that the undertaking would be very much to the purpose. . . .' The expense of this visit was borne by the State and comprised the use of carriages and six horses.

Leonardo drew maps of the lower course of the Arno (see R., Plate CXII) and work was begun in August 1504. He had previously acquired a thorough knowledge of the upper river course at Arezzo (see p. 345) and was therefore able to visualize its history. He combined his engineering with geologizing.

Underground, and under the foundation of buildings, timbers are found of wrought beams already black. Such

were found in my time in those diggings at Castel Fiorentino. And these had been in that place before the sand carried by the Arno into the sea had been raised to such a height; and before the plains of Casentino had been so much lowered by the action of the Arno in constantly carrying down earth from there.[26]

They do not know why the Arno never keeps its channel. It is because the rivers which flow into it deposit soil where they enter and wear it away from the other side bending the river there. . . .[112]

The eddy made by the Mensola when the Arno is low and the Mensola full.[113]

The work, started in August 1504, *was abandoned in October. But Leonardo's mind continued to dwell on the problem. A year later on meeting the Florentine engraver and medallist Niccolò di Forzore Spinelli, he noted down his account of methods of canalization adopted in Flanders.*

That a river which is to be turned from one place to another must be coaxed and not treated roughly or with violence; and to do this a sort of dam should be built into the river, and then lower down another one projecting farther and in like manner a third, fourth, and fifth so that the river may discharge itself into the channel allotted to it, or by this means it may be diverted from the place it has damaged as

was done in Flanders according to what I was told by
Niccolò di Forzore.*

How to protect and repair a bank struck by the water
as below the island of Cocomeri. . . .[114]

*In October 1503 Leonardo rejoined the painters' guild
in Florence. On 18 October the Signoria commis-
sioned him to paint a large fresco on one of the walls of
the new Sala di Gran Consiglio in the Palazzo Vecchio.
The painting was to commemorate a former victory over
Pisa, won by the generals of the republic in 1440 over
Niccolò Piccinino. Leonardo chose an episode in a battle
which took place near a bridge at Anghiari in the upper
valley of the Tiber, a terrific struggle for the colours be-
tween the opposing sides. The description of the battle
which was drawn up for his use has survived among his
manuscripts (cf. R., 669 note).*

Memorandum of events in the Battle of Anghiari

Florentines	Niccolò da Pisa
Neri di Gino Capponi	Count Francesco
Bernardetto de' Medici	Micheletto
	Pietro Gian Paolo
	Guelfo Orsino
	Messer Rinaldo degli Albizzi

Begin with the address of Niccolò Piccinino to the
soldiers and exiled Florentines, among whom was Messer
Rinaldo degli Albizzi. Then let it be shown how the first
mounted his horse in armour, and the whole army follow-
ing him: 40 squadrons of horse and 2000 foot soldiers went
with him.

And the Patriarch [of Aquileja] at an early hour in the
morning ascended a hill to reconnoitre the country, that
is the hills, fields, and a valley watered by a river; and he
beheld Niccolò Piccinino approaching from Borgo San

*Niccolò di Forzore Spinelli, engraver and medallist (1430–1514).

Sepolcro with his men and a great cloud of dust, and having discovered him he returned to the camp of his own people and spoke with them.

And having spoken he clasped his hands and prayed to God; and presently he saw a cloud, and from the cloud St. Peter* emerged and spoke to the Patriarch. . . .

500 cavalry were sent by the Patriarch to hinder or check the attack of the enemy. In the foremost troop was Francesco, the son of Niccolò Piccinino, and he arrived first to attack the bridge which was held by the Patriarch and the Florentines. Beyond the bridge on the left he sent infantry to engage our men who beat them off. Their leader was Micheletto whose lot it was to be that day at the head of the army. Here, at this bridge, there was a severe struggle; our men conquered and the enemy is repulsed. Then Guido and Astorre his brother, the Lord of Faenza, with many men reformed and renewed the fight, and rushed upon the Florentines with such force that they recovered the bridge and pushed forward as far as the tents. Against these Simonetto advanced with 600 horses to fall upon the enemy and he drove them back from the place and recaptured the bridge; and behind him more men with 2000 horse; and so for a long time the battle swayed. And then the Patriarch to throw disorder into the enemy sent forward Niccolò da Pisa and Napoleone Orsino, a beardless youth, followed by a great multitude of men. And then was done another great feat of arms. At the same time Niccolò Piccinino pushed forward the remnant of his men, who once more made ours give way; and had it not been for the Patriarch setting himself in their midst and sustaining his captains by words and deeds our soldiers would have taken to flight. And the Patriarch had some artillery placed on the hill and with these he dispersed the enemy infantry; and the disorder was so complete that Niccolò began to call back his son and all his followers, and they took to

* The battle was fought on St. Peter and St. Paul's day, 29 June 1440.

flight towards Borgo; and then began a great slaughter of men. None escaped except those who were the first to flee, or those who hid themselves. The fighting continued until sunset when the Patriarch gave his mind to recalling his men and burying the dead; and afterwards he set up a trophy.[115]

Leonardo composed the cartoon for this battle-piece in the Sala del Papa near Santa Maria Novella which was put at his disposal on 24 October 1503, and he continued to work there until its completion in February 1505. *He was also working on the portrait of Mona Lisa, the wife of Francesco Giocondo, which is now in the Louvre. While she was sitting for him he 'retained musicians who played and sang and jested in order to dispel that melancholy that painters tend to give their portraits'. According to Vasari he worked on this picture for four years and left it unfinished; while another Florentine portrait, that of Ginevra Benci, was said to have been so highly finished that 'it looked like Ginevra herself and not like a picture'. On 25 January 1504 Leonardo took part in a consultation on the placing of the colossal statue of David by Michelangelo, and voted in favour of the Loggia dei Lanzi against the majority. The names of some of the artists who took part occur in his notes of that time.*

Piero di Cosimo, Lorenzo [di Credi], Filippo [Filippino Lippi], [Andrea] Sansovino, Michelangelo [da Viviano, goldsmith], Cronaca [architect].[116]

On 4 May 1504 Leonardo received 35 gold florins for his work on the battle-piece. He was promised further monthly payments of 15 florins, and undertook to complete the cartoon by February 1505.

On 24 May 1504 Isabella d'Este wrote from Mantua

*begging him to paint a figure of the young Christ. He was
to be about twelve years old, the age when he disputed with
the Elders in the temple. She would prefer this to her own
portrait, and she would pay whatever he wished. Her one
preoccupation would be to give him pleasure. Leonardo
in reply promised to devote his spare time to this work.*

On *the 9th day of July 1504* on Wednesday at seven o'clock
at the Palace of the Podestà died Ser Piero da Vinci, notary,
my father. He was eighty years old, and left ten sons and
two daughters.[117]

*The following fragment of a letter, written some time
previously, testifies to his filial devotion.*

Dearest father, I received your letter on the last day of last
month and it gave me pleasure and pain at the same time:
Pleasure in so far as by it I have learned that you are well,
for which I thank God. But I was pained to hear of your
troubles. . . .[118]

On the morning of St. Peter's day *June 29, 1504* I took 10
ducats, and gave one to my servant Tommaso to spend.

On Monday morning 1 florin to Salai to spend for the
house.

On Tuesday I took 1 soldo for myself.

Wednesday evening 1 florin to Tommaso before supper.

Saturday morning 1 soldo to Tommaso.

Monday morning 1 florin less 10 soldi.

Thursday to Salai 1 florin less 10 soldi.

For a jerkin 1 florin.

For a jerkin and a cap 2 florins.

To the hosier 1 florin.

To Salai 1 florin.

Friday morning July 19 1 florin less 6 soldi.

I have 7 florins left and 22 in the box.

Tuesday the 23rd of July 1 fl. to Tommaso.

Sunday the *4th of August* 1 florin.

Friday the *9th of August 1504* I took ten ducats out of the box.[119]

Saturday morning *August 3rd 1504* Jacopo, the German, came to live with me and agreed that I should charge him a carlino a day.[120]

The following account, given by Giovanni di Gavina, a Florentine painter and friend of Leonardo, appears in the Codice Magliabecchiano: *'As Leonardo, accompanied by G. di Gavina, was passing the Spini bank, near the Church of Santa Trinità, several notables were assembled, who were discussing a passage in Dante, and seeing Leonardo, they bade him come and explain it to them. At the same moment Michelangelo passed, and one of the crowd calling to him, Leonardo said:* "Michelangelo will be able to tell you what it means." *To which the latter, thinking this had been said to entrap him, replied:* "Nay, do thou explain it thyself, horse modeller that thou art— who, unable to cast a statue in bronze, wast forced with shame to give up the attempt", *so saying he turned his back upon them and departed. Leonardo remained silent and blushed at these words.'*

Young Michelangelo procured a commission in August of 1504 to paint a companion piece to Leonardo's Battle of Anghiari in the Sala del Gran Consiglio.

On 31 October 1504 Isabella d'Este wrote to remind him of his promise to paint a young Christ for her. 'When you are vexed with that Florentine history be so good as to do my figure by way of relaxation.'

He had at this time begun to make studies for his picture of Leda and the Swan. These were admired and copied by the young Raphael, who arrived in Florence towards the end of 1504.

On 14 March 1505 *the great hall of the municipal council was made ready for Leonardo to paint his battle-scene on one of the walls.* He had completed the cartoon, which was exhibited along with that of Michelangelo. The two rival works seemed a revelation of the powers of art and served as a model to students, among whom was the young Raphael.

On that same day of March Leonardo went to Fiesole, where he owned a vineyard. On his way he stopped to watch the flight of a bird of prey. He was studying the principles of flight and planning to build a machine that was to start from the mountain top above Fiesole. The name of the mountain, 'Ceceri' signifying swan, seemed apposite. There is, however, no definite evidence that the experiment was actually tried out.

The little notebook on the flight of birds in the Royal Library at Turin dates from this time (see p. 88).

When the bird has great breadth of wings and a small tail and wants to raise itself, it will raise its wings vigorously and in turning, it will receive the wind under its wings. This wind surrounding it will drive it with swiftness as is the case with the 'cortone', bird of prey, which I saw as I was going to Fiesole, above the place of Barbiga, in *1505*, *on fourteenth day of March.*

From the mountain which is named after the great bird, the famous bird which will fill the world with its great fame will start on its flight.[121]

The first flight of the great bird from the summit of the Monte Ceceri will fill the universe with wonder; all writing will be full of its fame, bringing eternal glory to the place of its origin.[122]

The following dated note occurs in the same booklet.
On Tuesday evening the *14th day of April* Lorenzo came

to stay with me. He said that he was seventeen years of age; and on the *15th day of April* I received 25 florins from the chancellor of Santa Maria Nuova.[121]

Vespuccio will give me a book on geometry.[123]

Amerigo Vespucci, who gave his name to America, sprang from a Florentine family. The accounts of his journeys written from Portugal in 1503 and 1504 to friends in Florence were probably known to Leonardo. The extensive voyages of Spaniards and Portuguese had awakened interest in geographical problems.

Leonardo was sharing his passion for cosmographical studies with Giovanni Benci, kinsman of Ginevra Benci, whose portrait he had painted.

Map of the world from Giovanni Benci. Giovanni Benci has my book and jaspers.

Pandolfino's* book, Lactantius of the Daldi; Aristotle on celestial phenomena; Libraries at St. Mark's and at Santo Spirito; Have book bound.

Learn the multiplication of roots from Maestro Luca [Pacioli]; Rosso's mirror—watch him make it;

To make the bird; amount of material for the wings;

An apprentice for making the models;

Glovecase for Lorenzo de' Medici [Lorenzo Piero di Francesco, head of firm].

Have the vest dyed; repair the cloak; brass for spectacles; red Cordova leather; clothes from the custom house officer.[124]

On 30 April 1505 Leonardo received payment from the Signoria for work done in the Sala del Gran Consiglio. The customs duty on a parcel of clothes from Rome was also paid for him. Had he been to Rome?

Book entitled 'Of Transformation' that is of one body into

* See p. 360.

another without diminution or increase of substance, begun by me, Leonardo da Vinci on *the 12th day of July 1505.*[125]

The first portion of this manuscript deals with geometric solids.

Meanwhile Leonardo was painting the central group of his battle-scene on the wall allotted to it in the Sala del Gran Consiglio. He adopted a technical method by which the colours were to be made secure upon the wall by the application of heat, with unsuccessful results. Antonio Billi ascribes the failure to the artist having been cheated over his linseed oil.

On 27 April 1506 *the confraternity of the Immaculate Conception in Milan agreed to pay an extra 200 lire, in addition to the sum already paid, for the painting of the Virgin of the Rocks to Leonardo and Ambrogio de Predis. The picture was returned to the artists for finishing touches, and then rehung in the chapel; while Leonardo's earlier version known as 'Vierge aux Rochers' was taken to France. Cf. pp. 293 and 368.*

IV. SECOND MILANESE PERIOD
1506–13

In the spring of 1506 Charles d'Amboise, Lord of Chaumont, the French governor of Milan, planning to maintain the civilization of the Sforzas, invited Leonardo to join him. Leonardo left Florence with the 'Battle of Anghiari' still unfinished but with a promise to the Signoria, on 30 May 1506, *that he would return within three months.*

On 19 August 1506 *the French Chancellor at Milan, Geffroy Carles (Goffredo Karoli), wrote to Florence announcing that Charles d'Amboise asked for an extension of Leonardo's stay. Pier Soderini answered from*

Florence on 9 October 1506 that Leonardo had accepted a good sum of money, and had hardly more than begun the important work expected of him. Nevertheless he had to relinquish his claims, and Leonardo remained at Milan.

On 2 January 1507 Francesco Pandolfini, Florentine ambassador to Louis XII, wrote from Blois to the Signoria: 'Being this morning in the presence of the most Christian King, his Majesty called for me and said: "Your Government must do something for me. Write to them that I wish Master Leonardo, their painter, to work for me. And see that your Government command him to serve me at once, and not to leave Milan until I go there. He is a good master and I wish to have several things from his hand." I then asked his Majesty what works he desired and he answered: "Certain small panels of Our Lady and other things as the fancy shall take me; and perhaps I shall also cause him to make my own portrait."'

'His Majesty asked [says Pandolfini] if I knew him. I replied that he was a close friend of mine. "Then write him some verses", said the King, "telling him not to leave Milan, at the same time as your Governors are writing to him from Florence"; and for this reason I wrote a verse to Leonardo, letting him know the good will of his Majesty and congratulating him on the news.'

On 20 April 1507 the vineyard which Ludovico il Moro had presented to Leonardo was returned to him by an order of Charles d'Amboise. On 24 May 1507 the French king re-entered Milan in triumph. At the festivities Leonardo resumed his function as organizer of brilliant entertainments. Amongst the guests were Isabella d'Este and her brother Cardinal Ippolito d'Este.

One of the supporters of the French cause against the Sforzas who was now in power was the Milanese noble-

*man Gian Giacomo Trivulzi. In a will, dated August 1504,
he had made provision for a monumental tomb to be
erected in the Church of San Nazaro at the cost of 4,000
ducats. Leonardo made an estimate for this monument
which included a bronze life-size equestrian statue, an
elaborate eight-columned base with the figure of the
deceased carved in stone resting on the sarcophagus. This
commission seemed to offer an opportunity of creating
something that would compensate for the destruction of his
masterpiece, the colossal horse for the monument of
Francesco Sforza. But also this work, carefully planned
and calculated, was not brought to completion owing to
the unsettled times. We quote below a few items of the
estimate amounting to a total of 3,046 ducats. His sketches
for the memorial are at Windsor.*

The monument of Messer Giovanni Jacomo Trevulzo.
 Cost of making and materials for the horse. A courser as
large as life with the rider.
 For cost of material duc. 500
 Cost of pit and furnace for casting of framework duc. 200
 To make model in clay and in wax duc. 432
 To the workmen for polishing after its cast. duc. 450
 Cost of the marble for the monument duc. 389
 Cost of the work on the marble duc. 1075.[126]

*The size and function of each block is described, and the
cost of the work on each is quoted separately.
In the following letter, addressed to his stepmother,
Leonardo announces his intention of returning to Florence
for a brief stay in order to settle a litigation with his
brother over the estates of his father and uncle.*

In the name of God on *the 5th of July 1507.*
 My dearly beloved mother, sisters and brother-in-law,

I herewith inform you that I am well, thank God, and I hope the same of you. To remind you what to do with the sword that I left with you—take it to Piazza Strozzi to Maso delle Viole for him to be sure to keep it as I set great store by it; and I recommend to you those clothes. And remember me graciously to Dianira so that she should not say that I have forgotten her, and remember me also to my brother-in-law, and tell him that I shall soon be there for the whole month of September . . . and I shall settle the business with Piero so that he will be satisfied.[127]

On 15 August 1507 he returned to Florence with letters of recommendation from Charles d'Amboise and the French king to the Signoria pressing for a speedy settlement of the lawsuit with his brothers so that he may return to his work in Milan. In the following letter preserved in the library of Modena he asks the support of the Cardinal Ippolito d'Este in the same personal matter.

Most Illustrious, most Reverend, and my Unique Lord, the Lord Ippolito, Cardinal of Este. My Supreme Lord, at Ferrara. Most Illustrious and Most Reverend Lord.

A few days ago I arrived from Milan, and finding that one of my elder brothers refuses to carry out the provisions of a will made three years ago when our father died and because I would not fail in a matter that I esteem most important, I cannot forbear to request of your most Reverend Highness a letter of recommendation and favour to Ser Raphaello Hieronymo, who is now one of the members of the illustrious Signoria, before whom my cause is being argued; and more particularly it has been referred by his Excellency the Gonfaloniere to the said Ser Raphaello so that his lordship may have to decide and bring it to completion before the coming of the festivals of All Saints.

And therefore, My Lord, I entreat you as urgently as I

know how and am able, that Your Highness will write a
letter to the said Ser Raphaello in that happy and engaging
manner that you can use, commending to him Leonardo
da Vinci, your most humble servant as I call myself and
always wish to be; requesting him and pressing him that he
may not only do me justice but do so with kindly urgency:
and I have no doubt at all from many reports that have
reached me that as Ser Raphaello is most affectionately
devoted to Your Highness, the matter will proceed ad
votum. And this I shall attribute to the letter of your most
Reverend Highness, to whom once more I commend
myself. Et bene valeat.

Florence, *18 September 1507*
E.V.R.D.

your humble servant,
Leonardus Vincius, pictor.[128]

*During his visit to Florence Leonardo stayed in the house
of Piero di Braccio Martelli, a scholar and patron of
artists. At that time the sculptor Gian Francesco Rustici
was working in the same house on the bronze group of the
Baptist standing between a Pharisee and a Levite, now
placed over the north door of the Baptistry. Vasari reports:
'While Gian Francesco was at work on the clay model for
this group he wished no one to come near him except
Leonardo da Vinci who in making the moulds, preparing
the armature and at every point up to the casting of the
statues never left him; hence some believe that Leonardo
worked at them with his own hand or at least helped Gian
Francesco with advice and good judgment.'*

Begun in Florence, in the house of Piero di Braccio
Martelli, on the *22nd day of March, 1508*. And this is to be a
collection without order, taken from many papers, which
I have copied here.[129]

The above explanation served as prologue to a series of notes on physics (see Preface p. vii).

If you keep the details of the spots of the moon under observation you will often find great variation in them, and this I myself have proved by drawing them. . . .[130]

The following drafts of letters addressed to patrons and friends at Milan were written by Leonardo from Florence. They reflect a desire on his part to make sure of their support and of the privileges that had been promised.

Now that he was no longer young he was anxious to concentrate on his studies and to make arrangements accordingly.

I am afraid lest the small return I have made for the great benefits I have received from your Excellency* has made you somewhat angry with me, and that is why I have never had an answer to so many letters which I have written to your Lordship. I now send Salai to explain to your Lordship that I am almost at an end of the litigation I had with my brothers; and I hope to find myself with you this Easter, and to carry with me two pictures of two Madonnas of different sizes. These were done for our most Christian King, or for whomsoever your Lordship may please. I shall be very glad to know on my return thence where I may have to reside, for I would not give any more trouble to your Lordship. Also as I have worked for the most Christian King whether my salary is to continue or not. I wrote to the president† as to that water which the king granted me, and which I was not put in possession of because at the

* Another almost identical draft gives the name of the addressee as Antonio Maria, probably Antonio Maria Pallavicino, a distinguished Milanese noble, interested in the road and water system of Lombardy.

† Geffroy Carles, President du Dauphiné, Vice-Chancellor of Milan. See p. 359.

time there was a dearth in the canal by reason of the great
droughts and because its outlets were not regulated; but
he certainly promised me that when this was done I should
be put in possession. Thus I pray your Lordship that you
will take so much trouble now that these outlets are regu-
lated as to remind the President of my matter; that is to
give me possession of this water, because on my return I
hope to make instruments there and other things which will
greatly please our most Christian King. Nothing else occurs
to me. I am always yours to command.[131]

Magnificent President: Having oft-times remembered
the proposals made many times to me by your Excellency,
I take the liberty of writing to remind your Lordship of the
promise made to me at my last departure, that is, the pos-
session of the twelve inches of water granted to me by the
most Christian King. Your Lordship knows that I did not
enter into possession, because at that time when it was given
to me there was a dearth of water in the canal, as well by
reason of the great drought as also because the outlets were
not regulated; but your Excellency promised me that as
soon as this was done, I should have my rights. Afterwards
hearing that the canal was completed, I wrote several times
to your Lordship and to Messer Girolamo da Cusano,*
who has in his keeping the deed of this gift; and so also I
wrote to Corigero and never had a reply. I now send Salai,
my pupil, the bearer of this, to whom your Lordship may
tell by word of mouth all that happened in the matter about
which I petition your Excellency. I expect to go thither
this Easter since I am nearly at the end of my lawsuit, and
I will take with me two pictures of our Lady which I had
begun, and have brought on to a very good end; nothing
else occurs to me.

*Draft of a letter to Francesco Melzi, a young Milanese
noble, who was to remain his friend to the end of his life.*

* Member of the Milanese Senate.

Good day to you, Messer Francesco. Why, in God's name, of all the letters I have written to you, have you never answered one. Now wait till I come, by God, and I shall make you write so much that you will perhaps be sorry for it.

Dear Messer Francesco, I am sending thither Salai to learn from his Excellency the President what conclusion has been reached in the matter of the regulation of the water. . . .

Will you therefore have the kindness to answer me as to what has taken place and unless it is being settled will you for my sake be so kind as to urge the President a little and also Messer Girolamo Cusano to whom please commend me and offer my respects to his Excellency.[132]

Leonardo gave vent to his feelings in the following note:

First the benefices, then the works, then ingratitude, indignity and lamentations and then—[133]

In the summer of 1508 Leonardo returned to Milan, and in the following years worked under the patronage of Charles d'Amboise. He was not only court painter but also architect and engineer.

Memorandum of the money I have had from the King as my salary from *July 1508 to April next 1509.* First 100 scudi, then 100, then 70, then 50, then 20 and then 200 francs at 48 soldi the franc.[134]

The notebook known as MS. F which was begun soon after his arrival at Milan is entitled Di Mondo ed acque *and contains a plan for a treatise on water based on his own experience and observation. The notebook was used until 1513.*

Begun at Milan the *12th of September 1508.*[135]

Write first of all water, in each of its motions; then describe all of its beds and the substances therein, adducing always

the propositions concerning the aforesaid waters; and let the order be good, for otherwise the work will be confused. Describe all the forms that water assumes from its largest to its smallest wave, and their causes.[136]

I have seen motions of the air so furious that they have carried, mixed up in their course, the largest trees of the forest and whole roofs of great palaces; and I have seen the same fury with a whirling movement bore a hole and dig out a gravel-pit, and carry gravel, sand, and water more than half a mile through the air.[137]

Leonardo was working on a scheme for making the river Adda navigable and ensuring a waterway between Milan and the Lake of Como.

By making the canal of Martesana the water of the Adda has been greatly diminished through its distribution over many districts for the irrigation of the fields. . . .[138]

The following note is the only surviving description of the famous aqueduct built by the Veronese architect Fra Giocondo at the castle of Blois in order to provide water

for the gardens which were situated on a height. Fra Giocondo left France in 1506, when he was entrusted with the fortifications of Treviso which he completed in 1509, for the republic of Venice.

cd is the garden at Blois; *ab* is the conduit of Blois, made in France by Fra Giocondo; *bc* is, what is wanting in the height of that conduit; *cd* is the height of the garden at Blois; *ef* is the siphon of the conduit; *bc, ef, fg* is where the siphon discharges into the river.[139]

In the following note Leonardo refers to the League of Cambrai which united the great powers of Europe against Venice in 1508. The duchy of Milan had to prepare against hostilities on her eastern borders.

The Venetians have boasted of their power to spend 36 millions of gold in ten years in the war with the Empire, the Church, and the kings of Spain and France at 300,000 ducats a month.[140]

The maps of Brescian territory made by Leonardo and now at Windsor were presumably for purposes of defence or canalization.

On the *first of October 1508* I had 30 scudi. 13 I lent to Salai to make up his sister's dowry and 17 I have left.

Lend not! If you lend you will not be repaid, if you are repaid it will not be soon, if it is soon it will not be good coin, if it is good coin you will lose your friend.[141]

On 23 October 1508 Leonardo da Vinci and Ambrogio de Predis acknowledge the receipt of the last instalment amounting to 100 lire from the Confraternity of the Immaculate Conception for the picture of the Virgin of the Rocks (cf. pp. 293 and 359). Leonardo's lengthy disserta-

tion on fissures in walls and vaults may be dated about this time.

First write a treatise on the causes of the giving way of walls and vaults and then treat of the remedies. . . .[142]

The following notes throw further light on Leonardo's interests at this time.

Books from Venice.

Concave mirrors.

Philosophy of Aristotle, Meteorologica [On sublunary changes].

Archimedes on the centre of gravity.

Messer Ottaviano Pallavicino, for his Vitruvius.

The Dante of Niccolò della Croce.

Albertuccio [The philosopher Albert of Saxony].

Marliano on Calculation [De proportione motuum in velocitate].

Albertus [Magnus] On Heaven and Earth from the monk Bernardino.

Anatomy by Alessandro Benedetti.

Go every Saturday to the hot bath where you will see naked men.

Inflate the lungs of a pig, and observe whether they increase in width and in length, or increase in width while diminishing in length.[141]

He recalls past times, his lost friend Giacomo Andrea of Ferrara and Aliprando, former adherents of Ludovico il Moro (see p. 311).

Messer Vicenzo Aliprando, who lives near the inn of the bear, has the Vitruvius of Giacomo Andrea.[143]

In 1509 Fra Luca Pacioli's book De Divina Proportione

for which Leonardo had designed the illustrations was published in Venice.

28th of April 1509. Having for a long time sought to square the angle of two curved sides, that is the angle, which has two curved sides of equal curve, that is curve created by the same circle: now in the year 1509, on the eve of the calends of May, I have solved the proposition at ten o'clock on the evening of Sunday.[144]

Canal of San Cristoforo at Milan made on the *third day of May 1509*.[145]

This note is written on a careful drawing of sluices. For the supervision of work on this canal the French king conceded the right to a supply of water to Leonardo.

The granting of this right was followed by complications.

If it is said that by taking this water at Santo Cristofano, the King loses 72 ducats.

His Majesty knows that whatever he gives to me, of that he deprives himself. But in this case the King is not deprived of anything but it is taken away from those who have stolen it by altering the so-called mouths, which were enlarged by the thieves of the water. . . . If it is said that this is to the disadvantage of many it only is taking back from the thieves what they should restore. The magistrate does this constantly of his own accord taking more than 500 ounces of water, while the quantity agreed upon for me is only 12 ounces.

If it is said that this water of mine is of considerable value per year, here, where the canal is at such a low level, the ounce is hired at only 7 ducats of 4 lire each per year that is 70. If they say that this hinders the navigation it is not true, because the mouths supplying this water are above the navigation.[146]

The following entry in his notebook known as MS. G provides an approximate date for his studies of plant life on its pages.

1510, on the 26th of September Antonio (Boltraffio) broke his leg. He must rest 40 days.[147]

The sun gives spirit and life to the plants and the earth nourishes them with moisture. With regard to this I made the experiment of leaving only one small root on a gourd and this I kept nourished with water, and the gourd brought to perfection all the fruits it could produce, which were about 60 gourds of the long kind, and I set my mind diligently to consider this vitality and perceived that the dews of night were what supplied it abundantly with moisture through the insertion of its large leaves and gave nourishment to the plant and its offspring—or the seeds which its offsprings had to produce.[148]

South of Lake Como he admired the size of the chestnut trees.

At Santa Maria Itre in the Valley of Rovagnate in the mountains of Brianza are rods of chestnuts of 9 braccia and one out of 100 will be as much as 14 braccia.[149]

On 21 October 1510 Leonardo took part in a consultation on the choir-stalls of Milan Cathedral.
 Leonardo continued his studies in anatomy. The following note is written on a large sheet with drawings of muscles.

There are as many muscles of the feet as double the number of toes. But as I have not yet finished this discourse I will leave it for the present, and *this winter of the year 1510* I look to finish all this anatomy.[150]

According to Vasari the famous anatomist Marc Antonio della Torre helped Leonardo in his researches. He was teaching at the University of Pavia in 1511, and Leonardo probably refers to him in the following note:

Book 'on the water' to Messer Marco Antonio.

[With drawing of child in womb.]
The heart of this child does not beat and the child does not breathe because it lies continually in water, and if it were to breathe it would be drowned, and breathing is not necessary to it since it receives life and is nourished from the life and food of the mother.[151]

Another note may refer to the behaviour by students in the anatomy classes:

Make a discourse on the censure deserved by students who put obstacles in the way of those who practise anatomy and who abbreviate research.[152]

Many of his notes at this time refer to the study of embryology.

See how the birds are nourished in their eggs.[153]

Whether the child while within the body of the mother is able to weep or produce any sort of voice or no. The answer is no; because it does not breathe, neither is there any kind of respiration; and where there is no respiration there is no voice.[154]

Ask the wife of Biagino Crivelli* how the capon rears and hatches the eggs of the hen when he is in the mating season.
They hatch **the** chickens by making use of the ovens by the fire-place.

* Biagino Crivelli, at one time head of the crossbowmen of Ludovico il Moro.

Those eggs which are of a round form will be cockerels and the long-shaped ones pullets.

Their chicken are given into the charge of a capon that has been plucked on the under part of its body, and then stung with a nettle and placed in a hamper. When the chicken nestle underneath it, it feels itself soothed by the sensation of warmth and takes pleasure in it, and after this it leads them about and fights for them, jumping up into the air to meet the kite in fierce conflict.[154]

Monbracco, above Saluzzo—a mile above the Certosa, at the foot of Monte Viso has a quarry of stratified stone, white as Carrara marble and flawless, and as hard as porphyry or even harder; of which my friend Master Benedetto,* the sculptor, has promised to send me a small slab for the colours, *on the 2nd day of January 1511.*[155]

On 10 March 1511 Leonardo's patron Charles d'Amboise died.

On the tenth of December 1511 at 15 o'clock the fire was kindled. On the 18th of December 1511 at 15 o'clock this second fire was kindled by the Swiss at Milan at the place called DCXC.[156]

These two notes are written on drawings of conflagrations by Leonardo but are not in his handwriting.

Soon afterwards the French were defeated, and the son of Ludovico il Moro was restored to the Duchy of Milan with the help of Swiss soldiery. But fighting continued, and Leonardo remained in his home awaiting the outcome.

And I saw one whose heart burst as he fled before his enemies. And he poured out sweat mixed with blood through all the pores of his skin.[157]

* Probably Benedetto Briosco of Pavia.

O speculator about this machine of ours let it not distress you that you gain knowledge of it through another's death, but rejoice that our Creator has ordained the intellect to such excellent perception.[158]

Leonardo was continuing his anatomical researches. On a sheet with drawings of the diaphragm and various architectural sketches including a plan and elevation of a turret he wrote a date and the following notes.

January 9, 1513.
 The room in the tower of Vaneri.
 Look at the dead dog, its lumbar region, the diaphragm and the motion of the ribs.[159]

The following memoranda in the same manuscript throw further light on Leonardo's interests and occupations. He passed some time at the villa of his young friend Melzi, situated on the banks of the river Adda at Vaprio.

Memorandum
To go to make arrangements for my garden.
 Giordano, De Ponderibus.★
 The conciliator, the flow and ebb of the sea—
 Have two boxes made to go on a pack saddle
 Look to Boltraffio's lathe and have a stone taken away
 Leave the book for Messer Andrea Tedesco
 Make a balance with a cock and weigh the substance when heated and then weigh it again cold
 The mirror of Master Luigi
 Oil, rock oil;
[With drawing]
 a. b. the flow and ebb of the waters; proved at the mill of Vaprio That power shows itself to be greater which is impressed upon a weaker substance.

 ★ Jordanus' mathematical work of the beginning of the 13th century first published in 1496.

This conclusion is universal and applies to the flow and ebb to prove that the sun or moon impresses itself so much the more upon the waters as they are of less depth; and therefore the shallow waters of marshes must receive the cause of the ebb and flow with greater efficacy than do the mighty depths of the ocean.[160]

Of the power of a vacuum formed instantaneously.

I saw at Milan a thunderbolt strike the Torre della Credenza on its northern side, and it descended with a slow movement down that side and then suddenly parted from that tower and carried with it and tore away a part of the wall, three braccia in breadth and length and two in depth; and this wall was four braccia thick and was built of old bricks, thin and small.[161]

His love of animals and the belief that plants afford sufficient nutriment for man induced him to forgo animal food (cf. p. 382).

'King of animals' as thou hast been described. I should rather say 'king of beasts', thou being the greatest, because thou dost only help them in order that they may give thee their children for the benefit of the gullet, of which thou hast tried to make a sepulchre for all animals. . . .

Now does not nature produce enough simple [i.e. vegetarian] food for thee to satisfy thyself? And if thou art not content with such canst thou not by the mixture of them make infinite compounds, as Platina describes* and other writers on food.[162]

V. ROME, AMBOISE, 1513–19

In September 1512 a bloodless revolution in Florence permitted the return of the Medici. Giuliano, known as Il Magnifico, was placed at the head of the State; and in

* Bartolomeo Sacchi, called Il Platina, *De Arte Coquinaria.*

March of the following year his brother Giovanni was hailed by the Romans as Pope Leo X. Giuliano became Gonfaloniere of the papal forces. The rise of the Medici to power induced Leonardo to leave Milan for Rome in the hope of finding a more fruitful field for work under the patronage of the two art-loving sons of Lorenzo il Magnifico who would surely remember his Florentine origin and fame. His decision was taken after the exhausted French garrison had abandoned the castle of Milan on 19 September 1513 and there did not seem any likelihood of an early return of the French, who had been his patrons.

I left Milan for Rome *on the 24th day of September 1513* with Giovanni, Francesco Melzi, Salai, Lorenzo and il Fanfoia.[161]

In crossing the Apennines he passed the Sasso della Vernia, described by Dante as 'the frowning rock between the sources of the rivers Arno and Tiber'. On his way he looked out for fossils.

And I found some shells in the rocks of the high Apennines and mostly at the rock of La Vernia.[161]

The ancient bottoms of the sea have become mountain ridges.[163]

In Rome Leonardo was lodged in the Belvedere, a luxurious summer palace built on the top of the Vatican Hill. His patron, Giuliano de' Medici, was interested in art and science, but was weak and unstable.

Finished on the *seventh day of July* at the twenty-third hour at the Belvedere in the studio given me by the Magnifico. *1514.*[164]

It is not known what work was completed on this date. At this time the Pope had found in Raphael an artist

entirely to his taste. A story told by Vasari reveals his attitude to Leonardo, to whom he had given a commission to paint a picture. 'On learning that he had set out by experimenting on the varnish he proposed to use, the Pope exclaimed: "Alas, this man will never get anything done, for he is thinking about the end before he begins."'
Two Germans in Leonardo's employment were the source of much irritation, as is revealed in the following drafts of letters addressed to Il Magnifico. Among other complaints he states that his anatomical studies at the Ospedale di Santo Spirito were being misinterpreted. These notes give a sad picture of Leonardo's life in Rome. It was a period when his hopes of employment had been frustrated and his nerves were reacting to the misbehaviour of an apprentice.

So greatly did I rejoice, most illustrious Lord, at the desired restoration of your health that my own malady almost left me. But I greatly regret that I have been unable to satisfy completely the wishes of Your Excellency by reason of the wickedness of that German deceiver, for whom I have left nothing undone which I thought might give him pleasure, and at first I invited him to lodge and board with me so that I should constantly see the work he was doing and with greater ease correct his errors, and moreover he would learn the Italian tongue, and so be able to talk with greater ease without an interpreter.

At first his moneys were always given him in advance of the time, then he asked that he might have the models finished in wood, just as they were to be finished in iron, and wished to carry them away to his own country. But this I refused, telling him that I would give in drawing the width, length, height and form of what he had to do, so we remained at ill will. The next thing was that in the room

where he slept he made himself another workshop with pincers and tools and there he worked for others; afterwards he went to dine with the Swiss of the Guard where there are idle fellows, but he beat them all at it; then he used to go out and often two or three of them went together with guns to shoot birds among the ruins, and this went on until the evening. . . .[165]

As I saw that he was seldom in the workshop, and consumed a great deal, I sent him word that if he liked I could make a bargain with him for whatever he made and would give him what we might agree to be a fair valuation; he took counsel with his neighbour and gave up his room, selling everything and went to find . . .

This other has hindered me in anatomy blaming it before the Pope and likewise at the hospital; and he has filled the whole Belvedere with workshops of mirrors and workmen; and he has done the same thing in Maestro Giorgio's room. . . .

He never did any work without discussing it every day with Giovanni, who then spread the news of it and proclaimed it everywhere, stating that he was a master of such art: and as regards the part which he did not understand he announced that I did not know what I wanted to do, thus shifting the blame of his ignorance upon me. I cannot make anything secretly because of him for the other is always at his elbow, since the one room leads into the other. But his whole intent was to get possession of these rooms in order to get to work on the mirrors. And if I set him there to make my model of a curved one he would publish it.[166]

Leonardo evidently wished to keep his experiments to himself and could not trust his workmen. The model of a curved glass, referred to above, may have some connexion with a projected arrangement of lenses to serve as telescope. But it is doubtful whether the invention of this instrument

may be attributed to him since it was not in use till a century later. However, his notebooks contain sketches of machines for grinding and polishing lenses.

As I propose to treat of the nature of the moon, it is necessary that I first describe the perspective of mirrors, whether plane, concave, or convex.[167]

Construct glasses to see the moon magnified.[168]

[With plans]
Stable for the Magnifico . . . one hundred and ten braccia long and forty braccia wide . . . the lower part is divided into thirty-four rows for horses and each of these rows is divided into thirty-two spaces, called intercolumnar, each of which can accommodate two horses with a swing-bar interposed between them. This stable therefore can accommodate 128 horses.[169]

The following note was accompanied by drawings of a hand-operated mint, built to stamp coins for the Papal State. One side of the apparatus cut the metal disk and the other side stamped the impression.

Mint at Rome

All coins which do not have the rim complete are not to be accepted as good; and to secure the perfection of their rim it is requisite above everything that all coins should be a perfect circle; and be made perfect in weight, size and thickness.

Therefore have several plates of metal made of this same width and thickness all drawn through the same gauge so as to come out in strips. And out of these strips you will stamp the coins, quite round, as sieves are made for sorting chestnuts; and these coins can then be stamped in the way indicated above &c. . . .

This cuts the coins perfectly round and of the exact thick-

ness and weight; and saves the man who cuts and weighs and the man who makes the coins round. It therefore passes only through the hands of the gauger and of the stamper, and the coins are very superior.[170]

In the autumn of 1514 Leonardo made a trip to Lombardy, perhaps to look after his vineyard. He put up at an inn at Parma.

At the Campana at Parma on the *25th day of September, 1514.*[171]

On the banks of the Po near S. Angelo on the *27th day of September 1514.*[172]

At the end of the year Leonardo had returned to Rome. In a letter dated 14 December 1514 *his sister-in-law Alessandra, writing to her husband Ser Giuliano da Vinci in Rome, sent greetings to Leonardo, 'a very excellent and most singular man'. On the back of this sheet Leonardo noted that his book on 'Voice' was in the hands of Gian Battista Branconi, who was a confidential member of the papal court, a friend of Raphael. This book may have been submitted to the Pope in order to prove the absence of every element of heresy or scandal from his anatomical studies. It contained a description of the structure of the mouth and throat and of the mechanism of human speech.*

Messer Battista dell' Aquila has my book 'de vocie' in his hands.[173]

The same treatise is mentioned again in a notebook that Leonardo used during this time.

'De Vocie'—why a swift wind passing through the pipes makes a shrill sound.[174]

During his stay in Rome Leonardo made excursions into the neighbourhood, pursuing his interest in geology.

Let them show you where are the shells on Monte Mario.[175]

His project for draining the Pontine Marshes dates probably from this time. He drew a careful map of the district which is now at Windsor Castle (R., Plate CXIV).

The Magnifico Giuliano de' Medici left [Rome] on the 9th of January 1515 at daybreak to take a wife in Savoy; on the same day fell the death of the King of France.[147]

Leonardo here records the receipt of the news of the death of his former patron Louis XII on 1 January 1515. His successor Francis I set out at once to recover the duchy of Milan and won the battle of Marignano in September of that year.

On 14 December 1515 Pope Leo X held a secret conference with King Francis at Bologna, and Leonardo may have met for the first time the King, who some months later was to induce him to come to France. A statement in the Vatican archives regarding Leonardo's expenses at Bologna records that he received 33 ducats for himself and 7 ducats for Giorgio, the German, 40 ducats in all.

The Pope travelled via Civitavecchia, and Leonardo's notes on the antique ruins of the harbour may have been made on that journey. He profited by the visit in order to make a close inspection of antique Roman methods of construction.

[With drawings]
. . . Like this are the stones standing in front of the mole in the harbour of Civitavecchia. . . . A block is ten braccia

wide and 12 long and half a braccio deep built of mortar and slabs of tenacious tufa spongy and hard, tenacious in themselves without crumbling, and the surface of this cement is well plastered with perfect mortar and sand. The above mentioned half braccio of concavity is filled with big and hard gravel half a braccio deep, and over this gravel is placed a layer of mortar and minute pieces of brick, and this is a third of a braccio deep, over which the mosaic is laid with various designs of foliage and groups of stones in various colours; and these are the floors of the imperial rooms, built over the mole of the port; in front of these rooms were porticoes with big columns to which the ships were tied. And in front of this portico were nine steps down to the water: that is 3 braccia.[176]

In a letter dated 1515 Andrea Corsali writes to Giuliano de' Medici of some gentle people called Guzzati who refused to partake of food that had blood, who had agreed among themselves to do no harm to any living thing, 'just like our Leonardo da Vinci'.

With the death of Giuliano de' Medici on 17 March 1516 Leonardo lost his patron, and his hopes of finding a fruitful field for his activities in Rome were shattered. The following note reflects his disappointment. He was thinking of the brilliant outset of his career when Lorenzo il Magnifico had sent him to Ludovico il Moro, and of the indifference and incomprehension of the Pope, his son.

The Medici made me and ruined me.[177]

His last dated note written in Rome shows him interested in the measures of one of its basilicas.

San Paolo in Rome has 5 naves and 80 columns and in its width across the naves is 130 braccia, and from the steps of the high altar to the door is br. 155, and from these steps to

the farther wall at the back of the high altar br. 70, and the portico is 130 br. long and 17 br. wide. Taken *August 1516*.[178]

Towards the end of 1516 Leonardo accepted the invitation of Francis I and went to stay at the small castle of Cloux, near the royal residence at Amboise on the Loire. The French King had a sincere love of letters and art, and during his reign and that of his predecessor numerous Italian artists and craftsmen were installed at the court. He greatly admired Leonardo and told Benevenuto Cellini twenty years later 'that he believed no other man had been born who knew as much about sculpture, painting and architecture, but still more that he was a very great philosopher'. It is said that he enjoyed Leonardo's conversation almost every day.

The following note reveals Leonardo's attitude towards his listeners in conversation.

Words which do not satisfy the ear of the listener weary him or vex him, and you will often see symptoms of this in the frequent yawns of such listeners; therefore when you speak before men whose good will you desire, and see such an excess of fatigue, abridge your speech, or change the subject; and if you do otherwise you will earn dislike and hostility instead of the hoped for favour. And if you want to see in what a man takes pleasure, without hearing him speak, change the subject of your discourse in speaking to him and, when he presently becomes intent and does not yawn nor wrinkle his brow and the like, you may be certain that the matter which you are speaking is agreeable to him.[179]

Ascension Day at Amboise in Cloux. *May 1517*.[180]

On 1 October 1517 Rinaldo Ariosto wrote to Marchese

*Gianfrancesco Gonzaga describing a festival at Argentan
which had been organized by Leonardo for Francis I and
where a mechanized lion was much admired.*

On 10 October 1517 the Cardinal Luigi of Aragon
visited Leonardo's studio. He was accompanied by his
secretary Antonio de Beatis, who wrote the following
account of the event: 'In one of the outlying parts [of
Amboise] Monsignor and the rest of us went to see Messer
Leonardo da Vinci, the Florentine, who is more than
seventy years old, and is one of the most excellent painters
of the day. He showed His Eminence three pictures, one
of a certain Florentine lady done from life for the late
Magnificent Giuliano de' Medici,* another a young John
the Baptist, and a third the Madonna and Child seated
on the lap of St. Anne, all perfect. Nothing more that is
fine can be expected of him, however, owing to the
paralysis, which has attacked his right hand. A Milanese,
who was educated by him and paints excellently, lives
with him. Although Leonardo can no longer paint with his
former sweetness he can still draw and teach others. This
gentleman has written of anatomy with such detail, show-
ing with illustrations the limbs, veins, tendons, intestines
and whatever else there is to discuss in the bodies of men
and women in a way that has never yet been done. All
this we have seen with our eyes; and he said that he had
dissected more than thirty bodies of men and women of all
ages. He has also written on the nature of water, on
various machinery and on other matters, which he has
set down in an infinite number of volumes all in the vulgar
tongue; which if they were published would be useful
and very delightful.'

* Was this the Mona Lisa, which the King of France is said to
have bought from the artist for 1,000 gold crowns?

*In this note addressed to Leonardo he is given the title
'Peintre du Roy!' The writing is partly illegible.*

To Monsieur de Vinci . . . the horses of the king's equerry. . . .

 Continue the payment to Mons. Lyonard, painter to the
king. Amboise.[181]

*Plan to construct transportable houses near the royal
hunting lodge at Romorantin.*

On moving houses.

 Let the houses be moved and arranged in order; and this
will be done with facility because such houses are at first

made in pieces on the open places, and can then be fitted together with their timbers in the site where they are to be permanent.

Let the men of the country partly inhabit the new houses when the court is absent.

The main underground channel does not receive turbid waters, but that water runs in the ditches outside the town with four mills at the entrance and four at the outlet; and this may be done by damming the water above Romorantin.

There should be fountains made in each piazza.[182]

French canal project.

If the river *mn*, a tributary of the river Loire, were turned with its turbid waters into the river of Romorantin it would enrich the lands that it irrigated and would render the

country fertile to supply food for the inhabitants and it

would serve as a navigable canal for merchandise. . . .[182]

The eve of St. Anthony [*13 Jan. 1518*] I returned from Romorantin to Amboise and the king left Romorantin two days before.[183]

In May 1518 the French court at Amboise celebrated the baptism of the Dauphin and the marriage of Lorenzo de' Medici, the Pope's nephew, to a French princess. The festivities went on for weeks, and included a brilliant tournament. In the evening of 19 June 1518, *the king brought his great company of guests to Leonardo's château at Cloux where the court had been turned into a wonderful ballroom covered by a dome of deep blue fabric from which the sun, moon, and stars shone on the guests below. This magic night at Cloux brought the festivities at Amboise to a close.*

On the *24th of June, 1518*, the day of St. John, at Amboise in the palace of Cloux.[184]

This is the last dated note in Leonardo's hand.

LEONARDO'S WILL

April 23, 1519.

Be it known to all persons, present and to come, that at the court of our Lord the King at Amboise before ourselves in person, Messer Leonardo da Vinci, painter to the King, at present staying at the place known as Cloux near Amboise,

duly considering the certainty of death and the uncertainty of its time, has acknowledged and declared in the said court and before us that he has made according to the tenor of these presents, his testament and the declaration of his last will as follows:

And first he commends his soul to our Lord, Almighty God, and to the glorious Virgin Mary, and to our Lord Saint Michael, to all blessed angels and Saints male and female in Paradise.

Item. The said Testator desires to be buried within the church of Saint Florentin at Amboise, and that his body shall be borne thither by the chaplains of the church.

Item. That his body may be followed from the said place to the said church of St. Florentin by the collegium of the said church, that is to say by the rector and the prior, or by their vicar and chaplains of the church of St. Denis at Amboise, also the Minors of the place; and before his body shall be carried to the said church this Testator desires that in the said church of St. Florentin three grand masses shall be celebrated by the deacon and sub-deacon and that on the day on which these three high masses are celebrated, thirty low masses shall also be performed at St. Gregory.

Item. That in the said church of St. Denis similar services shall be performed as above.

Item. That the same shall be done in the church of the said friars and Minors.

Item. The aforesaid Testator gives and bequeaths to Messer Francesco da Melzo, nobleman of Milan, in remuneration for services and favours done to him in the past, each and all of the books the testator is at present possessed of, and the instruments and portraits appertaining to his art and calling as a painter.

Item. The same Testator gives and bequeaths henceforth for ever to Batista de Vilanis one half, that is, the moiety of his garden, which is outside the walls of Milan, and the other half of the same garden to Salai his servant; in which garden

aforesaid Salai has built and constructed a house which shall be and remain henceforth in all perpetuity the property of the said Salai, his heirs and successors; and this is in remuneration for the good and kind services which the said de Vilanis and Salai, his servants, have done him in past times until now.

Item. The said Testator gives to Maturina his waiting woman a cloak of good black cloth lined with fur, a . . . of cloth, and two ducats paid once only; and this likewise in remuneration for good service rendered to him in past times by the said Maturina.

Item. He desires that at his funeral sixty tapers shall be carried by sixty poor men, to whom shall be given money for carrying them at the discretion of the said Melzo, and these tapers shall be distributed among the four above-mentioned churches.

Item. The said Testator gives to each of the said churches ten lbs. of wax in thick tapers, which shall be placed in the said churches to be used on the day when those services are celebrated.

Item. That alms be given to the poor of the Hôtel Dieu, to the poor of Saint Lazare d'Amboise and, to that end, there shall be given and paid to the treasures of that same fraternity the sum and amount of seventy soldi of Tours.

Item. The said Testator gives and bequeaths to the said Messer Francesco Melzo, being present and agreeing, the remainder of his pension and the sums of money which are owing to him from the past till the day of his death by the receiver or treasurer-general M. Johan Sapin, and each and every sum of money that he has already received from the aforesaid Sapin of his said pension, and in case he should die before the said Melzo and not otherwise; which moneys are at present in the possession of the said Testator in the said place called Cloux, as he says. And he likewise gives and bequeaths to the said Melzo all and each of his clothes which he at present possesses at the said place of Cloux, and

all in remuneration for the good and kind services done by him in past times till now, as well as in payment for the trouble and annoyance he may incur with regard to the execution of this present testament, which however, shall all be at the expense of the said Testator.

And he orders and desires that the sum of four hundred scudi in his possession, which he has deposited in the hands of the treasurer of Santa Maria Nuova in the city of Florence, may be given to his brothers now living in Florence with all the interest and usufruct that may have accrued up to the present time and be due from the aforesaid treasurers to the aforesaid Testator on account of the said four hundred scudi, since they were given and consigned by the Testator to the said treasurers.

Item. He desires and orders that the said Messer Francesco de Melzo shall be and remain the sole and only executor of the said will of the said Testator, and that the said testament shall be executed in its full and complete meaning and according to that which is here narrated and said, to have, hold, keep and observe, the said Messer Leonardo da Vinci, constituted Testator, has obliged and obliges by these presents the said his heirs and successors with all his goods movable and immovable, present and to come, and has renounced and expressly renounces by these presents all and each of the things which to that are contrary.

Given at the said place of Cloux in the presence of Magister Spirito Fleri, vicar of the church of St. Denis at Amboise, of Mr. Guglielmo Croysant, priest and chaplain, of Magister Cipriane Fulchin, Brother Francesco de Corton, and of Francesco da Milano, a brother of the Convent of the Minorites at Amboise, witnesses summoned and required to that end by the indictment of the said court in the presence of the aforesaid M. Francesco de Melzo, who accepting and agreeing to the same has promised by his faith and his oath which he has administered to us personally and has sworn to us never to do or say nor act in any way to the

contrary. And it is sealed by his request with the royal seal apposed to legal contracts at Amboise, and in token of good faith.

Given on the *23rd day of April 1518 before Easter.**

And on the 23rd day of this month of April 1518 in the presence of M. Guglielmo Borian, Royal notary in the court of the bailiwick of Amboise, the aforesaid M. Leonardo da Vinci gave and bequeathed by his last will and testament as aforesaid to the said M. Baptista de Vilanis, being present and agreeing the right of water which the King Louis XII of pious memory lately deceased, gave to this same da Vinci, the stream of the canal of Santo Cristoforo in the duchy of Milan, to belong to the said Vilanis for ever in such wise and manner that the said gentleman made him this gift in the presence of Mr. Francesco da Melzo, gentleman of Milan, and in mine.

And on the aforesaid day in the said month of April in the said year 1518 the same M. Leonardo da Vinci by his last will and testament gave to the aforesaid M. Baptista de Vilanis, being present and agreeing, each and all of the articles of furniture and utensils in his house at present at the said place of Cloux, in the event of the said de Vilanis surviving the aforesaid M. Leonardo da Vinci, in the presence of the said M. Francesco Melzo and of me, Notary, &c. Borian.[185]

2 May 1519. *Death of Leonardo at Cloux.*

On 1 June 1519 Francesco Melzi wrote from Amboise to the brothers of Leonardo announcing his death. The will had been made valid by royal decree and would be sent as soon as a trusted person could be found. Meanwhile he wished to report that Leonardo had left to them his estate

* Date according to the French calendar. In 1518 Easter fell on 4 April, while in 1519 it fell on 24 April. The will was therefore written on 23 April 1519, nine days before his death.

at Fiesole and the 400 scudi deposited at 5 per cent. with the treasurer of Santa Maria Nuova at Florence.

'To me he was like the best of fathers', he wrote, 'for whose death it would be impossible for me to express the grief I have felt; and so long as these my limbs endure I shall possess a perpetual sorrow, and with good reason, since he showed to me day by day the warmest love and devotion. It is a hurt to anyone to lose such a man, for nature cannot again produce his like.'

12 August 1519. Entry in the register of St. Florentin at Amboise: 'In the cloister of this church was buried M.ᵉ Leonard de Vincy, noble Milanese, first painter, engineer and architect of the King, State mechanist, and sometime director of painting of the Duke of Milan.'

REFERENCES TO MANUSCRIPTS

Abbreviations used in referring to Leonardo's manuscripts

A, B, C, D, E, F, G, H, L, M, in the Library of the Institut de France. Published by Ravaisson Mollien, Paris, 1881–91. This publication includes

B.N. 2037, B.N. 2038, formerly in the Bibliothèque Nationale and now also at the Institut. They originally formed part of MSS. B and A.

C.A. Codex Atlanticus, at the Ambrosiana in Milan. Published by Giovanni Piumati, Milan, 1894–1904.

W. Manuscripts at the Royal Library at Windsor, catalogued by Sir Kenneth Clark, Cambridge, 1935.

Triv. Codex Trivulzi, Castello Sforzesco, Milan. Published by Luca Beltrami, Milan, 1891.

Trn. Small codex on the flight of birds in the Royal Library at Turin. Published in Milan, 1946.

Leic. Codex of the Earl of Leicester, at Holkham Hall, Norfolk. Published by Gerolamo Calvi, Milan, 1909.

S.K.M. I, II, and III. Codices Foster, in the Library of the Victoria and Albert Museum at South Kensington. Published by the Reale Commissione Vinciana, Rome, 1930–6.

B.M. Arundel MS. in the British Museum. Published by the Reale Commissione Vinciana, Rome, 1923–30

Ox. Sheets with annotated drawings at Christ Church, Oxford. Published by the Reale Commissione Vinciana, Rome.

V. Sheets with annotated drawings in the Academy at Venice. Published by the Reale Commissione Vinciana, Rome.

F.L. *Trattato* attributed to Francesco di Giorgio Martini, annotated by Leonardo, at the Laurenziana in Florence.

Numbers relate to folios. *r*. and *v*. mean recto and verso. o means cover of manuscript. For example: C.A. 150*v*. means back (verso) of folio 150 of the Codex Atlanticus; Trn. o means cover of codex at Turin.

Trat. *Trattato della Pittura* in the Vatican Library (Codex Urbinas 1270). A collection of transcripts made in the six-

teenth century from manuscripts that have since to a great extent been lost. Published by H. Ludwig, Vienna, 1882.

R. Richter, J. P. *The Literary Works of Leonardo da Vinci*, a comprehensive selection from the texts mentioned above with translation. This work includes a detailed history and analytical index of the manuscripts and numerous reproductions. Second edition, Oxford, 1939.

CO-ORDINATIONS

CHAPTER I

1. C.A. 119*v*.
2. C.A. 117*r*.
3. W. 19084*r*.
4. Triv. 20*v*.
5. B.N. 2038 19*r*.
6. C.A. 154*r*.
7. Trat. 33.
8. B. 4*v*.
9. Triv. 33*r*.
10. S.K.M. III. 14*r*.
11. C.A. 86*r*.
12. E. 55*r*.
13. C.A. 345*v*.
14. C. 23*v*.
15. S.K.M. III. 43*r*.
16. I. 18*r*.
17. C.A. 147*v*.

18. W. 19118*v*.
19. G. 96*v*.
20. W. 19084.
21. Trat. 1.
22. A. 8*v*.
23. Leic. 25*v*.
24. Leic. 11*r*.
25. A. 47*r*.
26. M. 57*r*.
27. F. 2*v*.
28. I. 130*r*.
29. G. 47*r*.
30. G. 8*r*.
31. E. 8*v*.
32. W. 19045*v*.
33. W. 19048*v*.
34. Leic. 29*v*.

CHAPTER II

1. C.A. 385*v*.
2. F. 27*r*.
3. B.M. 160*r*.
4. B.M. 175*r*.
5. B.M. 155*v*.
6. H. 95*r*.
7. F. 87*v*.
8. Leic. 15*v*.
9. Leic. 17*v*.
10. E. 12*r*.
11. C. 26*v*.
12. A. 26*r*.

13. Leic. 26*v*.
14. W. 19092.
15. B.M. 57*r*, *v*.
16. C.A. 84*v*.
17. F.L. 15.
18. C.A. 296.
19. W. 12579*r*.
20. Leic. 34*v*.
21. C.A. 20*r*.
22. B.M. 19*r*.
23. Leic. 36*r*.
24. C.A. 361*v*.

25. Leic. 31r.
26. Leic. 3r.
27. Leic. 36r.
28. F. 80.
29. Leic. 9v.
30. Leic. 10v.
31. C.A. 155r.
32. F. 23v.
33. W. 19108r.
34. C.A. 126v.
35. B.M. 30v.
36. Leic. 1v.
37. Leic. 6v.
38. Leic. 31v.
39. B.M. 138r.
40. C.A. 328v.
41. Leic. 10v.
42. C.A. 263v.
43. Leic. 13r.
44. Leic. 1v.
45. Leic. 32v.
46. Leic. 27v.
47. F. 35r.
48. C.A. 108v.
49. A. 61r.
50. A. 9v.
51. F. 87v.
52. C.A. 169r.
53. C.A. 270.
54. Leic. 4r.
55. F. 25v.
56. A. 55v.
57. C.A. 212v.
58. A. 54v.
59. A. 56r.
60. C.A. 171r.
61. B.M. 235r.
62. W. 19048r.
63. W. 19047v.
64. B. 4v.
65. B.M. 279v.
66. C.A. 190r.
67. E. 15v.
68. B.M. 94v.
69. B.M. 54r.

70. F. 56r.
71. W. 12669r.
72. F. 5r.
73. B.M. 184v.
74. C.A. 123r.
75. S.K.M. II. 117r.
76. V.
77. C.A. 117r.
78. W. 19009r.
79. B.M. 145v.
80. W. 19060.
81. B.M. 204r.
82. B.M. 205r.
83. Trn. 1r.
84. Trn. 2v.
85. S.K.M. II. 116v.
86. B.M. 195r.
87. B.M. 123r.
88. I. 22v.
89. B.M. 151v.
90. C.A. 253r.
91. B.M. 151.
92. H. 71v.
93. A. 34v.
94. C.A. 302.
95. A. 28r.
96. E. 42r.
97. I. 130v.
98. B.M. 176.
99. C.A. 108r.
100. E. 57r.
101. M. 44r.
102. M. 47v.
103. M. 45.
104. M. 48r.
105. M. 46r.
106. M. 49r.
107. M. 57.
108. G. 75r.
109. A. 35.
110. F. 51, 52.
111. C.A. 91v.
112. E. 58v.
113. M. 62v.
114. M. 63r.

115. M. 71*v*.
116. S.K.M. I. 44*r*.
117. S.K.M. II. 78*v*.
118. G. 87*r*.
119. E. 22*r*.
120. G. 73*r*.
121. G. 85*v*.
122. G. 72*v*.
123. I. 99*v*.
124. B.M. 82*r*.
125. I. 14*v*.
126. A. 24*r*.
127. S.K.M. III. 28*r*.
128. A. 34*v*.
129. A. 53*v*.
130. S.K.M. II. 74*v*.
131. S.K.M. III. 32*r*.
132. M. 83*v*.
133. Triv. 73*r*.
134. A. 27*v*.
135. A. 22*v*.
136. C.A. 155*v*.
137. E. 2*r*.

138. E. 35*r*.
139. S.K.M. II. 131*v*.
140. S.K.M. II. 85*v*.
141. S.K.M. II. 86, 87.
142. S.K.M. II. 132, 133.
143. C.A. 137*v*.
144. E. 59*v*.
145. C.A. 149*r*.
146. C.A. 81*v*.
147. M. 68*v*.
148. C.A. 93*v*.
149. S.K.M. II. 157*r*.
150. E. 69*r*.
151. S.K.M. II. 115*r*.
152. S.K.M. II. 51*r*.
153. A. 62*r*.
154. S.K.M. III. 83*r*.
155. S.K.M. III. 84*r*.
156. B.M. 191*r*.
157. F. 7*v*.
158. I. 17*r*.
159. S.K.M. II. 77*v*.
160. L. 53.

CHAPTER III

1. Trn. 3*r*.
2. F. 53*v*.
3. E. 54*r*.
4. K. 1, 3*r*.
5. W. 12657.
6. F. 41*v*.
7. C.A. 219*v*.
8. C.A. 168*v*.
9. Trn. 8*r*.
10. C.A. 108*r*.
11. G. 10*r*.
12. C.A. 395*r*.
13. F. 87*v*.
14. E. 28*v*.
15. E. 51*r*.
16. C.A. 45*r*.
17. Trn. 17*r*.
18. E. 45*v*.
19. E. 23*v*.

20. E. 23*r*.
21. E. 53*r*.
22. E. 46*r*.
23. E. 52*v*.
24. G. 63*v*.
25. F. 41*v*.
26. C.A. 66*r*.
27. M. 83*r*.
28. C.A. 168*r*.
29. Leic. 22*v*.
30. Trn. 11*r*.
31. C.A. 220*r*.
32. F. 53*v*.
33. C.A. 77*r*.
34. E. 54*r*.
35. E. 51*v*.
36. C.A. 308*v*.
37. L. 59*v*.
38. L. 58*v*.

39. L. 58, 59.
40. Trn. 6.
41. L. 62r.
42. E. 22v.
43. E. 37v.
44. E. 43v.
45. B.M. 166v.
46. G. 66r.
47. C.A. 377v.
48. B.N. 2037 10v.

49. W. 19116r.
50. C.A. 161r.
51. C.A. 381v.
52. Trn. 6r.
53. Trn. 16r.
54. F. 41v.
55. L. 61v.
56. L. 60v.
57. Trn. 8r.

CHAPTER IV

1. C.A. 90r.
2. W. 19019.
3. Trat. 511.
4. Trat. 19.
5. Trat. 28.
6. C.A. 345v.
7. Trat. 24.
8. C.A. 138r.
9. C.A. 135v.
10. C.A. 270r.
11. B.N. 2038 13r.
12. D. 8r.
13. W. 19150v.
14. B.N. 2038 1r.
15. C.A. 270v.
16. B.N. 2038 13v.
17. A .3r.
18. B.N. 2038 18r.
19. Trat. 6.
20. A. 1v.
21. B.N. 2038 12v.
22. S.K.M. II. 15v.
23. C. 21v.
24. C. 1r.
25. C. 13v.
26. C. 18r.
27. A. 8v.
28. A. 2v.
29. C.A. 101v.
30. A. 10v.
31. K. 120v.
32. A. 37v.

33. W. 19152r.
34. A. 37r.
35. W. 19118.
36. Trat. 3.
37. B.M. 160r.
38. B.M. 131v.
39. B.M. 132r.
40. Trat. 443.
41. Trat. 486.
42. B.M. 159.
43. F.L. 13v.
44. B.M. 232r.
45. Trat. 17.
46. C.A. 203r.
47. F. 49v.
48. C.A. 116r.
49. Trat. 33.
50. C.A. 204v.
51. C.A. 250r.
52. M. 80r.
53. B.N. 2038 21v.
54. W. 19076r.
55. W. 19152v.
56. E. 31v.
57. H. 90v.
58. B.N. 2038 32.
59. E. 32v.
60. A. 20r.
61. C. 10r.
62. B.N. 2038 29v.
63. B.N. 16v.
64. Trat. 93.

65. G. 3*v*.
66. E. 3*v*.
67. C.A. 179*r*.
68. G. 53*v*.
69. E. 18*r*.
70. Trat. 238.
71. Trat. 190.
72. Trat. 254.
73. W. 19076.
74. A. 19*v*.
75. A. 20*r*.
76. F. 75*r*.
77. C.A. 184*v*.
78. B.N. 2038 20*r*.
79. A. 26*v*.
80. Trat. 35.
81. Trat. 40.
82. B.N. 2038 25*v*.
83. W. 19109*r*.
84. G. 11*v*.
85. G. 29*r*.
86. B.M. 113*v*.
87. B.M. 172*v*.
88. C.A. 176*r*.
89. C.A. 270*r*.
90. E. o.
91. W. 19037 *v*.
92. M. 18*r*.
93. E. 6*v*.
94. Trat. 21.
95. Trat. 32.
96. V.
97. W. 19136.
98. W. 19131*v*.
99. W. 19140*r*.
100. B. 3*v*.
101. H. 31*r*.
102. B.N. 2038 28.
103. W. 19070*v*.
104. B.N. 2038 27*r*.
105. W. 19061.
106. W. 19017*r*.
107. W. 19061.
108. S.K.M. II. 116*v*.
109. W. 19010*v*.

110. B.N. 2038 30*r*.
111. B.N. 2038 29*v*.
112. Trat. 354.
113. Trat. 355.
114. E. 15*r*.
115. L. 27*v*.
116. W. 19038*v*.
117. L. 84*v*.
118. S.K.M. II. 50*v*.
119. W. 19070*r*.
120. Trat. 402.
121. Trat. 269.
122. Trat. 301.
123. Trat. 300.
124. C.A. 80.
125. C.A. 396*r*.
126. W. 19071*r*.
127. D. 5*v*.
128. K. 119*r*.
129. W. 19127*r*.
130. W. 19045*r*. and 19115*r*.
131. W. 19086*v*.
132. W. 19046.
133. C.A. 139*r*.
134. W. 19115*r*.
135. W. 19102*v*.
136. W. 19097*v*.
137. W. 12631*r*.
138. E. 16*r*.
139. C.A. 297*r*.
140. W. 12613.
141. W. 19030*v*.
142. G. 44*r*.
143. H. 109*r*.
144. B.M. 64*v*.
145. W. 19115.
146. W. 19070.
147. B.N. 2038 29*r*.
148. W. 19121*r*.
149. B.N. 2038 17*v*.
150. B.N. 2038 4*r*.
151. B.N. 2038 17*v*.
152. B.N. 2038 18*r*.
153. Trat. 60.
154. Trat. 501.

155. G. 32*v*.
156. G. 35*v*.
157. G. 33.
158. G. 16*v*.
159. G. 37*v*.
160. B. 17*v*.
161. G. 5*r*.
162. G. 14*r*.
163. G. 36*v*.
164. I. 12*v*.
165. W. 19103*v*.
166. G. 51*r*.
167. G. 27*r*.
168. E. 6*v*.
169. G. 8*r*.
170. Trat. 829.
171. Trat. 368.
172. Trat. 180.
173. Trat. 68.
174. Trat. 20.
175. Triv. 36*v*.
176. C.A. 139*r*.
177. B.N. 2038 20*r*.
178. B.N. 2038 29*v*.
179. B.N. 2038 17*v*.
180. Triv. 6*r*.
181. C.A. 199*v*.
182. B.N. 2038 21*r*.
183. S.K.M. II. 62*r*.
184. Trat. 264.
185. B.N. 2038 16*r*.
186. B.N. 2038 22*v*.
187. Trat. 66.
188. B.N. 2038 30, 31.
189. B.N. 2038 18*v*.
190. B.M. 169*r*.
191. B.N. 2038 21*r*.
192. W. 12665.
193. C.A. 354*v*.
194. Trat. 13.
195. B.N. 2038 20*r*.
196. Trat. 8.
197. Trat. 29.
198. Trat. 30.
199. B.M. 136*r*.

200. C.A. 382*v*.
201. Trat. 32.
202. B.N. 2038 20*r*.
203. B.N. 2038 19*v*.
204. B.N. 2038 20*r*.
205. Trat. 27.
206. K. 49.
207. B.M. 176*r*.
208. B.M. 173*v*, 190*v*.
209. A. 9*v*.
210. A. 23*r*.
211. C.A. 360*r*.
212. Trat. 31.
213. Trat. 40.
214. C.A. 215*v*.
215. C.A. 227*v*.
216. Trat. 4.
217. B.N. 2038 24, 25.
218. A. 50*r*.
219. S.K.M. II. 93*r*.
220. B. 27*r*.
221. B.M. 159*v*.
222. Leic. 21*r*.
223. B.M. 192*r*.
224. B. 36*r*.
225. B. 16*r*.
226. B. 29*v*.
227. C.A. 158*v*.
228. C.A. 271*v*.
229. S.K.M. III. 44*v*.
230. Trat. 58*a*.
231. B.N. 2038 27.
232. B.N. 2038 16*r*.
233. Trat. 77.
234. C.A. 184*v*.
235. B.N. 2038 26.
236. B.N. 2038 2*r*.
237. Trat. 23.
238. B.N. 2038 28*r*.
239. C.A. 122*v*.
240. B.N. 2038 20*v*.
241. C.A. 221*v*.
242. Trat. 39.
243. C.A. 76*r*.
244. G. 8*r*.

245. B.N. 2038 25*v*. 247. G. 33*r*.
246. C.A. 141. 248. S.K.M. III. 66*r*.

CHAPTER V

1. H. 5*r*.
2. H. 5*v*.
3. H. 6*r*.
4. H. 6*v*.
5. H. 8*r*.
6. H. 8*r*.
7. H. 9*v*.
8. H. 9*v*
9. H. 10*v*.
10. H. 17*r*.
11. H. 14*v*.
12. H. 17*v*.
13. H. 19, 21.
14. C.A. 67*r*.
15. C.A. 76*r*.
16. H. 44*r*.
17. B.M. 42*v*.
18. C.A. 175*v*.
19. C.A. 257*r*.
20. C.A. 145*r*.
21. I. 64*r*.
22. I. 65*r*.
23. C.A. 370*r*.
24. B.M. 42*v*.
25. C.A. 117*r*.
26. C.A. 370*v*.
27. I. 66*v*.
28. C.A. 137*v*.

29. I. 66*v*.
30. C.A. 37*v*.
31. C.A. 129*v*.
32. I. 64*v*.
33. I. 66*r*.
34. C.A. 119*r*.
35. C.A. 150*v*.
36. M. 58*v*.
37. C.A. 306*v*.
38. H. 63*v*.
39. H. 49*v*.
40. B.N. 2038 34*v*.
41. H. 40.
42. C.A. 117*v*.
43. S.K.M. II. 63*r*.
44. Ox.
45. W. 12700*v*.
46. C.A. 289*v*.
47. Trn. 17*v*.
48. W. 12282*r*.
49. W. 12701.
50. B.M. 155*r*.
51. B.M. 156*r*.
52. C.A. 145*v*.
53. C.A. 214*v*.
54. C.A. 311*r*., 96*v*.
55. I. 139*r*.

CHAPTER VI

1. S.K.M. III. 72*r*.
2. G. 89*r*.
3. L. 0.
4. S.K.M. III. 17*v*.
5. C.A. 109*v*.
6. C.A. 71*r*.
7. C.A. 12*v*.
8. C.A. 76*v*.
9. S.K.M. III. 55*r*.

10. S.K.M. III. 29*r*.
11. Triv. 34*r*.
12. C.A. 71*v*.
13. C.A. 112*r*.
14. C.A. 252*r*.
15. C.A. 91*v*.
16. Triv. 27*r*.
17. H. 33*v*.
18. C.A. 76*r*.

19. C.A. 29*v*.
20. B.M. 156*v*.
21. C.A. 398*v*.
22. C.A. 289*v*.
23. W. 19045*r*.
24. B.M. 156*v*.
25. S.K.M. III. 20*v*.
26. H. 89*v*.
27. H. 60*r*.
28. H. 32*r*.
29. H. 16*v*.
30. C.A. 76*v*.
31. L. 90*v*.
32. F. 96*v*.
33. W. 19001*r*.
34. Triv. 4*v*.
35. B.M. 147*v*.
36. C.A. 78*v*.
37. W. 19038.
38. Triv. 12*r*.
39. H. 119*r*.

40. H. 118*v*.
41. B. 3*v*.
42. Triv. 23*v*.
43. C.A. 39*v*.
44. C.A. 59*r*.
45. Triv. 40*v*.
46. Triv. 2*v*.
47. C.A. 119*v*.
48. C.A. 320*r*.
49. C.A. 71*r*.
50. W. 12642*v*.
51. S.K.M. II 41*v*.
52. H. 60*v*.
53. F. 96*v*.
54. C.A. 156*v*.
55. F. 5*v*.
56. W. 19115*r*.
57. Trn. 12*r*.
58. W. 12494*v*.
59. B.N. 2037 10*r*.
60. C.A. 65*v*.

CHAPTER VII

1. C.A. 66*v*.
2. C.A. 4*v*.
3. C.A. 252*r*.
4. C.A. 288*v*.
5. C.A. 262*r*.
6. C.A. 12*v*.
7. C.A. 324*r*.
8. C.A. 297*v*.
9. C.A. 391*r*.
10. B. 18*r*.
11. C.A. 333*r*.
12. B. 89*r*.
13. Triv. 6*v*.
14. C.A. 214*r*.
15. C.A. 270*r*.
16. B.N. 2037 5*v*.
17. C.A. 225*r*.
18. W. 19059.
19. B. 4*r*.
20. Leic. 10*v*.
21. B. 12.

22. C. 15*v*.
23. W. 12319.
24. W. 12294.
25. C.A. 291*v*.
26. Leic. 9*v*.
27. B. 58*r*.
28. C.A. 147*r*.
29. B. 66*r*.
30. B.N. 2038 34*v*.
31. S.K.M. III. 88*r*.
32. S.K.M. III. 62*v*., 68*r*., 15*r*.
33. S.K.M. III. 86*r*.
34. S.K.M. III. 2*v*.
35. H. 106*v*.
36. W. 12347.
37. H. 64*v*.
38. S.K.M. III. 49*v*.
39. H. 124*v*., 125*r*.
40. H. 65*v*.
41. Leic. 32*r*.
42. H. 38*r*.

43. H. 41r.
44. H. 105r.
45. H. 88v.
46. H. 98r.
47. H. 48v.
48. S.K.M. II. 159r.
49. S.K.M. II. 70v.
50. S.K.M. II. 28v.
51. S.K.M. II. 64v.
52. S.K.M. II. 65r.
53. W. 12592.
54. S.K.M. II. 158v.
55. S.K.M. II 3r.
56. S.K.M. II. 6r.
57. C.A. 323.
58. C.A. 318r.
59. I. 49r.
60. C.A. 231r.
61. I. 28v.
62. I. 34r.
63. 38v.
64. I. 32r.
65. C.A. 315v.
66. C.A. 335v.
67. I. 107r.
68. L. 94r.
69. Trat. 36.
70. C.A. 167v.
71. L. 15r.
72. C.A. 2r.
73. Leic. 4r.
74. Leic. 10v.
75. C.A. 87v.
76. Leic. 28r.
77. C.A. 211v.
78. C.A. 104r.
79. I. 130v.
80. I. 120v.
81. C.A. 210r.
82. C.A. 247r.
83. C.A. 230v.
84. C.A. 234v.
85. B.M. 270v.
86. C.A. 227v.
87. L. o.

88. L. 6v.
89. W. 12665r.
90. C.A. 193r.
91. L. 77v.
92. L. 33v.
93. L. 2r.
94. B.M. 279v.
95. L. 94v.
96. L. 21r.
97. Leic. 9r.
98. L. 6r.
99. L. 78v.
100. L. 91r.
101. L. 19v.
102. L. 78r.
103. K. 2r.
104. L. 72r.
105. L. 36v.
106. L. 77r.
107. L. 66v.
108. B.M. 202v.
109. B.M. 229v.
110. W. 19027v.
111. W. 19114v.
112. W. 12279.
113. Leic. 18v.
114. Leic. 13r.
115. C.A. 74.
116. B.M. 191r.
117. B.M. 272r.
118. C.A. 62v.
119. C.A. 71r.
120. B.M. 271v.
121. Trn. 18v.
122. Trn. o.
123. B.M. 132v.
124. B.M. 190 and C.A. 120r.
125. S.K.M. I. 3r.
126. C.A. 179v.
127. C.A. 132r.
128. R. 1348.
129. B.M. 1r.
130. B.M. 19r.
131. C.A. 317r.
132. C.A. 372v.

133. C.A. 335r.
134. C.A. 192r.
135. F. 1r.
136. F. 87r.
137. F. 37v.
138. F. 76v.
139. K. 100 r.
140. C.A. 218r.
141. F. o.
142. B.M. 157r.
143. K. 109v.
144. W. 19145r.
145. C.A. 395r.
146. C.A. 93r.
147. G. o.
148. G. 32v.
149. G. 1r.
150. W. 19016.
151. W. 19102.
152. W. 19063.
153. W. 19103.
154. W. 19101.
155. G. 1v.
156. W. 12416.
157. W. 19119v.
158. W. 19075v.
159. W. 19077.

160. W. 19092.
161. E. 1r.
162. W. 19084r.
163. E. 4r.
164. C.A. 90v.
165. C.A. 247r.
166. C.A. 182v.
167. B.M. 94r.
168. C.A. 190r.
169. C.A. 96v.
170. G. 43r.
171. E. 80r.
172. E. cf. R. 1376 B, note.
173. C.A. 287r.
174. E. 4v.
175. C.A. 92v.
176. C.A. 63v.
177. C.A. 159r.
178. C.A. 172v.
179. G. 49r.
180. C.A. 103r.
181. C.A. 174v.
182. B.M. 270v.
183. C.A. 336v.
184. C.A. 249r.
185. R. 1566.

INDEX

PRINTED IN GREAT BRITAIN
AT THE UNIVERSITY PRESS, OXFORD
BY VIVIAN RIDLER
PRINTER TO THE UNIVERSITY